LOOKING *for* MEXICO

LOOKING *for*

MEXICO

Modern Visual Culture and National Identity

John Mraz

DUKE UNIVERSITY PRESS

DURHAM AND LONDON 2009

To Isaac and Anna Lee,
who bring joy into my life,

and in memory of
Alfonso Vélez Pliego

CONTENTS

All translations from Spanish are mine unless otherwise indicated; in some cases, I have taken the liberty of condensing texts to make them more coherent.

I have used italics for certain Spanish terms that would be awkward, perhaps misleading, to translate. The following are brief definitions of those terms:

braceros: Mexican workers who were legally contracted to work in the United States under the Bracero Program, which lasted from 1942 to 1964

campesinos: people from the countryside, peasants

caudillos: strong men and rulers, as are *caciques* on a more limited scale

charros: cowboys on *haciendas*

Científicos: a group of entrepreneurs and ideologists that held great power during the rule of Porfirio Díaz, whose era is referred to as the Porfiriato (1876–1911)

costumbrismo: a genre of imagery and literature that focused on traditional customs and dress

hacendados: the owners of *haciendas*, large ranches

historia patria: the official history employed to construct a unified notion of the fatherland

Informe: the yearly presidential speech to the congress and the nation, comparable to the State of the Union Address in the United States

mexicanidad: Mexicanness; *lo mexicano* is a variety of *mexicanidad* that developed in the postrevolutionary period

ninguneo: the act of ignoring someone, who will then be *ninguneado*, treated as a nobody

pocho: the cultural mix of Spanish and English; the *pachuco* is an extreme expression of *pocho* culture

soldaderas: essentially camp-followers employed by soldiers as paid servants. During the revolution, they provided food and medical attention to the combatants.

Tehuanas: women from the Tehuantepec isthmus, dressed in traditional clothing

ACKNOWLEDGMENTS

In a way, this book began with, and has been consistently propelled by, invitations from friends to talk about Mexican photography and cinema in relation to issues of national identity: Janet Esser Brody at San Diego State University, Randal Johnson at the University of California at Los Angeles, Ryan Long at Oklahoma University, Eric Zolov at Franklin & Marshall College, Pedro Castillo at the University of California at Santa Cruz, Wendy Adelman at the Museum of Art and History in Santa Cruz, Paolo Knauss at the Universidade Federal Fluminense, Luis Ignacio Sainz at the Universidad Autónoma Metropolitana, Alejandro Castellanos at the Centro de la Imagen, John Perivolaris at the University of Manchester, Seth Fein at Yale University, Jim Krippner at Haverford College, Francisco Mata at the Universidad Autónoma Metropolitana-Xochimilco, Kazuyasu Ochai at Hitotsubashi University, Greg Crider at Wingate University, and Jaime Vélez and Fernando Osorio at the Escuela Nacional de Conservación, Restauración y Museografía. I thank them all for the stimulating exchanges that accompanied and followed my lectures. I am also grateful to Natalie Hartman, director of Latin American Studies at Duke University, for publishing a working paper, *Envisioning Mexico: Photography and National Identity*, which was a very early attempt to organize my thoughts about this topic.

The privileged conditions provided by the Instituto de Ciencias Sociales y Humanidades "Alfonso Vélez Pliego" of the Universidad Autónoma de Puebla made it possible to carry out this work. I have tried to express what I owe to Alfonso Vélez, founder of ICSYH, in dedicating this book to him. I would also like to thank Roberto Vélez Pliego and Agustín Grajales Porras, who, as directors of ICSYH, permitted me to structure my teaching around

this book's topic and displayed great comprehension of my absences during its writing.

This book could not have been written without the research of Mexican scholars in the history of their visual culture, as well as the many interlocutors who have helped me understand the country in which I have chosen to live: Jaime Vélez, Ariel Arnal, Patricia Massé, Fernando Aguayo, Ricardo Pérez Montfort, Rebeca Monroy, Rosa Casanova, Juan Carlos Valdéz, Arturo Aguilar, Beatriz Malagón, Ángel Miquel, Daniel Escorza, Miguel Ángel Berumen, José Luis Sánchez Estevez, Maricela González Cruz, Alberto del Castillo, Francisco Montellano, Julia Tuñon, Jack Lach, Ana Lau, Mari-Carmen de Lara, Polo Best, Gonzalo Rocha, Lucero González, Waldemaro Concha, Jimmy Montanéz Pérez, Jorge Luís Reyes, Elsa Medina, Pedro Valtierra, and Enrique Villaseñor. I thank all of them for our interchanges, and I would also like to recognize the labors of Pablo Ortiz Monasterio, Alfonso Morales, and José Antonio Rodríguez, who as editors of *Luna Córnea* and *Alquimia* have provided crucial forums for histories of Mexican photography.

I am grateful to the following friends for answering questions that arose in the course of writing this book: Jack Womack, Francisco Mata, John Hart, Paul Vanderwood, Drew Wood, Rodrigo Moya, and Pedro Meyer.

I thank the following for their extraordinary generosity in aiding me to provide images for this book. My *primo político*, Armando Bartra, allowed me to ransack his collection of *Presente*, a magazine unavailable in any public archive. Salvador Plancarte, sub-director de la Filmoteca de la Universidad Nacional Autónoma de México (UNAM), has been a constant source of information as well as materials on cinema. Several photographers gave me images from their archives: Rodrigo Moya, Héctor García, Elsa Medina, Pedro Valtierra, and Pedro Meyer. Ángel Miquel offered me pictures from his personal collection, as did Marco Buenrostro. Fernando Osorio, director of the Dirección de Artes Visuales de la Fundación Televisa aided me in obtaining access to that collection. Emma Cecilia García gave me a helping hand in approaching the collection of Manuel Álvarez Bravo, and I am grateful to Aurelia Álvarez Urbatjel for her assistance.

The time I spent working with Ana Mauad at the Universidade Federal Fluminense in Rio de Janeiro was invaluable in clarifying certain issues, and I am grateful to the Coordenação de Aperfeiçoamento de Pessoal de

Nivel Superior (CAPES), Ministério da Educação of Brazil for giving me a fellowship during 2004–2005. I also thank Professors Toshio Yanagida and Genaro Castro-Vázquez, of Keio University in Tokyo for enabling my access to facilities there.

Marysa Navarro gave me love and hell just when I needed it.

Gustavo Cubero assisted me throughout the writing of this work, and over the past few years I have given courses on this book's topics, in which a number of students have made invaluable observations, including Alejandra López Camacho, Ivan González Nolasco, Dolores Cabrera, Esther Cuatzón, Fidel Pérez, Noel Merino, and Osbaldo Zuñiga.

I thank Chuck Churchill, Paul Vanderwood, and Ryan Long for reading and critiquing parts of this book, and the anonymous readers for Duke University Press for their comments on the manuscript.

Finally, I once again acknowledge the constant and critical presence, and participation, of Eli Bartra, who read and commented on the entire book. I thank her for her help, her patience, and her love. This work has been a long haul for her as well.

None of this book's text has appeared in the form it takes here. However, earlier versions of some sections were published in the following works:

Essays on Emilio Fernández, Gabriel Figueroa, Fernando de Fuentes, *Redes*, Jorge Negrete, Pedro Infante, Sara Garcia, María Félix, and Cantinflas, in *The International Dictionary of Films and Filmmakers*, 4 vol. (London and Chicago: St. James and Macmillan Presses, 1984–87). Republished as www.filmreference.com (Thomson Gale, 2006).

"Foto Hermanos Mayo: A Mexican Collective," *History of Photography* 17, no. 1 (1993).

"How Real Is Reel? Fernando de Fuentes's Revolutionary Trilogy," in *Framing Latin American Cinema: Contemporary Critical Perspectives*, ed. Ann Marie Stock (Minneapolis: University of Minnesota Press, 1997).

"Manuel Alvarez Bravo," in *Encyclopedia of Twentieth-Century Photography*, ed. Lynne Warren (London: Routledge, 2006).

"Mexico/USA: Visual Transculturation and National Identity," *Transit Circle: Revista Brasileira de Estudos Americanos* 5 (2006).

La mirada inquieta: Nuevo fotoperiodismo mexicano: 1976–1996 (Mexico City: Centro de la Imagen, 1996).

"Moreno Reyes, Mario (Cantinflas), 1913–1993, Actor and Comedian," in *Encyclopedia of Mexico: History, Society and Culture*, ed. Michael S. Werner (Chicago: Fitzroy Dearborn Publishers, 1997).

"Negrete, Jorge, 1911–1953, Actor and Singer," in *Encyclopedia of Mexico: History, Society and Culture*, ed. Michael S. Werner (Chicago: Fitzroy Dearborn Publishers, 1997).

"The New Photojournalism of Mexico, 1976–1998," *History of Photography* 22, no. 4 (1998).

"Photographing Mexico," *Mexican Studies / Estudios Mexicanos* 17, no. 1 (2001).

"Picturing Mexico's Past: Photography and *Historia Gráfica*," *South Central Review* 21, no. 3 (2004).

"Representing the Mexican Revolution: Bending Photographs to the Will of *Historia Gráfica*," in *Photography and Writing in Latin America*, ed. Marcy E. Schwartz and Mary Beth Tierney-Tello (Albuquerque: University of New Mexico Press, 2006).

"The Revolution Is History: Filming the Past in Mexico and Cuba," *Film Historia* 9, no. 2 (1999).

"La trilogía revolucionaria de Fernando de Fuentes," in *El cine mexicano a través de la crítica*, ed. Gustavo García and David Maciel (Mexico City: Universidad Nacional Autónoma de México, 2001).

"Valdés, Germán (Tin Tan), 1915–1973, Comedian," in *Encyclopedia of Mexico: History, Society and Culture*, ed. Michael S. Werner (Chicago: Fitzroy Dearborn Publishers, 1997).

With Eli Bartra: "As duas Fridas: História e identidades transculturais," *Estudos Feministas* 13, no. 2 (2005); "Las Dos Fridas: History and Transcultural Identities," *Rethinking History* 9, no. 4 (2005); "Las Dos Fridas: Historia e identidades transculturales," *Secuencia: Revista de historia y ciencias sociales* 65 (2006).

With Jaime Vélez Storey: *Trasterrados: braceros vistos por los Hermanos Mayo* (Mexico City: Archivo General de la Nación, 2005); *Uprooted: Braceros in the Hermanos Mayo Lens* (Houston: Arte Público Press, 1996).

Identity is an optical illusion.
GUILLERMO GÓMEZ PEÑA

INTRODUCTION

T his is a subjective book, formed by my experiences in Mexican visual culture, my interests, and my opinions about what is important; I have made no attempt to be encyclopedic, for such a work would be unwieldy and, inevitably, selective as well.[1] I wrote this book with a U.S. audience in mind and have tried to provide a synthesis of some of the questions, the individuals, the styles, and the issues that I have found to be crucial to Mexico's modern visual culture, in the hopes of stimulating further research.[2] And, in that sense, it is more oriented toward opening up the enormous possibilities offered by the extraordinary wealth, and relevance, of this culture than in providing a definitive study of an almost infinite object. In the course of writing, each time I began with a new topic, I was left with the haunting sensation that it could easily lead off into book-length projects, as could almost any subject in the manuscript.

I have chosen to focus this work around the issue of identity, recognizing that I am entering a potential minefield that easily blows up in the faces of those who dare to tread there. A slippery concept in the best of cases, national identity is particularly problematic in Mexico, where it was long employed as the ideological justification for one of the world's longest-lasting party dictatorships (which ended in July 2000). To complicate matters even further, I am comparing image makers from historical periods in which the question of *mexicanidad* was explicitly addressed—for example, Hugo Brehme, Tina Modotti, Manuel Álvarez Bravo, Luis Márquez, Emilio "El Indio" Fernández, and Gabriel Figueroa—with later creators who may be surprised at my readings of their works, and even resistant to the notion that they were exploring that issue.[3] Finally, though I focus on individual "authors," I also examine the larger apparatus that almost always mediated,

and usually determined, the vision projected by photographers and cineastes: the visual culture created by government programs and publications, as well as the private sector's mass media industries, which have a complex relationship to the regime. Nonetheless, despite these perils, and caveats, I still think that it may be revealing to examine some of the ocular strategies for representing Mexico.

Identity does not grow up from the ground, nor drop down from the skies. Identity is not something given once and for all, nor is it discovered; it is constructed, deconstructed, and reconstructed endlessly. There is no Identity; there are only the different positions adopted in producing it. As Stuart Hall asserted, "Perhaps, instead of thinking of identity as an already accomplished historical fact . . . we should think of identity as a 'production,' which is never complete, always in process, and always constituted within, not outside, representation."[4]

I believe that identity construction in Mexico has been carried out largely through the modern visual cultures of photography, cinema, and picture histories. Benedict Anderson has argued that newspapers and novels "provided the technical means for 're-presenting' the *kind* of imagined community that is the nation" in eighteenth-century Europe.[5] Thomas Benjamin believes that the "master narrative" of Mexico has been produced by "poets, journalists, teachers, politicians, and writers."[6] I doubt that these media had such importance in Mexico, where low literacy rates have traditionally created a culture of images more than of words, and there are few bookstores, compared to countries such as Argentina. Further, Catholicism is a theology of images, especially so when compared to iconoclastic religions such as Judaism, Islam, and Protestantism. Mexican churches are noted for their icons of suffering saints, and reproductions of the national symbol, the Virgin of Guadalupe, are ubiquitous.

Perhaps the very credulity extended to images was the reason for transmitting what I perceived to be a remarkable television event. Juan Diego, the Indian on whose serape was miraculously stamped the Virgin's image in 1531, was named a saint by Pope John Paul II, who visited Mexico in 2002 to celebrate this. Among the hoopla over the canonization of Juan Diego and the Pope's presence was a reconstruction aired on Televisa (one of the two consortiums that control Mexican television). We see Juan Diego come from the field for a drink of water; the Virgin stands and watches, waiting to

be discovered. Suddenly, Juan Diego sees her, and her image is printed on his *tilma*, the cloak within which he has been miraculously gathering roses in the winter (the first Mexican photograph?).[7] The announcement was shot in black and white to give it a documentary feel, and perhaps for that reason the channel felt it was necessary to label it throughout with a conspicuous caption, "Re-creation" (*Recreación*), so that none of the audience would be left with the impression that newsreel teams were present in the sixteenth century to record the encounter.

I define modern visual culture as that produced by technical images and sounds: photography and cinema are the media I will focus on in this book.[8] I identify the credibility that photographic reproduction generates as one of the elements of its modernity; since the invention of photography in 1839, people have tended to assign it a higher truth value than they do to other visual expressions. Because it is the result of a certain "mechanical reproduction," it is believed in ways that other visual media are not, and its status as a "window onto the world" gives it enormous influence. I consider massification to be the second key element of visual modernity. Although the daguerreotype produced exact likeness, it could not be reproduced and distributed (and thus could not enter into the construction of identity as would the *carte-de-visite*, once it was invented in the 1850s). The *tarjeta de visita* (as the *carte-de-visite* was known in Mexico) was only the first step in the massive circulation of technical imagery, for it was followed by the postcard, the rotogravure machine that permitted the publishing of photographs in newspapers and magazines, and the cinema that would be seen by millions. Finally, I believe that a crucial aspect of modern visual culture has been the creation of celebrities. Thanks to widely circulating credible imagery that appears on *tarjetas*, postcards, screens, and the pages of illustrated magazines, the process of creating fame has been reversed: before, people who were famous for having accomplished something in reality were then accorded recognition in the media but, as this culture developed, individuals become celebrities simply for appearing there.

Mexico's otherness has made it one of the most photographed countries in the world; it has also created a ready-made stereotype of Orientalism that many image makers find attractive.[9] The question is how this otherness has been reproduced in photographs and movies—that is, how it is positioned in the production of identity—because picturesque representation is not only

a function of *what* is chosen but of *how* things are photographed as well. The reasons that Mexico is so photogenic are largely historical, although nature lends a helping hand with dramatic volcanoes, rolling cloud formations, and tropical splendors. Of course, the Mexican Revolution was one of the first of the world's great social cataclysms to be extensively photographed and filmed; icons from that struggle still permeate identity discourse. However, Mexico's visual uniqueness is provided principally by the extraordinary profusion of the architectural and human "vestiges" of the great pre-Columbian civilizations and the privileged colonial experience; the human vestiges are in some ways the result of an underdevelopment that keeps many Mexicans living in pasts that modernity would have eradicated. Those pictured in archaic and marginal forms of labor were known as "Mexican types" in the nineteenth century, but these unfortunates continue to be incorporated by contemporary photographers, both Mexican and foreign, as symbols of *mexicanidad*.

Picturing Mexico's otherness as exotic is problematic. The picturesque is first of all a political problem, because it is a strategy by which people whose skins are a bit darker are made to appear a little less human; those who take the pictures, and see them published, are somehow more human than those who are in them. The consequences of this can be seen in the facility with which "white" nations invade and control "darker" countries. The second problem with the picturesque is that it favors nature over history, essentialism over action. People are portrayed as products of nature, passive and quiescent, incapable of acting in the world, or simply irrelevant. Hence, better a nostalgia for a past that never existed than efforts to construct a future. Third, the folkloric presents an aesthetic problem for creators, in that it offers the easy way out; great artists know that it is the difficult tasks that will bring out the best in them, and they reject the picturesque as facile.

History is a fundamental element of identity but, again, it is a question of *how* the past is represented. To cite Stuart Hall again, "Far from being grounded in a mere 'recovery' of the past, which is waiting to be found, and which, when found, will secure our sense of ourselves into eternity, identities are the names we give to the different ways we are positioned by, and position ourselves within, the narratives of the past."[10] Historical photographs are everywhere in Mexico. Huge banners with the faces of Francisco I. Madero, Pancho Villa, and Emiliano Zapata hover over politi-

cal rallies. Restaurant walls are flavored by sepia-toned reproductions of soldiers embracing their sweethearts in train stations. Bureaucrats in government offices labor under the gaze of legendary heroes. Hotel and bank lobbies are decorated with pictures of cavalrymen under wide-brimmed sombreros who ride their steeds through cornfields, while the unfailing *soldaderas* (camp-followers) walk alongside. Markets of folk art have the inevitable stall dedicated to vendors of washed-out, overexposed copies, often from the Casasola Bazaar, as well as other forms of visual history: postcards, calendars, posters, T-shirts, jackets, coffee mugs, ashtrays, and other bric-a-brac. Illustrated magazines and newspapers reproduce classic images constantly, as do the multitude of illustrated *historias gráficas* celebrating Mexico's revolutionary past, where the pictures are fused with texts to instill a *historia patria* that will teach love of the fatherland.

Historia gráfica is the medium that most explicitly assigns meaning to historical photographs. Picture histories occupy a significant niche in Mexico, and this genre has a long trajectory, most apparently in the large format, multi-volume series that reproduce thousands of photographs, accompanied by an uneven assortment of texts. Since the 1920s, the story of Mexico's past has often been told through illustrated histories, and it continues to be an important forum in which leading historians have participated, including scholars with the prestige of Lorenzo Meyer, Enrique Florescano, Luis González y González, Javier Garciadiego, and Álvaro Matute, among many others. A main metatext of the *historias gráficas* is the presentation of Mexican history as if it were the domain of Great Men, a concept I employ in analyzing these works.[11]

Cinema is clearly fundamental in the construction of identities, but I have written very selectively about films in this book. Mexico has a prolific cinema industry and has produced more movies than any other national cinema in Spanish; hence, I felt that I should limit myself to what I consider to be significant films about particular issues.[12] The representation of the Mexican Revolution is obviously paramount in constructing *lo mexicano*, and I have attempted to examine the degree to which selected works might be said to have created a *historical* or an *essentialist* vision of that struggle and of revolutionary identity. Further, I felt that the fictional reconstructions of Frida Kahlo's life offered an opportunity to explore the issue of transculturalism in the twenty-first century, as Mexico and the United

States grow ever closer. I also decided to examine the star celebrities that so marked Mexican cinema, because they were models for cinematically defining *mexicanidad*, centered as they were at the core of a mediatic world of film, photography, and illustrated magazines.

Moreover, I have chosen to focus on works that move me aesthetically with their narrative power and/or visual style. Those who like Mexican genres of which I am not a fan, such as melodramas or wrestling films, will consider me biased in my feeling that the enormous majority of those works are of little interest to me. Nonetheless, mine is a decision based on some experience. I had no preconceptions about Mexican cinema when I moved to the country, and I began feverishly to make notes about the films I saw daily on television, as well as those to which I went, planning for some eventual study. But, within a few years, I found that it simply did not hold my attention, beyond what would have been a "sociological" perspective. I believe that the method of visual culture should include an element of aesthetics, which is absent from much of Mexican cinema.

Susan Buck-Morss remarked in 1996 that "visual culture, once a foreigner to the academy, has gotten its green card and is here to stay."[13] Today, the study of modes and techniques of visual address is fundamental to thinking critically about the times in which we find ourselves, and crucial for an education relevant to a world undergoing an "image revolution" on a scale so unprecedented that we are warned about the dangers of "hyper-visuality." Indeed, the incipient development of visual studies programs has been a direct—if tardy—reaction to the hegemony of images in contemporary society. The power exercised by the myriad of pictures which inundate our daily lives has generally received little attention in academia because they are produced by new and/or "unrespectable" media: photography, film, video, advertising, computers. Hence, when we think of Mexico's rich and vast visual culture, we probably picture Aztec effigies, skulls etched by José Guadalupe Posada, Frida Kahlo's self-portraits, and the murals of José Clemente Orozco, Diego Rivera, David Álfaro Siqueiros, and Rufino Tamayo. However, though the work of Mexican painters and lithographers has been fundamental in exploring national identity, technical images and sounds may be even more formative.

Mexicans sometimes seem to be "obsessed" with the question of identity, as the photojournalist Francisco Mata Rosas once remarked to me in a con-

versation. From whence such obsession? To some degree, it can be seen as a product of the conquest and subsequent racial conflict between Spaniards, Indians, and their offspring, the mestizos, a group that was to become the very symbol of nationality.[14] It can also be attributed to a justifiable pride in a unique past, composed of great pre-Columbian civilizations, a colonial period in which Mexico was the crown jewel of the Spanish empire, and a social revolution that anticipated those that would follow in the rest of the world throughout the twentieth century. Without question, it has served as a defense against the encroachment of the United States, whether in the form of direct military invasions or in the neocolonial culture that can to-day be seen at movie theaters, where the vast majority of films come from the northern neighbor, or on the sweatshirts that declaim, "Property of the Dallas Cowboys."[15] It is, as well, a result of the Mexican Revolution. The effervescence that followed the armed struggle of 1910–17 freed Mexicans from the "Frenchified" culture that so marked the reign of the dictator Porfirio Díaz (1876–1911), and led to the recovery of Mexico's Indian populations. Too, the reconstruction of the country was effected through the creation of a New Order that undertook a process of state formation that utilized *mexicanidad* as a way of legitimating its rule; only in recent years has this nationalism begun to be questioned by the neoliberal politics that have reigned since 1982.[16]

Modern visual culture began to arrive in Mexico with the first daguerreotypes in 1839, but it became bound to identity issues with the 1847 invasion by the United States, the point of departure for chapter 1, "War, Portraits, and Porfirian Progress (1847–1910)." In the world's first photographed war, Mexicans posed for and directed images expressing their positions. The *tarjetas de visita* were the first great visual mass medium, and these small portraits marked the onset of the celebrity culture that so dominates today's society. *Tarjetas* were expressive of personal and national identity; people wished to present themselves as modern and successful, though at the other end of the social scale, the *tarjetas* pictured lower-class "Mexican types," engaged in folkloric tasks and posed in front of exotic scenarios, introducing the picturesque style that would become a major trope for photographing the country. Commercial photography was largely the domain of foreigners such as William Henry Jackson, Charles B. Waite, and Winfield Scott, who were hired by businesses to document the country's modernization under

Porfirio Díaz, stimulating external investment and tourism. One who stayed to live in Mexico was Guillermo Kahlo, contracted by the government to photograph colonial architecture, an expression of the regime's interest in pushing a Hispanic, rather than Indian, sense of nation. Photojournalism begins around 1900, and it appears to have largely provided pictures of high society resplendent in Parisian attire, of factories with docile workers in orderly rows, of government functionaries inaugurating new public works and other demonstrations of progress, which reached its apogee with the celebration of the Centenario in 1910. There are few pictures of the Porfiriato's darker side, although John Kenneth Turner provided some.

Emiliano Zapata dresses with the sash and sword of Cuernavaca's authority after taking the city; a centaur-like Pancho Villa gallops toward the camera; "Adelita-the-*soldadera*" stares forcefully forward as she hangs out of a railroad car—these striking images of the Mexican Revolution come from the Casasola Archive and are among those featured in chapter 2, "Revolution and Culture (1910–1940)." From the outbreak of the struggle, Mexico was flooded by photographers and filmmakers who came to document the first great conflagration accessible to modern media. To defend his territory, Agustín Víctor Casasola formed a photojournalist agency, hiring some photographers to work for him and buying images from others. The Casasola agency and archive was a family business and became the source of the first of the *historias gráficas* that most modern Mexicans have seen. The effervescence that followed the war found expression in photography and film. Photographers faced a dilemma in portraying Mexico: whether to opt for the temptation of reproducing the beautiful exotic facade or look for different, and more difficult, ways to represent the country. Hugo Brehme and Luis Márquez followed the picturesque formula, while Tina Modotti produced the first critical photojournalism in Latin America in the pictures she made for *El Machete*, the Mexican Communist Party's newspaper. Manuel Álvarez Bravo shared Modotti's rejection of the exotic option, a pivotal decision in the development of antipicturesque photography. On the big screen, Fernando de Fuentes created his masterpieces during 1934 and 1935, *El Compadre Mendoza* and *¡Vámonos con Pancho Villa!*

The Mexican Revolution moved to the right in 1940, and the culture that reflected its institutionalization is examined in chapter 3, "Cinema and Celebrities in the Golden Age." Emilio Fernández and Gabriel Figueroa con-

verted the traumatic struggle for social justice into a confused tangle of meaningless atrocities, melodramatic theatricality, and a stunning visual style. History was reduced to trappings and still lifes: interchangeable uniforms, statuesque magueys, baroque chapels, exotic Indians, steely *charros*, and the visages of celebrity stars. The latter became profoundly implicated in the construction of *lo mexicano* during this period, due in part to the collaboration between the cinema industry and the illustrated press. The rise and decline of Cantinflas reflects the ebb and flow of revolutionary culture. He started out as the archetypical *peladito* who turns the table on the wealthy through ingenuity, but he eventually came to embody what Mexican critics describe as the worst stereotypes of their countrymen. His only authentic rival in comedy was Tin Tan, marginalized by official culture because his *pachuco* personage symbolized transculturation, modernity, urbanization, and the breakdown of traditional values. The *charro* is as much a metonym for Mexico as is the cowboy for the United States, and this figure is analyzed through its different incarnations. Jorge Negrete depicts the seigniorial *charro*, ruler of the *hacienda*. Pedro Armendáriz embodies the revolutionary *charro*, riding his steed through magueys while dressed in ambiguous military costumery. Pedro Infante is the postrevolutionary *charro*, sensitive and entering modernity as an urban worker. Women are encapsulated in the figures of the mother, the Indian, and the shrew. Sara García was Mexico's self-sacrificing matron in more than fifty movies. Dolores del Río went from cosmopolitan stardom in the United States to become a humble little Indian girl in Fernández's films. María Félix has been described as the principal myth of Mexican cinema where, if she played the role of the shrew tamed on several occasions, it was nonetheless not a part of her extrafilmic persona.

The nationalism fomented by the dictatorship of the Partido Revolucionario Institucional (PRI) was determinant in turning the search for identity into an excuse for inequality; this phenomenon, and the responses it provoked, are considered in chapter 4, "Illustrated Magazines, Photography, and *Historia gráfica* (1940–1968)." The picture press of *Hoy, Mañana*, and *Siempre* was instrumental in constructing a regime of patriarchal presidentialism. More than one-fourth of all the articles in these publications focus on the president, and the unconditional adulation given him was extended to the wealthy and powerful. Attempting to redefine the "Mexican style," the

magazine *Presente* openly denounced presidential corruption and illegality during the regime of Miguel Alemán (1946–52), becoming a milestone in the press before it was destroyed. Like most photojournalists, Enrique Diaz participated wholeheartedly in unbridled admiration for the rulers, while *campesinos* and Indians were portrayed in the picturesque style. However, dissidents such as the Hermanos Mayo and Hector García provided a critical look, focusing on the underside of Mexico's "miracle." Gustavo Casasola began to plumb the family archive in the 1940s, producing the first version of the large and profusely illustrated *Historia gráfica de la Revolución Mexicana*, which was steadily revised and republished throughout the century. In 1962, it was joined by *Seis siglos de historia gráfica en México*, another huge collection with thousands of photographs crammed onto the pages of many large volumes that also went through multiple reprintings.

The 1968 student movement is a watershed in Mexican history and identity; it opens chapter 5, "New Ocular Cultures and the Old Battle to Visualize the Past and Present (1968–2007)." Cineastes have offered a variety of interpretations of '68, beginning with the legendary documentary *El grito* by Leobardo López. In 1975, Felipe Cazals directed *Canoa*, a reconstruction of the 1968 killing of students by *campesinos* egged on by a priest, which became what I call a "phantom '68." An attempt to deal directly with the repression was Jorge Fons's *Rojo amanecer* (1989), a film about the Tlatelolco massacre, and one of the most articulate expressions of the "Imperfect Cinema" concept engendered by the New Latin American Cinema. In the 1970s, the independent daily press opened its pages to a New Photojournalism that brings a critical eye to picturing Mexico. At the same time, photographers such as Graciela Iturbide and Flor Garduño continue the tradition of exoticism, reconfiguring *mexicanidad* in the guise of women rather than *charros* and *chinas poblanas*. The presidency of Miguel de la Madrid (1982–88) was the last gasp of "Revolutionary Nationalism," and it paid for the writing, visual research, and massive printings of several voluminous series of picture histories, in all of which the Great Men of History are on center stage. The question of transculturalism—as well as history and gender—is brought to the fore through an analysis of the fiction films made about Frida Kahlo. Finally, I contrast the representational poles of digital imagery and neorealist form. Pedro Meyer is a pioneer of digitalization and founder of the bilingual Internet site "Zonezero: From Documentary to Digital Pho-

tography." One effect of the digital revolution may be the loss of the very credibility by which we define "modern" media. Francisco Vargas offers the counterpoint in his documentary-style film *El violín* (2007), which utilizes realist technique to reassert the power of technical imagery to be a witness to the real world.

In sum, the modern visual culture of photographs, films, illustrated magazines, and picture histories has been a powerful agent in the construction of Mexico's national identity since 1847, perhaps even the dominant one after around 1920. Of course, all cultures are formed by the communications systems they create and within which they find themselves. But each society will also have its particular archetypes, its unique natural settings, its own peculiar past, and its respective present. Mexico has been blessed and damned with the extraordinarily photogenic possibilities offered by ancient civilizations, colonial monuments, and an underdevelopment that has been seen too often as grist for the picturesque mill. Mexicans make themselves through—and have been made by—the webs of significance spun by modern media; that is the subject of this book.

WAR, PORTRAITS, MEXICAN TYPES,

AND PORFIRIAN PROGRESS (1840–1910)

M odern visual culture began to appear in Mexico around the same
time as an event that was definitive for national identity. The in-
vasion and occupation of Mexico from 1846 to 1848 was a determinant
step toward U.S. hegemony and Mexico's underdevelopment; coinciden-
tally, it was also the onset of today's hypervisual world. The Mexican War
(or "North American Intervention," as it is called south of the border) was
the first conflict in the world to be documented in both lithographs and
photographs, harbingers of the mass communications that dominate con-
temporary existence.

Since 1848, the United States has represented the most powerful foreign
influence over Mexico, which is essentially a neocolony of its great northern
neighbor. Although the United States usually determines Mexico's political
arrangements through economic forces rather than direct military inter-
vention, war established Mexico's subaltern status; the country was dis-
membered and lost half of its territory, an area encompassing present-day
California, Texas, Nevada, Utah, Arizona, New Mexico, most of Colorado,
and parts of Wyoming, Kansas, and Oklahoma. Even today Mexicans feel
this loss, though they often turn it into a typically ironic and self-deprecating
jest, which demonstrates the remarkable blend of resentment, admiration,
and distrust they feel for "Americans." It is not uncommon to hear Mexicans
joke that the *gringos* not only took half of Mexico, they took the best half:
that which is paved with super highways, populated by booming modern
cities, and flourishing with irrigated agriculture.

U.S. readers eagerly awaited the latest eyewitness accounts from the

front, and newspapers engaged in an intense competition to satisfy them. At the same time, technological innovations in lithography created a medium that reached a broad audience with increasingly credible images. The number of lithographs of the Mexican War is considerable, but those made of the country's veritable nucleus, Mexico City's central plaza, the Zócalo, illustrate the different ways in which this struggle was represented. U.S. lithographs of the entry into the Zócalo by General Winfield Scott and his army generally showed the occupying army being greeted as liberators: one (by Christiane Schuessele) depicted the streets filled with prosperous Mexicans cheering the invaders and waving U.S. flags, while the orderly ranks paraded by with arms sheathed, receiving the benedictions; another (by Christian Mayr) included well-attired Mexican women who hailed the invaders with their handkerchiefs from the balconies, as General Scott tipped his befeathered headdress in acknowledgment.[1]

The backgrounds for these lithographs were copied from an earlier cityscape of the Zócalo, realized by Carl Nebel in 1836. Nebel was a German artist who traveled throughout Mexico from 1829 to 1834 and either continued to live in Mexico City or returned during the U.S. occupation. In his rendition of "Genl. Scott's Entrance into Mexico," Nebel provided quite a different image, which probably comes closest to capturing the tense hostility between Mexicans and U.S. forces during the invasion.[2] The streets are empty of the Mexican families that appeared in the Schuessele and Mayr lithographs, while U.S. troops mill about on alert. In the foreground, a "*lépero*," a metonym for those groups of indigents that harassed the occupying army, prepares to throw a stone at the entourage that, sabers drawn, guards General Scott; above, Mexican snipers peer down from the roof at the invading army. Cannons have been drawn up to put down any popular uprising, and those Mexicans not actively resisting look on largely from behind windows and curtains. It is difficult to say whether Nebel's depiction was the result of his on-the-spot observations of relations between Mexicans and U.S. soldiers or expressed the sympathies he may have developed for a country he had visited at length.

It is also interesting to ask whether Nebel's view was shared by George Wilkins Kendall, a U.S. newspaper editor and correspondent who invited Nebel to make this lithograph (and eleven others) for the work in which they originally appeared, *War between the United States and Mexico Illustrated*,

published in 1851. Kendall had founded a leading penny press newspaper, the *Picayune*, which was a "fervent organ for annexation and expansion at the expense of Mexico."[3] However, despite his imperial enthusiasm, he was caught up in the reigning obsession for eyewitness accuracy, which led competing newspapers to claim their articles were "daguerreotype reports." Kendall went to Mexico during the war, and his experiences there must have convinced him of the hostility felt toward the invaders, though he may also have felt the necessity to include some measure of resistance in order to establish his credibility. The strategy worked, at least in the United States, where the images were universally lauded for their truthful and impartial representation—"with the faithfulness of a daguerreotype reflection"—and are today considered to be the most authoritative of the Mexican War lithographs.[4]

We do not know what Mexicans in 1851 might have thought of Nebel's rendering of Scott's entrance, but recent commentaries indicate that they are sensitive about it. One scholar, Fabiola García Rubio, is disturbed by its widespread use in primary school textbooks throughout the nation.[5] Though García Rubio acknowledges the shortage of Mexican images of the war, she nonetheless is bothered by the complacent and uncritical way in which this image is employed as an illustration for children's history books. She asks whether the editors have really looked closely at this picture of the U.S. flag flying over the Zócalo and insists that this is not a positive vision of Mexican history. The cartoonist Rafael Barajas ("El Fisgón," the Snooper) also finds the image disturbing. He depicted President Felipe Calderón (2006–12) sleeping soundly, his dream bubble filled with the Nebel lithograph as a representation of the "Plan Mexico" that would tie the country even closer to the United States.[6] It should be noted that both Barajas's reproduction and García Rubio's analysis omit reference to the *lépero*'s resistance.

In 1848, a recognized Mexican lithographer, Plácido Blanco, produced a book, *Apuntes para la historia de la guerra entre México y los Estados Unidos*. However, Blanco appears to take no side in the conflict, and the images are conventional portraits of Mexican and U.S. military commanders, as well as battle maps.[7] To find pictures depicting an active response to the invasion, we must turn to some that are much less sophisticated than those made by lithographers such as Nebel or Blanco. Attributed to Abraham López, two tiny prints that were published in *calendarios*, a sort

of almanac, offer the view from underneath. In the first, "El Pueblo apedrea los Carros" (The people stone the wagons), we see the representation of an 1847 incident in which a U.S. caravan was attacked by Mexicans in the Zócalo.[8] A year later, López published another small image depicting a scene in the main square, "Los azotes dados por los Americanos" (Whipping by the Americans), which showed the public punishment of a man who had attempted to kill a U.S. soldier.[9] The flogging evidently produced greater resistance, for the gathered crowd began to throw stones; U.S. dragoons then attacked and dispersed them.

Daguerreotypes were widely known by the time of the Mexican War, for they began to arrive in Mexico and the United States in 1839, shortly after their invention in France. Though they were unique, one-of-a-kind images that could not be reproduced, they became the first popular form of photography, and the invading U.S. forces were accompanied by itinerant photographers, who were among the thousands of their countrymen who seized the business opportunities offered by military occupations. The daguerreotypists made pictures of the soldiers as souvenirs, as well as photos that could be sold to lithographers and transformed into publishable prints; these images are the first photographs of war made in the world. Most of the few surviving daguerreotypes appear to have been taken in or near Saltillo, while U.S. forces occupied that city during 1847 and 1848. There are some interesting exterior images of mounted troops and foot soldiers, but the bulk of the daguerreotypes are studio portraits of officers who gaze off at an angle, indifferent to the camera and spectators, assuming the pose of Matthew Brady's "Illustrious Americans."[10]

Among the daguerreotypes made by U.S. photographers, that of a "Mexican Family" (as it is identified on the back) is singular (see figure 1). If Mexico was soon to become a favorite spot for those photographers seeking picturesque views, there is nothing exotic about this image! Eleven people have been assembled for the picture: five women, four adolescent boys, a young girl, and an obscured figure that appears to be an older man. The absence of adult males is significant: they probably made themselves scarce in Saltillo, because they were either suspected of serving in the resistance or were actually involved in it. And the variety of poses also makes the image far from what would be a typical family photograph. At the picture's center, the oldest adolescent assumes a defiant pose and returns the camera's gaze,

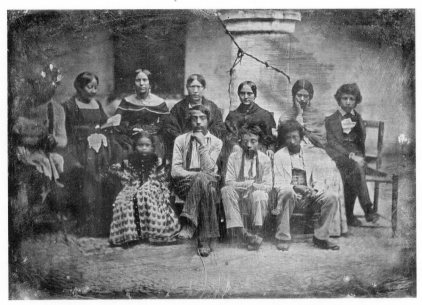

1. Anonymous. Mexican family captured by U.S. photographer, Saltillo, Coahuila, 1847. Amon Carter Museum, Fort Worth, Texas.

while the young girl next to him seems to share his attitude, hands on her hips and her elbows akimbo. Three adolescent males slouch and appear to fidget. Three of the women sit in neutral face-on postures, though another woman assumes a classic pose for paintings, pretending to be reading a book. One woman holds a hand to her face, perhaps ashamed to be appearing in the scene. In general, they seem to be an uncooperative group, and the reports of atrocities committed against the Mexican population by U.S. troops in the Saltillo area may account for their apparent discomfort.[11] The fact that most of the participants look back at the camera may reflect an ignorance of the portrait conventions followed by a substantial majority of the posing U.S. officers in other Mexican War daguerreotypes, who face away at an angle. However, the returned gaze may also represent a sense of identity expressed through resistance.

The war's most intriguing daguerreotype, and probably the first instance of a directed "photojournalistic" scene, was produced by a Mexican surgeon, Pedro Vander Linden, to recreate his role in the conflict.[12] The doctor was in the midst of amputating a soldier's leg when his position was overrun by U.S. forces, and he wrote a scintillating text about the experience that was

published in the official government journal just three weeks afterward.[13] There he described how honor would not allow him to abandon a man in the middle of amputating his leg, although the rain of cannon fire made death seem inevitable. When U.S. soldiers arrived, they were at the point of shooting him. However, as he dramatically narrated it, "I don't know what emotion led me to throw myself in front of their rifles, showing my hands dripping with blood and holding a piece of the amputated leg. I shouted, 'Respect humanity. We are surgeons.' My words were like magic. An officer appeared from among them, who raised their rifles with his sword, and those men were from then on our friends and protectors. They brought me wounded from both sides, and we treated them, as is required by humanity and our regulations."[14]

It is unclear when Pedro Vander Linden restaged this scene, and the daguerreotype did not appear with the text (it was not possible to publish photographs in periodicals until the 1890s). He probably realized it relatively soon after the incident, though there is no reason to assume that "it must have been reconstructed only hours after the battle," as Olivier Debroise asserts.[15] Rather, the soldiers' clean dress uniforms—Vander Linden wears medals!—and faces that show little sign of battle fatigue would seem to indicate that the doctor wrote up his report quickly but waited to pose the daguerreotype. Moreover, the sergeant's stump has no bandage to stem the bleeding and appears to be healed. The image was made in collaboration with a U.S. daguerreotypist, because Vander Linden was taken prisoner at the battle of Cerro Gordo. He was forced to remain with the U.S. forces as a doctor until he left Mexico accused of treason, probably because he had been a favorite of Santa Anna, who fell with the U.S. victory.[16] Hence, one imagines that both the picture and the text were motivated by his need to project his commitment to Mexico, especially as a foreigner.

The "prodigious exactitude" with which the daguerreotype portrayed the visible world signaled the onset of a culture built around the credibility of technical images.[17] However, because they were prohibitively expensive for more than 95 percent of the population, and each picture was unique (non-reproducible), they did not enter into the mass circulation that later formats would enjoy. Daguerreotype cameras arrived in Veracruz in December of 1839, introduced by a French resident of Mexico, Louis Prélier, who eventually had to auction them off for want of buyers.[18] Photography was brought

into Mexico by foreign owners of stores that sold a wide variety of European luxury items to the upper class. Most of its early practitioners were also foreigners, itinerant photographers who traveled about the country making portraits for a limited market of wealthy clients. Perhaps photography can best be seen as one of the importations of modernity, another expression of the desire to join those on the cutting edge.

A leading liberal thinker, Mariano Otero, expressed the fascination with photography of those who wished to transform Mexico: "The national representation should be the image of society, taken by a daguerreotype."[19] Unfortunately, in a country of enormous inequalities, many were excluded from the picture by its price. In the early 1840s, a daguerreotype could cost from two to sixteen pesos, depending upon its size, when the monthly wage for a housekeeper was around eight to ten pesos, and that of a chambermaid was about four to five pesos.[20] As in the rest of Latin America, the absence of a middle sector in Mexico greatly reduced the amateur image makers who might have taken the landscapes, panoramas, and urban views so characteristic of early photography in Europe and the United States, as well as clients to whom the professionals could have sold such pictures. Apparently, most Mexican daguerreotypes were portraits, and they were almost always of the well-off, dressed in European styles, though one or another surviving image presents us with men attired in the *charro* clothing favored by *hacendados*, and women who cover themselves with traditional Mexican *rebozos* (shawls).[21] Although the cost of photography dropped quickly, first with the ambrotype and then sharply with the *carte-de-visite*, about the only way a working woman could be in an early daguerreotype was as a nursemaid holding a child. In that case, the portrait was obviously not of her, and her necessary but accidental presence was sometimes resolved by covering her with a sheet.[22]

Tarjetas de visita and other French Invasions

The *tarjeta de visita* (*carte de visite*) marked the real ascendance of modern visual culture in Mexico, as it did throughout those parts of the world to which it arrived. Combining the credibility of the daguerreotype with mass production and wide circulation, this medium launched technical images into the very center of social existence, where they created the celebrity, constructed a bourgeois self-image of elegant modernity, and prettied up

the lower classes; they also documented the poor, the prostituted, and the imprisoned. Invented in France by André Adolph Disdéri during the early 1850s, the diminutive (2 1/2 × 4 inch), *cartes de visite* were made by four-lensed machines that could record quadruple images or take them in rapid succession. The glass negatives were printed on paper, mounted on cardboard, and cut into individual pictures. Unskilled labor played a major role in photography for the first time, and prices were greatly reduced: a dozen *cartes de visite* cost less than a single daguerreotype, and they could be reproduced by the thousands.

The *tarjetas de visita* quickly became avidly exchanged personal calling cards that embodied the image one wished to give of oneself. They were collected in albums that every respectable family displayed in their living rooms to evidence their lineage and exhibit their connections; there, they were jumbled together with *tarjetas* of celebrities that incorporated this sovereign personage of modern life into the personal sphere. The albums also sometimes included "national types," engaged in what today appear to be exotic street trades. The *cartes de visite* achieved enormous popularity, and millions participated in the "card mania" craze, buying them in a wide variety of stores. Photography evolved into a mass commercial venture, impelled by royal patrons such as Queen Victoria, owner of more than a hundred albums with portraits from every foreign court; and Napoleon III assured the acceptance of Disdéri's invention by having himself and his family photographed in poses that portrayed him as a democratic president.

Napoleon's imperial adventure of placing Ferdinand Maximilian of Hapsburg and his wife, Carlota, on thrones in Mexico coincided with the introduction of the *tarjeta de visita* and resulted in the first real boom of photography in this country. The royal couple understood and utilized the power and credibility of visual culture to promote themselves as no Mexican politicians had before, and Carlota was obstinate in her efforts to acquire *cartes de visite* for her numerous collections.[23] They were the first celebrities to appear massively in *tarjetas de visita*, and no other public figures rivaled the interest they provoked. Their pictures began to circulate even before Maximilian had accepted the throne, their portraits were present at all ceremonies and official acts, and they appointed a court photographer, Julio de Maria y Campos.[24] In an ocular appeal to nationalism that identified them with the Virgin of Guadalupe, a cornerstone of *mexicanidad*, they were

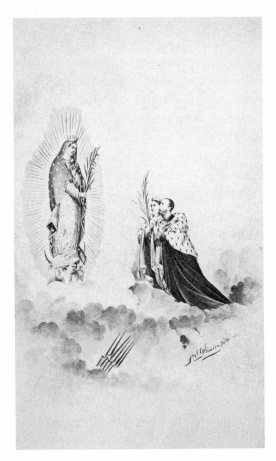

2. Anonymous. A post-mortem memoriam in which the Emperor Maximilian and the Empress Carlota kneel before the Virgin of Guadalupe, holding the palms of martyrs, ca. 1867. Amon Carter Museum, Fort Worth, Texas.

portrayed in a mourning souvenir as if kneeling before her, holding palms (associated in Christian art with martyrdom), while bayonets threatened them (see figure 2). The court with which they surrounded themselves became pasteboard celebrities as well. These included their chamberlains, the great church dignitaries, ministers of state, the royal princes (descendents of Emperor Agustín de Iturbide), the royal dames that attended Carlota, and even their doctors, coachmen, and masters of the hunt.

Less august personages were also subjects for the *tarjeta de visita*. In 1864, Maximilian ordered the registration of prostitution and utilized *tarjetas* to identify sex workers; their regulation was basically to protect French soldiers, though it can also be seen as one expression of the scientific modernization carried out by the occupation. The Register of Public Women in-

cluded portraits and information about 590 prostitutes. One might imagine that these images offered as little space for the expression of individual identity as did similar registers of criminals, servants, market carriers, shoeshine boys, and chauffeurs. However, the women's participation in the photo sessions demonstrated a wide variety of responses, because they could have their pictures taken at any photo studio, and they clothed themselves as they wished for the required full-length portraits. Some are elegantly garbed in modish hats, capes and gowns, while others appear to have used the same borrowed dress.[25] Certain prostitutes have evidently had no experience with the camera and are wary of it. But those more conversant with the *tarjeta*'s conventions attempt to present themselves in the poses associated with "decent" women, and some even ape the image projected by celebrities: one took on a pose associated with the Empress Carlota and had herself pictured reading a book. There are portraits that convey a sense of tension with the photographers, in which the women look back defiantly at the camera. In a few *tarjetas*, prostitutes seem to incarnate their role, posing as libertines by lifting their skirts and exhibiting their feet. The photos of these women demonstrate a process in which some took the opportunity to project identities in a situation that was intended only to establish their identification.

Heroes of the resistance such as Benito Juárez, Sebastián Lerdo de Tejada, and Porfirio Díaz also also recognized the uses of *tarjetas de visita*, although it was only with his death in 1872 that Juárez finally reached the celebrity status of the imperial monarchs, when the firm of Cruces y Campa sold 20,000 copies of his image.[26] The U.S. and French occupations left Mexicans with a fragile sense of national identity, and the partnership of Antíoco Cruces and Luis Campa tapped into the reconstruction by offering Great Men as models to emulate. The success of the Juárez *tarjeta* led them to create a visual history of Mexican rulers from 1821 to 1874, which was composed of fifty-two portraits with brief biographies on their backs.[27]

Tarjetas of politicians, scientists, authors, clerics, actresses, and singers were also disseminated in the pantheon of the suddenly, and sometimes inexplicably, famous. They were sold in great quantities at any store with the right to market images, though foreigners appear to have controlled their distribution, as well as the general sales of photographic materials and equipment.[28] Hence, Mexican celebrities were joined by foreign heads of state and royalty, of which the most popular seems to have been Napoleon

III and his relatives. However, since U.S. firms were particularly important, *tarjetas* of Abraham Lincoln, Andrew Johnson, Ulysses Grant, and Robert E. Lee circulated widely.

The sorts of people made into celebrities by the *tarjetas de visita* are surely fundamental to the formation of identity. However, it is equally intriguing to examine the *tarjetas* in which individuals fashioned their own representation, with little expenditure, for the cost of having a set made was quite reasonable compared to the daguerreotype, about the amount a department store clerk earned in two days, or the price of leather shoes.[29] Notwithstanding the apparent opportunity to create an image of one's own, it appears that the commissioned *tarjetas* offered little scope for individuality, resulting instead in a uniformity that accorded with society's expectations of what successful and modern people ought to look like. Body language, clothing, and scenery combined to create a code of material and social well-being, perhaps somewhat more elegant than the "plain settings" usually chosen by U.S. portraitists.[30] Bodies were posed to articulate a demeanor of elegance and decorum. Clothing was almost always of European styles, and men commonly wear suits with ties and vests (if not in military uniforms or clerical gowns), though the rare exceptions are dressed in traditional *charro* outfits. Although the studios were filled with props and accessories such as columns, balustrades, and draperies, the sobriety and discretion of the scenes constructed by Cruces y Campa, the most prestigious of the firms producing *tarjetas*, resonated with the respectability of their bourgeois clients.[31]

bourgeois femininity

Women and children were pictured in particular ways. Women's hands were carefully placed so as to demonstrate the innocence, timidity, and modesty of the photographed, which often required that her hair be put up.[32] As one writer observed of women's portraits in the nineteenth century, "In them all is scrupulous prudence, placid leisureliness, bland and adorable reserve."[33] While women's attire is usually modeled on that of Paris and London, the typical *rebozo* makes an occasional appearance. Children were represented in pose and clothing as little adults.

The *tarjetas de visita* embodied a curious irony in relation to the individual. At a time in which the idea of individual identity was slowly expanding—and the photographic process itself offered an ideal mode for incarnating particularity—the standardization of pose, setting, and clothing created

what has been described as the "tyranny of the *carte de visite*."[34] Patricia Massé argued, "*Tarjetas de visita* cancelled the possibility of representing a particular subject, and individual identity was covered by a mask of a generalized social type."[35] The clients of the studios were portrayed, and represented themselves, as bourgeois individuals, part of the larger modernizing class to which the photographed aspired or belonged, even if sometimes the clothes in which they posed were borrowed for the picture.[36] However, despite the stereotyping to which they were subject, the commissioned *tarjetas* are portraits, for the subjects were known by name and surname.

The *tarjetas de visita* that Cruces y Campa created of what they described as "Mexican types" represent their anonymous objects in quite another light. These images depict a wide variety of street trades, carried out by individuals identified only by their occupation. Hence, they must have served in part to buttress bourgeois identity by representing that which they were *not*: the nameless masses engaged in manual labor. In fact, work was rarely pictured and, rather than being real practitioners, the individuals that appear in these *tarjetas* were models that were taken to the photographic studios, dressed in decent attire, and provided with the appropriate props.[37] They were generally pictured selling the merchandise they had ostensibly manufactured, often in front of scenery reproducing urban environments more elaborate than those provided for the portraits of the better-off. Cruces y Campa portrayed *pulqueros* (*pulque* makers dressed as *charros*) arriving with their pigskins full of the alcoholic cactus beverage at a picturesque backdrop recreating a *pulquería*, "El recreo" (recess) (see figure 3). This same setting was used in another image to represent an "*enchiladera*" selling enchiladas in front of the establishment, though it was framed so as to eliminate the sign of "El recreo," while including another that offered "Ricos pulques de S. Bartolo." Bakers appear with large baskets of bread, which they sometimes carry on their heads. Basket makers (*cesteros*) stand amid piles of hand-woven wicker ware. An offal seller holds strands of intestine that have been filled to make sausage. Tapers hung on poles are sold by candle makers. *Aguadores* visibly strain under the weight of the water they allegedly lug from house to house. Vegetable sellers, apparently from Xochimilco's floating gardens, sit in small dugouts, their produce displayed as evidence of their activity. The list of items hawked is almost inexhaustible: birdcages, flowers, fish, pots, sleeping mats, chicken, fruit, hides, cloth, shawls, stock-

3. Antíoco Cruces and Luis Campa. Models dressed as *pulqueros* (cactus "beer" makers-transporters-sellers) with the pigskin containers for the beverage, on a set in the Cruces y Campa studio for a *tarjeta de visita* of "Mexican types," Mexico City, ca. 1870. Collection of Marco Buenrostro.

ings, tortillas, coffee, Judas dolls, noisemakers, sweets, ice cream, guitars, tamales, and rope.

A few individuals were photographed as if in the act of working. An *entulador* is shown replacing the strands of tule that form chair seats, a public letter writer appears at his desk attending a illiterate client, and uniformed soldiers, policemen, night watchmen, and firemen pose as if on duty.[38] In one of the very few rural scenes, a *tlachiquero* sucks the liquid (*aguamiel*) out of a maguey's core to make *pulque*, on a set composed of real magueys, dried bushes, and a painted backdrop designed to appear as the countryside. Women's work occurs in the home environment, which is easily reconstructed through the presence of chairs, tables, and dish racks, as well as placing religious images on the wall; there, *molenderas* grind corn kernels

by hand in the "kitchen" to make tortillas, while *planchadoras* iron clothing in another part of the "house."

Photography posed a particular problem for the reigning social order in that its capacity for mechanical reproduction allowed the misery in which many Mexicans lived to be easily documented and advertised at home and abroad. Needful of foreign investment that might be scared off by such undesired publicity, Mexico's rulers were always concerned to hide this, and at least as early as 1866 laws began to appear against "obscene and indecent" images, which were in part an attempt to impede pictures of poverty from circulating.[39] Hence, one imagines that the *tarjetas* of the decorative street vendors, usually dressed in clean clothing—with their hair combed, faces washed, and beards trimmed—created a "deserving poor" who were ostensibly independent and industrious. This imagery co-opted the space that the truly impoverished demanded by their ubiquitous presence in reality, converting them into an "undeserving poor," a residuum whose moral weakness was reflected in their indigence.

Cruces y Campa's *tarjetas* of "Mexican types" demonstrate the limit of what was permitted in representationally integrating the heterogeneous metropolitan population into a nation, as workers who participated in and reinforced the existing situation. However, such sellers were in fact members of the reserve labor pool, the informal and unprotected sector within which millions of Mexicans still eke out a living. Massé argues that the pictures of types formed "a medium at the service of knowing the fatherland, aimed at removing the anonymity of the photographed, and recognizing their identity through their clothing, work and customs. The ideological and political intention was precise: to seat the bases for a national consciousness."[40] Nonetheless, in the process, the *tarjetas* also dehumanized the underdogs, categorizing them in line with contemporary Positivist pseudoscientific social theories that naturalized class distinctions.

The *tarjetas* of types ignored the largest groups of employed urban workers, featuring instead the most colorful of the street trades, staged within appropriately designed settings. Cruces y Campa's depiction of national types preserved unique aspects of their culture in the midst of a modernizing process that was flattening out local variety, and it documented aspects of a disappearing economic system in which artisans sold that which

they produced, a life form threatened by the new society represented in the bourgeois portraits. Hence, these constructions played off of the country's "natural" exoticism and must have provoked a certain voyeuristic interest among the accommodated members of the class that bought them—in some cases to use as ads for cigar factories—contributing to the widespread diffusion of a picturesque Mexico. Yet Indians are relatively limited in their appearance, perhaps because they were considered by thinkers such as Ezequiel Chávez as being "still incapable of conceiving a nationhood," as well as constituting a drag on "the great machine of progress."[41]

The importance attained by the images of popular types is difficult to determine. Olivier Debroise argues that they "enjoyed an enormous success in the nineteenth century," while a scholar of European *cartes de visite* asserts that "only rarely does one find pictures of peasants, workers or craftsmen in this small format."[42] Perhaps the Orientalism of colonial and postcolonial situations, with their tapestries of local color, offered greater grist for the picturesque mill.[43] The *cartes* of the types can also be seen against the background of the long artistic tradition of depicting the laboring poor, beginning in the late medieval period, and including such masters as Rembrandt van Rijn, Pieter Brueghel, Diego Velázquez, and Bartolomé Murillo, though they must have a more immediate relation to well-known nineteenth-century series representing the "street cries" of peddlers in Paris and London.[44] And they are certainly an expression of that era's predilection for portraying nations in the form of picturesque types, for example the celebrated works published about the English and French "Painted by Themselves" (1840–42), a genre copied throughout Europe and Latin America in the succeeding years and realized in Mexico as *Los mexicanos pintados por sí mismos* (1854).[45]

The *tarjetas* of the Mexican types also had their national roots. They may have owed something to a genre unique to the country, the paintings of the *castas* realized during the eighteenth and early nineteenth centuries, which pictured some aspects of urban labor, as well as street vendors of charcoal, fruits, and vegetables. Liberal thinkers of the nineteenth century such as Ignacio Altamirano had been inciting artists to occupy themselves with Mexican themes, criticizing the Academic painters for choosing to portray biblical stories rather than national history, local customs, and popular

types.[46] Provincial artists such as Agustín Arrieta of Puebla may have been moved by the Liberal critique, for he became Mexico's "maximum representative of the *costumbrista* current of the nineteenth century."[47]

Foreigners: Popular Types, Pre-Columbian Ruins, Postcards, Pornography, and Denunciation

Mexico must be one of the countries most photographed by foreigners, and their imagery has been incorporated into visual constructions of *mexicanidad*. The existence of cultures strikingly different from those in the developed world, at once modern and deeply traditional, as well as geography stunning in its variety—all easily accessible from the United States—made it a natural object of the camera's lens. Only Egypt attracted as many photographers as did Mexico in the nineteenth century.[48] However, if outsiders brought a fresh way of seeing Mexico, this was conditioned by both the interests that promoted their travels, as well as by their own cultural baggage. Before photographers arrived, European painters—motivated by scientific interests and often coupled with imperial designs—had set the aesthetic preconditions for representing Mexico as a picturesque land abounding in exotic types. Alexander von Humboldt was the first to correct some of the more fanciful inventions concocted by artists who had never visited the New World, though the realism of his imagery led to *costumbrismo*.[49]

A genre of imagery and literature that focused on traditional customs and dress, *costumbrismo* emphasized the peculiar flavor offered by an otherness composed of extraordinary social diversity; of course, the extreme class differences that provided a prime ingredient to the local color were disguised, and the conflicts they produced remained invisible. Humboldt had inaugurated the tradition of "picturesque journeys" with his *Atlas pintoresco* (1810), and European traveler-reporter-artists such as Johann-Moritz Rugendas, Claudio Linati, Carl Nebel, Daniel Thomas Egerton, and Eduardo Pingret followed his lead; the unique scenes of the marginalized and archaic that they encountered and recreated would become a prime element in forging a vision of Mexico and Mexicans.[50] The influence of these artists in creating a characteristic way of picturing Latin Americans seems to have been crucial; as José Antonio Navarrete argues, "The imagery of the popular types [created by *costumbrista* artists] seems to have made a particular con-

tribution, with profound political implications, to the developing national-ist imaginary."[51]

The visual stereotypes had been set in place by *costumbrista* painting, but they would always be mediated by photography's precise reproductions. Hence, foreign image makers captured scenes of the underclass very differ-ently than their representation as the "honorable poor" by Cruces y Campa. The pictures produced by two French photographers, Désiré Charnay and François Aubert, both on imperial missions, demonstrate a gritty realism and may reflect the immediate influence of the extravagantly praised photos made in the early 1850s by Charles Nègre of Parisian beggars and working-class poor such as ragpickers and chimney sweeps.

Although Désiré Charnay was not the first foreigner to photograph ex-tensively in Mexico, he embodies many of the aspects that characterized the early image makers. Commissioned in 1857 by Napoleon III to carry out archeological explorations in the Yucatán on the eve of the French invasion, Charnay thus represents "one of Europe's proudest and most conspicuous instruments of expansion, the international scientific expedition."[52] His vi-sual research in Southeast Mexico was published in one of the first photog-raphy books to appear in Mexico, the *Albúm fotográfico mexicano* in 1858.[53] The work had been assembled for the Louvre Museum, but it was an impor-tant step in incorporating the pre-Hispanic past as a fundamental element of *mexicanidad*.[54] The unveiling of ancient Mexico was useful to construct-ing an identity in the midst of instability, but the portraits Charnay made of the underside were less acceptable and point to fundamental differences between how these individuals were photographed by foreigners and by Mexicans. Delayed in Mexico City for almost a year, Charnay developed a relationship with the printer Julio Michaud, with whom he collaborated to produce an album of "Mexican types," who appeared in "12 photographs that represent the most fantastic outfits and types in the republic."[55] None-theless, the Mexican public evidently did not recognize itself, for sales were not what they had hoped for, no doubt because the camera registered with too great detail the unwashed bodies, grimy hair, and filthy ragged clothing of individuals such as birdcage vendors (see figure 4).

François Aubert, a Frenchman who arrived during 1864, seems to have manifested the same tendencies when he depicted the Mexican poor, whom

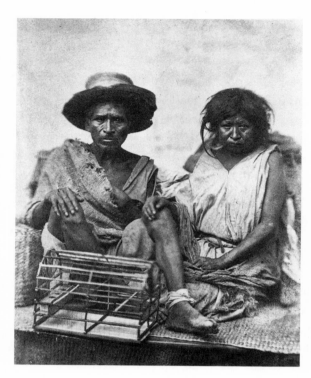

4. Désiré Charnay. Birdsellers, Mexico City, ca. 1858. Inv. # 426332, SINAFO-Fototeca Nacional del INAH.

he also captured in a different way than would Cruces y Campa a decade later. Aubert was evidently one of the favored photographers of the royal couple, and he made many images of them, their court, and Maximilian's end.[56] Although Aubert focused on the more exotic of the occupations, some of his pictures of popular types demonstrated photography's disquieting capacity to document the underside with disturbing clarity.[57] Further, at least two of Aubert's photographs present a distinctly unpicturesque Mexico: in one, an old woman straining under the weight of kindling looks back at the camera with a pained expression; in the other, a young girl in filthy clothing carries a child on her back and stares at the photographer with a hostile glare.[58] It is difficult to say whether the young girl's picture is an attempt to construct a Mexican version of notorious Parisian images of flower girls/coquettes/prostitutes, an exemplary undeserving and immoral poor that were fresh meat for the child pornography market. Aubert's photographs were probably intended for a European public, as they were either sent directly to Europe or returned with him when he left Mexico shortly after Maxi-

milian's execution. He made a spectacular "reportage" on that event that included scenes of destruction in Queretaro taken after the decisive siege by the republican army, the convents where the emperor was imprisoned, the firing squad, Maximilian's body after having been embalmed, and his bloodied clothing.[59] These images circulated widely in a Europe aghast at the execution of a royal prince by an elected president of Indian origin.

The reputation of being an unstable, lawless land governed by aborigines who refused to respect colonial rule(s) made it difficult for Mexico to receive the foreign investment it needed to establish its infrastructure. A precondition for economic development was remodeling the country's image, and the Porfirian regime engaged in a determined, well-funded process to "correct the 'errors' of world opinion concerning Mexican climate, politics, and society."[60] The railroad and the photograph were among the main protagonists of nineteenth-century technology and central actors in the new narrative promoting a modern nation. Integrating Mexico into a country by overcoming a geography that made internal communication laborious and expensive, the railroad was also the most important backdrop for the propaganda imagery.[61] Moreover, the railroad made it possible to take cameras into areas formerly inaccessible. The promotional campaign carried out by the Porfirian government was an intense effort to attract foreign investment and to foment tourism. Photographs made by invited artists like William Henry Jackson, as well as by entrepreneurial "knock-abouts" such as C. B. Waite and Winfield Scott appeared in a wide variety of media, including illustrated magazines for the Mexican bourgeoisie (*El Mundo Ilustrado*) and for potential foreign investors and tourists (*Modern Mexico*), tourist guidebooks (*Terry's Guide to Mexico*), published photographic albums, and postcards.

Picture postcards emerged as one of those transient yet enormously popular fads so characteristic of modern visual culture. By the 1870s, governments in Europe and the United States had recognized the potential of issuing postal cards, which were strictly utilitarian small prestamped plain cards for short business or social communication.[62] The fact that sixty million postal cards had been sold within the six months after they appeared in the United States demonstrated their appeal, and businesses transformed the older, dull postal card into a dynamic new medium, the postcard, by putting pictures on the front. This transformed their appeal: what had for-

merly been disdained by the "elegant and refined" became collector's items, as procuring postcards turned into a "mania," and special albums (as was the case with *cartes de viste*) were soon common in the family room.[63] The sheer numbers of postcards sent by mail indicates their astounding popularity: in 1908, the U.S. Post Office handled almost seven million, by 1913, that had increased to almost a billion.[64] The fad, however, was short-lived: by the end of World War I the craze for picture postcards had waned in the developed world, although it would continue in Mexico until 1930.

The first postcard issued in Mexico, in 1882, carried the effigy of Benito Juárez, and nationalist themes seem to have been a recurring topic.[65] The bulk of Mexican production, however, seems to have focused on typical views of nature, buildings, and monuments, as well as the representation of marginal groups, who were usually depicted in the *costumbrista* style, "with particular interest in the description of daily life by means of picturesque personages and folkloric scenes."[66] Hence, the identification between the nation and popular types was effected as street vendors, watermen, carriers of all types of heavy and awkward burdens (including coffins), human taxis, public letter writers, and washerwomen were presented as stereotypes of *mexicanidad*, much as they had been in the images of Cruces y Campa. Although no accurate circulation figures are available, postcards were sold everywhere: in department stores and hotels, at cigar stands and the entrances to theaters and bullfights, as well as in the tourist establishments that sprouted up, such as the Iturbide Curio Store, the Aztec Store, and the Sonora News Company.[67] Until around 1910, postcards were produced by professional photographers, both foreign and Mexican, including Guillermo Kahlo, Hugo Brehme, C. B. Waite, Eduardo Melhado, and H. J. Gutiérrez, though the constant plagiarizing by card makers creates difficulties in tracing the authors.

Focusing on three U.S. photographers who worked in Mexico during the late Porfiriato exemplifies the motivations that brought such men to the country and offers insights into the mediations of their imagery. William Henry Jackson was a well-known landscape photographer when he was contracted by the Mexican Central Railway to inform potential investors and tourists about the accessibility of a strange and different land, to document the victory of technology over a seemingly obdurate nature, and to celebrate "an American colonial power that would move to center stage in

a few years."[68] The Mexican adventure was simply another assignment for Jackson, although the Boston financiers who owned the railway company provided him with an exceptional level of support, including a train car and crew of fifteen men to assist him on the different trips he made in 1882, 1883, and 1892.[69] The situations of C. B. Waite and Winfield Scott are somewhat different. Neither had Jackson's recognition as a photographer when he arrived in Mexico and, though both worked for the railroads at some time, neither enjoyed the assured position Jackson had. Rather, they belong to what Beatriz Malagón has described as the "second wave" of foreign photographers, archetypically modern men who were eminently mobile and linked to a variety of business opportunities often created by foreign investors, including rubber plantations, mines, real estate, and tourism.[70]

The imagery made by Jackson, Waite, and Scott is enormously varied. A number of photos are related directly to train travel: cars stop in vista points so the passengers can look off into infinite distances; *campesinos* in typical clothing and wide sombreros pose next to tracks cut out between lush hills while a snow-capped volcano hovers behind; trains are pictured under colonial aqueducts, emphasizing the counterpoint of the traditional and the modern; and innumerable bridges in hostile settings attest to the triumph of science over nature (the photographed bridges were of steel, while those made of wood, which were in the majority, went undocumented).[71] Tourism is visually stimulated by the amenities offered at hotels such as the "Diligencias" in Puebla or the "Redón" in Silao, Guanajuato, as well as scenes of well-furnished gentlemen's bars and women reading leisurely on terraces. Of course, what most attracted tourists were the infinite differences offered at such a short distance from their homes. Postcards of pre-Columbian ruins and colonial architecture drew visitors and contributed to a developing national identity based on a shared past. At the same time, these image makers also participated in the construction of the new *mexicanidad* fomented by the Porfiriato, photographing the public works and the factories that were transforming the country.

The photographs that we today find the most interesting—and which in their time contributed to constructing notions of national identity— are scenes in which people are engaged in making and selling handcrafted articles.[72] Men carve washtubs out of logs or dry bricks in the sun, while children sell sombreros stacked some twenty-high on top of their heads. Water

and food arrive thanks to antiquated services—*aguadores* pull their carts of water jugs by hand and food vendors carry "lunch baskets" suspended on poles over their shoulders. At times these photographers captured artisan activities of some beauty, such as the weaving of reeds around bottles to protect them. In other images, they focused on the making of folk art, showing Indian girls painting ceramics by hand, potters turning out ornamental figures, women embroidering, and huge Judas figures offered for sale. By documenting the folk art that often went unnoticed by Mexican photographers, these foreign picture makers may have contributed to the discovery of this form of popular expression, which became so crucial to postrevolutionary identity.

Although their motives may have been to celebrate the creation of a new and dynamic Mexico, as well as to entice visitors to exotic (but safe) locales, their photographs were also indexes of the crushing poverty and underdevelopment in which so many Mexicans lived. The legend etched by Waite on one photograph read "The poor are always with you," and many pictures proved that: little girls in rags huddle in the street or in front of their miserable huts; a boy covered only in a torn jacket begs for a cent, hat in hand; an entire family participates in a communal delousing (see figure 5).[73] It has been argued by scholars of Mexican photography that these photographers were constructing a view of "everything that was considered to be distinctively and characteristically Mexican" and that "a great percentage of their portraits were of 'Mexican types.'"[74] It is not clear, however, that they were engaged with the intentionality that had characterized Cruces y Campa's creation of *Tipos mexicanos*. Instead, the fact that their images were taken on site rather than posed in a studio provides such density of social detail that the photographed are contextualized to such an extent that it would be difficult to make many of them into "types." Of course, some images of the more picturesque trades reproduced a *costumbrista* vision, but the realism of these photographers (which may derive from an aesthetic naïveté in the case of Waite and Scott) kept them from developing the exotic expressionism of, for example, Hugo Brehme.

Images depicting misery were unacceptable to the Porfirian regime as a representation of Mexico. When the official newspaper, *El Imparcial*, reported on the arrest of C. B. Waite in 1901, the text criticized "travelers who look for the most ridiculous, the most degenerate, and the most miserable

5. Winfield Scott (attributed to Charles B. Waite). Postcard of what appears to be a communal delousing, Mexico, ca. 1900. Archivo General de la Nación, Fondo Propiedad Artística y Literaria, Colección C. B. Waite, sobre 105.

in Mexico, exhibiting us in a state of barbarity"; the reporter was incensed by what he described as typical tourist pictures made by "J. G. Wheite" of "miserable huts, the indispensable woman grinding corn, the market carrier, the water seller, and the drunk. . . . dirty and uncombed women with their clothes torn, and men made into degenerates by all the vices." [75] However, a functionary alert to the services Waite provided to the government must have called the police and *El Imparcial* on his behalf, for three days later the paper stated that all was due to a mistake (while providing a model of the images preferred by the regime): "El señor Waite has spent much time traveling around the country to take pictures of the most beautiful and notable monuments, the most picturesque landscapes, and the best buildings of Mexico." [76] Although foreign photographers such as Jackson, Waite, and Scott may have run afoul, at times, of the Porfirian demand for a positive and optimistic image of Mexico, the extensive documentation they carried out was absent from the work of Mexican photographers, as was any hint of social criticism. Instead, it appears that Mexican photography around the railroad was more concerned to picture the multitudes, perhaps because the images documented newsworthy events. [77]

The specific pictures for which Waite was arrested point to the complex

intertwining of poverty and pornography. Waite was said to have "disdained the more cultured parts of the capital" in order to make images that "spoke very badly of Mexico," which he had evidently been allowed to send without problems.[78] But when he returned to the post office with a new package of photographs, these were discovered to be of "completely naked children presenting their deformed and hairless bodies," and he spent three days in jail for violating postal codes against "indecent" images.[79] Scott had run into similar problems in the United States, where he was accused in 1894 of using his position as the director in charge of creating a photographic register of Chinese immigrants to convince young girls to pose nude for him.[80] Scott beat the charge when no such pictures were discovered by the police, but the fact that some twenty images can be found among his Mexican photographs of young girls bathing nude or posing so as to emphasize their prepubescent sensuality indicates that he (and Waite) may well have been exploring a well-developed market in Europe, where erotic postcards of young girls numbered five times those printed of adult pin-ups.[81]

The ways in which poverty offers the opportunity to depict an "innocent" (nonthreatening) female sexuality can be seen in a photograph (figure 6) where a young girl poses in rent clothing, which expose her differently than if she were to appear openly demonstrating her body, either proud of her sex or unconcerned about having it seen.[82] The same message is provided in the images of young girls bathing in a stream who shyly cover their genitals and yet-to-develop breasts, here embodying the modesty expected of white women but placed closer to nature. Of course, child porn may have been part of a yet uninvestigated sexual tourism, and at least one U.S. viewer was attracted enough to write directly to Porfirio Díaz, with an accompanying image from a tourist guide: "Dear Sir: I have a very serious question and favor to ask of you. I would very much like to know who this young woman is; if it is not possible to find her, look for someone similar. I love her dearly and wish to communicate with her; my hope and desire is that she comes from a poor family."[83]

One foreigner who went against the grain of celebrating the pictorial duplex of exoticism and modernity was John Kenneth Turner, who transformed the meaning of the typical photographs made by others in his celebrated book *Barbarous Mexico*, while providing some of his own images to denounce what he described as "slavery" in Porfirian Mexico.[84] Turn-

6. Winfield Scott
(attributed to
Charles B. Waite).
Young girl posing,
Mexico, ca. 1900.
Archivo General
de la Nación, Fondo
Propiedad Artística y
Literaria, Colección
C. B. Waite, sobre 77.

er's book had first appeared as magazine articles during 1909 in *American Magazine*, and the official Mexican press countered quickly with a two-pronged attack. Some papers appealed to nationalism, attacking Turner's denunciations as yet another *gringo* aggression.[85] *El Imparcial* was a bit more subtle; utilizing the transnational power of the press, it joined forces with the newspaper chains run by William Randolph Hearst, who owned vast tracts of land in Mexico, a country about which he remarked, "I really don't see what is to prevent us from owning all of Mexico and running it to suit ourselves."[86] Hearst had evidently enslaved Yaqui Indians that the government had forcefully deported from their homes in Sonora and was using them in his southern plantations. *El Imparcial* considered him a good friend of Díaz and Mexico and asserted that Turner's reports did not do justice to the country. After an "impartial study based on reports that cannot be doubted," a journalist sent to Mexico by Hearst, Othaman Stevens, concluded that it was a prosperous nation, whose capital was among the greatest in the world.[87] The fact that Stevens did not speak a word of Span-

ish, preferring to conduct his interviews in French, may have tainted his perspective and certainly must have limited drastically his informants.

Some of the pictures published in the 1911 edition are the usual picturesque suspects, but the semantic ambiguity of photographs gave Turner the opportunity to give them a critical turn. Hence, while Waite described the *campesino* who appears in one image as a "Hot Country Laborer," Turner's cut line stated that the man was a "Type of *'enganchado'* [hooked] or plantation slave."[88] Another Waite photo, of folkloric "Wood Carriers," pointed to the constant problem of low wages, affirming that "a Mexican laborer is cheaper than a horse."[89] Other photographs, some of which can be found in the Casasola Archive, document the exile of Yaquis to the Yucatán, the police presence, and executions. Among the images which Turner may have taken are those made "from a flashlight by the author" of flophouses in which many people sleep on the floor, wrapped in *petates* [reed mats]; he accompanied one with this commentary: "Twenty thousand sleep this way every night in Díaz's capital alone."[90] Turner may well have been influenced by another muck-raking reporter, Jacob Riis, whose work documenting slum dwellings in New York City, *How the Other Half Lives*, had been an instant success in 1890 as the first mass-market photographic book, and who produced several more denunciatory works in ensuing years. In articles and book form, *Barbarous Mexico* had a sensational impact in Mexico, the United States, and England and was evidently credited by Francisco I. Madero as having been important to the development of the revolutionary movement.[91]

Guillermo Kahlo: Architectural Identity

If Guillermo Kahlo were alive today, he would probably express sentiments similar to those of a distinguished Brazilian intellectual, who reflected ironically, "I used to be 'Sergio Buarque de Holanda,' now I'm just 'Chico's dad.'"[92] Before becoming known as "Frida's father," Guillermo Kahlo was highly recognized for his photographs of Mexico's architecture, both colonial and modern, which were made with great artistry and technical proficiency.[93] Kahlo was born in Germany and traveled to Mexico in 1891, where he joined Mexico City's small but active German community and worked as an accountant to maintain his first Mexican wife and their daughters.[94] When his wife died, Kahlo immediately remarried another Mexican, Matilde Calde-

rón González, with whom he would have more children, among them the famous Frida. Matilde's father, Antonio Calderón, was a photographer, and the two convinced Guillermo to make his living with the camera Antonio loaned him. Having acquired some knowledge of technique from his own father, an amateur image maker and merchant of photographic materials, Kahlo then worked for a German hardware store in Mexico City, the Casa Boker, and he used his connection with them to bring a complete set of equipment from Germany.[95] He began taking pictures of buildings owned by German entrepreneurs, and his first real commission was to document the construction of the Boker Building during 1899 and 1900.

Around this time, Kahlo opened his studio and declared himself a specialist in "buildings, house interiors, factories, machinery, etc."[96] Kahlo's decision to concentrate on the photography of architecture and industry seems to reflect a happy coincidence between the possibilities offered by his situation and his personality. Taciturn and reserved, his imagery of the colonial past and the industrializing present had in common the absence of people.[97] A rigorous worker with extraordinary professional skill, he repre-sented the sort of foreigner with whom the Porfirian regime wished to construct the new Mexico. The Porfiriato was in full flight, and images were required that attested to the flamboyant progress being made in the country. Kahlo provided photos of prosperous industries and Frenchified houses for books subsidized by the government or entrepreneurs, as well as for the officialist picture magazine *El Mundo Ilustrado*, media which served to document development and to stimulate foreign investment. He produced a number of picture albums—some with as many as fifty photographs—and his work *Mexiko 1904* offers a vision of Mexico City as the showplace for Porfirian modernity.[98] The work had been commissioned by Robert Boker, perhaps to attract German investors, and Kahlo created the appearance of a clean and orderly metropolis by shooting the most sanitized and modern areas from above and afar. He also alluded to the seat of political power by extensively documenting Chapultepec Park and the president's residence, Chapultepec Castle, a cornerstone of Mexican history since the boy cadets (*niños héroes*) jumped to their death from its walls rather than be captured by U.S. soldiers during the Mexican War.

Kahlo was commissioned by the treasury secretary, José Yves Limantour, to make a visual inventory of all the church buildings acquired by the gov-

ernment under the reform laws of 1857, as well as to document new govern-
ment constructions. These projects began in 1902 and were undertaken as
part of the celebrations in 1910 of Mexico's Centenario (Centennial) of In-
dependence, the culminating act of Porfirian propaganda. One of the most
important programs was dedicated to publications that would demonstrate
the country's development and display its cultural patrimony. As many of
the new buildings were in the first phases of construction, Kahlo began by
portraying the colonial structures. During four years, Kahlo traveled around
Mexico carrying a thirty-five-pound camera and heavy lenses (the lightest
of which weighed three and a half pounds), as well as glass plates that were
almost a pound each. Given the weight of the equipment and materials,
Kahlo was limited to photographing buildings found in cities that could be
reached by train.

The government's decision to finance photography of the colonial churches
was part of its strategy to redefine *mexicanidad*. Rediscovering the value of
these monuments represented a change of mentality: colonial society had
been proud of Baroque art, but the struggle for independence had neces-
sarily produced a generalized rejection of everything related to New Spain
during the first fifty years of the nation.[99] The Europeanization of Porfirian
society led to a vindication of that past, for the elite monitored the styles
of Paris and London and adjusted their tastes accordingly. Although such
neocolonial attitudes placed Mexico's popular culture in a subordinated
position, they also offered an alternative to that of the powerful northern
neighbor. Fearful of being overwhelmed by the United States, Porfirian
intellectuals killed two birds with a single stone by coming to the defense
of the Baroque churches: on the one hand, European culture was favored
over national expression while, on the other, Mexico's historical depth was
contrasted to the shallowness of the Johnny-come-lately to the north.

With a technical capacity superior to that of his Mexican contempo-
raries, Guillermo Kahlo was probably the ideal photographer to carry out
the project of documenting the colonial churches. He had abandoned the
5 × 7-inch format employed by almost all photographers of the time and
taught himself to work with a large format camera that produced nega-
tives of 11 × 14 inches. Although the camera was significantly heavier, Kahlo
could print by direct contact from the negatives and avoid having to make
enlargements, which were problematic in this period.[100] The weight of the

7. Guillermo Kahlo. Cathedral of Mexico City, ca. 1910. SINAFO-Fototeca Nacional del INAH. Inv. # 7084, SINAFO-Fototeca Nacional del INAH.

camera and the materials made it impossible to carry equipment to illuminate, so he had to depend on natural light. Hence, patience was essential to his aesthetic, in terms of deciding where to place his camera, as well as waiting until the light was as he desired. The results demonstrate the control he had over his technology and art: thanks to the sharp contrasts he attained between light and shadow, his images have a high definition that provides depth and a quality of detail that even today is difficult to achieve (see figure 7).

It is instructive to compare Kahlo's imagery to that of other photographers during this period. Portraits were a basic genre, as can be seen in the work of Cruces y Campa, Natalia Baquedano, and the Valleto brothers, among others. However, it appears that Kahlo made few portraits, and those were essentially taken of his family during the postrevolutionary period, when he found it difficult to get the commissions he had received earlier because of his connections to the Porfirian regime. Although he worked for *El Mundo Ilustrado*, his images of buildings are not really the sort of photo-

journalism produced by the Casasola brothers, Agustín Víctor and Miguel. Kahlo's photography is also distinct from that of other foreigners such as William Henry Jackson, C .B. Waite, Winfield Scott, or his fellow German emigrant, Hugo Brehme. The picturesqueness found in much of their work is absent in Kahlo's, as are the classical "Mexican types," or any form of social criticism. Austere, informative, and apparently objective, Kahlo's imagery is almost scientific, as if in accord with the dictates of Porfirian Positivism. The world he photographed was, in the end, the European cosmos that he found in Mexico, with which he was in accord.

Kahlo carried out the largest and most systematic inventory of the colonial churches. The subsequent uses made of these photographs permits us to reflect upon the ambiguity and polysemia of these thin slices of "reality." The original commission given Kahlo to photograph the churches was inspired by the interest in monumentalizing Mexico's European heritage. However, when they were republished during 1924–27, the illustrated books produced by the revolutionary artist Dr. Atl had the opposite intention: that of exalting the work carried out by the anonymous Indians who constructed those churches.[101] In line with the rediscovery of Mexico's autochthonous population during the postrevolutionary effervescence, Dr. Atl emphasized that "the Indian was invariably the maker of the architectural works and, in many cases, their author."[102] Today, these photographs serve yet another purpose: they are visual sources that preserve as no other the architectural forms of a past endangered by industrial pollution and earthquakes.

Agustín Víctor Casasola: Photojournalism and Modernity in the Porfiriato

Agustín Víctor Casasola was the father of an archive and a dynasty that profoundly influenced how Mexicans perceive their national history and the revolution that formed their modern identity.[103] Born in 1874, he entered into journalism some twenty years later, working as a reporter for several newspapers, a common practice among journalists in this period.[104] Prominent among his employers were *El Universal* and *El Imparcial*, periodicals of Rafael Reyes Espíndola that, like their editor, were journalistically innovative and politically rightist. Casasola began illustrating his news stories with photographs around 1901 in the reactionary Catholic newspaper *El Tiempo*.[105] However, he eventually—and appropriately—settled in with

Reyes Espíndola, in *El Imparcial*, the predominant daily of the late Por-
firiato, and that which most reflected its character: modern, commercial,
and conservative.

Although impartiality was not really a priority in Reyes Espíndola's pub-
lications, the name he chose for the newspaper that "set the period's tone"
and fundamentally transformed Mexican journalism, was significant.[106]
Mexican periodicals had often been linked to certain groups or ideas, and
the titles of some preceding papers evidenced their affiliation, for example,
El Partido Liberal, *El Monitor Republicano*, and *El Socialista*. Dubbing the
new publication "The Impartial" asserted that it was engaged in an osten-
sible search for objectivity and truth, in line with the Positivist precepts of
the official ideologues, the "Científicos," who backed it, and in accordance
with the "end of ideology" established by Díaz's blurring of liberal and con-
servative battle lines.[107] Reyes Espíndola aimed to establish the believability
characteristic of modern publications based on information (rather than
opinion). This journalistic mode had been stimulated by international news
agencies, such as the Associated Press, and being "up-to-the-minute" be-
came increasingly essential to entering the developed world. Newspapers in
other countries had been utilizing this format for decades, and by the late
nineteenth century U.S. editors such as Joseph Pulitzer and William Ran-
dolph Hearst were taking it to its extreme in "Yellow Press" dailies such as
the *New York World* and *San Francisco Examiner*.[108] Following this tendency,
El Imparcial rejected the old style of Mexican journalism, which privileged
editorials written by experienced essayists, to adopt the contemporary
mode, in which news is collected in the street by reporters and presented
to readers as if they are allowed to decide its meaning for themselves.

This was a fundamental transition from a press oriented toward active
and informed readers to one that promoted passive consumers, and well-
known writers for the established periodicals felt that pragmatism and
vulgarity were replacing beauty and originality. They related this transfor-
mation to the taking on of U.S. values and invoked nationalism in their re-
sponse to the threat of "reporterism," as it was then called. One lamented,
"The chronicle has died at the hands of reporters. Where else could report-
ers have come from if not from the country of revolvers, where the repeat-
ing journalist, instant food, and electricity flourish? From there we got the
agile, clever, ubiquitous, invisible, instantaneous reporter who cooks the

hare before trapping it."[109] In *El Partido Liberal*, an editorialist critiqued the commercialism that would replace the conscientiousness of traditional Mexican essayists to write well: "The *repórter* [*sic*] is a pernicious foreigner, and the name itself embodies the foreignness of this individual. The dictionary does not recognize the word, because the reporter knows nothing of grammar. But the reporter, which in Spanish means 'busybody', has entered by the right of conquest to the language, journalism, and social life. And he is almost the king of the press. It is the Yankee who brings in money for the editors."[110]

The founder of the modern Mexican press, Reyes Espíndola understood that massification was the key, so—aided by government subsidies—he drastically lowered the price in order to attract readers: at a time when most newspapers charged eight to ten *centavos*, his—at one cent—was Mexico's first "penny press."[111] He far outdistanced competitors, publishing more than ten times his nearest rival. On the front page of each day's edition, he listed the number of papers printed, and the constant increment of *El Imparcial*'s readership became an example of and synecdoche for Porfirian progress. His newspaper's popularity was a combination of the low price and the way in which he catered to what he believed the "great monster" (as he referred to the public) demanded: sensationalist news.[112] He initiated the dissemination of police reports; known as the *nota roja* (red note), they became very popular in Mexico. He was also the first to seriously explore the creation of desire among his readers, filling 25 percent of the newspaper's space with advertisements. *El Imparcial* was designed to prioritize the ocular and was originally subtitled "Illustrated morning daily"; the plant contained departments of drawing as well as photography.[113] The very first image to be published in three colors by a Mexican newspaper fused modernity and fatherland: in 1902, the national flag was printed on *El Imparcial*'s front page in red, green, and white as proof of technological achievement.

Such technical advances did not come cheaply. Fortunately for Rafael Reyes Espíndola, he was in the inner circle: he shared with Díaz their Oaxacan origin, had married a governor's daughter, and became the compadre of José Yves Limantour, the powerful treasury secretary. He appears to have been the most favored of the journalists on the state dole; "Even the dogs in the street know about the subsidy," wrote Limantour.[114] These connections had enabled him to found *El Universal* in 1888, with the help of Limantour

and other members of the Científico group. Porfirio Díaz felt secure enough after his third reelection in 1892 to do away with the pretense of democracy; he began to cut back on subsidies and to jail dissident journalists. However, at a time when the editors of some twenty periodicals languished in prison, and the number of newspapers had been reduced by one third over eight years, Reyes Espíndola was being subsidized to the tune of a thousand pesos a week, from an account that required no justification.[115]

The subsidy was determinant in founding the most important illustrated magazine of the Porfiriato, *El Mundo Ilustrado*, in 1894 and the newspapers *El Mundo* and *El Imparcial* in the following years. He placed them on the cutting edge by importing the best European high-volume rotogravure presses and Linotype machines that gave him an insurmountable advantage over his rivals and were themselves symbols of development. Reyes Espíndola and Limantour spoke openly (later) about the subsidy. Limantour felt that the Díaz regime had needed "a periodical of mass circulation that was entrusted with explaining and defending the government's acts, projects, and decisions. . . . That was the role *El Imparcial* filled satisfactorily." Reyes Espíndola echoed his sentiments: "The subsidy was paid for services rendered."[116]

Police reports were privileged in *El Imparcial*, and its pages were filled with news of disasters, train crashes, streetcar accidents, fires, thefts, murders, suicides, and assaults, though the paper also covered the official acts of the president, governors, ministers, and foreign diplomats, as well as cultural activities such as theater and opera.[117] Of course, it was necessary to maintain a certain credibility among the public not reduced to passive consumption, and the paper did cover "real news" about social problems such as the strikes at Cananea and Rio Blanco, albeit from an officialist position.[118] However, giving priority to the *nota roja* served various functions. Morbid tales of sadistic rapists, tragic weekend jaunts, and young women dishonored by priests distracted from the more serious news. Moreover, these stories planted fear in readers and reinforced class anxieties, for the terror of the lower order's brutality could only be allayed (if momentarily) through the police and penitentiary.[119] The *nota roja*—which continues to enjoy great popularity in Mexico—transforms people into mutilators and mutilated; with no socioeconomic analyses to explain such horrendous occurrences, the only solution is the strong arm of a powerful patriarch.[120]

Previous periodicals had demonstrated a certain sense of responsibility to educate their readers with philosophical discussions and ideological orientation, but Reyes Espíndola realized that playing to their lowest instincts was much more profitable: "Not giving preference to sensationalist information means crashing into the public's indifference."[121] An editorial in the critical daily *Gil Blas* offered a different perspective, calling instead for a journalism that "drives away the fantastic creations of ignorance, which deify evil and make the human spirit a slave of fear."[122]

However, Reyes Espíndola had pictures on his side. He was the first editor in Mexico to utilize the halftone process (photoengraving) to publish photographs, a key technological breakthrough that became the backbone of the new journalism. Images were a necessary component to the notion of discovering the news, of encountering reality in the street, because they interlocked with the texts to "prove" the truth of what was placed before the readers. Both the news items and the photos belonged to the same logic of modernity, which was finally based on the inductive principles of the Enlightenment, that "truth" was to be discovered from observation of the world rather than through abstract philosophizing. These ideas must have appeared novel to a Mexican society still recovering from the effects of a Counter-Reformationist colonialism, and the participation of photography, among the newest of scientific technologies, was no doubt definitive in convincing readers that this was the perfect embodiment of empirical validation and verification.

The newspapers of Reyes Espíndola appear to have employed images largely in relation to the *nota roja*. When his paper *El Universal* began allotting significant space to pictures—the first Mexican daily to do so—they were initially dedicated to European anarchists and the fear they inspired.[123] On turning its visual edge toward Mexican subjects, this newspaper also focused on criminals, for the subjects of the first two lithographs published in *El Universal* were a known rapist and cutthroat, and a man condemned to death for a crime of passion. In sections such as "The Gallery of Thieves," this periodical emphasized the uses of imagery in disclosing the criminal physiognomy, scientifically proving that felons came from the lower strata of evolution. The first photo published in *El Imparcial* was of a captured criminal in 1901 and, over time, graphic reportage began to acquire a certain independence from the text, until intricately illustrated stories of murder

and mayhem took precedence over any real news about the country's situation.

The focus differed in the weekly magazine *El Mundo Ilustrado*, where the presumed objectivity of photography was fused with the purported impartiality of the new reportage style to prove that the progress and stability alleged by the dictator's discourse were there for all to see. The imagery of the illustrated serial seems to have centered on the Great Men that made Porfirian Mexico. Díaz's presence is ubiquitous, and he is featured opening new markets, medical schools, electric plants, theaters and jails, unveiling statues of Great Chiefs, receiving homage from foreign governments, heading up charity festivals, making trips throughout the republic, opening sessions of congress, giving awards to the best military students, celebrating his silver wedding anniversary, and appearing at military parades, as well as at balls and banquets to celebrate his reelections.[124] He is joined by other male figures, among them, Limantour, Vice-President Ramón Corral, Guillermo Landa y Escandón (mayor of Mexico City), state governors, church leaders, military officers, diplomats, and functionaries. The international news focused on European royalty and the crimes committed by anarchists.

Culture was not neglected, though it was of a particular sort and practiced by a limited group. *El Mundo Ilustrado* knew who their public was and took pride in them: "Our weekly has always been for the elegant people of Mexico, and should therefore be an echo of the gatherings and entertainments to which they concur."[125] To that end, the magazine published photos of society congregations: banquets, balls, and fiestas, as well as the sports that developed in the Porfiriato, from basketball to horse races. The constant charity fairs were also featured: a seemingly infinite number of *kermesses* and *jamaicas* were pictured that were designed to show concern for the "other half," though they really served as little more than bandaids for the era's extreme social injustice. The idea was to show a stable and progressive society, relaxed and harmonious in a deserved well-being, and not uncaring for the less privileged.

Nonetheless, though *El Mundo Ilustrado* pictured the wealthy participating in charitable activities for the less fortunate, the latter were excluded from its pages: for example, the only Indian to appear in the periodical was a dead one.[126] Hence, for the magazine, being Mexican was achieved through becoming modern and prosperous: the models offered for emulation were

entrepreneurs and functionaries in frock coats, sometimes accompanied by their *señoras* in fancy imported gowns. Before the Porfiriato, the "Mexican types" created in Cruces y Campa's *tarjetas de visita* had provided a representational space for the "decent poor"; now, however, the underside was largely banished from the progressive nation constructed in the illustrated magazines, which reduced the broad panorama of social and ethnic variety in Mexican society to the successful or the criminal.[127] Furthermore, there was none of the critical photography made in the United States around this period by Jacob Riis and Lewis Hine. This can be attributed to the economic difficulties that the independent periodicals faced in acquiring the equipment that made photoengraving possible, and which left any photographers who might have had an interest in critiquing Porfirian rule with no place to publish their images (although *El Hijo del Ahuizote* and *El Diablito Rojo* did print some devastating caricatures, and José Guadalupe Posada is legendary for his broadside engravings of protests and people suffering from poverty).[128]

Magazine readers were encouraged to clip out the photographs and collect them—as they had with *tarjetas de visita* and postcards—or frame them for posterity.[129] And the future seemed to be on Reyes Espíndola's mind when he launched his magazine, somehow intuiting the importance press photographs would acquire for Mexican visual history: "It will be an illustrated weekly, with the pretension of resuming the principal events, and fixing them in the most complete way possible so that they will serve as a living memory to the generation that follows."[130] He later reiterated this message and linked it to national identity, "We seek to make *El Mundo Ilustrado* a magazine that . . . is sensitive to the formation of patriotic history (*Historia Patria*) with data that shines a light on our way of being."[131]

A shrewd judge of talent, Reyes Espíndola invited Agustín Víctor Casasola to work for *El Imparcial* in 1904.[132] The editor had assembled an impressive group of photographers for his periodicals, among them Manuel Ramos, José María Lupercio, and Guillermo Kahlo, although his appreciation for the visual was apparently limited to the sales it promoted. Casasola had similar commercial instincts, combined with a love of photography; once he had decided to pick the camera as his medium, he seems rarely to have put it down.[133] Upon joining *El Imparcial*, he dedicated himself full-time to his new profession as photojournalist, and his extraordinary com-

mitment began to gain him a reputation in 1910, when he earned a twenty-five-peso bonus for "excessive achievement of duties," for jumping into a bullring to capture the action up close.[134]

It is difficult to know which pictures in the Archivo Casasola were taken by whom, because Agustín Víctor acquired images taken by many photographers that were incorporated into the collection without specifying their maker, among them those of his brother, Miguel, with whom he founded a studio "Casasola Fotógrafos," and worked together at *El Imparcial*.[135] Hence, rather than analyzing the imagery of Agustin Víctor from the perspective of authorship, it may be more useful to consider his work as typical of photojournalism in the Porfiriato; scholars of Casasola have noted that his style during this period was characteristic as well of his fellow graphic reporters, all of whom followed the line marked for the official press.[136]

I would like to examine four Porfirian pictures found in the Archivo Casasola that we may take as representative of the type of imagery that Agustín Víctor and Miguel Casasola made during that era. I have chosen these images because they have been reproduced on different occasions in works on the Casasola photography and can thus be said to have entered into that discursive context.

The first is of Porfirio Díaz, the most photographed individual of his reign, taken at a ceremony in July 1910 in homage to Benito Juárez's death (see figure 8).[137] Díaz had enveloped himself in a myth he helped to construct: consecrating Juárez's tomb (1880), naming a great avenue for him (1887), making the centennial of his birth a celebration for the entire country (1906), and dedicating the Juárez Hemicycle (1910). In this picture, Díaz participates in the public activities that he fomented to link himself to the country's greatest hero, thus legitimizing his own rule. Here, he sits on what appears to be a throne, embossed with the national coat of arms, a photograph that demonstrates the historical origin of Mexico in the formula Díaz = Juárez. While this picture has found an acceptance among recent editors of photography books, this was not the case when it was made, for it was not published as part of the extensive coverage of this much-publicized event. Instead, *El Imparcial* included several photos that were more formal and taken at a greater distance.

The second photograph invokes technological progress in the creation of a new Mexican identity. José Limantour gazes out from atop a construction,

8. Agustín Víctor Casasola (?). Porfirio Díaz and Enrique Creel at a ceremony commemorating the death of Benito Juárez, Mexico City, 19 July 1910. Inv. # 6208, Fondo Casasola, SINAFO-Fototeca Nacional del INAH.

his head shielded from the tropical sun by the umbrella an assistant holds, as he inaugurates the public works that channel water from Xochimilco to Mexico City (see figure 9).[138] Bringing drinking water into the metropolis and draining the Valley of Mexico to prevent flooding were among the great engineering accomplishments of the late Porfiriato. They were considered of such importance that Miguel Casasola was contracted by the Mexico City government to register this process, from 1906 to 1912, and he may well have taken this photograph.[139] Here, Limantour and other men—dressed inappropriately for the spring heat in dark suits, stiff-collared shirts, waistcoats, and ties—stand above and apart from the Mexican laborers who, in work clothes and sombreros, look up at them. An embodiment of the extreme class differences heightened by vertiginous modernization, this image is an early (spontaneous) version of what Tina Modotti would compose during the postrevolutionary effervescence to portray *Those on top and those on the bottom*.[140] Perhaps the critique was evident to the *El Imparcial*'s editor, because the photo was not published at the time. Only with the revolution would those below once again be incorporated into *mexicanidad*.

9. Miguel Casasola (?). José Ives Limantour at the opening of the waterworks that will bring potable water from Xochimilco to Mexico City, 18 March 1910. Inv. # 35001, Fondo Casasola, SINAFO-Fototeca Nacional del INAH.

The third photo shows Porfirian society at play: a group of well-dressed citizens stroll around at the Condesa racetrack, expressing the tranquility brought by Porfirian order and progress, the women protecting themselves from the sun with parasols and broad-brimmed hats (see figure 10).[141] This image is also an example of modern photojournalism, in that the photographer took the picture spontaneously, without asking the subjects to pose. Along with other images found in the Archivo Casasola, it contradicts a commonplace that is often repeated: "Photography in the final years of the *porfiriato* still largely conformed to the formal, static models established by the studios."[142] Whether it was Agustín Víctor, Miguel, or another lens man, it is clear that the photographer and his equipment were capable of capturing candid scenes, in which movement within the frame gives the picture a modern feel.

Finally, we see the other side of society's face in a searing example of *nota roja* imagery: the execution of three men for murder in Chalco, Mexico State, in April 1909 (see figure 11).[143] Evidently Agustín Víctor and Miguel Casasola traveled around the country to cover different assignments, among them, Díaz's 1902 visit to Veracruz, his 1906 tour of Yucatán, and his 1909 meeting with U.S. President William Howard Taft on the border.[144] The col-

10. Agustín Víctor Casasola (?). Condesa racetrack, Mexico City, ca. 1910. Inv. # 5869, Fondo Casasola, SINAFO-Fototeca Nacional del INAH.

laborative counterpoint of such officialist reportage was the *nota roja*, and this photograph, which was evidently taken by Agustín Víctor, raises some interesting questions. Why was the case of the policeman Tomás Morales's murder of such import that Agustín Víctor and other reporters made the trip to Chalco, then at some distance from Mexico City? Did the triple execution offer an unusual opportunity to give a forceful object lesson, "an example so that the law would be respected," as a reporter for *El País* noted?[145] To what degree might we consider the execution to have been a media event? *El Imparcial* put the story on the front page for three days and provided ample graphic reportage with six photos, and other papers also covered the execution. Though many inhabitants of Chalco had hurriedly and noisily fled "so as not to witness the execution," there was evidently a large crowd on hand.[146] Hence, one imagines that the pictures might have served different purposes. They could have reassured the national bourgeoisie and foreign investors about the iron hand that reigned in Porfirian Mexico; they may have functioned as examples for any evildoer thinking of violating the dictates of order and progress; and they could also be read as symbolizing the elimination of that part of Mexico which the Científicos were eager to eradicate.

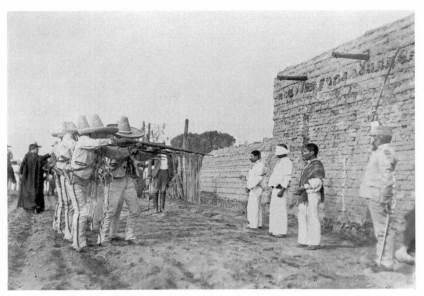

11. Agustín Víctor Casasola (?). Execution, Chalco, Mexico State, 28 April 1909. Inv. # 196863, Fondo Casasola, SINAFO-Fototeca Nacional del INAH.

The photograph combines the spectacular fact of a triple execution with elements usually associated with the typical and exotic. Sandaled *campesinos* dressed in the traditional white clothing, one in a many-colored vest, face a row of uniformed Rurales, the Porfirian police whose visages are hidden under their sombreros, while a finely booted official oversees the shooting. *El Imparcial*'s reporters provided a text worthy of the periodical's thirst for blood: "The bodies fell simultaneously, slowly backward, and a hoarse whisper flowed from either the enormous holes made by the bullets or their tightly-pressed lips. The clothing smoked from the gunpowder, and their contractions denoted an extraordinarily cruel suffering. A death rattle like that of a sheep with its throat cut escaped from the three bodies. Their families sobbed, and their cries filled the countryside. Those of us who were present will never forget it."[147]

I have encountered no Porfirian photographs in the Casasola Archive that question the regime or the prevailing social injustices.[148] Hence, I would argue that the vast majority of Mexicans were excluded from the Porfirian imagery made by Agustín Víctor, Miguel, and the photographers whose work ended up in the archive. This is almost certainly a result of the political

leanings of Agustín Víctor and the fact that there were no media in which to publish such photographs, had the picture takers been interested in making critical commentary.

The Last Waltz

In September 1910, the Porfirian regime staged a spectacular and sumptuous celebration marking the hundredth anniversary of national independence.[149] Díaz paraded a vision of Mexican development and cosmopolitanism for the world to see, displaying to foreign guests an exotic land in the midst of feverish modernization; at the same time, he gave his own *pueblo* their first public lesson in visual history. The Centenario had been in planning for some time, and the original idea was to commemorate it in conjunction with a world's fair, as the United States and France had done with their centennials of the American and French revolutions.[150] Although a world's fair proved to be beyond its means, the government did spend extravagant sums on the Centenario's festivities, the large contingents of invited outsiders, and the many constructions that testified to progress. Throughout the month of September, the nation played host to thirty-one "civilized countries" who had been called to join Mexico in its "deserved rejoicing."[151] New buildings and monuments were inaugurated, while the foundation stones for others were laid; academic congresses and scientific expositions opened; speeches, receptions, balls, parades, and processions were endless. The activity most oriented toward local consumption was the staged pageant of Mexican history, the *Desfile histórico* (Historical Parade).

Leading image makers filmed and photographed the festivities extensively, including Salvador Toscano, Guillermo Kahlo, Manuel Ramos, and Agustín Víctor Casasola.[152] Great numbers of images were published in the illustrated magazines and as postcards, as well as collected together in imposing, expensive, and abundantly illustrated works, among them the official chronicle that was coordinated by Genaro García, director of the National Museum of History, Archeology, and Ethnology.[153]

The Centenario offered a vision of national identity that included both the past and the present. The reinterpretation of Mexico's yesteryears was constructed largely through the *Desfile histórico*, which García affirmed had been "the most arduously prepared of all the Centennial's festivities, because of the necessity to carefully choose the history scenes that would

be presented."[154] Reflecting the Hispanic bias of Porfirian culture, the *Desfile* focused on what García described as "three great epochs of national existence": the conquest, the colony, and the independence movement, a periodization that eliminated the pre-Columbian past almost entirely. The social violence that had characterized all three moments was minimized in order to produce a proper *Historia Patria*. Hence, the conquest was represented by the moment in which Moctezuma, borne on a chair by his vassals, went out to meet with Hernán Cortés, astride a white horse. The portrayal of the colony reiterated the theme of Indian rendition, for it was encapsulated in the bewigged viceroy and royal judges who rode horses in the "Paseo del pendón" (Parade of the Banner), a celebration that marked the final victory of the Spanish over the Aztecs. Independence was embodied in the entrance of Agustín de Iturbide into Mexico City on horseback, with feathered cocked hat and fancy military uniform.

It is significant that the *Desfile* placed great emphasis on the fidelity of historical detail.[155] In stressing authenticity of costume and characters, it replicated the supposed objectivity of the reportage and photography in the Porfirian press, wrapping itself in "trappings" that were presented as more fundamental to understanding the national past than informed interpretations. Despite this pretense, the choice made as to who was the progenitor of independence created one of the more meaningful ironies of Mexican historiography. This Centenario largely ignored Miguel Hidalgo, whose presence was limited to one float in the Business Parade, where his bust was placed next to those of Juárez and Díaz (thus linking the latter to the nation's greatest heroes), and the arrival of his baptismal fountain (making Hidalgo safe by returning him to the Church). Instead, the Historical Parade celebrated the 1821 triumph of Iturbide's reactionary force.[156] The *Desfile*'s organizers requested that women participants in the parade be "the very prettiest," no doubt a further reflection of their concern with historical accuracy.[157]

The reception of the *Desfile* was said to be exceptional. The program was printed and circulated profusely by the press, and García asserted, "The crowd passed all expectations, flowing over into the streets and avenues; it completely filled the Zócalo; people were crammed onto the balconies and the stands, in the store windows, doorways, and portals, leaving no window, rooftop or vista unoccupied in order to admire the spectacle. . . . The press estimated that some 50 to 70 thousand people attended the celebration."[158]

However, the only photos in the *Crónica oficial* that really show any sort of crowd were all taken from the same spot, at the entrance to the Zócalo; it is impossible to gauge the number of spectators from this angle, but most of the windows are occupied with them, as is about a third of the roof. The one panoramic shot of the Zócalo reveals what would be considered an unexceptional attendance, if compared to other images taken on Independence Day or similar activities in other years, and the plaza is nowhere near full.[159] García may have exaggerated the attendance, as did the organizers of the Centenario in Guadalajara.[160]

The new identity that Díaz had been constructing for over two decades was displayed at the Centenario and, as documented in García's book, foreign recognition was given the privileged place that one would expect from a regime dependent on external financing rather than an internal market. The *Crónica oficial*'s first two chapters are devoted to representing the participation of foreign governments and colonies in the festivities, and Mexican reverences to their presence.[161] They offer an interminable photographic stream of diplomats with their wives; imposing exteriors and ornate interiors of the houses that served as embassies or lodged the special commissions; arriving royalty and officers from the ships that brought the commissions; and functionaries presenting their credentials to Porfirio Díaz. After his initial appearance in the book's frontispiece, the dictator rather unexpectedly disappears until the ceremony in which he placed the first stone for the Giuseppe Garibaldi statue donated by the Italians, and he is then shown fulfilling the same function with the monuments for George Washington, Alexander von Humboldt, and Louis Pasteur, presents from the U.S., German, and French governments. Foreign acknowledgment resolved long-standing grudges and incorporated Mexico into a peaceful international scenario, as the Spanish were photographed returning the clothing of José María Morelos, whom they had executed in 1815, and the French were shown restituting the keys to Mexico City, which they had supposedly taken during their invasion.

Efforts to include Mexico's underclass were complicated by the necessity to make it internationally palatable. Among the signs indicating Mexico's approbation by external arbiters was the hosting of the Seventeenth Congress of Americanists. Delegates presented papers asserting the racial inferiority of Indians, but a tour of the recently reconstructed Teotihuacán

pyramids demonstrated the splendors of an idealized ancient past; Indians were easier to incorporate into the nation when kept at a safe distance.[162] The amenities of contemporary Mexico were brought home when visitors to the archaeological site sat down to a feast in the "Grotto Porfirio Díaz."[163] *El Imparcial* had called for banning the poorest from the city center in order to safeguard foreign guests, but the governor decided that picking up the beggars and street urchins would be enough, since the celebration would largely take place in the newer "ideal" city built along the Paseo de la Reforma.[164] The organizers insisted that "the Centenario's festivities were not exclusively dedicated to society's upper class"; the government "understood the necessity to gladden the poor and to help the needy."[165] The events that essentially bookend the Centenario activities signaled the considerations taken in favor of the less-advantaged: constructing a mental asylum and expanding the penitentiary!

Cosmopolitan Mexico was incarnated in the imagery of new public works and buildings and the placing of cornerstones for even more signs of progress. Díaz is pictured in a flurry of inaugurating various institutions whose openings were timed to impress the Centenario's guests. As the "patriotic month" of September began, the dictator kicked off the festivities by initiating the spacious Castañeda Mental Hospital, sitting at the Presidential Table and touring the grounds with invited guests. His presence dominated the initiations of the Teacher's College on 12 September and the National University on 22 September.[166] Among many other Centenario activities, he identified himself with two symbols of nationality, being photographed while inaugurating the Column of Independence on 16 September and the Juárez Hemicycle two days later. He is also shown placing the cornerstone for the Legislative Palace on 23 September. His vice-president, Ramón Corral, is pictured on 17 and 21 September, leading distinguished foreign visitors around the waterworks, and he is shown inaugurating one of the last projects presented at the Centenario, the amplification of Belem Penitentiary, on 29 September.

Illumination was a central protagonist and visual metaphor of the Centenario.[167] The newer urban areas for the wealthy had been extensively electrified, and lighting up that cityscape was key to representing the modern mentality. The *Crónica oficial* contains many photos of buildings, both public and private, profusely illuminated by "torrents of electricity": "The

city was wrapped in a true mantle of light, whose immense tongues of fire ascended to the heavens, as if the city had been consumed in a vast fire or consecrated on a colossal pyre in memory of its heroes."[168] Progress and nationalism were portrayed hand-in-hand, as lights on the street corners formed arcs with the three colors of the Mexican flag, and "between the Cathedral's two towers a huge national banner seemed to be suspended in the air, made up of uncountable light bulbs."[169] Photographs of the luminous city must have offered a double whammy of the up-to-date: they testified to Mexico's electrical capacity and they demonstrated the technical capabilities of the photographers who took the pictures.

Image was fundamental to the Porfiriato and, as filmmakers were counted on to join photographers in rendering tribute to the Centenario, leading cineastes such as Salvador Toscano, the Alva brothers, and Enrique Rosas recorded it enthusiastically.[170] Early documentary cinema had presented many of the same themes as the illustrated magazines, including a sharp focus on Díaz, as cineastes filmed and distributed movies of his trip to Yucatán in 1906 and his meeting with William Howard Taft in El Paso three years later, as well as his horseback ride in Chapultepec Park (a short exhibited during almost a year!)[171] The first Mexican fictional film based on a real script had been *El grito de Dolores* (1907), a poorly received panegyric about the Hidalgo revolt that was nonetheless obligatorily exhibited every 15 September.[172] The historical theme was explored during the Centenario with the production of *El suplicio de Cuauhtémoc* (Cuauhtémoc's torture), though another filmmaker had offered to make a movie about the independence movement.[173] However, the most important cinematic activity of the Centenario was documenting the events and screening them the very next day, often to the foreigners who had participated in them; when the Palacio Theater programmed for the local audience, the *Desfile histórico* was the first film shown.[174]

Porfirio Díaz had presented to the Centenario's visitors an "ideal" Mexico City, which was meant to be taken as a synecdoche for the entire country: developed and cosmopolitan, ordered and progressive. If the Centenario was, as Mauricio Tenorio argues, "the apotheosis of a nationalist consciousness," it was of a kind that excluded many Mexicans who would soon be engaged in a struggle that, among other things, would redefine the identity imposed by the Porfiriato.[175]

REVOLUTION AND CULTURE (1910–1940)

T he Mexican Revolution put a very different face on the country. Suddenly, ordinary people appeared in photographs, periodicals, and documentary film, replacing the "Mexican types" within which they had previously been shoehorned, as well as the suits and Victorian dresses that had so dominated Porfirian representations. Combatants with crossed bandoliers were only the most immediate of the apparitions. As nonconformity and unrest spread, images of striking seamstresses, and villagers protesting against their town's *caciques*, joined the familiar fare of the upper crust's social activities in the illustrated magazines.[1] The armed struggle received extraordinary coverage by both commercial and private image makers from its very beginnings: the battle for Ciudad Juárez in May 1911 attracted some 1,500 "Kodak fiends" from El Paso, who daily went down to the Rio Grande or stood in relative safety on rooftops to shoot the action.[2] As the struggle developed, photographers and filmmakers poured into Mexico to document the world's first great social conflagration, taking advantage of the relatively free access to the action, especially when compared to the strict censorship exercised during World War I. The film historian Jay Leyda reflected on the exceptional documentation of the revolution in modern media, stating that he had once fantasized about making a movie that would "attempt to bring together the newsreel footage of this world-shaking event, filmed by cameramen sent there from every film-producing country of the world. I even dreamed of a fascinating world tour, digging in London and New York newsreel archives, finding Mexican footage in Copenhagen and Stockholm . . . in Berlin and Vienna."[3]

U.S. cinematographers and photographers had the most immediate entree. The revolution was reported daily in U.S. newspapers, and exten-

sively filmed for U.S. newsreel companies. The interest developed through written and visual reportage led to the production of fictional films, which largely demonstrated the necessity of U.S. intervention to assure democracy.[4] Mexicans were portrayed as violent and treacherous bandits who terrorized an anarchic, exotic, and confusing land in films such as *The Greaser's Revenge*, *Bronco Billy and the Greaser*, and *The Greaser's Gauntlet*, the latter by the famous director D.W. Griffith. Some U.S. films demonstrated sympathy for the revolutionaries, but the racism was nonetheless so pronounced that the only thing pictured as worth fighting for were the "beautiful señoritas" who, at risk from the uncontrollable sexuality of Mexican males, "readily betray their own kind and submit themselves unreservedly to the 'superior race,' succumbing always to the charms of the gallant and 'refined' North Americans."[5]

Postcards became a huge business along the border, and many embodied the same attitudes, portraying "greasers" and "bandits" in chains or as stiffened corpses grotesquely held up as trophies by smiling U.S. soldiers. The photographs that were made for postcards, and the messages that were written on them, conveyed a particular disdain for Mexicans: "Photo images of Germans during World War I, or even Spaniards during the Spanish-American War, were not nearly as sinister or degrading as those of Mexicans during the revolution."[6] Other postcards picked up the familiar theme of sexual conquest, picturing U.S. soldiers and sailors with Mexican women who were intimated to have loose moral standards.

Caught in the chaos that was redefining the nation, faced with racist characterizations from U.S. media, and suddenly flooded with image makers from all over the world, Mexicans constructed representations of their nationality different from those produced by foreigners, as well as dissimilar to those inherited from the Porfiriato: "Cinematographic images contributed, together with photography, painting, and literature, to fix a new vision of *lo mexicano* in the collective consciousness."[7] Director of what would later become a landmark documentary compilation, *Memorias de un mexicano*, Salvador Toscano appealed to Venustiano Carranza's officials for aid in 1915, arguing that cinema was "a medium to counteract the effects produced by denigrating U.S. movies, as well as those of films manufactured by other groups, such as the Villistas [followers of Pancho Villa], because movies easily impress the masses with their real scenes that are faith-

ful copies of life. The result will be greater than propaganda in a hundred newspapers."[8] Although his main preoccupation was protecting his movie salons and production company, for which he assumed the façade of neutrality, Toscano was attracted to Francisco I. Madero's movement from its beginning and had traveled to Puebla to document the destroyed house of Aquiles Serdán, who was killed in "heroic resistance" to Porfirio Díaz in 1910.[9] Upon Madero's triumph in 1911, the director made paid propaganda for that cause, which allowed him to explore the narrative possibilities of creating a national history in cinema, instead of making newsreels that were ephemeral. Toscano produced and distributed *La historia completa de la Revolución* in 1912 and later extended it to 1915, upon aligning himself with the Constitutionalist forces of Venustiano Carranza after Victoriano Huerta's fall in 1914.

Leaders recognized the importance of spreading their images around as propaganda for themselves and their causes and so employed cameramen and photographers, usually Mexicans, or included them in their ranks. Newsreels about the struggle, as well as documentary compilations, were shown throughout the country and became very popular, as were the photographs that were published in newspapers and illustrated magazines or printed as postcards. One of the first to enlist was Jesús H. Abitia, who was probably the only individual to practice extensively both photography and filmmaking.[10] A childhood friend of Álvaro Obregón, he had been involved with the northern opposition to Díaz from its inception and had saved Madero's life when he visited Hermosillo.[11] In 1913, Abitia entered the ranks of Carranza's army, whose commander, much concerned to replace Madero's image with his own, "cultivated a tenacious and overwhelming inclination to exhibit himself in effigy."[12] Abitia was designated "the Constitutionalist Photographer," and he followed those forces about the nation, recording battles, triumphs, and camp life, with Carranza and Obregón in the foreground. He edited this documentary footage into feature-length productions such as *La campaña constitucionalista* (1915), and although his films no longer exist, the surviving material was eventually made into *Epopeyas de la Revolución*.[13] Coming under fire on a number of occasions, he was once saved by his camera when it took the force of an exploding grenade that destroyed his equipment but left him untouched. Abitia also produced several series of postcards that were sold to officers and soldiers alike as

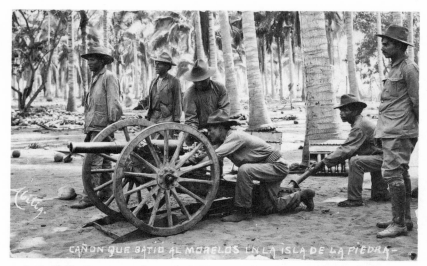

12. Jesús Abitia. The cannon that sunk the Huertista ship *Morelos* at La Piedra Island, Mazatlán, May 1914. Fondo Juan Barragán, expediente 2581, Centro de Estudios sobre la Universidad, Universidad Nacional Autónoma de México. IISUE, AHUNAM/Fondo Juan Barragán.

13. Jesús Abitia. Money printed by the Carrancista army with a photo by Jesús Abitia, ca. 1914. Collection of Ángel Miquel.

souvenirs and reproduced in the press. Entrusted by Obregón with printing up the Constitutionalist money, he placed his photographs of Madero and a battle scene on the bills (see figures 12 and 13).

The Zapatistas also had their photographers and filmmakers. One documentary, *La Revolución zapatista*, celebrated that movement, the only such film to be made during the armed struggle by a Mexican about a losing cause.[14] Although the movie's director is unknown, the man who became

Emiliano Zapata's photographer has been identified: Amando Salmerón, member of a family photography business in Guerrero.[15] Salmerón documented the triumph of *campesino* forces linked to Madero's movement in 1911, and Zapata asked him in 1914 to become the image maker for his army, charged with registering "the principal points of combat, and the leader, officers, and soldiers of the bad government who fall prisoner."[16] Though Zapata appears to be nervous and uncomfortable in the sequence filmed by Salvador Toscano at the meal in Mexico City with Pancho Villa and Eulalio Gutiérrez in 1914, he recognized the importance of modern communications media and participated in constructing his portrayal. Salmerón covered the Zapatista forces, making portraits of Zapata and taking pictures of soldiers armed at times with bows and arrows.[17] His friendship with the leader is evidenced in the dedications inscribed on the photographs' backs by Zapata, as well as in the 30-30 carbine that he gave to Salmerón.

Among the first chieftains to fully grasp the power of modern, transnational media, Pancho Villa signed a contract with the Mutual Film Corporation in 1914 for $25,000, giving the company exclusive rights to film his battles and executions, which he was obligated to carry out in daylight or to recreate if they could not be recorded; he was to wear the uniform created by the company (although he was only permitted to use it when filming).[18] At this moment, Villa's movement was receiving support from the U.S. government and businessmen, impressed by the discipline he maintained over his forces; he was also the darling of leftists such as John Reed, for whom he was the personification of social revolution.[19] Hence, he was shown in a positive light, and his natural charisma enabled him to project himself to U.S. audiences as a Robin Hood. While Villa was being filmed before the battle of Ojinaga, one of the photographers who made the publicity stills took what became the most famous photograph of the chieftain, that of him galloping on a horse toward the camera with his soldiers behind, a centaur who seems to share his mount's wildness.[20] Exhibited at a publicity exposition organized by Mutual, the image caught the eye of U.S. publishers and appeared in the illustrated magazines *Leslie's* and *Collier's* in early 1914, along with many other photos of Villa. He became the subject of a fictional film, with Raoul Walsh as the young Villa, that represented him as entering the revolution to revenge his sister's rape by a federal officer.[21] As Villa began to lose battles to Obregón, and the United States recognized the

Constitutionalists as the legitimate government, Villa tightened the screws on U.S. interests; after his 1916 attack on Columbus, New Mexico, his cinematic persona was relegated to that of a bandit, the usual status accorded Mexicans.

Some of Mexico City's more established image makers appear to have sided with whoever was in power. The Alva brothers made cinema for Díaz before the revolution but went over to Madero once his armed movement triumphed; they then became apologists for Huerta in 1913, after he overthrew Madero during the Tragic Ten Days.[22] Agustín Víctor Casasola probably followed much the same route, less concerned with making a commitment to any particular cause than developing strategies to compete with the myriad of foreign photojournalists covering the war and ensuring that the photographs would be available for future uses, commercial and historical. In 1912 he founded a newsphoto agency, the Agencia Mexicana de Información Gráfica. There, he accumulated images from many sources, beginning with the photo archive of El Imparcial, which closed in 1914. Casasola was both a photojournalist and an entrepreneur, contracting men to work for him or purchasing images. He invites comparison to Matthew Brady, who referred to himself as an "impresario" while organizing a corps of twenty men to cover the U.S. Civil War; moreover, Alan Trachtenberg's observation that "more than any other American, Brady shaped the role of the photographer as a national historian" could also be said of Casasola.[23] However, his was also a typically Mexican business, formed around the family: he founded the agency with his cousin, Gonzalo Herrerías, and incorporated family members, including his brother, Miguel, his sons Gustavo, Ismael, Agustín, and Mario, and his daughters, Dolores and Piedad. Among the photographers who appear to have worked for him or sold him their images are Eduardo Melhado, José María Lupercio, Abraham Lupercio, Samuel Tinoco, Jerónimo Hernández, Víctor León, Luis Santamaría, Manuel Ramos, Antonio Garduño, and Hugo Brehme.[24]

Because Agustín Víctor was not very forthcoming in identifying the authors of images in his archive, he was for many years acclaimed to be *the* photographer of the revolution. He had presented himself in that role as early as 1921—at least implicitly—by excluding the names of the photographers whose images he incorporated in his *Albúm histórico gráfico*.[25] During an interview in 1926, he claimed to have participated in "all the phases of the

revolutionary epoch, and very particularly the Constitutionalists and Don Venustiano Carranza, in Queretaro, where [I] spent a long period."[26] In 1988, the Partido Revolucionario Institucional (PRI) made him a key element of identity, eulogizing him in a publication that was part of the series "Cultural Nationalism. Forgers of Mexico," where they consecrated the Casasola myth, dubbing him "the graphic chronicler of the Mexican Revolution" and asserting that "Casasola took the camera into all of history's corners . . . [and] was present in every civic and military activity of the armed movement."[27] Perhaps taking note of the difficulties that such travels would have entailed, the PRI hack had contradicted himself a page earlier by trying to extend the enterprise to the family (despite the fact that only Miguel, and Gustavo, at age fourteen, would have been old enough to have participated), following the strategy mapped out by Gustavo Casasola in 1960, when he asserted that "the Casasolas were in the north, in the west, in the south and in Veracruz during the U.S. intervention."[28] In yet another text it was alleged that "various family members covered the Revolution. Some in the north, another in the south, another in the northeast, and the rest covered Mexico City. Agustín was the photographer for the 24th Brigade, that was with the Constitutionalist army."[29] Antonio Rodríguez, a Portuguese art critic exiled in Mexico, intuited that Agustín Víctor must have acquired images from other photographers, and he credited him with the historical foresight to construct an archive with which to recount the epic struggle: "Casasola was everywhere, with Pascual Orozco and with Felipe Ángeles, now in front of Huerta, and later together with Carranza; but when his gift of ubiquity failed him, he looked for his better colleagues and, with no sense of inferiority, acquired their photos, thinking in the documentary collection that he projected donating to the future so that a page so palpitating of Mexico's history would not remain empty."[30] The myth continues: as Ignacio Gutiérrez noted, "To date, it is affirmed generically that 'The Casasolas are the photographers of the Mexican Revolution.'"[31]

Recent scholarship seems to indicate that the Casasolas' coverage of the revolution was largely limited to Mexico City. Agustín Víctor did accompany Porfirio Díaz to Veracruz when the dictator left Mexico in 1911; he and Miguel also evidently made images in Morelos of the Zapatista movement (though the focus fell on the federal troops fighting against them); and he eventually ended up in Querétaro, connected to the Constitutionalists.[32]

Miguel Casasola apparently preferred dynamiting trains for Obregón's army to being a photographer, abandoning his camera in 1914 and returning to it only in the 1920s.[33] Gustavo was sent, at age fourteen, to cover the Convention of Aguascalientes, but the other Casasola children were too young to do anything but help in the laboratory. My own experiences with the Casasola Archive have left me with the distinct impression that Agustín Víctor's photography during the revolution was an extension of the political and social imagery he had made of the ruling class for *El Imparcial*: the *caudillo* in turn—Díaz, Madero, Huerta, Villa, Zapata, Carranza, Obregón—and their general staffs, as well as pictures of their womenfolk visiting the underprivileged. Studies analyzing the negatives, as well as comparing the credits given to published photos with images from the Casasola Archive, have confirmed my suspicion.[34] He did photograph warfare on at least one occasion, when he, Miguel, and other photojournalists documented the Tragic Ten Days and took what would have to be included among the early instances of real combat photography in the world—although they were preceded by those that Jimmy Hare (and other foreigners) made during Madero's uprising on the northern frontier in 1911.[35] Nonetheless, rather than a "revolutionary" photographer, Agustín Víctor was a committed entrepreneur, a lover of photography, a visionary of the picture histories that would become so central in constructing national identity, and an excellent photojournalist who was probably most at home in conservative publications.

What made Agustín Víctor exceptional were his organizational capacities, his extraordinary work habits, and his ability to get along with everyone, particularly with those in power. He founded an archive which today contains a half-million images and is considered vital to national identity: "They are in our life and our history because they have become indissolubly integrated into our Mexican patrimony."[36] However, before he (and Gustavo) began to use that archive to produce the *historias gráficas* that would so mark his nation's culture, he focused on achieving recognition for photojournalists, who had evidently received little respect during the Porfiriato. In 1911, Agustín Víctor created the first Association of Press Photographers in Mexico and, in meeting with interim president Francisco León de la Barra, he set the stage for the continued adulation of patriarchy. Casasola expressed his gratitude for "having inaugurated a stage of photojournalistic freedom almost unknown here" and hastened to assure de la Barra that

the purpose of their association was to provide fraternal aid, in the spirit of the old mutualist organizations rather than the new labor unions that were appearing: "Ours is not an industrial mass that opposes our productive force against the businesses that require our services; it is a cordial grouping of good and honorable men."[37] The principal activity of the association appears to have been the organization of the first exhibit of photojournalism in Mexico, through which he personally guided the recently elected Francisco I. Madero in an effort to stay close to the presidential figure and to disassociate himself from the anti-Madero sentiments of his former connections in *El Imparcial*. When photojournalists were threatened, Agustín Víctor was in the front line of their defense. He attempted to interview Emiliano Zapata in 1912, but the leader, no doubt aware of Casasola's antipathy for his cause, refused to receive him and warned him to leave immediately.[38] He did so, but the train (which Casasola missed) was attacked, and three journalists were killed: Ignacio Herrerías (Agustín Víctor's cousin), León Strauss, and a photographer named Rivera. Casasola led the protest against their assassination.[39]

Notwithstanding the importance of his activities in organizing the photojournalist guild, his fame rests largely on the fact that the classic revolutionary icons that form a fundamental element of the nation's visual identity have all been attributed to Agustín Víctor Casasola at one time or another. These images are ubiquitous: appearing on banners for political causes, both officialist and dissident, the walls of public buildings, T-shirts, the pages of *historias gráficas*, newspapers, and illustrated magazines, as well as being incorporated in both classic and recent mural paintings. Among the various revolutionary icons, I find five of particular interest: Emiliano Zapata standing solidly in *charro* raiment, a sash across his chest, with a carbine in one hand and the other on a sword; Francisco Villa galloping toward the camera; Villa lolling in the presidential chair next to Zapata; "Adelita-the-*soldadera*" peering intensely from the train; and Victoriano Huerta hidden in the shadows together with his general staff (the latter two discussed in chapter 5).

The picture of Emiliano Zapata with carbine and sword has become an international revolutionary icon equaled only by Korda's famous image of Che Guevara as the "Heroic Guerrilla"; they must be the most reproduced photographs from Latin America (see figure 14).[40] Although authorship of

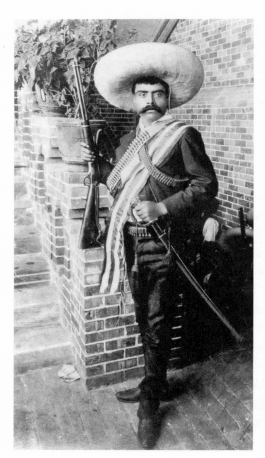

14. Hugo Brehme. Emiliano Zapata, Cuernavaca, Morelos, May 1911. Inv. # 63464, Fondo Casasola, SINAFO-Fototeca Nacional del INAH.

the image has usually been claimed by the Casasolas, the *guerrillero*'s suspicions of Agustín Víctor probably made that impossible. It is now considered to have been taken by Hugo Brehme in late May 1911, at the Hotel Moctezuma in Cuernavaca.[41] The fact that a foreigner could get close to the fearsome warrior reinforces the idea of Zapata's concern for constructing his own image; he may have felt that an outsider would be more neutral, and that the image would thus reach eyes outside the country, for he had little trust in the Mexican media (and rightly so, considering the uses made of this picture). José Guadalupe Posada evidently interpreted it into a lithograph almost immediately and put it out on a broadsheet, but the photo itself was not published until two years later in the press.[42] Time was required to dis-

connect the image from newsworthy events so that it could be converted into an illustration to attack Zapata.

As the research of Ariel Arnal has established, the photograph is of intriguing complexity.[43] It may represent a startlingly graphic depiction of triumph. Zapata is dressed with the tricolored general's sash and sword that Manuel Asúnsolo had worn as a symbol of his status as the Maderista authority in Cuernavaca, a demonstration of the prerogative Zapata had apparently acquired to determine who would govern the city and Morelos.[44] However, Asúnsolo held onto power in Cuernavaca and appointed a planter-friendly banker to be governor of the state, so his surrender of the sash and sword may have been more symbolic than real. At the same time, wearing these emblems could represent an attempt on Zapata's part to legitimate his movement. He and his *campesinos* were portrayed in the Mexico City press as cruel and ferocious savages, and they were invariably pictured within the "iconographical type" of the bandit.[45] In his pose, Zapata may be attempting to counteract that mindset, presenting himself as a professional soldier, with the rank of general, and thus a man deserving of Madero's political recognition, which was vital at that moment. If so, he would have been disappointed to discover that the photo was not published until April 1913, when it was used to illustrate an article calling for the extermination of the Zapatistas and describing their leader as "Attila of the South" and a thief.[46]

The icon of Villa in the presidential chair, Zapata next to him, entered into circulation immediately, when it was published in periodicals the day after the event in December 1914.[47] The Mexico City press did not comment on the image, other than to provide a minimal description of the individuals appearing in it. However, a newspaper from Veracruz (where Carranza's forces were in power) did have something to say about it, though it was not until almost two months after Obregón had retaken Mexico City at the beginning of 1915. The article referred to a "primitive," "barbarous," and "vain" Villa, who ruled by fear, and was "playing at being president"; it went on to declare that the scene was the "antithesis" of Christ on the cross: "Villa, amoral, the bandit triumphant and smiling, between two brigands, surprised at a triumph that unites the three in the same second of arrogance."[48] Little is known about the circumstances surrounding the photo's making, though an attempt was made to incorporate it into the Casasola

myth in the PRI panegyric on Agustín Víctor, where it was alleged that Villa approached the photographer while in the National Palace and asked, "So, have you been working hard?"; when Casasola responded that he had, Villa then directed himself to all the photojournalists present, whom he warned, "Be very careful, we don't want a bunch of dead photographers here." The graphic reporters are said to have fled the palace immediately.[49] It is difficult to imagine that Villa would have been moved to address Agustín Víctor, who had been associated with *El Imparcial*, and equally hard to conceive of Villa threatening wholesale the assembled journalists, given his consciousness of the power wielded by the press.

Villa's pretensions to the presidency became history when the U.S. invasion of Veracruz during 1914 shifted the balance among the contending revolutionary forces by giving to the Constitutionalists the massive arms shipment it captured there.[50] The generalized outrage that Mexicans felt on being occupied (again) by the United States was perhaps summed up best in a documentary, *La invasión norteamericana*, shown in 1914, that abandoned the partisanship of filmmakers usually attached to one leader or another.[51] The narrative compared pre-invasion Veracruz with the destruction caused by the United States, contrasting "yesterday's bustling Veracruz, free and sovereign, with today's, trod upon by our eternal enemy."[52] However, there were variations in picturing even this, one of the most traumatic episodes of nationhood, as can be seen by comparing the images of two photographers who documented that intervention and the resistance to it, P. Flores Pérez and Eduardo Melhado.[53] Both photographers took pictures of the occupying forces: contingents of armed Marines storm down the docks upon their arrival; U.S. naval police carry out an inspection; Marines relax in a plaza, drinking from large cups; sitting behind a Remington typewriter, two Marines look up at the photographer. They also documented aspects of the city's destruction, the death of civilians, and the solidarity among the port dwellers who provided aid to the wounded and participated in funeral marches of protest for dead heroes.

Flores Pérez and Melhado were photojournalists and so covered aspects of the invasion necessary for their publications, as well as making images for sale as postcards. Melhado, who was probably from Mexico City, documented the revolution throughout the country, eventually working in the Casasola Agency.[54] However, P. Flores Pérez was evidently from Veracruz,

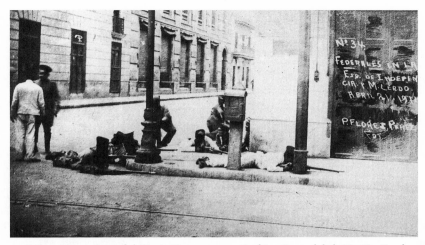

15. P. Flores Pérez. Streetfighting in Veracruz, 1914. Archivo General de la Nación, Fondo Propiedad Artística y Literaria, Colección Flores Pérez, Intervención norteamericana, G-1, E-2.

and his photography seems to express that, because when he took pictures of the occupying intruders, he often foregrounded Mexican dead as a way of pointing to U.S. responsibility. Some photos were spontaneous, such as that in which he captured a U.S. sailor with his rifle pointed down at bloodstained civilian corpses shortly after intense street fighting.[55] Flores Pérez did not limit his camera to denouncing the war against civilians; he also evidenced opposition to the invasion. One picture documents a crowd gathered in front of military headquarters, demanding weapons with which to resist (according to the legend written on the photo). Another image shows Mexican soldiers lying flat in what appears to be street fighting but, at the photo's margin, two men seem to be standing rather carelessly in conversation, making one doubt whether it was made during combat (see figure 15).[56]

The difficulties of photographing actual fighting may have led Flores Pérez to direct scenes that would provide visual evidence of opposition and civilian casualties. Intent upon denouncing the invasion and attesting to resistance, the photographer created images that show men firing into and out of houses in ruins, bodies scattered about, and children who ostensibly peer at fighting from behind a wall. In one picture ("Effects of a Machine-gunning"), we see a man pointing with a pistol, next to three

corpses; in another photo taken of the same scenario and from the same position—titled "Destruction caused by a Machine-gunning"—the man with the pistol seems to be leaving, while on the ground the three corpses have changed into other bodies, lying in different positions![57] Comparing these two images makes it clear that Flores Pérez reconstructed scenes. An obviously posed photo evidences his intentionality even more clearly: here, two Marines posture gallantly in firing position, but a "dead" Mexican has been placed in the foreground, providing an obvious victim of U.S. imperialism.[58] It is instructive to contrast this image to a similar photo staged by Melhado: a group of four heroically posed Marines fire their 45's out toward the enemy, aiming through a gaping hole in a bombed-out building.[59] The fact that these photographs were staged in no way invalidates them as historical documents, for the resistance that P. Flores Pérez pictured, whether in real combat imagery or post facto recreation, represented opposition to the intervention, by the populace and by the photographer.

Packaging the Revolution

The idea of creating visual histories of the armed struggle had begun in its midst, when cineastes compiled their footage into feature-length documentaries and editors brought out commemorative albums, such as that produced in honor of Venustiano Carranza by the governor of the state of Mexico in 1916.[60] In 1921, Agustín Víctor Casasola published what would be the first of the photohistories from his archive for which the family would acquire renown: *Albúm histórico gráfico*. His project was ambitious, above all in a country devastated by civil war: he planned to bring out fifteen volumes of two hundred pages each, which were to cover the period from James Creelman's 1908 interview with Porfirio Díaz to the presidency of Álvaro Obregón (1920–24). He must have believed that there would be a market for images of the recent conflagration, but the series did not have the commercial success he had hoped for, because only five volumes were eventually produced.[61] It is difficult to ascertain at this point to what degree Casasola enjoyed official support, though it is almost impossible to imagine that he would have undertaken such an expensive enterprise without at least the promise of being subsidized, and his close connections to the government offered that opportunity.

President Obregón was involved in a process of legitimating the New

Order, both within and without Mexico. History has often served revolutionary regimes, testifying to their link with the continuum of the national past and demonstrating their profound differences with the preceding government. Obregón's most determined attempt to remold the nation's perception of the past was the festivities he organized in 1921 to celebrate the Centennial of the Consummation of Independence, thus incorporating his administration into the pageant of Mexican history, while hoping to replace in the public's mind the Centenario that Porfirio Díaz had so sumptuously commemorated in 1910. The 1921 festivities emphasized Mexico's revolutionary identity, its Indian origins, and its mestizo character, expressive of the postrevolutionary recovery of typical Mexican culture embodied in artistic nationalism, popular music, and folk art.[62] This was distinct from the representation of Mexican history promulgated in the 1910 Centenario, which was that of pyramidal and corporative power incarnated in the figures of past heroes: the emperor Moctezuma, Hernán Cortés, the colonial viceroys, and Agustín de Iturbide.[63]

Casasola's *Albúm histórico gráfico* may well have been designed to join the 1921 Centennial in creating a new chronology, one in which *La Revolución* assumed a primordial function, and Agustín Víctor presented himself as the principal photographer of that struggle.[64] Nevertheless, Agustín Víctor's historiographic model appears to have been derived from the Porfiriato's monumental narrative of modernization driven by a *caudillo*. Certainly, Great Men dominate the albums, where they appear in some 70 percent of all the photos, while individuals who are or will be Mexican presidents are in 40 percent.[65] Photographs abound of "Madero haranguing his troops," Villa staring down from atop his horse, Díaz receiving delegations of army officers in support, revolutionary leaders and their staffs, Madero signing official documents, Francisco de la Barra taking the oath of office, and Díaz surrounded by his supporters as he departs the country. The exotic element offered by the underside is explored in images of Chamula Indian revolutionaries, giant and dwarf, as well as in one of the two photos in which women appear: the "female General Staff" for General Ramón Iturbe stand with 30-30 carbines, their white dresses creating a photogenic contrast with the general's dark suit (see figure 16).[66]

Agustín Víctor pretended to an objectivity "free from all partisanship and naked of all political passion."[67] The two historians he invited to write

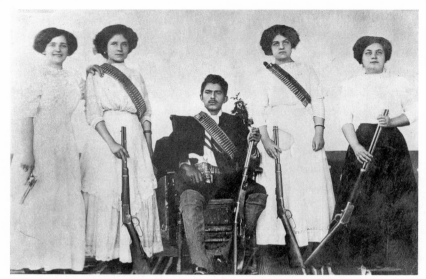

16. M. Yáñez. "General Ramón F. Iturbe and his female General Staff." Topia, Durango, May 1911. Inv. # 186666, Fondo Casasola, SINAFO-Fototeca Nacional del INAH.

the (minimal) texts for the first two volumes were highly respected and had been members of the Porfirian cultural elite. Luis González Obregón was the director of the Archivo General de la Nación from 1910 until he was removed by Venustiano Carranza in 1917, but he stayed on as the chief of historians; he was a regular collaborator in Rafael Reyes Espíndola's *El Mundo Ilustrado*. Nicolás Rangel was proposed by the senate to compile a book for the Centennial of the Constitution of 1824. However, the ideology of the *Al-búm histórico gráfico* is secreted less by the relatively limited collaboration of these intellectuals than by the structure created by Casasola. The album's general deference to Díaz is articulated in volume 2 through the interspersing of Porfirian order and progress with the chaos unleashed by Madero's campaign for real elections. Hence, one narrative develops in which workers in coats and ties meet with the president, German diplomats assemble to award him the "Collar of the Red Eagle," and the Científicos gather in their shiny top hats, well-lustered footwear, and elegant overcoats. The photos that most typify this storyline of Díaz-the-modernizer were taken at the first airplane flights in Mexico; there, dressed in a stylish derby hat—an English cultural icon—he chats with French air ace Rolland Garros. This history of progress is interrupted increasingly by destroyed trains, dark-skinned

rebel chieftains with cartridge belts crossed over their chests, gatherings of poorly-dressed masses in Mexico City streets, and stiffened corpses hanging from telephone posts and trees.

Together with consolidating the new regime, President Obregón needed to secure the recognition of the United States. Facing powerful interest groups opposed to the normalization of diplomatic relations—above all, the oil companies, right-wing organizations such as the American Legion, and associations formed to protect U.S. citizens in Mexico—Obregón recognized the necessity of contesting their rabid anticommunist and racist rhetoric. His strategy was to "vigorously extend and intensify knowledge of Mexico in the exterior . . . [publishing] books by Mexican authors [as well as] photographs and movies that reveal the national ambience," and at least one expensive photographic book was produced within the photography workshop of the sections dedicated to "Information and Propaganda" and "Publicity, Press, and Information" in the Secretariat of Foreign Relations.[68] Obregón spent a considerable fortune attempting to educate U.S. politicians about Mexico, and the budget of the 1921 Centennial was weighted toward paying the expenses of visitors.

Whether the *Albúm histórico gráfico* was subsidized by the Obregón government is unclear, but there are indications that the albums were designed to appeal to the U.S. public, first because texts are in English as well as Spanish, the only works from the Casasola Archive to be translated.[69] Moreover, the narrative begins by highlighting the role of the United States in Mexican matters, beginning with the Creelman interview and then moving on quickly to the meeting of the Mexican dictator with President William Howard Taft. The suspension of the series shortly before the representation of the Tragic Ten Days has been interpreted as a result of the fact that some of those involved in Madero's assassination were still active in public life; hence, demonstrating their activities could have caused "a politically uncomfortable, if not explosive, situation."[70] However, the United States was also deeply implicated in that overthrow of a democratically elected president, through the figure of its ambassador, the infamous Henry Lane Wilson.[71] Moreover, the United States invaded Veracruz a year later in 1914, an event that would have been particularly difficult to portray in a manner that would be acceptable to both Mexican and U.S. readers. Another explanation for the termination of the series may be related to a negative response by

Mexicans to the English texts (a familiar, if complex, issue): the last volume published in the 1920s promised that in the future the English version would appear separately.[72]

The situation of Agustín Víctor Casasola as an "amphibian"—with one foot in the Porfiriato and the other in the revolution—can be appreciated in the aesthetic strategies he employed with the photographs in the *Al-búm histórico gráfico*. Rather than printing the photos so as to enhance their transparency, reflecting the modernist worldview of photography as a window onto the world, Casasola utilized nineteenth-century illustration techniques, inspired by Porfirian publications. Hence, many photos are obviously (and poorly) retouched, although their later use in Casasola Archive publications demonstrates that a good original existed. Casasola also constructed collages with images and put oval portraits of individuals into photographs of general scenes. One eminently premodern picture combines collage, retouching, and inserts to construct an image that links Madero, the revolution, and the nation: a Mexican flag and a rifle have been placed against a wall; above, an oval portrait of Madero has been inserted; below, writing appears on the photograph (though it simulates graffiti on the wall), "Long live Madero. Ciudad Juárez. May 10, 1911," the date that city was captured, marking the defeat of Díaz. Even the most realistic photos lose their credibility with the insertion of these portraits, including one apparently taken in combat, but Casasola was evidently willing to sacrifice that for a higher cause. All the inserts place Great Men into what would otherwise be images of anonymous combatants or cityscapes. Through this tactic, Casasola insisted that history—and the new nation itself—had been forged by male chieftains.

La mexicanidad: Exotic or Not?

Social revolution sweeps away established ways and makes problematic the very structures of identity that had reigned until that pivotal moment. Such was the case in Mexico, and the postrevolutionary effervescence of cultural nationalism that followed in its wake centered on discovering *lo mexicano* in lieu of seeking solutions from without; in the early 1920s, the philosopher Antonio Caso encapsulated these sentiments: "It would be worth more to know what we have at home than to import foreign theses discordant with the palpitations of the Mexican soul."[73] Given the surge of patriotism in this

period, it is ironic that the controversy about how best to photographically portray *mexicanidad* is most easily embodied—at least initially—in the different aesthetics adopted by foreigners: on one side, Hugo Brehme, on the other, Edward Weston and Tina Modotti.

The positions represented can be summarized as the picturesque and the antipicturesque.[74] Brehme, and Mexicans such as Luis Márquez and Rafael Carrillo, were traditionalists who constructed a romantic vision of a bucolic rural Eden absorbed in its nature and peopled by *charros* and *chinas poblanas*, regional figures that were transformed into national archetypes.[75] Their aesthetic was at one with their content, using the camera like a nineteenth-century paintbrush to offer what appeared to be transparent, fine art–inspired images of beautiful, idyllic scenes. Edward Weston, Tina Modotti, and Manuel Álvarez Bravo were experimenters who broke with painterly notions of art and sought to establish photography as a medium in its own right, with its own possibilities and limitations. They rejected the picturesque and focused on modern urban life as found in telegraph lines, typewriters, and toilets.[76]

Although folkloric subjects were foregrounded by the traditionalists, form is as important as content in determining a picturesque portrayal: it is a question not only of *what* is photographed but *how* it is depicted. Hence, consider the differences between women carrying water jugs as portrayed by Hugo Brehme and Tina Modotti. Modotti's image is a dramatic composition, in which the pottery—and the exquisitely irregular rivulets of water that run down it—dominate the frame and immediately catch the eye; next we see the arm bent and hand clenched in the effort to shoulder such weight; then we catch a glimpse of a faceless *campesina*, condemned to a life of arduous tasks, and the merest hint of a *rebozo* cushioning the woman's back against the jug that rests on it, a shawl incorporated into the labor process rather than as an exotic trapping (see figure 17). The image by Brehme has neither the aesthetic power nor the social sensitivity of Modotti's. Six women in lacy white peasant blouses and ruffled skirts are lined up in a luxuriant tropical setting, standing statically, with towels providing bases for water vessels that sit on their heads without being held.[77] The fact that the women do not have to sustain the jugs indicates that they may be empty, but even if they were full, the balancing act provides the expected image of exotic ease. Facing sideways, the women look ahead, with the exception of

17. Tina Modotti. Woman with water jug, Oaxaca, ca. 1928. Dirección de Artes Visuales de la Fundación Televisa, AC.

the lightest-skinned one, who returns the camera's gaze. The same contrast can be carried out with pictures of *campesinos*. In Brehme's photo, the peasants loll lazily against whitewashed adobe walls, chatting away their day.[78] Modotti's rendering is quite another matter. Shooting from almost directly overhead in a style reminiscent of the "foreshortening" aesthetic favored by Soviet photographer Alexander Rodchenko and employing an oblique angle, she captured *campesinos* in movement, their sombreros slightly blurred as they strode forcefully toward Mexico City's Zócalo to participate in a May Day march.[79] Even landscapes can differ, as Amy Conger demonstrated in comparing images made by Brehme and Weston of almost the identical scene in Lake Patzcuaro, in which the latter's formal power transformed a picturesque scenario into abstract expressionism: "Brehme recorded a quaint and somewhat condescending scene to remind the tourist at home of the peaceful, complacent, and colorful poverty of rural Mexico: dilapidated shacks, spindly trees, and fishermen on the edge of a lake with gentle hills and cotton-puff clouds receding back to the horizon. From the same spot,

Weston organized a composition on his ground glass that was divided into three horizontal bands. . . . This complex study of light and form is an extremely dynamic composition."[80]

Modern scholars of Mexican photography argue that Brehme constructed "a graphic system of *lo mexicano*," creating a "visual vocabulary" of *mexicanidad*, that constitutes "the base of today's national identity."[81] His photography was influenced by the Pictorialist movement, which reflected painterly principles of composition and idealized the rural life. More importantly, it embodies classical notions of the picturesque. Nature overwhelms humans and their existence: rugged cliffs of craggy stones and twisted trees tower over shacks embedded in vegetation; in the midst of an open plain, an immense yucca tree renders a burro and rider insignificant; a gargantuan organ cactus dwarfs the *campesino* standing in its shadow; snow-capped volcanoes provide the ultimate backdrop.[82] Buildings—both pre-Columbian and colonial—show the onslaught of rain and sun, the wear and tear of time, as do the dewy-eyed, grandfatherly old men who appear in his few portraits. All is made beautiful: ramshackle huts of stone or adobe provide a texture for the camera that is reiterated in rock walls and village markets, where all radiates tranquility and well-being.

Following the precepts of the *costumbristas*, and the scent of foreign sales, Brehme's camera sought out exotic subjects, which are almost always dressed in traditional, rather than modern, clothing. Utilizing regional types to generalize *lo mexicano*, Brehme took many images of women from Tehuantepec (*tehuanas*) posing in their extravagant headwear, as well as the omnipresent *charros* and *china poblanas*, wooing from behind colonial windows or while seated in cactus (!), at times posing in front of lacquer plates, and usually accompanied by a symbolically charged sombrero, fundamental elements of Mexican curios. The nation was pictured as being an assemblage of archaic production and distribution. Among the producers were fishermen standing in ancient dugouts, farmers laboring behind oxen in wooden stocks, and *tlachiqueros* sucking *aguamiel* from magueys; among the venders were girls with forty sombreros piled on top of their heads, boys jauntily carrying buckets of water suspended from their shoulders, and bird sellers weighed down by the enormous cages they bear.

In Brehme's photography, the sources of nationhood are a past made nostalgic and a nature that formed the essence of *mexicanidad*. Hence, the

pre-Columbian period is incorporated in images such as that of an Indian boy posed so as to be completely enveloped by the reconstructed Mixtec ruins at Mitla, Oaxaca, his ragged clothing absorbed by folkloric yesterdays.[83] Much the same message is created in the photo of a beggar sitting on the steps in front of the Baroque church outside Acatepec, Puebla.[84] The fact that both the boy and the beggar are seated, depicted in quiescent positions, asserts that they passively accept this fate. Nature is represented as the quintessence of Mexico, and *campesinos* are portrayed as products of earth and sky: they seem to grow out of the land—like the magueys which frame them from below—and flow down from the rolling clouds that cluster about their heads (see figure 18). Here is patriarchy exemplified by three generations dressed in their Sunday best—clean, white, and sparkling for the photographer. The misery of the countryside—much of which is a product of relatively recent historical forces—was turned into an aesthetic cliché by Brehme, who fused nostalgia for pre-Columbian and colonial architecture with nature itself to argue that this has forever been Mexico's plight.

Born in Germany, Brehme arrived to stay in Mexico during 1906. Because his images provided the Orientalism that people expected to see, they received massive diffusion in national and international media, where their acceptance led to his meteoric ascent.[85] Highly proficient in photographic technique, and working within well-established fine-arts canons, his pictures were easily consumed. He described his work as "Artistic Photography," though he demonstrated no interest in formal exploration. Rather, Brehme relied on his artiness and photography's credibility to create commercial images, beginning with postcards, which were sold by the thousands within Mexico and in greater numbers outside the country. His work was extensively published in tourist guides, illustrated magazines, newspapers, and books in Germany, the United States, and Mexico, including *National Geographic*, where his idealized and beautified exoticism found a home.[86] Nonetheless, his fame was secured with the appearance of two works about "Picturesque Mexico" in 1923–25.[87] It was not easy to publish books of photographs in a country destroyed by war, although these were probably financed and consumed largely by foreigners. In these works, Brehme alternated images of pre-Columbian and colonial architecture with beautiful landscapes, and one or another of the "popular types," including *charros* and *tehuanas*. Modern Mexico is absent from the books, as is the

18. Hugo Brehme. Campesinos, maguey, and clouds, ca. 1925. Inv. # 373320, SINAFO- Fototeca Nacional del INAH.

revolution, despite the fact that Brehme had made some excellent images of the Zapatista movement.

As might have been expected, Brehme's romantic imagery was exactly the sort of thing the government needed, and he collaborated enthusiastically to promote tourism.[88] His influence in the succeeding decades was enormous, perhaps most expressively in the cinematography of Gabriel Figueroa. Brehme was a traditionalist, both aesthetically and politically. He gave the people and the government what they wanted to see, rather than challenging them to think about photography or Mexico in different ways. His construction of *mexicanidad* is, finally, socially myopic and retrograde for at least two reasons. One is obvious: he ignored the grinding poverty in which most Mexicans lived. The other is worse: his vision of *lo mexicano* portrayed an antiquated people produced by an idyllic nature in which their problems are insignificant; their activity is irrelevant to the modern world, and they are incapable of making history.

The struggle between those who felt Mexico was best represented in exotic-archaic terms and those who looked for new ways to depict the nation was intense.[89] When Manuel Álvarez Bravo and other vanguard photographers were awarded the top prizes in the 1931 contest organized by La Tolteca cement company, and Brehme was assigned a low position, it signaled a fundamental shift in the field. The editors of the magazine *Helios* (with whom Brehme had close connections) were moved to attack the direct, realist vision that Weston and Modotti had introduced, and the winners were accused of having "slipped into an imitation of foreign exoticisms."[90] *Helios* was a racist and anti-Semitic organ of the Asociación de Fotógrafos de México, an organization controlled by the most conservative photographers in the country.[91] The charge was a cheap appeal to xenophobia, for the picturesque "irritated" Edward Weston: he considered it "calendar art," and he did all he could to avoid it.[92] "Trash" was the word Tina Modotti used to describe the photography of "colonial churches and *charros* and *chinas poblanas*."[93]

Weston and Modotti came to Mexico in 1923, part of the exodus of U.S. intellectuals and artists who fled the materialism, puritanism, and conservatism of their country in pursuit of a more "authentic" and "unmechanized" existence, sometimes attracted by the possiblity of participating in a revolutionary society.[94] The couple quickly became part of the ferment around the muralists, where her leftist background and beliefs found ready company. Having more in common, politically and aesthetically, with the muralists than the photographers of Mexico, she documented their paintings and evidently planned a film on their work together with the novelist B. Traven.[95] The artists not only transformed Mexican walls with their imagery; they also participated in the creation of *El Machete*, the newspaper of the Mexican Communist Party. This periodical was a challenge to the government—it would have to go underground in 1929—and one of the sites where battles over *mexicanidad* were staged. The newspaper's founders considered visual images to be a fundamental element; David Álfaro Siqueiros insisted that pictures be given priority: "Articles ought to illustrate the drawings, rather than drawings illustrating the articles."[96] However, the periodical's staple was engravings, not photos, and the only photographs published there prior to Modotti's were fuzzy portraits of Soviet leaders. She joined *El Machete*

in 1925, and when her photos appeared there in 1928–29 they constituted what may well be the first instances of critical photojournalism in Latin America.

As a Marxist, Modotti rejected the essentialist formulations by which picturesque photographers defined *mexicanidad*. Instead, Modotti's pictures assert that Mexican identity must be grounded in the historical reality of the country rather than its natural attributes. Consider, for example, how she went about representing the *campesinos* who are recruited so often as convenient sources of folkloric imagery. In the photo of a peasant family accompanied by two individuals, a pile of corncobs composes the bottom of the frame, serving as a metaphor for the maize on which Mexican culture is based.[97] A dark doorway bifurcates the image: on one side we see the family grouped together, on the other stands a *ladino* dressed in a Western suit, an interloper in the traditional *campesino* culture who is accompanied by a single peasant. Is it possible that Modotti was commenting on "internal colonialism," where *ladinos* carry out the same sort of imperialism with respect to the Indian communities that the United States does in relation to Mexico?[98] If so, she offers the response to such a situation in another image, where *campesinos* are gathered to read *El Machete*, the headline of which demands, "All the land, not pieces of it."[99]

Modotti called attention to the gap that existed between revolutionary rhetoric and reality in at least two photos published in *El Machete* that documented social injustice despite the promises of the progressive 1917 constitution: one of a little girl holding a metal bucket, and another of two women who appear to be passed out near the door of a cantina.[100] Focusing on the class disparities that continued to be a dominant feature of Mexican life, Modotti photographed in the street to construct a series published in *El Machete* from May to the end of July, 1928 that compared images of the rich and poor to offer "The Regime's Contrasts"; a photomontage, *Those on top and those on the bottom*, closed out the series.[101] In the bottom half of the picture, a poor man sits on the curb of a city street forlornly holding his head in his hand. In the top half, a billboard looms with a painted advertisement from a fashionable men's store: a monocled light-skinned man in a tuxedo is helped into his overcoat by his mestizo butler, and the pitch for the Estrada Brothers clothiers claims that they "have everything a gentleman needs to

Canciones Rovo
lucionarias (Músi-
ca y letra) por
C. Michel:
Pedidos al Apar-
tado 2031
México D. F.
Precio: 20 cts.

19. Tina Modotti. Ad for the communist folk singer Concha Michel, *El Machete*, 1 June 1929, 3. Biblioteca Central Universitaria "José María Lafragua," Universidad Autónoma de Puebla.

dress elegantly from head to toe." Although Modotti had herself repudiated "tricks or manipulations" in her essay "On Photography" (1930), her objection was to utilizing such strategies to create "artistic effects"; evidently, employing such tactics for political purposes was different.[102]

Not content to represent the laboring class in such submissive postures, Modotti also depicted their energy, solidarity, and resistance. Her image of a worker unloading bananas captures his strength and agility; it also dynamizes class portrayal by showing him in the action of turning.[103] Further, the image draws attention to worker solidarity in the man who aids him by placing the bunch of fruit on his shoulder. Her emphasis on proletarian unity was also prominent in a picture of two laborers on a construction site who work together to carry a heavy stone sculpture up a plank; here, Mexican underdevelopment is highlighted in the absence of machinery that would facilitate this process, but the cooperation among laborers overcomes the obstacles.[104] This photo also redefines the often exotic depictions of *cargadores*, those carriers of weighty and awkward burdens that are often the objects of folkloric imagery. Modotti took this position one step further by showing a woman holding the communist banner, thus indicating a gendered rejoinder to class oppression.[105]

Modotti's transformative strategy in relation to national symbols took place on two fronts. On the one hand, she filled Westonian form with social content, for she worked with still-life objects in the rigorous way that he had taught her but focused on revolutionary symbols instead of the toys and toilet he so exquisitely photographed. On the other hand, she historicized Mexican emblems by linking them to the international socialist movement. The prime instances of this are the still-life compositions she created of the guitar, the corncob, the bullets, and the sickle, a metaphoric call to incorporate communist ideals into the Mexican Revolution. What the original intention was in making these images is not yet clear, but one of them was published in *El Machete* as an ad for Concha Michel, a radical folk singer (see figure 19). There, by placing the objects against a *petate*, she provided a texture which gives the photo a visual depth of which Weston would be proud.[106] The lowly bed of the poor, the *petate* alludes to the folk culture which was a foundation of the national identity that had begun to develop during the 1920s.

Manuel Álvarez Bravo: Ironizing Mexico

The *petate* offers a key to unraveling the complex relationship of Edward Weston to the depiction of *mexicanidad*, for although he introduced modernist photography in Mexico and was a definitive influence for Manuel Álvarez Bravo, the latter would picture national symbols—such as the grass sleeping mat—in a different way from Weston or Modotti.[107] Today the most renowned photographer in the history of Latin America and the cornerstone of this art in Mexico, Álvarez Bravo was the first from his country to take an antipicturesque stance in representing it. When he began photographing in the 1920s and 1930s, artists who constitute a veritable who's who of the lens immediately acknowledged his capacity: Weston, Modotti, Paul Strand, and Henri Cartier-Bresson. The respect that he engendered was encapsulated in Cartier-Bresson's response when someone likened Álvarez Bravo's imagery to Weston's: "Don't compare them, Manuel is the real artist."[108] He achieved international recognition for work which reached expressive heights from the late 1920s through the mid-1950s, and his creative powers were such that the founder of surrealism, André Breton, sought him out in 1938 to commission an image for the catalogue cover of an important

Parisian exhibition. He composed a complex ode to the surrealists' use of sexuality, dream, and pain as roads to new ways of seeing: *La buena fama durmiendo* (The good reputation sleeping). Unfortunately, it could not be included in the exhibit; evidently Eastman Kodak would not send it through the U.S. mail because of the full-frontal nudity.[109]

When Álvarez Bravo began photographing in the 1920s, the muralists were at the visual forefront in constructing *mexicanidad* and he earned his living by documenting their wall paintings for sale to the public, as well as for the magazine *Mexican Folkways*, after Tina Modotti's expulsion from the country left the job vacant.[110] The painters were an enormous influence on him, and he felt that he had learned composition from photographing their works, as well as from that of the lithographer José Guadalupe Posada.[111] Recording the epic murals must have made Álvarez Bravo aware of photography's constraints, as well as the fact that photographers were thought of as providing a service, in this case for *real* artists, rather than using their medium for self-expression. Influenced by the insistence of Weston (which he received via Modotti) on the necessity of defining photography's uniqueness, he participated in the struggle to distinguish it from other visual arts: "Photography has its limits. What is important for a photographer is to know them, understand them precisely, and give them a personal interpretation. Reality itself is one limit that presents photography with specific problems."[112] For example, the inherent otherness of Mexico necessarily appeared when the camera was raised, and photographers divided around the question of what was to be done with it. Despite having been attracted initially to the medium by Brehme's imagery, Álvarez Bravo perfected a much more sophisticated approach to representing his culture. Conscious both of Mexico's otherness and the way in which that has led almost naturally to stereotypical imagery, he swam counter to the stream of established clichés, using visual irony to embody contradiction.

Diego Rivera singled out this aspect of his contribution to defining their nation: "Álvarez Bravo's photography is Mexican by cause, form, and content; anguish is ever-present, and the atmosphere is super-saturated with irony."[113] Crucial in decodifying and recodifying signs of cultural identity, irony offers the possibility of portraying something distinct from, or even contradictory to, what one appears to be representing, and Álvarez Bravo is the supreme ironist of Mexican photography, for he understood and worked

within the particular constraints imposed by that medium. Like all imagery, photographs are analogical; the only way to say no is to incorporate that which one is negating; for example, "no dogs" is represented by showing a dog with circle around it and a line drawn through it (dogs/no). In order to say "not picturesque," Álvarez Bravo had to display the exotic and then cut back against the expectations awakened by its folkloric elements, thereby taking the image in the opposite direction to critique it. The fact that the image includes both sides of the equation creates a complex situation. On the one hand, it makes the picture more articulate because you can see what is simultaneously being negated; on the other, it increases the ambiguity characteristic of photographs.

Consider *Sed pública* (Public thirst), the 1934 photo of a boy drinking water from a village well.[114] This image contains many aspects of the picturesque: a small country boy perches on a battered village well to drink the water that flows into it, dressed in the typical loose white *campesino* clothing and posed against an adobe wall that provides texture. The exotic elements notwithstanding, the photograph is "punctured" by the light that seems to concentrate itself on the dusty foot that juts forward into the frame, a foot that is too individual to allow this figure to "stand for" the Mexican peasantry or embody their otherworldliness.[115] It is *this* boy's foot, not a typical *campesino*'s foot, and it goes against the picturesque generalizations raised by the other elements, thus "saving" the image through its very particularity. A similar tactic can be observed in *Señor de Papantla* (Man from Papantla, 1934), an image which is arguably the most articulate Indianist photograph, a genre that almost invariably represents indigenous people as exotic.[116]

Álvarez Bravo's search for *mexicanidad* led him to reconfigure national symbols. For example, consider his 1927 photo of a rolled-up mattress, *Colchón* (Mattress).[117] Here, he chose not to use the beautifully textured, folkloric *petates* that were considered a national symbol and had provided depth to the still lifes created by Modotti and Weston. Instead, Álvarez Bravo photographed a modern mattress, but with the twist that its bands of shading make it look like the well-known Saltillo serapes. Another photo, *Arena y pinitos* (Sand and little pines), is an early image from the 1920s that demonstrates that the young photographer was much influenced by Pictorialism and the then-pervasive interest in Japanese art.[118] Infusing Mexican meaning into international art forms, Álvarez Bravo created the back-

ground to his "bonsai" with what is in essence a mini-Popocatepetl, one of the volcanoes that dominate the Valley of Mexico. His recurrent imagery of the maguey cactus demonstrates his interest in playing with a ubiquitous symbol of Mexicanness; in one photo he "modernized" the maguey by making it appear as if the central flower stem that sprouts from these plants had been converted into a television antenna.[119]

Death is a central theme of Mexican culture, and Álvarez Bravo took it on in his unique style. In a 1956 photo, *Señal, Teotihuacan* (Signal, Teotihuacan), three girls stand as if transfixed, apparently staring at a large advertisement painted on the wall for a local funeral home. Between the words "*Cajas*" (Caskets) and "*Mortuarias*" (Funeral), a black hand with a grotesquely large extended finger indicates where coffins can be acquired and, metaphorically, seems to point the way to the great beyond.[120] A watch around the hand's wrist serves as a macabre reminder of time's inexorable passing, but it is ridiculously tiny. One girl seems to catch her breath in the face of mortality, her hand raised to her mouth, and two—ghostlike because of their movement when the shutter clicked—appear to be already on their way to the Promised Land.

Great Men are invariably placed at the heart of the identities created by national histories, and Álvarez Bravo has reflected on these figures in a picture that demystifies the patriotic reverence they are usually accorded. In the photograph, *Sr. Presidente Municipal* (1947), the artist depicted a town's elected leader seated unassumingly at his desk (see figure 20).[121] Behind and above him loom images of the fatherland's founders: a painting of Miguel Hidalgo, often referred to as "Padre de la Patria," and a primitive drawing of Benito Juárez are accompanied by the picture of another hero, on horseback, which may well have been cut from official textbooks. The juxtaposition between such fetishized adulation and the ordinariness of the local administrator offers a different vision of the patriarchalism that is so often prioritized as a source of the nation, and it critiques the "false heroism" exalted in illustrated histories by emphasizing the unexceptional, everyday sort of labor it takes to keep a town running.[122] The peeling paint on the wall and the rudimentary facilities convey the same combination of economic difficulties and dignity that the municipal president projects, reminding us of the common dust from which all of us, including heroes, have been made.

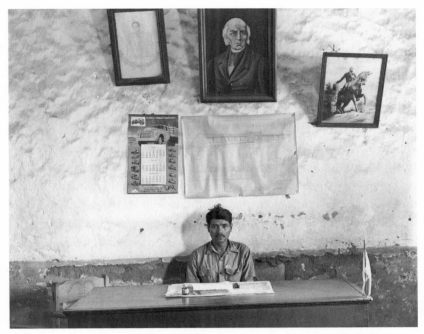

20. Manuel Álvarez Bravo. *Sr. Presidente municipal*, 1947. Collection of Asociación Manuel Álvarez Bravo, Copyright Colette Urbajtel.

The politics of Álvarez Bravo are often discussed in relation to his most famous photograph, *Obrero en huelga, asesinado* (Striking worker, assassinated, 1934). However, I would argue that his politics—and his search for Mexico's essence—are embodied in his portrayal of daily life activities rather than in overt social commentary. When I once asked him if he had not taken "political" photographs other than *Obrero en huelga, asesinado*, he referred to *Los agachados* (The bent men, 1934), an image of men seated with their backs to us at the counter of a local *comedor* (luncheonette), the shadow of the roll-up door placing the top halves of their bodies in the shade.[123] This picture is from the same period as *Obrero*, when the photographer was involved with LEAR, the League of Revolutionary Writers and Artists.[124] There are certainly hints of criticism here: the diner's modesty matches the men's clothing, the way in which the men bend over the counter could be a metonym for their subjugation, and the chains that are wound through the chairs' rungs (to keep them from being stolen) could be metaphors for the tethers that fix us to our worksites. Nonetheless, the

image is not of labor but simply of men lunching together; whatever critique it makes remains implicit. This picture is characteristic of his images, which are often understated, almost transparent portrayals of individuals whom he seems to have "discovered" within their natural habitats, in the fashion of his friend Henri Cartier-Bresson, rather than to have "created" through the conspicuous visual rhetoric and direction of photographers such as Paul Strand or Hugo Brehme. Avoiding overt expressivity, Álvarez Bravo's is an almost unperceivable technique designed to catch ordinary people in quotidian activities, where they are neither sentimentalized nor romanticized.

The photographer's understated aesthetic is probably one reason for his tardy recognition north of the border, although his resistance to representing Mexicans in the conventional discourse of the exotic is no doubt more important. As late as 1976, the photographic critic A. D. Coleman noted Álvarez Bravo's "remarkable absence from all the standard reference works on photographic history," despite the fact that he had long been admired by many of the twentieth century's great artists.[125] He was essentially unknown in the United States prior to a modest exhibit in Pasadena, California (1971), which later passed through New York's Museum of Modern Art without causing much of a stir. Subsequent exhibitions were held in Washington, D.C. (1978), and San Diego (1990) and their catalogue essays facilitated his entrance into histories of world photography. His consecration was assured when he returned to the MOMA in 1997 for the definitive exhibit of 175 photographs curated by Susan Kismaric. However, his eventual acceptance seems to have been related to the infamous and ubiquitous presence of money: the MOMA's image selection appears to have been designed to promote U.S. owners' holdings of vintage prints in what might be described as a strategy of "ghoul marketing." Most of the photos came from U.S. collections, and the exhibit no doubt increased their value manifold when Álvarez Bravo reached the end of his long life soon after the exhibit.

The definitive influence that Manuel Álvarez Bravo has had on Latin American photography is a result of having developed a distinct style while discovering his country. During the 1930s, he traveled around Mexico working for the magazine *El maestro rural* (The rural teacher). That experience brought him into direct contact with *campesino* and Indian communities, whose ways of life were completely alien to urban dwellers such as Álvarez

Bravo, born next to Mexico City's Zócalo, the son of teachers in a family that prized culture. As he noted later, "It gave me the opportunity to take my personal photographs and was the starting point of a new departure for me—a new way of seeing and a new way of working."[126] Although he opened a commercial studio in 1939, he soon left it to work in the film industry and to teach photography, because there was no real market for art photography in Mexico until the 1970s. In fact, Álvarez Bravo was almost always involved in education: in 1929 he began to instruct photography at the Academia de San Carlos, the leading school of fine arts, and later carried out the same duties in the Mexican Institute of Cinematography and the Film Studies Center of the Universidad Nacional Autónoma de México. Among his pupils were Nacho López and Héctor García, who learned under him in the 1940s and continued his focus on daily life activities in their photojournalism, which—though less artistic—had more of a bite. Another was Graciela Iturbide, who would go on to do a different sort of documentary work. Álvarez Bravo's rejection of facile picturesqueness, his insistently ambiguous irony, and his redemption of common folk and their quotidian subsistence formed the pillars of photography in Mexico and clearly defined an anti-exotic aesthetic for portraying *mexicanidad*.

The Revolutionary Trilogy of Fernando de Fuentes

The cataclysmic civil war not only called into question the elitist identity constructed during the Porfiriato and brought the *pueblo* into the foreground but *La Revolución* itself became a fundamental element of nationality.[127] However, as Enrique Florescano has pointed out, "*La Revolución* is not just the series of historical acts that took place between 1910 and 1917, or between 1910 and 1920, or between 1910 and 1940; it is also the collection of projections, symbols, evocations, images and myths that its participants, interpreters, and heirs forged and continue constructing around this event."[128] Perhaps the most pervasive of the myths is that propagated by the official history that essentially maintains that this was a prolonged struggle of the revolutionaries—Francisco I. Madero, Venustiano Carranza, Alvaro Obregón, Emilio Zapata, and Pancho Villa—against the old regime of the Porfiriato and its sequel, Victoriano Huerta, which they eventually overthrew and replaced. Concerned to construct a master narrative that

co-opts difference into the service of national conglomeration and legitimizes the PRI dictatorship as the revolution's sole heir, these heroes were conflated into the same "Family," denying the fact that this struggle was defined more by the warfare among the forces than by the battle between the old and new orders.[129] At the level of mass culture—textbooks, statues, monuments, photographic displays—this official history has dominated the representations of *La Revolución*. Cinema has been one of the important staging grounds for officialist evocations, images, and myths, as more than sixty films have been made in which the civil war serves as the context for the movie's story.[130]

Among the best films made by Mexicans on this struggle is what I describe as the "revolutionary trilogy" directed by Fernando de Fuentes: *Prisionero 13* (1933), *El compadre Mendoza* (1933), and *¡Vámonos con Pancho Villa!* (1935).[131] The trilogy does not in any way glorify the civil war, as, for example, Miguel Contreras Torres had done in the first sound film made on it, *Revolución (La sombra de Pancho Villa)*, whose "exalted and patriotic pretensions" would become typical of films about this event—and about Villa.[132] Rather, looking at the trilogy in terms of Mexico's best-known twentieth-century muralists, I find the movies more in the tone of José Clemente Orozco than of Rivera or Siqueiros: they emphasize the pain and torment, rather than the transformations; they exude a disenchantment with the revolution's shortcomings instead of celebrating its achievements.

Considered as a whole, the trilogy is perhaps most interesting because of the fact that de Fuentes chose to focus on the three losing sides—Huertismo, Zapatismo, and Villismo—as well as differentiating between forces that would later be lumped together in the official history of the revolutionary institutionalization. In the period during which de Fuentes directed these works, it was still possible—perhaps even inevitable—to take account of the differences between the Zapatistas, Villistas, and Carrancistas. This may also have resulted from the fact that he made these films in a *relatively* tolerant era: the years immediately preceding the accession to power of Lázaro Cárdenas (1934–40) and early in his presidency. Hence, although two of the movies suffered direct government interference, they were not subject to the distortions wrought by the ideological consolidation of the 1940s that would become characteristic in film and other cultural productions. In the

future, movies about this conflict would almost always be set in either the unproblematic Huertista period (when the revolutionary forces were united against him) or in an abstracted, ahistorical situation in which the exact allegiances of the protagonists remain unclear.

Prisionero 13 was first shown in 1933, but it was quickly retired from theaters because of objections by the army.[133] The movie follows the life of Colonel Julián Carrasco, an alcoholic officer in the Porfirian and Huertista armies. He mistreats his wife, who leaves the house with their infant son; we see the boy grow to manhood under his mother's care, as the film moves into the period of Huerta's dictatorship. Some conspirators against Huerta are rounded up and condemned to be shot. The mother and daughter of one prisoner bribe Carrasco to let him go free. As Carrasco has already turned in the list to the governor, he orders a subordinate to capture a substitute at random, who turns out to be Carrasco's son. The colonel is unaware of this, and the boy's mother attempts to alert him to the danger, but she is delayed by Carrasco's guard. When he comprehends that his son is to be shot, he hurries to the execution site in an attempt to save him. He would be too late, but—in an ending evidently tacked on in a vain effort to mollify the military's censure of the film—he awakens and discovers that it was all a dream caused by drinking.

Despite the artificial return to the Porfiriato at the end, the representational context of *Prisionero 13* is the period of Huerta's rule; contemporary reviewers such as Luz Alba and Denegri clearly identified the film as taking place at this time.[134] The movie occurs largely within a military scenario of camps, offices, and barracks, reflecting the militarization of society under Huerta.[135] The historical referent in *Prisionero 13* is certainly Huerta, for Carrasco's alcoholism is a distinct allusion to Huerta's drinking, which was so notorious that one diplomat's wife remarked that the only two foreigners Huerta knew well were Hennessy and Martell.[136] In the visual narrative, the ubiquitous presence of the bottle and the bomb on Carrasco's desk is a constant allusion to alcohol and militarism as the defining structure of his existence. Carrasco's corruption and cruelty also are in accord with the role that Huerta has been assigned as the *"Corruptor de sociedades,"* the "Usurper" and "Murderer."[137] Here, Carrasco's unlawful freeing of a conspirator in return for a bribe and his cold-blooded execution of an inno-

cent person reflect the generalized corruption and repression under Huerta, manifest in his unlawful overthrow and assassination of Madero, as well as in the disbanding of congress and the jailing of deputies in 1913.[138]

The representation of Carrasco/Huerta as the villain of the revolution is very much in line with his portrayal in the official historiography that would develop during the 1940s. Most modern historians seem to concur that Huerta was a typical counterrevolutionary military dictator, although some from the United States have attempted to tell a different side of the story.[139] Whatever the truth of Huerta's "black legend," it serves to "whiten" the reputations of other revolutionary leaders who were often as corrupt and not much more progressive. However, it appears more likely that de Fuentes was following a widely accepted reputation of Huerta as the murderer of Madero, the usurper of power, and the corruptor of morals, rather than reflecting an official position which had not yet consolidated itself to the degree that it would thereafter.

Historical detail in *Prisionero 13* is sorely lacking. Both military and civilian dress are obviously from the 1920s and 1930s, perhaps one of the reasons for which the army objected to its "denigrating" image and had the film retired from distribution. However, there is no development of warring ideologies, interests, and classes. The political goals of the "conspirators" whom Carrasco executes are at no point defined, and they are almost all dressed in middle-class clothing, with the exception of a father and son, who appear to be from the urban proletariat. Further, the only "political" declaration in the film is when the prisoner who seems to be the leader Enrique Madariaga shouts "¡Viva la Revolución!" just before he is shot.

Prisionero 13 was considered one of the first movies to address national issues. In reviewing it, Juan Bustillo Oro (later a well-known director) argued that Mexican film had been a "servile imitation" of foreign cinema because it had ignored "themes that are flesh of our flesh and the breath of our sweet and equally terrible land." Calling this "the first Mexican film," he felt that it constituted the primary step toward the creation of a national identity: "The first task before Mexicans is to discover themselves. . . . Only by discovering ourselves can we create our country. . . . The day that we have a theater and a cinema equal in moral and revelatory value to *Prisionero 13* we can say that our nationality has begun to develop, that we have been saved."[140]

The next year, de Fuentes's new film on the revolution, *El compadre Mendoza*, also provoked commentaries about national character, although in this case they were protestations against identifying Mexicans with a "vile traitor."[141] The impact of these two movies within the context of the sensitivities surrounding the question of identity in this period can be appreciated by the remarks of the reviewer Alfonso de Icaza, who wrote in 1934: "We've spent our entire life protesting the fact that our neighbor denigrates us, and now we make films that exhibit repugnant sores. . . . If we follow the path marked out by *Prisionero 13* and *El compadre Mendoza* our films will assure that the fame of bandits that the Yankees have given us will be replaced by a worse one: that of traitors. . . . Is that how we have been?"[142]

El compadre Mendoza narrates the travails of Rosalío Mendoza, an opportunistic *hacendado* during the period between 1913 and (roughly) 1919. Mendoza pretends to be a friend to all sides: when the Zapatistas come to his hacienda, he celebrates their arrival, feeds the troops, and dines with the officers under a photo of Zapata; with the Huertistas, he does the same, except beneath an image of Huerta; at the moment the Carrancistas become a force in the area, he buys and exhibits a photo of Carranza . . . when the Carrancistas are present (see figures 21, 22, and 23). Mendoza marries Dolores, the young daughter of a ruined landowner. On the night of their wedding, they are surprised by the Zapatistas. A Huertista officer is present, and Mendoza is at the point of being executed alongside him. He is saved by a Zapatista general whom he had met earlier, Felipe Nieto, with whom Rosalío and Dolores later become close friends during his frequent visits to the hacienda. Eventually, Rosalío asks Felipe to be the godfather (*compadre*) of his forthcoming son, and he accepts. Felipe develops a strong attachment to Dolores, and to the boy who has been named after him. It is clear that Dolores is as attracted to Felipe as he is to her, but they deny their love because of their commitments to Rosalío. Times become increasingly difficult for both the Zapatistas and Mendoza. The *hacendado* wishes to leave for Mexico City, but this is made impossible when the train carrying his entire harvest is burned. Afraid for the safety of his family, Mendoza agrees to betray Felipe, who is killed by the Carrancistas.

The film's "cruel and macabre" finale was evidently much commented on, for an interviewer asked de Fuentes about it on the day after the premiere in April 1934. De Fuentes replied that he was searching for a Mexi-

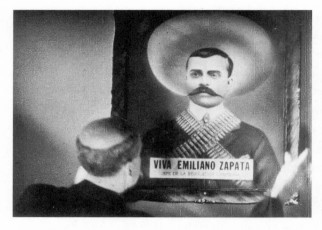

21. Atenógenes, *hacienda* administrator, and portrait of Emiliano Zapata. Frame enlargement, *El compadre Mendoza*, 1934. Filmoteca de la Universidad Nacional Autónoma de México.

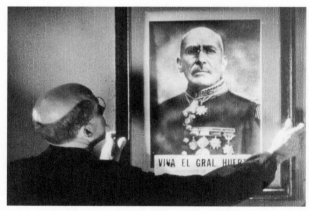

22. Atenógenes, *hacienda* administrator, and portrait of Victoriano Huerta. Frame enlargement, *El compadre Mendoza*, 1934. Filmoteca de la Universidad Nacional Autónoma de México.

23. Atenógenes, *hacienda* administrator, and portrait of Venustiano Carranza. Frame enlargement, *El compadre Mendoza*, 1934. Filmoteca de la Universidad Nacional Autónoma de México.

can aesthetic, not trying to make another copy of Hollywood's "happy endings." "We believe that our public is sufficiently cultured to be able to stand reality's bitter cruelty. It would have been easy to make the story so that the final outcome was happy, as we're accustomed to see in American films; but we think that Mexican cinema ought to be a faithful reflection of our severe and tragic way of being . . . and not a poor imitation of Hollywood."[143]

Contemporary reviewers characterized this extraordinary work as the best Mexican film made up to that point.[144] It is still considered to be a masterpiece.[145] De Fuentes evinces a clear sympathy for the Zapatistas. The movie opens with a tracking shot that follows what appears to be a ploughed furrow; but, as the camera catches up with the "plough," we see that the "furrow" was made by a rifle's butt an exhausted Zapatista is dragging. The opening sequence serves to create identification with the Zapatistas, the "little guys" for whom the audience naturally roots against the more powerful forces of Huerta and Carranza; it also immediately establishes the relationship between the Zapatistas and the land, a metaphor underlined by later references to the Plan de Ayala, Zapata's instrument of agrarian reform.

Zapatismo is personalized through the figure of Felipe, who is shown to be of a high moral character, capable of denying his love for Dolores and of being committed to the struggle for a common good. Within the film, identification with Felipe is effected through the fact that all the other main characters love him, and even the Carrancista who finally has him killed, Colonel Bernáldez, says that "he is not one of those who can be bought." Felipe's ideals are in contrast to the absence of any such articulated commitments on the part of either the Huertistas, embodied in Colonel Martínez, or the Carrancistas, incarnated in Bernáldez; they are depicted as being interested only in defeating the Zapatistas. Thus, the film implicitly juxtaposes the revolutionary demand of Zapatismo for an equitable distribution of land—while recognizing that there are certain Zapatistas, for example, *El Gordo*, who are bloodthirsty—with the lack of social programs on the part of the other groups, whose sole concern is portrayed to be that of gaining power. At one point, Colonel Bernáldez does use the argument of nationalism to convince Mendoza to betray Felipe, asserting, "In the end, all we want is the good of the country." By placing these words in the mouthpiece of the New Order (Carrancismo), de Fuentes acutely presaged the politics

of "National Unity" that would reign supreme from the 1940s on—in one form or another—as an indispensable component of the PRI ideology.

However, perhaps the sharpest difference with official history in the film is the fact that the Carrancistas take on the role of the enemy earlier occupied by the Huertistas. Embodying the Zapatista point of view, the movie's "heresy" consists of equating the two factions; to place Carrancismo and Huertismo in the same camp would be anathema in almost any form of Mexican history, filmic or written. In this sense, *El compadre Mendoza* is even more critical than *¡Vámonos con Pancho Villa!*, for in the latter, a title appears—"Año de 1914"—at the very beginning to indicate that the struggle depicted is that between the Villistas and the Huertistas. Thus, *Vámonos* implicitly subscribes to an official history which was beginning to be conceived around the time of its production, while *Mendoza* was an explicit challenge to the ideological concoction which would soon come to dominate Mexican culture.

Mendoza is a representative of the bourgeoisie, but although his portrayal by Alfredo del Diestro enables us to see his human side, the film precludes any identification with him by showing that his only concerns are to preserve his family and the good life he leads. The cognac he so often consumes and that he offers to the leaders of the rival bands in their turn functions as a metaphor for that good life and those expensive social lubricants that are used to deny the reality of class conflict. All accept the drink on the different occasions except Eufemio Zapata, who prefers mezcal, a drink *"para machos"* (and, by extension, *para mexicanos*). At the end of the film, when Mendoza has arranged the meeting of Felipe and Colonel Bernáldez, he serves them cognac to occupy Felipe while the soldiers who are to shoot him get into position. After Felipe has been killed, the Carrancistas wish to hang his body from the front gate of the hacienda. This is too much for Mendoza and he cries out, but Bernáldez shrugs off his objections by offering him cognac. The mediocre hero caught between the warring forces, Mendoza not only arranges the meeting between them but he also brings us into human contact with both camps.[146] He experiences no crises of either conscience or consciousness as a result of his hypocrisy, except at the end, when he is tormented by Felipe's assassination. Other than in this final agony, however, the only times that he addresses his duplicity is to convince

the different forces that his friendships with the opposing bands have been useful to all concerned.

Earlier, in one of the more "politicized" sequences, Dolores asks Felipe if he couldn't just stop fighting. He replies that he will, sometime in the future when the Plan de Ayala has triumphed, there is peace, and the *campesinos* own the lands they work. Felipe's voice is off-camera; Mendoza appears on-screen during these statements, frowning, ostensibly at the domino game he has in front of him. However, the contradiction of a *hacendado* supporting a struggle so that *campesinos* could own land is made obvious, and the film cuts to a close-up of Dolores toward the end of Felipe's comments, as if she shared the Zapatista's dreams. In the film's denouement, the crisis generated by the revolution has forced Mendoza to define himself; he identifies himself in terms of his class.

If *El compadre Mendoza* demystifies Carrancismo as a revolutionary movement, *¡Vámonos con Pancho Villa!* "demythifies" one of the great legends of that struggle. *Vámonos* follows the fates of six *campesinos*, "Los Leones de San Pablo": Tiburcio, Melitón, Martín, Máximo, Rodrigo, and Miguel Ángel. They join up with Villa's forces after the occupation of their town by the Huertistas makes life increasingly hazardous. The Leones encounter Villa distributing corn from a train, and he accepts them in his army. During a battle, Máximo ropes a machine gun and dies after giving it to Villa. Martín is the next to die, again heroically while blowing a hole in the enemy's fort. Tiburcio, Rodrigo, and Melitón attempt to trick a Huertista officer and bring about the surrender of his forces. Their ruse is discovered and they are to be hanged in sight of their own lines; however, as fat Melitón is strung up, the rope breaks. Their *compañeros* arrive to rescue them, but in the firefight Rodrigo is killed by friendly fire from the Villistas. Villa incorporates the three survivors in his elite corps, the *dorados*. In a bar, the three participate in a "game" resembling Russian roulette: thirteen men sit closely around a table in a darkened room; one throws a cocked gun into the air, whose discharge is designed to eliminate one—he with the most fear—of the unlucky number. The bullet wounds Melitón and, when the others complain that they are still thirteen, Melitón shoots himself in the head. Miguel Ángel becomes ill but accompanies the troop to Zacatecas. There he is discovered to have smallpox, and Tiburcio is ordered to kill

him and burn his body and all his belongings. Villa arrives to check out the contaminated train car and Tiburcio attempts to talk with him. Knowing that Tiburcio has been exposed to smallpox, Villa shrinks back in fear and, warning Tiburcio to keep his distance, he tells him to stay put until the danger is past. Disheartened by the death of all his friends and disappointed by Villa's faintheartedness, Tiburcio walks away from the revolution down a train track. (In the original script, and in an existing copy of the film, Villa encounters Tiburcio some years later and urges him to rejoin the revolution. When Tiburcio declines because of his family, Villa kills his wife and daughter. Angered, Tiburcio points his rifle at Villa. In the extant alternative film copy, Fierro shoots Tiburcio, and Tiburcio's son rides off with Villa; in the alternative script, Tiburcio is overcome by Villa's power, he lowers his rifle, and both he and his son ride off with Villa.)[147]

The first superproduction of Mexican cinema—and still voted as the best film ever made in the country—*¡Vámonos con Pancho Villa!* cost a then-astronomical one million pesos and marked the introduction of modern cinematographic equipment—synchronized sound, Mitchell cameras, and "gamma" curve developing—in national cinema.[148] If in *Prisionero 13* de Fuentes had been forced to dress his actors in contemporary costumes because of economic pressures, in this film he had at his disposition a train, a regiment of troops, munitions, artillery pieces, uniforms, cavalry, and military advisors.[149]

The financial support that de Fuentes received makes it clear that he enjoyed official backing for this work to a degree hitherto unknown in Mexican film. This appears to have been a result of a decision within the Cárdenas regime, prompted by various intellectuals, to promote a national cinema through government subsidies. A precedent had been set the year before, when the secretary of public education under Narciso Bassols had produced *Redes*, a "Mexicanist" film of penetrating social criticism.[150] Evidently, the Cárdenas government was instrumental in financing the construction of the new CLASA (Cinematográfica Latino Americana, S.A.) studios, which were equipped with state-of-the-art technology.[151] *Vámonos* was the first film produced by CLASA, and it is clear that, at the very least, the government indirectly subsidized this work, for CLASA declared bankruptcy immediately after releasing the film and received a subvention from the Cárdenas government in the amount of the movie's cost.[152]

The role Cárdenas may have played in relation to this film raises some most interesting questions about the cultural politics of his regime. The Cardenist period is often conceived of as one of considerable liberty and relatively little government interference in cinema.[153] Nonetheless, the existence of alternative endings in both script and film has led to speculation as to who was responsible for the changes. In general, scholars of Mexican cinema have tended to blame them on government censorship, which would not permit the showing of such cruelty on Villa's part.[154] Nonetheless, it is crucial to point out that, for Cárdenas, Villa was not part of the "revolutionary pantheon." In a diary entry, which Adolfo Gilly describes as the "birth certificate of the Revolution's official history," Cárdenas stated that Obregón, Madero, Zapata, and Carranza "should be venerated for their transcendent participation in the struggle for social justice."[155] The fact that Cárdenas did not include Villa could indicate that the criticism this film renders of him (as we will see below) is in fact a result of official interests. Villa's popularity was problematic for the New Order: he inspired more songs, stories, and movies than any other revolutionary *caudillo* but went unmentioned in the press until the 1960s—except for one note about the decapitation of his cadaver—and was only made into an official national hero in 1965.[156] Thus, it may well be that after filming the alternative ending, it was de Fuentes who decided to eliminate it because he felt it was too extreme.[157]

The allegiance of the Leones is to Pancho Villa, not to the revolution: they refer time and again to the need they feel to demonstrate their manliness to the *jefe*, and their actions are motivated by this, rather than any other consideration, even their own interests. In depicting the personalism of Villismo—and its lack of ideology—the film is an accurate representation of the way in which individual loyalties functioned as the cement of that movement.[158] Crucial in achieving such commitment was Villa'a well-documented charisma.[159] This may be one of the areas in which films can contribute to history, for cinema may be able to convey personal appeal better than written words. The film medium allowed de Fuentes to communicate the sensation of charisma through the actor Domingo Soler. Of course, Soler is *not* Villa, and the attractiveness he exudes as an actor may well be entirely at odds with that of the Centaur of the North, although he stated that he had dedicated himself to "absorbing Villa."[160] Whether one

agrees that Soler succeeds or not—and many would concur with Jorge Ayala Blanco that Soler's personification is "exemplary"—the film at least does give a feel for the intricacies of personal allegiances that might be more difficult in writing.[161]

Nonetheless, what de Fuentes accomplishes with the personage of Pancho Villa goes beyond immediate historical realism, for he demystifies Villa through a complex process of identification and alienation. He does this first of all in the title: although Villa is the personage who appears to define the work, he is not the central figure. An early movie reviewer complained about Villa being a peripheral character, but this is part of the film's brilliance.[162] The title creates the expectation that Villa will be the main protagonist, but it is the six Leones who are at the heart of this work; Villa only appears when he is historically important—performing public feats such as distributing corn, goading his men in battle, and making decisions about the army's well-being, as in having Tiburcio shoot and burn Miguel Ángel.

Villa's dispensing of food to the hungry and his direct participation in battle are documented historical facts.[163] The incident in which Villa shows fear of smallpox, though credible, has not been documented; disease, however, was one of the main causes of death during the revolution, and its inclusion is an important historical detail.[164] Nonetheless, even more crucial than its realism, this final scene represents the culmination of the long alienation process which de Fuentes has carried out in relation to Villa. In the beginning, we immediately identify with Villa because the Leones join up with him, convinced that only he can resolve the situation. When we first see him he is engaged in a socially beneficial activity, providing corn for the hungry and promising them land when he wins. The people's gratitude is registered in out-stretched hands and smiling faces. Villa's gruff but good-humored interview with the Leones assures them they have made the right decision to follow him. After the first battle, the Leones' admiration for and adherence to Villa is strengthened when he insists that Rodrigo keep the revolver—his first booty—that he attempted to give Villa. Stating that he prefers his own pistol, Villa "legitimizes" his position of *caudillo* by shooting the prickly pears off some cactus through a hole he has cut in the bottom of his holster. The extreme difficulty of the shot demonstrates Villa's skill, the hole cut in the holster shows Villa's intelligence and cunning; all are

necessary requirements to be a leader of warriors. The fact that the Leones are greatly impressed by Villa's feat furthers their (and our) identification with him.

As the film continues, however, it insistently cuts back against the very attachment that it fostered. In contrast to the vast majority of films about Villa, *Vámonos* is an anti-epic: it contains all the elements for an epic about the revolution but holds Villa-the-legend at bay through a constant distantiation.[165] We are confronted with Villa's legendary cruelty, as in the execution of captured band members once he has ascertained that he does not need any more bands. The film's brilliance in delineating the duality of Villa's character is demonstrated in the fact that it is Villa himself who creates sympathy for these musicians; they never appear on camera. When asked by one of his subordinates whether they should be executed, Villa responds: "No man, how barbaric. Poor musicians, why would we shoot them? Put them in one of the brigades." Informed that all the units have their own bands, and some even have two, an irritated Villa erupts: "Well then, shoot them. Why are you bugging me with this?"

We identify unconditionally with the Leones, which serves to alienate us from Villa, for his callousness is made evident in his increasing indifference as they die one after another. When the first, Máximo, dies, Villa pats his body on the back; however, when the third, Rodrigo, is killed, Villa shrugs and says that it's a shame, but everybody has to die. The process of distancing the audience from Villa is completed in the last scene, when he arrives to check the contaminated train car. Tiburcio, despondent, sees Villa and his face brightens up. He moves toward and attempts to establish contact with Villa, the one real commitment of the Leones and the only thing that could make sense of all his suffering. But Villa, terrified of smallpox, makes Tiburcio keep his distance: we are as repelled by Villa's fear as we are by his insensitivity, and our rejection is corroborated by Tiburcio's disenchantment. The Leones' deaths are particularly demystifying when compared to the heroic demises to which we are well accustomed in films about the revolution (or war movies in general), for three (Rodrigo, Melitón, and Miguel Ángel) die in ways that seem to insist that the civil strife was a "fraternal bloodbath," or as metaphors for the murder of the revolution by the revolutionaries. Finally, the fact that Villa is one of the core legends of *La Revolución* makes

it conceivable to think that the alienation de Fuentes achieves in relation to this personage could be applicable by extension to the revolutionary *caudillos* in general.

Compared to the other two movies in the trilogy—or to almost any of the other films on this struggle—*Vámonos* is rich in historical details. The form utilized by de Fuentes is crucial, for much of the film is shot in what José de la Colina described as a "*plano americano* that enabled the showing of characters in relation to their context, as well as with other characters."[166] Aside from the use of a visual style facilitating the incorporation of considerable contextual information, de Fuentes also employs montages of images to capture daily activities among the army.

The film's fertile social fabric is largely woven around the image of trains. When the Leones go to join Villa, the segment opens with a beautiful high-angle pan of a bustling station. Then the camera roams about through scenes reminiscent of the photographs from the Casasola Archive: interspersing shots of people chatting, seated in the open doors of railroad cars—buckets of flowers and birdcages nailed to the sides—with takes of letters being written on typewriters by scribes, and film of recreational activities, such as lasso twirling in front of the customary crowd of onlookers. The activities of women are included: in *Vámonos* we see them selling prepared food to lines of soldiers, grinding corn, sewing clothes, and fending off the advances of unwanted suitors. As the trains pull out of the stations, the troops piled on top of the cars and hanging onto the front of the engine are a powerful evocation of well-known revolutionary tableaux. In his employment of the train, de Fuentes offers us one of the best examples of what cinema can bring to history: the capacity to present vital facets of reality that are constantly present (for example, geographic settings, weather, daily activities, and technology) without falling into aggressive symbolism or a distractingly overburdened text, as could occur by insistently mentioning them in writing.

The train, however, is not only the site for a relatively "thick" recreation of the quotidian; it is also a permanent backdrop against which the film's dramas are played out. The train was a central protagonist of the civil war, a struggle which was, in the words of one participant, "made on rails."[167] In *Vámonos*, the train is at the hub of events: the film opens in a depot, where Miguel Ángel is beaten by the Huertista officer; the Leones go to join up

with Villa at a railroad junction, and when they first see him, he is standing in a train car; the captured Leones are marched along tracks to be hanged; the death of Miguel Ángel takes place in a railroad car; and Tiburcio walks away from the revolution along the ties. Like Villa and the Leones, the train-as-protagonist begins by promising much and ends up being the site of disillusion; it too is a synecdoche for *La Revolución*.

CINEMA AND CELEBRITIES IN THE GOLDEN AGE

T he revolutionary governments took a turn to the right in 1940 and, along with much else, representation of *mexicanidad* underwent a significant transformation. Before, nationalism had been a vital and many-faceted effort to create a new identity. Under Manuel Ávila Camacho (1940–46), "National Unity" became an officialist doctrine designed to assure the homogeneity of *lo mexicano* as the social gains realized by the Cárdenas regime were slowed or reversed. With Miguel Alemán (1946–52), the "Counterrevolution" entered definitively in power, and the institutionalization that was carried out (made explicit in the name of the new party he created, Partido Revolucionario Institucional) left little room for plurality or diversity.[1] The ruling regime took on the characteristics that would define Mexican politics at least until 2000: an all-powerful and untouchable president, a party dictatorship, the skillful control of mass organizations, and, perhaps most importantly, the use of nationalism to obscure differences of class and ideology.[2]

La Revolución by Fernández and Figueroa

If they had not already existed, it would have been necessary to invent the team of director Emilio "El Indio" Fernández and cinematographer Gabriel Figueroa for the new national project of "patriotic delirium."[3] Their manneristic visual style, folkloric themes, and exotic protagonists—coupled with Fernández's distinctive Indian physiognomy—made them integral elements in the culture of state nationalism and the leaders of the Mexican School of Cinema, within what is known as the Golden Age of the 1940s and early 1950s.[4] As have many Latin American artists and intellectuals, Fernández discovered his fatherland by leaving it. He had fled Mexico during the re-

bellion of Adolfo de la Huerta (1923–24) and had a vision while digging ditches in Hollywood: "I understood that it was possible to create a Mexican cinema, with our own actors and our own stories, without having to photograph *gringos* or *gringas* or tell stories that had nothing to do with our people. . . . From then on the cinema became a passion with me, and I began to dream of Mexican films."[5]

Making nationalist movies was Fernández's obsession, but as the stories he devised rarely rise above the level of trite melodramas, that which most distinguishes motion pictures by Fernández and Figueroa is the striking visual style the cinematographer created. The origin of this aesthetic has been much discussed, though one possible source has rarely been considered— Hugo Brehme, who had explored ad nauseam the picturesque possibilities of volcanoes, cactus, clouds, and *campesinos*.[6] Instead, this imagery is usually associated with the Soviet director Sergei Eisenstein and his cameraman Edward Tisse. In 1930, they began filming a work that was to be called *¡Qué viva México!* but never completed it (though several versions were subsequently edited). Perhaps it is Eisenstein's and Tisse's use of sharp low-angle shots and expressive compositions that seem to point them out as the fountainhead of classical Mexicanist cinematography. Fernández claimed to have seen pieces of Eisenstein's film in Hollywood; in fact, at times he alleged that Eisenstein himself had been present at the screening, though this was impossible because the Soviet was denied a visa to edit his work in the United States.[7] Moreover, Fernández's description of what he acquired from Eisenstein strays from the question of formal composition: "I learned the pain of the people, the land, the strike, the struggle for liberty and social justice."[8] I am tempted to think that Fernández was flattered by Mexican intellectuals who enthusiastically discovered stylistic similarities, and the director allowed himself to become convinced that the Soviet had been a major influence on his work.

Eisenstein's effect may have arrived by a more circuitous route, Luis Márquez. In 1922, Márquez had gone to work for the Secretariat of Public Education, then in patriotic ferment under José Vasconcelos's direction.[9] Winning his first international recognition for photography that same year—medals from the Brazilian government for his traditional Mexican scenes—he quickly became the head of cinematography for the National Art Institute. He traveled incessantly around the country, picturing it in

24. Luis Márquez. *The Patriarchs*, Patzcuaro, Michocán, 1934. Colección Luis Márquez, Archivo Fotográfico Manuel Toussaint, Instituto de Investigaciones Estéticas, Universidad Nacional Autónoma de México.

the bucolic, idealizing fashion of Brehme, as in one photo titled *The Patriarchs*, with its requisite weathered visages, gnarled hands, billowing clouds, and ancient work instruments (see figure 24). He dedicated his long and productive life to documenting Mexican folklore and published widely in illustrated magazines and books from the 1930s until the year of his death (1978).[10] When Eisenstein was granted permission to film in Mexico, he was assigned "counselors" to aid his project and to keep an eye on what he was saying about the revolutionary rulers. One of them was Márquez, who also contributed his intimate knowledge of the countryside to the project.

Márquez was always proud of having been a member of Eisenstein's crew, and his most significant collaboration in cinema, *Janitzio* (Carlos Navarro, 1934), was no doubt marked by his experience with the Soviet director. He had first visited the island in Lake Patzcuaro in 1923 and wanted to share what he saw with the world—the landscapes, traditions, and the colorful *pueblo*.[11] He wrote the script, formed the crew, chose the locations, and took the stills for what one reviewer called "the first great movie with Mexican spirit."[12] In casting the film, he looked for actors with physical characteristics that were "purely Mexican," and the lead was given to Emilio Fernández,

who always recognized the debt he owed Márquez: "When he knew that I was going to be a director, he took off my blindfold to show my perplexed eyes the Mexico I now know through his eyes and his marvelous sensitivity."[13]

U.S. image makers such as Paul Strand and John Ford have also been mentioned as the inspiration for the Fernández and Figueroa aesthetic. Strand's film *Redes* might have been important, though Fernández's confusion as to the role of Fred Zinnemann, who he maintains was a "great photographer," may indicate that the Mexican director's references to that work were constructed after the fact.[14] Considered to be among the most accomplished of that medium (ever), Strand was a political and aesthetic radical, much attracted by the cultural experiment underway in Mexico, and already famous when he was invited to Mexico in 1932 by the noted composer Carlos Chávez, one of the new culture's key figures, and Narciso Bassols, a Marxist who was then the secretary of public education. Bassols and Chávez wanted to produce films "with the people and for the people," but the first (and only) movie to be realized was a work portraying life and struggle in a fishing village, *Redes*, which was finally released in 1936.[15] Strand's exquisite camera work contains many of the elements typical of the *mexicanidad* that would be propagated by Fernández and Figueroa, focusing on the beauty of natural and human forms: rolling masses of luminous clouds, swirling eddies of water, fishermen's nets draped out on lines to dry, palm fronds against thatched huts, bronzed visages reflecting sunlight. *Redes* is an obligatory reference in Mexican cinema, and although his might be considered a precursor of Fernández and Figueroa's visual style, Strand's cinematography of the physical environment creates an ambience that is transformed through human labor and struggle, in contradistinction to the overcharged and ahistorical symbolism that nature acquires in the films by the Mexican director and cinematographer. Further, like his fellow U.S. image maker Edward Weston, Strand was concerned to avoid the exotic perspective that is characteristic of Fernández and Figueroa (and of Márquez); he preferred to film Mexicans "as . . . fellow human being[s]" rather than from the perspective of "the white race who found them 'interesting, picturesque and acute.'"[16]

Figueroa was a "disciple" of the cinematographer Gregg Toland, but he always insisted that the single most important inspiration for his art came

25. Pedro Armendáriz rides off into a landscape of cactus, volcanoes, and dramatic cloud formations. Frame enlargement, *Flor silvestre*, 1943. Filmoteca de la Universidad Nacional Autónoma de México.

from the Mexican muralists, particularly David Álfaro Siqueiros.[17] This is consistent with his description of his style as "first and foremost nationalist."[18] In works such as *Flor silvestre* (1943), *Enamorada* (1946), *María Candelaria* (1943), *La perla* (1945), and *Maclovia* (1948), extreme low-angle takes were combined with a curvilinear perspective, deep-field focus, and infrared filters to produce what became known internationally as "Figueroa's skies."[19] Believing that the most important aspect of cinematography is illumination, Figueroa drew a distinction between filmmaking in London, for example, where there is little natural light, and Mexico, where the sun is dramatic and piercing. He felt that the Mexican ambience itself had to be interpreted; for example, he used infrared filters to highlight the monumental masses of cloud formations reflected by the sun and make them a vital part of the panorama (see figure 25). The picturesque human elements of this aesthetic are mythical figures emptied of history: revolutionary *charros* and their steeds gallop through sculptural cactus; stony Indian faces are set off by white shirts and dark *rebozos*; flower sellers in Xochimilco's canals move

past long rows of tall, thin trees; fishermen in dugouts with butterfly nets reflect the rising sun. Despite the narrative limitations, Figueroa's visualization of Mexico's natural and cultural environment provided a dramatic context for the filmic narratives, which were enhanced by Fernández's instincts for costuming, directing scenes with horses, and discovering locations worthy of the cameraman's abilities.

Mexican moviemakers participated eagerly in the state-subsidized orgy of nationalist uniformity, and the great majority of their films are of only sociological interest.[20] However, Fernández and Figueroa produced visually striking movies that achieved international recognition, enjoyed popularity in Mexico (even, eventually, among the cultural elite), and continue to attract attention today. Enthusiastically conscious contributors to the officialist invention of national identity, they fabricated a homeland beyond history or politics, which emerged from those characteristics that, Fernández believed, "give us inexhaustible material: Mexico's landscape and customs."[21] The best known of Fernández and Figueroa's works were set in the countryside where, for the director, "all has always been the same."[22] It is not surprising that the director would make ahistorical films set in some mythical unchanging past, for he asserted that he lived "in a fourth dimension where time doesn't exist."[23] Nonetheless, Fernández's atemporal conception of reality would seem to be at odds with what he tells us about his background, although that discrepancy demonstrates conclusively how closely he was attuned to the ruling ideology and mirrored its contradictions: "My own films have been based on the experience of my life with my own people. I belong to a very humble family. On a social level we all form one class in Mexico, this was assured by the Revolution. Everyone is alike with one conscious thought, which is Mexico."[24] Fernández lived outside time, beyond history, but he himself attested to the "classless" society, and the nationalism, produced by the revolution.

The most important of Fernández and Figueroa's movies set in the period of the armed struggle are *Flor silvestre* and *Enamorada*, films of extraordinary visual power and impelling music, which are generally considered to be melodramas.[25] However, the director was offended by that category, and when a French critic questioned him about this genre, he exploded: "For you the lives of Mexicans are melodramatic; for us they're a drama. What would

you have me do to have it considered a drama? Shall I cut off my mother's head? Or my father's balls? When you say we make melodramas, you are ridiculing us. When you say my movies are melodramatic, it's as if you were saying that they are shit."[26] Fernández's protestations notwithstanding, these films are melodramas in the sense of wallowing in sentimentality rather than making their audiences think, constructing nostalgic fantasies instead of facing social realities, and relying on an antiquated *costumbrismo* that offers a window onto a picturesque world in place of using cinema to reveal its own mechanisms of manipulation.[27]

Flor silvestre recounts the tale of a rich man's son, José Luis (Pedro Armendáriz), who loves a poor woman, Esperanza (Dolores del Río). Their relationship causes friction with José Luis's parents, particularly the father, who rules his home as uncontestedly as did the Mexican president the nation. José Luis joins the revolution to make a new reality, but neither he nor anybody else in the film can leave behind the patriarchy represented by his father, even when the latter has died.[28] Here, it would appear that Fernández is portraying a revolutionary transformation of class, race, and gender relations. However, he is not really offering a vision of conflicting worldviews, one of which corresponds to an outdated past and the other to a revolutionary present, as did the Cuban director Tomás Gutiérrez Alea in *Memories of Underdevelopment*.[29] Rather, Fernández paints patriarchy as natural, and inevitable; it is not a result of history but an essential condition of human existence. Hence, José Luis is unable to extricate himself from his father's shadow and becomes obsessed with revenging his death, which drives the narrative forward and eventually leads to his own execution. Esperanza is submission distilled, as she expresses in the movie's most exaggeratedly lachrymose sequence when she agrees to leave José Luis because of his mother's objections. However, these difficulties are resolved, and they live happily together until bandits capture Esperanza and their son, intent upon revenging themselves for what they believe was José Luis's role in killing the brother of one (to revenge his father). Posing as revolutionaries, the outlaws force José Luis to surrender to them and, in one of the most exquisitely painful scenes ever filmed, they execute him in front of Esperanza, she with their baby in arms. *Flor silvestre* was a critical success; one critic praised it as "the most courageous and realistic film that has been

made in Mexico. It is thought, written, directed and acted '*a la mexicana*' [in the Mexican way]. . . . A vigorous manifestation of MEXICAN CINEMA that, for the first time, honors our race."[30]

Enamorada is essentially a version of Shakespeare's *Taming of the Shrew*. General José Juan Reyes (Pedro Armendáriz) takes the city of Cholula and eventually wins over Beatriz (María Félix), the rebellious daughter of a wealthy city elder. The film opens with a remarkable example of nationalism: when José Juan's army of *campesinos* (presumably Zapatistas) takes Cholula, their first act is to raise a Mexican flag—standing on a colonial arch against white clouds, with a trumpet playing, as the credits end. The implication is that those they have defeated were not Mexican. The revolution brings education: José Juan frees the schoolteacher so he can reopen the school, gives him the pay he was owed, and doubles his salary.[31] It also brings social leveling: Juan José is a "*pelado*" from the lower classes, come to power thanks to the armed struggle; Beatriz is "*gente decente*."[32] Theirs is a tumultuous relationship that is resolved by way of his essentially beating her into submission, a violence celebrated in the film, as it usually is in Mexican cinema.[33] Having been given the stick, Beatriz then accepts a carrot from machismo and listens, enchanted, to the serenade sung by the mariachis that José Juan has brought to her; Figueroa's camera lingers over her eyes in an unforgettable sequence that is enriched by the music of the Trío Calaveras. As the song makes reference to the scorn she might feel for José Juan's poverty, Beatriz (and the camera) swing to look at the portrait of Robert (her rich U.S. fiancé), an audiovisual allusion to the popular notion that *gringos* may be good at making money but Mexicans are better at love. Beatriz leaves Robert at the altar. In the last sequence of the film, which Figueroa considers the best ending he ever shot, Beatriz tags along behind José Juan's horse, silhouetted against the volcano Popocatépetl.[34] *Enamorada* was well received, and one reviewer described it as "an intensely Mexican film, which can be shown on the world's screens proclaiming the pure beauty and unique style of Aztec cinema."[35]

In the revolutionary trilogy of Fernando de Fuentes, history is a living mesh which imposes itself upon the lives of those caught in it, shaping their social relationships.[36] With the movies of Fernández and Figueroa, the revolution is converted into a confused tangle of meaningless atrocities, and historical contexts are reduced to trappings, ornamental facades that have no

relation to the situations they purport to be representing. We are, of course, accustomed to encountering these in what we generally term costume dramas, films which utilize earlier times simply to provide a period setting but demonstrate no respect for, nor interest in, the radical otherness of past ages. Though we tend to think of trappings as bothersome but inoffensive violations of historical reality, *Enamorada* intimates that they may not be innocent. One example of the ways in which they give off ideology is the representation of Juan José, who dresses in three different uniforms. When he first appears in the film he is outfitted as a Zapatista, with a large *sombrero* and bandoleers crossed over his chest; later, he is evidently a Villista officer, for he wears a hat characteristic of those forces; at another point, he is clearly clothed in the uniform of the federal army that is fighting against the insurgents—whom he apparently leads! (See figures 26, 27, and 28.) What is the meaning of such a historical aberration as having the lead character dress indiscriminately in the uniforms of opposing armies? The crucial officialist myth of the Mexican Revolution is that it is a struggle of the "good guys"—Zapata, Villa, Carranza, Madero, and Obregón—against the "bad guys," Porfirio Díaz and Victoriano Huerta. Fernández replicates the official line and, in accordance with his essentialist and ahistorical vision, goes it one better by conflating Zapatismo, Villismo, and the Federal Army through the device of Juan José's uniforms.

By removing the social origins of character motivation, Fernández and Figueroa reduce the revolution to a variety of still-life forms. One is the natural landscape that, as in picturesque photography, dominates the scene: panoramic valleys marked by the sudden thrust of volcanic formations provide the backdrop; majestic magueys and statuesque cacti jut into the images and frame the protagonists; and over it all, the billowing clouds are made impossibly luminous by infrared filters and curvilinear perspective. Architectural landscapes are also important stages, whether shot in long takes of the seemingly endless arches of Cholula's plaza or the camera's extended play over the baroque convolutions of Puebla's El Rosario chapel. People as well are converted into a form of still life by Fernández and Figueroa: picturesque *campesinos* under broad *sombreros*, steely *charros* atop fiery stallions, women whose abnegation is registered in the shawls within which they are wrapped.

The faces of the stars are yet another landscape. Actors such as María

26. Frame enlargement, *Enamorada*, 1946. Pedro Armendáriz as Zapatista. Filmoteca de la Universidad Nacional Autónoma de México.

27. Frame enlargement, *Enamorada*, 1946. Pedro Armendáriz as Villista. Filmoteca de la Universidad Nacional Autónoma de México.

28. Frame enlargement, *Enamorada*, 1946. Pedro Armendáriz as Federal Officer. Filmoteca de la Universidad Nacional Autónoma de México.

Félix and Pedro Armendáriz were celebrities, and the films of Fernández and Figueroa were vehicles for them; they generate the identification that makes the public believe in the fictional-historical figures they characterize as well as ratify the greatly distorted reconstruction of the revolution, all the while bringing it into the present of their fans' daily lives. Fernández was particularly concerned with the gaze projected by actors—"The moment you blink, the scene is over"—and he converted the stars' facial features into phantasmagoric representations of the revolution: in *Enamorada*, the flashing eyes, fixed stare, and raised eyebrows of María Félix face off against the piercing glare, prominent teeth, and abundant mustache of Pedro Armendáriz.[37] It is crucial once again to contrast this aesthetic structure to the films of Fernando de Fuentes. The actors in *Compadre Mendoza* and *¡Vámonos con Pancho Villa!* were known, but they were not stars like Félix and Armendáriz, and they were certainly not celebrities.

Fernández's melodramas contain strong doses of machismo, reflecting the director's assertion that his nationality is male: "Mexico is Mexico, and for that very reason is masculine."[38] Fernández personally incarnated national stereotypes by dressing as a *charro*, throwing folkloric fiestas at which only Mexican food and tequila were served, and in insisting that his wives and girlfriends wear typical clothing. The director was fearful that U.S. cinema was "Americanizing" his countrymen. He wished to "Mexicanize Mexicans"; he believed that every nation ought to make its own cinema but that all were imitating U.S. films.[39] Nonetheless, his megalomania led him to the extreme of revealing that his was a construction: "Even Mexicans didn't know what Mexico was like until I showed it to them," and "There is only one Mexico: that which I invented."[40] He dedicated his life to consecrating *mexicanidad*, and he might well be encapsulated in the name of his second film, *Soy puro mexicano* (1942), which premiered on Independence Day with a title song that describes the pleasure of "being *macho* among *machos*."

Fernández was not without those who questioned his agenda. One of the most knowledgeable and biting was Julio Bracho, who directed the fabled *La sombra del caudillo* (The caudillo's shadow) in 1960, which was probably the film most critical of the political arrangements developed by the party dictatorship until Jorge Fons's *Rojo amanecer* (Red dawn, 1988). *La sombra* was censured by the government, the most spectacular instance of cine-

matic censorship, and not released until 1990. In 1951, *Hoy* asked Bracho to reflect on Fernández and Figueroa's cinema, and he delivered a devastating broadside. He began by noting the extraordinary cinematography but felt that it had been put to a poor use:

> I despise the picturesque. Any amateur knows that, in art, the picturesque is the anti-artistic, because anybody can achieve this easy refuge for those incapable of real creativity. Figueroa's beautiful photography, and clever propaganda, allowed this cinema to pass itself off as the only authentic Mexican film, when it is precisely the most inauthentic: the equivalent, in movement, of the classic postcard of the little Indian (*indito*), the little burro, and the cactus that tourists like so much; they not only hide, but ridicule as well the tragic essence of the cactus, the burro and the Indian. Being picturesque, this cinema has been neither brilliant, revolutionary, nor extraordinary, but ordinary, demagogic, and primary.[41]

In the films of Fernández and Figueroa, the centrality of stars (and the off-screen presence of celebrity director and cinematographer) combines with the curvilinear form, the depth-of-field focus, and the low camera angles to monumentalize the revolution as history, an epic still life. All the extended scenes that show species of "landscapes"—be they of nature, colonial architecture, anonymous extras, or the faces of the stars—offer the same master narrative: the Mexican Revolution is a mythic form given once and for all—of volcanoes and clouds, of ancient structures, of picturesque clothing, of superficial beauty, of the party dictatorship that ruled the country for seventy years.

Celebrity-Stars and *lo Mexicano*

During the 1940s, the celebrity arrived to stay in Mexico, largely fomented by the media culture developing around cinema and the illustrated magazines.[42] Although this eminently modern persona had begun to appear with the first mass-produced photographic images, the *tarjetas de visita* initially tended to celebrate individuals who had achieved recognition for achievements in the real world and then entered into media's virtual universe, for example, Benito Juárez. In the twentieth century, the process was reversed: people of few (or no) accomplishments became famous for being seen on the screen and the pictorial pages. Mexico lagged a bit behind the United

States in creating native celebrity-stars, but in the 1940s they were being constructed at the movies and in the new periodicals.

The magazines' articles generally held the opinion that the country's cinema ought to be expressive of national identity. Vicente Vila asserted, "The root of Mexican film, its definition, its style and essence, its own personality, and even its best business are found in the inexhaustible vein of being Mexican, which makes it distinct from other cinematography."[43] However, this writer argued that films were lacking in *mexicanidad* because directors were too taken with the exotic and typical to deal with real national problems.[44] Other essayists echoed Vila's preoccupation with the picturesque, asserting that the films defamed the nation by portraying it as a country of "drunk, murderous, and trouble-making *charros*."[45] However, the question of how to express *lo mexicano* was not easily resolved. Vila himself recognized the importance of tradition: "Without the *charro*—more widely stated, without the typically national—the cinematographic business would be something amorphous, without character."[46] Others, for example the organic intellectual Vicente Lombardo Toledano, decried the "abuse of folkloric themes," signaling the ways in which local cultures had been transformed into a nationalist soup, with the result that Mexican cinema's audience was composed of "ignorant tourists for whom Indian communities could be mixed together with regional dress, music, and speaking patterns, without them noticing that they were imbibing a *cocktail* instead of a pure drink."[47] Writers recognized that the problem is that curios bring box-office success: "The typical sells. Without this label, or songs and big sombreros, nobody would believe it was produced by Aztecs. Mercantile interests not only deform the authentic, they also adapt it to their necessities and make it folkloric."[48] One writer pointed to the importance of individual artists in rescuing *lo mexicano*, mentioning "among the few that are worthy," Emilio Fernández, Gabriel Figueroa, Cantinflas, Dolores del Río, Pedro Armendáriz, María Félix, and Jorge Negrete.[49]

Movie stars were a staple of the illustrated magazines, and they appeared with regularity. Hollywood celebrities were frequently pictured—*Hoy*'s first cover featured Clark Gable and Carole Lombard. However, Mexican actors and actresses were an essential component of the periodicals, a reflection of their enormous popularity in Golden Age cinema, as well as part of the apparatus creating them. A product of mass media, celebrity-stars must

be analyzed as "star texts" created by films but also as "media texts," constructed with studio publicity as well as promotion and criticism by periodicals.[50] True stars are highly individualized archetypes that articulate the dominant ideology, at times embodying values that are in crisis. Mexico was undergoing the profound transition from a rural and agricultural society to one that is urban and industrial, and stars served to redefine a changing national identity. As Carlos Monsiváis commented, "It is not really a 'Golden Age' of film, but of the public that, among other things, trusts that these idols will clarify how to manage the new forms of life, orienting them in the vertigo of transformations."[51] Moreover, by personalizing archetypes, stars individualize fate, and it is no accident that this occurs at precisely the point in which problems within Mexico are "decollectivized"; the end of class struggle decreed by "National Unity" is the first early step toward privatization, both personal and economic.[52] The emergence of stars is one symptom of this process—and of the industry that sprouted to promote them—though they also obviously speak to something very deep in the national imagination that enables the audience to connect with them, and not other actors.

Celebrity-stars can be studied as expressions of national archetypes: the *peladito* (Cantinflas), the *pachuco* (Tin Tan), the *charro* (Jorge Negrete, Pedro Armendáriz, Pedro Infante), and the long-suffering woman (Sara García, Dolores del Río, María Félix). The individualization of these archetypes, their power and depth, depends upon the actors; lesser actors inhibit identification, but these stars were somehow able to create public personas of such power that they came to express central features of Mexicanness for their audience. They were so recognized in this period that they sometimes played themselves, incorporating their names as elements of self-reflexivity that call attention to and play with the virtual world created on screen and in the magazines. To consider one example, Pedro Infante and Jorge Negrete were called by their real names in the only film in which they appeared together, the entertaining *ranchera* comedy *Dos tipos de cuidado* (Two wild and crazy guys, 1952). However, their star texts were reversed in the film: Infante's role was Pedro Malo, while Negrete's was Jorge Bueno, characterizations opposite to the ways in which they were perceived by the audience, for whom Negrete was a wealthy and well-placed *charro*, petulant,

aggressive, and resentful, while Pedro was the humble macho, subdued, stoic, and noble.[53]

From *Peladito* to *Pachuco*

The public personas of the two greatest Mexican comedians embodied archetypes of *lo mexicano* that were sharply opposed; as a consequence, they received greatly differing treatment from the illustrated press. Cantinflas (Mario Moreno) created the *peladito*, an embodiment of *mestizaje*, the Spanish-Indian racial mixture that is the Mexican genotype and the cornerstone of the revolution's nationalist cultural project. The *pachuco* of Tin Tan (Germán Valdés) is a transnational hybrid produced by the clash of U.S. and Mexican cultures, a picaresque city rogue that incarnates a rapidly transforming Mexico, increasingly urban, intent upon industrialization, and attracted to, as well as wary of, the United States. The darling of the picture magazines, Cantinflas appeared in their pages more than any other star, while Tin Tan was largely ignored (*ninguneado*, treated as a nobody), an expression of the generalized disdain expressed toward *pachucos*. Cantinflas himself made disparaging, if humorous, remarks about this figure in at least two films, *Puerta . . . joven* (1949) and *Si yo fuera diputado* (1951); in the former, he rubbed his eye and commented on the spread of this bothersome subculture: "I don't know what I've got in my eye, because all I see are *pachucos*."

The degree to which Cantinflas was conceived as a synecdoche for *mexicanidad* can be appreciated in the statement of a sharp cultural observer (as well as a committed leftist who shared few political ideals with the comic), Antonio Rodríguez: "It is no exaggeration to say that Cantinflas is today the only citizen—other than the president—in whom is realized the unity of all Mexicans."[54] One of the greatest idols of Spanish-language cinema, Cantinflas gained international recognition through his rendering of a purely local character, who the comic defined in the following way: "A prototype of those from poor towns or humble city districts. A man with a superficial education, or none at all, but with much ingenuity, a Mexican characteristic. Practically non-existent socially, he has great astuteness, and a large, gentle, and open heart. An optimist, he firmly believes that anything is possible. He is like millions of men in Mexico and other Latin American countries."[55]

29. Cantinflas as *peladito*, poster for *Aguila o sol*. Filmoteca de la Universidad Nacional Autónoma de México.

Cantinflas's character is the Spanish-speaking world's equivalent of Charlie Chaplin's tramp. However, his invention embodies not only the fusion of Indian and Spaniard; it also represents the lumpenproletariat created by the impact of the unplanned and uncontrolled urbanization that dramatically transformed Mexico from a society of towns into a conglomeration of unmanageable metropolises, dominated by the largest of them all, Mexico City. A product of this abrupt transition, the *peladito* is essentially a shrewd and folkloric country bumpkin who, streetwise in ways only the powerless learn to become, has discovered how to function in an urban setting. According to Cantinflas, he is a *campesino* who has been turned into a citizen (see figure 29).

The *peladito* has its roots in the search for identity that marked the post-revolutionary period. In 1934—around the time Cantinflas was developing his persona on stage—Samuel Ramos produced the first systematic exploration into the Mexican being, *Profile of Man and Culture in Mexico*, where he described the *pelado* as "the most elemental and clearly defined expres-

sion of national character."[56] Literally, *pelado* means "peeled," stripped clean, broke; however, it is used most frequently as a reference to the shaved heads often seen on Mexico City's lumpen, a form of lice control and hence a derisive appellation. Turning a class trait into a national characteristic, Ramos argued that the *pelado* has two personalities: a fictitious entity opposed to and dominating the real being. According to the philosopher, these warring personalities result in a sense of self-distrust and an insecurity as to his (and, by extension, his country's) identity. One writer reflecting on Cantinflas asserted that it is precisely his "doubling [*desdoblamiento*] of personality that all Mexicans carry within."[57]

Cantinflas began his career in the *carpas*, the popular theaters, and he described the invention of his doubled persona as a function of the stage fright he once felt there: "Mario Moreno remained paralyzed in front of the crowd until, suddenly, Cantinflas took charge of the situation and began to talk. He desperately babbled words and more words, senseless, foolish words and phrases."[58] Cantinflas's enormous gift for impromptu verbal invention is the very essence of his comedy, and in Mexico the name has been turned into a verb (something relatively uncommon in the Spanish language as compared to English): *cantinflear* means to talk a lot and *apparently* say nothing. The name is also without doubt related to drunkards' nonsensical and sometimes violent verbiage; although the later, moralistic Cantinflas would certainly have denied it, it is clearly a reference to *cantinas*, those Mexican bars that were (and mostly remain) men's domain. Many sequences in his earlier films take place in these locales of inebriation and male bonding.

Up through the 1950s, Cantinflas's humor derived largely from the ways in which the *peladito* turned the tables on the rich and powerful, confusing them with their own tools of domination. Language offered an obvious arena; as the instrument of the educated, it is one of the ways the privileged classes maintain their position. Nonetheless, language is a front on which the *peladito* excels. Cantinflas explained that, when you are faced with society's power, "the explanation demanded by the policeman whose hat you stepped on or the boss whose shirt front you just spilled catsup down, the *pelado*'s defense is to talk, talk, talk."[59]

A good example is offered in the film *Gran hotel* (1944). Cantinflas has just secured a job as bellboy in a swanky and tightly run hotel. The manager has the staff lined up in military files; as their names are called, they leave

ranks and stand at attention in front of him while he inspects their uniforms and assigns their tasks. When Cantinflas appears, the manager is appalled at his disarray and exclaims, "Who dressed you?" The rapid-fire answer is pure Cantinflas or, as is often heard in Mexico, *pura cantinflada*:

I did it all by myself. You know, what happened is that the pants they gave me, I think they either don't go with the jacket or I don't know what happened, because on one side they're really baggy right?, and on the other side even more so, and they made a sort of a pleat, listen, and I felt very uncomfortable, and going around in uncomfortableness, with something that you don't like, because pants ought to conform to the body and I have fallen hips and the body naturally follows the sense of gravity, according to the anatomical things who are those that study the human body, right?, who see, well, a pleat on one side then that means that on the other side the body is sort of half-fallen. OK, so I said, the problem with adjustments: if the pants are fixed right, I pay and if not, I don't pay, because also, "Why should one pay for an adjustment that one doesn't owe?," or even less. So, that doesn't work out, right? And I say, if they bring the pants and they fit me well and they go with the jacket, then yes. If not, well, I still have two pairs of pants, this one and the old ones, so, I make a little thing like this out of the two so that it's stylish. Don't you think so?

Millions delighted at seeing the tables turned on the punctilious manager, as the comic's guile subtly but tenaciously disarmed him with what appears at first glance to be nonsense. Nonetheless, here is an instance in which "*cantinflear*" does not mean "to say nothing." Instead, he is insisting on the equality promised by the New Order to all who participate in capitalism; in spite of being a *peladito*, he asserts that he is entitled to the same treatment given anyone who has money, however little: "If the pants are fixed right, I pay and if not, I don't pay."[60] This is an important lesson, for it extends the notion of social identity to include the many Mexicans who are poor. Nationalism also figures in the speech of the hotel's manager, for he has a Spanish accent. In films made during the 1940s, such as *Romeo y Julieta* (1943), *Gran hotel*, and *Puerta . . . joven*, Cantinflas often surrounded himself with Spanish and Argentine actors in order to emphasize the pecu-

liarities of the Mexican way of speaking, described by the television celebrity and magazine writer Pedro Ferriz as "the best mirror of our soul."[61]

Cantinflas began in starring roles teamed up with the comedian Manuel Medel, with whom he made three films, *Así es mi tierra* (1937), *Aguila o sol* (1937), and *El signo de la muerte* (1939). The first of these was directed by Arcady Boytler and played off of the period's two dominant genres, which Fernando de Fuentes had recently defined: the revolutionary epic and the rural musical comedy known as a *comedia ranchera*. Situated in 1916, *Así* begins with the return of a general to his home town and ends with his leaving to rejoin the struggle, now accompanied by Cantinflas. The revolution's presence is largely confined to the film's opening and finale, but the Eisensteinian aesthetics that Boytler, a Russian immigrant, incorporates are a cinematic reference to it. Though the movie starts out as a musical, Boytler quickly moved Cantinflas into the foreground, where he eclipsed the love story that was usually at this genre's center. The comic demonstrates his verbal virtuosity most spectacularly in the scene where he avoids being shot by appearing to assume his aggressor's position as his own. But he also alludes to the frustration he feels at being unable to articulate his feelings; after hearing an intellectual reflect on the difficulties of life in the country, Cantinflas remarks, "I hear you speak, and it makes me envious because I suddenly feel things and want to explain them, but I explain what I don't feel when I try to say them."

In *Aguila o sol* and *El signo de la muerte*, Cantinflas and Medel were placed in an urban setting and given a more prominent billing in the credits. *El signo* included as collaborators important figures such as Salvador Novo and the composer Silvestre Revueltas, but the direction by Chano Urueta is weak. The movie is a chaotic scramble of the "who-done-it?" and horror genres that mixes in a neo-Aztec ritual sacrifice reminiscent of U.S. films about Egyptian mummies. Most of the action takes place in a museum, where the messianic and fanatical Indianism of the director and his followers is a reference to the revolution's official *indigenismo* and to Manuel Gamio, the intellectual who most emphasized the continuing contribution of the ancient civilizations in forging the fatherland.[62] The sacrifice sequence functioned as an allusion to Gamio's defense of that practice, as well as picturing the Indian's savagery, which would only be overcome with the

mestizaje that was a pillar of the revolution and the essence of Cantinflas's character.

One particularly crazy scene of *El signo* is that in which Cantinflas frantically searches for help in order to rescue the heroine, who is about to be sacrificed in the museum's cellar. He encounters Medel, the museum guard, who, ignoring his tongue-tied entreaties, makes him imbibe tequila. Cantinflas gets drunk and, the attempted rescue completely forgotten, is transformed into the Empress Carlota through a series of dissolves that end with him dressed in an elegant gown and dark wig (the second time in the film he appears in women's clothes). Medel turns into the Emperor Maximilian—with frock coat, golden wig, and medals—and the two climb into a carriage together as if to sleep, while the screen fades to black. The utter insanity of the situation—with its overtones of transvestism, homosexuality, and alcoholic liberation—evinces the infinite possibilities of freedom in the immediacy of anarchic pleasure.

Such insanity was typical of Cantinflas's comedy during his most creative period, from 1940 to 1960, and at its center were the *peladito*'s constant violations of what was considered acceptable behavior in polite society. The film that marked his definitive enshrinement was *Ahí está el detalle* (1940), in which he played a drunken and lecherous glutton who refuses to allow anybody to speak on his behalf in court. Instead, he represents himself, and his nonsensical double-talk confuses a courtroom of lawyers, infecting them with his incoherent verbiage. He finally wins by tenacity rather than the logic of his argument, a lesson not lost on individuals with limited literacy caught in a Byzantine system of law. Here, his comic technique served to criticize the social control that the legal system maintains over the uneducated through language that often appears to be as obscure and unintelligible as that employed by Cantinflas and which restrains people from speaking for themselves.

As his character became increasingly defined, he felt that he needed more autonomy to improvise. His following movie, *Ni sangre, ni arena* (1941), was about bullfighting, one of his great passions. During the filming, he quarreled with the well-known director, Alejandro Galindo, but formed a lasting relationship with the assistant director, Miguel M. Delgado, and the writer, Jaime Salvador, who from then on became the mainstays of Cantinflas's movies. The absolute control he had over his films permitted him to

direct the development of his media text to a large degree, but the lack of association with more demanding directors or writers may have stunted his growth. His enormous popularity and considerable wealth isolated him and made him a prisoner of his own celebrity.

For a number of years, the team of Cantinflas, Delgado, and Salvador made genuinely funny movies, always based on the formula of the *peladito* confronting the powerful and besting them on their own grounds. For example, in *Gran hotel*, Cantinflas appears in a screwball sequence at a very fancy night-club where he throws his dance partner about as if she were a rag doll, until he finally heaves her (a stuffed mannequin prop) into the middle of the dining patricians. Later, as the hotel's bellboy, he makes wealthy tourists carry their own luggage. In *El supersabio* (1948), he is a scientist's assistant who defies the multinational Petroleum Trust Company by telling them a truth that they, corrupt as they are, take to be a lie and are thus fooled by their own mendacity. In *El bolero de Raquel* (1956), he returns to the night-club scenario to ridicule the rich and pretentious, as well as their "watchdogs": bodyguards, maids, and managers. These elements of irreverence and lunacy were an important factor in Cantinflas's comedy, but they became increasingly rare as his career advanced.

The comic's decline begins in 1951 with *Si yo fuera diputado*, a film for which he wrote the script. In this work, he becomes a congressman, his first character to break with the *peladito*'s marginality. A contemporary critic felt that there was such a difference between this and his former films that she had no alternative but to call for the return of the underdogs he had always played.[63] His decadence is clear in *El analfabeto* (1960), where his personage is incarnated as an illiterate who works as a bank guard and eventually learns to read and write, thanks to Mexican public education. However, here Cantinflas is not the shrewd, if ignorant, *peladito* of yore; rather, he is a quasi-retarded childlike simpleton who is easily tricked. The film's social vision is meaningful; gone are the affronts toward the powerful that characterized his earlier films: the bank's owner is good while his employees are bad, and the church is fundamental to the illiterate's "salvation."

Cantinflas's subsequent films are preachy, tedious, and humorless; his formerly vital attitude toward the uses and abuses of language is replaced with word games that essentially deny the existence of social problems. He represents roles he had earlier critiqued, lecturing from the stances of

priest, doctor, professor, diplomat, politician, and policeman (the latter role is particularly galling!). However, these personas do not allow him the liberty of the marginal, for you cannot infuse socially admired roles with the *peladito*'s anarchic insanity without calling into question the very basis of the society. Under the guise of being nonideological, he openly encouraged an antipolitical solution to Mexico's problems, suggesting in (and as) the *Padrecito* (1964) that entering into politics is a cardinal sin. In *Su excelencia* (1966) his arrogance was unbounded: there, taking himself *very* seriously, he offered the Christian doctrine as a solution for the world's problems in an international scenario meant to represent the United Nations.

Criticism of Cantinflas appears to begin in the early 1950s, and in 1967 Carlo Coccioli caused a tempest in a teapot when he inveighed against U.S. President Lyndon Johnson for considering the comic to be the "incarnation of Mexico."[64] Contemporary Mexican writers have been quite censorious of him. To the film critic Jorge Ayala Blanco, he "parades the worst stereotypes of the Mexican people."[65] Roger Bartra considers that Cantinflas offers a clear example of the ways in which the mass nationalist culture created by the PRI utilizes and distorts authentic popular expression.[66] He argues that the slang Cantinflas takes as a jumping-off point is in fact a language profoundly engaged with the world from which it comes, but that *cantinflismo* empties it of meaning and converts it into a way to avoid commitment and evade responsibilities. For Bartra, the comedian is an excellent metaphor for the peculiar strategies through which the single-party dictatorship legitimates itself by constructing a labyrinth of contradictions that permits the most radical appearances, while knowing that the original meaning of the people's demands will inevitably be lost in the maze of corridors, waiting rooms, and offices; "Cantinflas's message is transparent: misery is a permanent state of stupid primitivism that must be vindicated in an hilarious form."[67] Carlos Monsiváis notes how the dangerous shadow existence of the *pelado* is transformed into the famous Mexican diminutive, the *peladito*, a nonthreatening and inoffensive rogue.[68]

In 1954, a book about Cantinflas's "philosophy" declared that he "had created a metaphysic of Mexican life" and "had defined the Mexican soul."[69] However, today his *peladito* looks like a stereotype of a people who are "ignorant, corrupt, fatuous, hypocritical, and lazy," as one letter defending Coccioli asserted.[70] To be fair to Cantinflas—perhaps better stated, to be

fair to his millions of fans—it is important to understand the appeal he had as a representative of underdogs who depend on their quick wit(s) to survive in an ostensibly democratic but profoundly unequal society. Mexicans exhibit a natural inventiveness and an uncommon playfulness with words, so his character finds a resonance in the nation's identity: a neocolonized individual who shapes his being in a situation of oppression. Cantinflas was at his best when he apparently had nothing to say; but the logical extension of the *peladito*'s political and social underdevelopment—and his rejection of reality—is a privatization and isolation that is the antithesis of the socially corrosive humor which made Cantinflas famous. His decline followed a natural course: as he became increasingly wealthy from playing an underdog, his characterization lost the vital link to reality which had nourished it, and it became a shell of trappings: old clothes and picturesque prattle. His aping of the *peladito*'s words, dress, and way of being made many laugh, but he ceased to be a constructive element of Mexican identity some time ago.

It is significant that Cantinflas was not attacked for corrupting the Spanish language despite his wordplay, while Tin Tan was much criticized for the combinations he created by mixing Spanish and English phrases, the first evidence on the Mexican screen of what would come to be known as "Spanglish." Tin Tan spent his youth in Juárez, where the border region's fluctuating and problematic identities provided the inspiration for the persona he developed while working as a radio announcer, where he was "Superpachuco," and then on stage. His linguistic gymnastics reflected those origins by incorporating foreign cultures and languages, thus differing from the verbal convolutions of Cantinflas. He usually aped English expression, though he was also wont to launch a phrase in French or Italian, above all when in fancy dress, mumble some Portuguese, or to allow his speech to become contaminated by other Spanish accents, suddenly talking like the Cubans or Andalusians with whom he is conversing. He revolted not only against the strict rules of the Royal Academy (Real Academia de la Lengua) that so stifled linguistic creativity but also in opposition to the revolutionary dictum that Mexico was a product of Spanish-Indian *mestizaje*. Tin Tan's *pachuco* was a permeable character, infected by the international cultures around him.

The *pachuco* was an affront to the new nationalism as well as to traditional notions of *mexicanidad*. One of the most penetrating analyses of *lo*

mexicano was carried out by Octavio Paz, and it is significant that he begins his famous meditation on national identity, *The Labyrinth of Solitude* (1950), by examining the *pachuco*: "His whole being is sheer negative impulse. . . . The *pachucos* do not attempt to vindicate their race or the nationality of their forebears. Their attitude reveals an obstinate, almost fanatical will-to-be, but this will affirms nothing specific except their determination . . . not to be like those around them."[71] Paz concludes that the *pachuco* is "a pariah, a man who belongs nowhere," a perspective clearly reflecting a world not yet accustomed to today's globalization.[72] The *pachuco* "was demonized both linguistically and socially," and the illustrated magazines expressed the general disdain, which often focused on language.[73] In describing the *pochos* that "denigrate the country more than anybody," one writer explained, "They abominate their mother tongue, do not want their children to learn it and, as they have not learned either English or Spanish, they cannot express themselves correctly, but mix the two idioms and introduce absurd translations of Spanish."[74] A cover of *Hoy* created by the fine cartoonist Bernal Arias showed a man garbed in *pachuco* clothing who was attempting, without success, to interest a woman in Mexican dress.[75] The film industry participated in painting a negative image of this figure: "Cinema taught society that the *pachuco* is synonymous with the pimp, the lady's man, the lazy bum, the billiard-hall habitué, the kept man; the demonization is total and the only thing left for him is the bonfire."[76]

Tin Tan was singled out for his role in promulgating *pachucos*. He was reproached for attacking the national identity, and letters were apparently sent to the secretary of public education by intellectuals and writers asking that the secretariat prohibit his movies because they "denigrated" the country.[77] One reader of *Siempre!* was so offended that he mailed the magazine a letter from Guadalajara, referring to "the disastrous school that Tin Tan implanted with his poor imitations of the kept men across the border who, taking advantage of the war, dedicated themselves to exploiting the gullible women of those fighting in the front."[78] However, the Marxist intellectual José Revueltas felt that his influence was positive: "Since I met him I became most interested in the phenomenon of interculturation undergone by the Mexican on the other side of the border. I had formerly seen that with prejudices, but it helped me understand the language problem."[79]

The comic rendered a critique of the status quo that was both social

and aesthetic. In film after film he ridicules the wealthy and those who govern. The rich are frivolous and far from admirable; their only interests are their jewelry, cocktail parties, and being amused by entertainers such as Tin Tan. The state is sometimes presented in the form of policemen who are haughty and careless of the law, allowing prisoners to strip new arrivals of their clothes. Tin Tan's comic sidekick for almost his entire screen career was Marcelo, his *"carnal"*; in *El rey del barrio* (1949), Marcelo plays a cop who gives Tin Tan permission to rob because Mexico is full of "millionaire crooks," an obvious reference to the unrestrained corruption of Alemán's rule.[80] Tin Tan is often referred to as an *"igualado,"* that is, someone who considers him or herself to be at the same level as the speaker but who presumably is not. The connotation of class discrimination is obvious, for an *igualado* is someone who does not know or refuses to accept his or her place in society, and that is certainly an apt description of Tin Tan. The filmic strategy was as radical a departure from the norm as was the social commentary. When Tin Tan and Marcelo speak to the camera in *El rey*, they break through the screen and the illusion that it is a window onto the world. This degree of reflexivity was rarely utilized in Mexican cinema during this period, but the comic violated the norms of modern cinema by establishing a complicity of irony with the audience that seemed to deconstruct the film itself. Another expression of self-referentiality can be seen in his tactic, employed on many occasions, of introducing his moniker in the most unlikely situations. For example, in *Chucho el remendado* (1951), he passed an office door on which appeared a sign: "Dr. Germán Valdés, Specialist in Mental Infirmities." Germán Valdés was Tin Tan's real name, and so he commented that it somehow "rang a bell." Well it should have, for *"Tin Tan"* is the Mexican equivalent of "Ding Dong."

The United States is a major presence in Tin Tan's movies. He burst upon the scene dressed in the "impractical" apparel of the *pachuco*—the "Zoot Suit," with its wide-brimmed hat and long feather, the too-large jacket and its exaggerated lapels with the shirt collar outside, the pants baggy around the legs and narrow in the cuff, the key chain that droops below the knee, the outrageous shoes with Cuban heels—in *Hotel de verano* (1943), *El hijo desobediente* (1945), and *Músico, poeta y loco* (1947), constantly interjecting English words and phrases (see figure 30).[81] In *Soy charro de levita* (1949), reference is made to the U.S. invasion of 1847. Caught up in a showdown

30. Semo (Simón Flechine). Tin Tan as *pachuco*, Mexico City, ca. 1950. Inv. # 329514, Fondo Semo, SINAFO-Fototeca Nacional del INAH.

with the bad guy, Tin Tan has only an empty squirt gun, and the bad guy ridicules his lack of ammunition. The comic responds with a saying from the Mexican War that is much repeated: when the U.S. general entered Churubusco, the fort that defended the southern entrance to Mexico City, he asked the commander where the munitions were. Tin Tan aped his utterance: "If there were any munitions, you wouldn't be here." In movies such as *Simbad el mareado* (1950), he chased after U.S. women who were usually portrayed as being so dim-witted that the only thing attracting him was their money, but his humor also takes a self-effacing look at myths about Mexican machos. In *Viva Chihuahua* (1961) Tin Tan finds himself in Juárez with a couple of young U.S. women. The *gringas* are delighted, squealing, "Oh, *maravilloso*, a Latin lover." The comic attempts to get the women drunk, but it is Tin Tan himself who ends up stewed, while the women continue drinking. They finally tire of him: "These Latin lovers can't hold anything, they're very little." Finally, his constant use of English infects

others, hence in *No me defiendes, compadre* (1949) his girlfriend tells other women to "shut up."

One of his best films is *Calabacitas tiernas* (1948).[82] As the movie opens, Tin Tan (playing himself) is shown as a blend of *pachuco* and *pelado*. The exaggerated *pachuco* garb of his previous films is toned down for *Calabacitas*, perhaps as a result of pressure from producers to abandon this role.[83] Dressed very shabbily, Tin Tan accosts any and all women he comes across, including one to whom, offering himself, he remarks, "Here is your Robert Mitchum." They rebuke him, commenting disparagingly on his sorry state, and referring to him as a *pelado* and *igualado*. Convincing a friend, with whom he grew up in "El Paso, Tejas," to loan him a suit, he attempts to get an audition in a night-club. There, an employee turns the tables on him by affirming his Mexicanness when spoken to in English: Tin Tan asks affectedly, "Can you show me the way?," to which the worker replies, "The *buey* [ox] is you."[84] Through a convoluted plot, Tin Tan comes to function as the night-club owner; when he finds a checkbook, he proceeds to write checks indiscriminately, ignorant of and unconcerned by the fact that there are no funds to cover them.[85]

Contrary to the officially proclaimed "National Unity," *Calabacitas* portrays Mexico as a country where different nationalities gather: a Spaniard runs the pawnshop and an Argentine is the real entrepreneur of the night-club. However, Tin Tan internationalizes the situation even more by bringing in a Brazilian singer, Cuban dancer, and Spanish flamenco group; further, he proceeds to take on their national characteristics when singing, dancing, and talking with them. English is a constant referent, as the comic frequently utters phrases such as "The show must go on" and "Excellent, baby, wonderful," sprinkling in single words—above all, "dollars"—incessantly. In the finale, however, the battle between the women for Tin Tan is won by the Mexican who came from the same Mexico City barrio as he, and that is where they end up, married and having a child (with his face) every year, Tin Tan washing dishes in a frilly apron. As is the case in another great Tin Tan movie, *El rey del barrio*, the apparent reconciliation with *mexicanidad* at the conclusion pales alongside the transnational excitement that the movie foments throughout.[86]

Tin Tan made an enormous number of films, starring in perhaps 150,

while appearing in another ninety-five.[87] Between 1956 and 1959, he starred in thirty movies and was the biggest box office draw in Latin America for Mexican cinema.[88] There are those who believe that he burned himself out with too much work, women, and wine. However, if some of these movies are a lamentable waste of his talent, there are gems among them. Moreover, it could be argued that, though Cantinflas was an appropriate metaphor for the national character of the postrevolutionary period, his *peladito* may not have the relevance to today's hybrid culture that Tin Tan's *pachuco* does. As Guillermo Gómez Peña reflected, "Mexican identity (or better said the many Mexican identities) can no longer be explained without the experience of 'the other side,' and vice versa."[89] Rather than looking to pre-Columbian ruins or revolutionary monuments as a source of identity, the *pachuco* constructs a transnational future.[90] Tin Tan's irreverence, creativity, and self-reflexivity make him fresh today—perhaps the only Mexican comic from the past still relevant to today's youth—while his opposition to the narrow and exclusive nationalism of the 1940s and 1950s heralded the syncretism that so marks contemporary culture.[91]

Charros: Seigniorial, Revolutionary, and Postrevolutionary

The *charro* is as representative of Mexican maleness as is the cowboy of "American" machismo. This visual archetype had entered into the imaginary with the nineteenth-century *costumbristas*, and moved to center stage in the picturesque photography of Hugo Brehme. In the 1940s, it was welded to the revolution by directors such as Emilio Fernández, as well as stars such as Jorge Negrete, Pedro Armendáriz, and Pedro Infante, to create a new model for men: the pistol-toting, horse-riding, woman-beating, tequila-drinking, sombrero-wearing *hombre de verdad* who, I believe, contributed enormously to constructing the unique character of Mexican machismo. Prior to 1940, the word *macho* appears to have been used rarely, and almost always disparagingly; there is no evidence that the exaggeration characteristic of modern forms existed before that date.[92] That the concept entered into common usage with positive attributes (as a synonym for "brave" or "manly") may signal the importance it acquired in reality, both social and virtual.[93] This is the period in which an intimate link was forged between machismo and nationality; as Matthew Gutmann observed, "Beginning especially in the 1940s, the male accent itself came to prominence as a

national(ist) symbol. For better or worse, Mexico came to mean machismo and machismo to mean Mexico."[94]

Though the *charro* is a distillation of Mexican machismo, his development is related to the United States. On one hand, he is a national variation of the cinematic cowboy that enjoyed such popularity on U.S. screens. On the other, he is created precisely as a reaction to the "Americanization" that was extending itself throughout Mexican society, and which Fernández dedicated his cinema to combating.[95] Jorge Negrete and Pedro Infante are among the first *charros cantores*, the singing horsemen reminiscent of U.S. stars such as Roy Rogers and Gene Autry. However, Negrete and Infante were raised to the level of "idols." As one scholar of mass media commented, "The Mexican idol differs from Argentine or U.S. stars. He is not only someone who sings and acts in movies, he is a being that has it all; he has reached fame thanks to his voice, his presence, his acting gifts, and his reputation as a conqueror of women. The idol is above all the idealized image that Mexicans would like to have of themselves."[96]

Jorge Negrete was considered a "symbol of Mexico."[97] He burst into cinematic prominence in *¡Ay, Jalisco, no te rajes!* (1941) with his characterization of "el ametralladora" (the machine gunner), a revolutionary *charro*. Nevertheless, his public persona served more to embody the haughty arrogance of the feudal *hacendado*. Although similar to the U.S. buckaroo in terms of setting and genre objects—six-guns and horses in a rural environment—Negrete's seigniorial *charros* occupied a highly stratified universe, enclosed and peopled with individuals grouped into social hierarchies, which differed greatly from the cowboy's wide-open frontier and democratic pretense. His films' narratives are propelled by male bonding and competition, which are confined to particular terrains: the *cantina*, where maleness is determined by the quantity of alcohol consumed, and the gunfight, which can sometimes be sublimated into a duel of singing voices, above all if the film is a *comedia ranchera*. Consolidating machismo and nationalism, Negrete's movies explicitly present the *charro* as a model for *mexicanidad*: in *No basta ser charro* (1945), he sings, "*Ser charro es ser mexicano*" (To be a *charro* is to be a Mexican), and the song that closes another film, *Me he de comer esa tuna* (1944), links this archetype to the "*Virgen morena* [brown Virgin (of Guadalupe)], her country, and her God—noble, valiant, and loyal."

Women occupy a minor role in Negrete's movies, and the camera often

relegates them to secondary planes. Like any property, women are interchangeable: they can be stolen at the altar from men too weak to protect their interests (*El rebelde*, 1943), and they can be gambled between friends (*Me he de comer esa tuna*). Of course, women *are* represented as being capable of using ploys to gain a hold on men's hearts and pocketbooks, as when María Félix invents a tale of rape in *El rapto* (1953); hence, we can understand why Negrete described them as "the most poisonous creatures in the world" in *¡Ay, Jalisco, no te rajes!* However, they are finally little more than cinematic shadows in the *charro*'s cosmos, insignificant in comparison to his male friends and rivals.

Negrete was well known as a singer but became a genuine celebrity thanks to *¡Ay, Jalisco!* A very limited actor, he resolved that largely by performing his public persona. Although this was not uncommon in Mexican cinema, the structure created around Negrete took the auto-referential to the self-reverential. Hence, in *No basta ser charro* he plays the role of Ramón Blanquet, a *charro* who coincidentally bears a striking resemblance to Jorge Negrete and so serves to provoke constant references to the star, who is so great a figure on the national stage as to be recognized in a village without a theater. Negrete also appears as "himself" in "documentary" inserts: when a record of his is played, the film cuts to him singing with the Trio Calaveras; when the front page of the newspaper *Excelsior* has a headline about his disappearance, the women reading it become hysterical. The craze for *comedias rancheras* had begun in the 1930s, initiated by Fernando de Fuentes's box office smash, *Allá en el Rancho Grande*, which had been imitated repeatedly; it was one of the most popular film genres in this period and an expression of the nostalgia for the Porfiriato fomented by the mass media. Advertising for *No basta ser charro* began by conceding that there had been too many *charro* flicks; the public was satiated. However, the director, Juan Bustillo Oro, promised that this film would be different because it would interface the star with his own myth.[98] Nonetheless, the possible reflexivity that such a tactic could have offered to criticize cinema's virtual world was instead put to the service of validating and enhancing its myths. Moreover, Negrete was incapable of playing any role other than himself, so the promised *mano-a-mano* could not take place. The formula was repeated up to his very last movie, *El rapto*. This film's attraction derived from two off-screen "personal" dramas. One was the studio-arranged "very Mexican style" mar-

riage of its stars, María Félix and Negrete, both "dressed in authentic Mexican attire."[99] The second was the widespread knowledge that he was dying at the age of forty-two; this would be his last movie. The couple's cinematic tussles functioned as referents to their "real life" marital disagreements, and the film ends with Negrete walking off into his last sunset while a character says, "We'll not see him in this town again."

Song is the aesthetic core of the *ranchero* comedies: the *charro* serenades his sweetheart outside her window, battles his rivals with guitars, sings of his sorrow over the *cantina*'s table, or joins in a chorus on horseback. Negrete had a magnificent voice he had trained in hopes of singing opera professionally, and in 1934 he did sing some arias at one of the functions in the Palace of Fine Arts: he opens *Dos tipos de cuidado* with a magnificent rendition of "O sole mio."[100] In bitter competition with Pedro Infante to determine who would reign as the king of the *charros cantores*, Negrete was the winning songster. However, his lack of warmth presented a poor contrast to the genial and charismatic Infante. Handsome, aloof, and omnipotent, Negrete was the ideal personification of the *hacendado*: the unchallenged master of the *hacienda* who ruled with an iron, if paternalistic, hand over the *campesinos*, *vaqueros*, and women of his patriarchal universe. This aspect of Negrete's persona was detected from the beginning: he was cast as *El fanfarrón* (The showoff, 1937), a disagreeable braggart in one of his first films. The hauteur he projected on-screen would have made it impossible for him to play the humble Indians that Infante and Armendáriz sometimes undertook. In the end, Negrete characterized the poles of machismo: the power and the solitude, the self-reliance and the pitilessness, the braggadocio and the fear of never being quite man enough.

The film critic for *Siempre!*, Vicente Vila, reported Pedro Armendáriz's suicide this way: "Living and dying with his pistol in hand, he was entirely Mexican."[101] Armendáriz seemed cut out for the role of revolutionary *charro*: he captured Cholula (and María Félix's heart) in *Enamorada* and then again in the remake, *Del odio nació el amor* (1949), led forces against false revolutionaries in *Flor silvestre*, formed a couple with the legendary *soldadera* in *La Adelita* (1937), rode with Villa's crack cavalry in *Con los dorados de Villa* (1939), and played the Centaur of the North in *Pancho Villa vuelve* (1949). He was cast as a *charro* set in a timeless past for many more films, including *El charro y la dama* (1949), *Jalisco nunca pierde* (1937),

Bugambilia (1944), *Bodas de fuego* (1949), *Los tres alegres compadres* (1951), *La casa colorada* (1947), *Entre hermanos* (1944), and *Juan Charrasqueado* (1947), the work that Vila considered to be "one of the most abominable expressions of Mexican cinema about a supermacho, tequila-drinking, murdering, *charro* who looks for fights when not taking advantage of the local women."[102] Vila had known Armendáriz as a smiling and unaffected youth who preferred to speak in English, but he felt that his many roles as a *charro* gunslinger had turned him into an aggressive and uncontrollable facsimile, dangerous when inebriated and armed; he became "a victim of an objectionable cinema that uses swaggering pistol-toting drunk *charros*, and other destructive and auto-destructive fauna, to create a very bad example: a typical and false archetype of *mexicanidad.*"[103]

Armendáriz starred in the best films that Emilio Fernández directed, constructing together with Gabriel Figueroa a nationalism based on diametrically opposed elements: the brazen *charro* and the timid little Indian girl. He played the lead in "El Indio's" second movie, *Soy puro mexicano* (1942), where he was a *charro* who—rather anachronistically—does battle with, (and eventually defeats) the Axis powers of World War II. Sentenced to be executed as a Robin Hood bandit, Pedro is offered the opportunity to aid the Allies. He laughs incredulously at the idea: "Imagine, Mexico fighting on the same side as the *gringos.*" He also chortles when the disguised German spies say they are "*puro mexicano*"; nationalism is a result of birthplace, *mexicanidad* cannot be acquired. The most convincing and powerful of the revolutionary *charros* are those created by the team of Armendáriz, Fernández, and Figueroa in the moving *Flor silvestre* and the entertaining *Enamorada.*

The loftiness Armendáriz projected gained him many roles as officer—general, major, lieutenant—as well as foreman and pirate captain, but his acting range was great, and he was also capable of playing stereotypical natives for Fernández and Figueroa's Indianist films.[104] In *María Candelaria* (1943), he was a humble flower seller in Xochimilco who tries to protect his wife from an evil storekeeper and a savage *pueblo* intent upon destroying them. Armendáriz repeated the role in *La perla* (1945) and again in *Maclovia* (1948), where he played poor native fishermen. These films offer a Manichaean vision: on one side, the noble, simple, authentic Indians, and on the other, modern society: mendacious, materialistic, and false. *María*

Candelaria won an award at Cannes in 1946, the first film from Mexico to achieve international recognition, and a critic felt that *La perla* was "one of the most deeply Mexican films."[105] Despite the fact that these works put Indians on the screen, the scripts called for Armendáriz to demonstrate that they were submissive, long-suffering, archaic vestiges from the past that were well-nigh feebleminded. There was little room for them in the modern nation being constructed.

Still considered to be the "most authentic Mexican hero" and the "incarnation of the Mexican *macho*" fifty years after his death, Pedro Infante was capable of playing a range of roles, among them simple-minded *inditos* (little Indians), as he did in *Tizoc* (1956).[106] However, he demonstrated his acting skills more effectively by performing multiple personas in several films: he played triplets born in three different towns in *Los tres huastecos* (1948), took on the roles of father and twin sons in *Ansiedad* (1952), and played an insufferable film star and a poor town dweller in his last film, *Escuela de ratas* (1956). Nonetheless, he was at his best in male-bonding movies such as *¿Qué te ha dado esa mujer?* (1951), *A toda máquina* (1951), and *Dos tipos de cuidado*, the only film in which Infante and Negrete appeared together. The narrative that drives these movies is centered on how men work out their relationships through "cleansing" them of complications caused by women.[107] In *Dos tipos de cuidado*, the primacy of male love is asserted when Negrete complains of Infante's supposed treachery: "When a woman betrays us, well, we forgive her—because finally she's a woman. But, when we're betrayed by the man we think is our best friend—ay, Chihuahua—that really hurts." This is visually articulated in *¿Qué te ha dado esa mujer?* by the sequence in which the men appear to be singing to their girlfriends, but the camera and editing make it apparent that their love song (the film's title) is really directed to one another (see figure 31). Finally, the ending of this film reiterates the message: the men are united with their girlfriends, but the primary connection is expressed through the zoom-in on the men's clasped hands in the last shot.

Infante played a revolutionary *charro* in a few films, including *El ametralladora* (1943) and *La mujer que yo perdí* (1949), but he may more readily embody a postrevolutionary machismo that expresses a greater complexity than the brute maleness it had represented until that time. For example, the star played against his reputation as a notorious Don Juan in *Dicen que soy*

31. Pedro Infante and Luis Aguilar sing to one another. Frame enlargement, *Que te ha dado esa mujer?*, 1951. Filmoteca de la Universidad Nacional Autónoma de México.

mujeriego (They say I'm a womanizer, 1948), undercutting the expectation created by the film's title.[108] Instead, he suggested that it is more virile to suffer than to cause suffering, dolefully complaining, "They say I'm a womanizer who plays around, but I feel lonely." In *Nosotros los pobres* (1947), Infante vindicates the right of men to express emotion: a friend is ridiculed for crying, and he defends him by insisting that he has the "liberty of sentiments." If one had to pick a representative title from Infante's film, it would be *El inocente* (1955). He often takes on the role of a son under the influence of a strong mother (twice played by Sara García) or who finds himself expressing obedience to an increasingly irrational patriarch, as in *La oveja negra* (1949) and its sequel, *No desearás la mujer de tu hijo* (1949). In the famous trilogy by Ismael Rodríguez, *Nosotros los pobres*, *Ustedes los ricos*, and *Pepe el toro* (1952), he is cast as a gentle father, "poor but spirited, manly but tender, a joker but honorable, a good son but also a lover, a fighter but capable of expressing affection."[109]

Writing on the fiftieth anniversary of Infante's death, Heriberto Yépez seemed to go further than previous writers in questioning Infante's am-

biguous, even contradictory machismo, asserting that his public persona was a "*Bello Agachado*," literally "a beautiful bent man."[110] In what might be considered to be an expression of his own hypermachismo, Yépez argues that, rather than operating in accordance with the usual codes, Infante represents a person of "diminished force," the "inoffensive men" that women prefer: "Infante's feat was that of opening his breast, having renounced the traditional hardness of the Mexican macho. And, as we can see in his personages, on renouncing barbarity, on renouncing machismo, he remains paralyzed, and does not know how to return to being active."[111] Nonetheless, I would argue that his characters are *not* wimps but complex personas, trying to do the best they can in complicated gender relations and oppressive socioeconomic situations. As Infante himself said, "The personages in which I have been cast are very peculiar people with multiple personalities: they are both unreflective and responsible, superficial but solemn; they are half 'crazy' and half serious; they get sad easily and, just as easily, they are happy; they cry and they laugh, they hurt and they sing, all in lightning succession."[112]

The unrivaled idol of Mexican film, Pedro Infante was as much a projection of his personality as he was an actor. It could be said that Infante at his best played himself on the screen: a "Good Joe" who is an open, uncomplicated, and sincere representative of the people.[113] In contrast to the icy distance of Jorge Negrete or the hauteur of Pedro Armendáriz, Infante recognized and reveled in the audience's presence, often looking directly into the camera, winking and laughing, while singing his *rancheras*. He charmed everyone but the bad guys as he acted and sang his way through screen vehicles usually constructed around him. Directors, costars, and scriptwriters were of secondary importance; people everywhere, from Tierra del Fuego to the Rio Grande, went to see Pedro because he concentrated a quality that seems to characterize Mexico and other parts of Latin America: *amor fati*, the happiness that can be lived by loving one's fate.[114] Infante projected an apotheosis of joy about being in the world, with his friends and his women, that was, and continues to be, contagious.

A folk hero who could be tender or sentimental without compromising his masculine image, Infante met his end in the flamboyant manner that gave the final touch to his persona. He believed that God had made him a pilot, but other flyers demurred, describing him as "*loco*"—a judgment con-

firmed by several near-fatal crashes prior to the final one, which heightened his mystique as he died the death of a daredevil, speeding in the most modern of machines. His funeral was a tumultuous event, attended by the leading celebrities and accompanied by mariachi bands; 100,000 people filed by his closed casket, and 150,000 squeezed into the cemetery.[115] He remains an idol: his films are shown constantly on television, and his records sell widely. Some 10,000 people attended an event commemorating the twenty-fifth anniversary of his death, and on the fiftieth anniversary, thousands appeared in the Mexico City cemetery where he is buried, as well as in Mérida, Yucatán, where his plane crashed, and another 20,000 went to an event for him in Culiacán, Sonora, the state where he was born, demonstrating that his is an immortality rivaling that of idols such as James Dean and Marilyn Monroe. The vitality of Pedro Infante—his style, grace, and charm—has not lost its allure.

Effacing Women: Mother, Indian, Shrew

In recent years, some scholars of Golden Age film have suggested the primacy of actresses in constructing Mexico's cinematic identity. Susan Dever asserts, "It is especially the movies' female patriots—roles played paradigmatically by stars María Félix and Dolores del Río—who mediated nation and *hispanidad*."[116] Julia Tuñon's argument for "women's centrality" in the films of Emilio Fernández is accomplished by conflating them with Indians: "Through El Indio's cinema, the national acquires a gendered character: essential Mexico is indigenous, ergo it is feminine. . . . Although in all his films the Indians are defeated and the women vanquished, the feminine principle, the indigenous principle, dominates and conquers."[117] I do not find these postulations convincing; instead, I would ask: What sort of roles were available to women in a cinema dominated by machismo? Gender roles are necessarily complementary. As Gregory Bateson affirmed, "It is not enough to say that the habit system or the character structure of one sex is *different* from that of another. The significant point is that the habit system of each sex cogs into the habit system of the other; that the behavior of each promotes the habit of the other. We find, for example, between the sexes, such complementary patterns as spectatorship-exhibitionism, dominance-submission, and succoring-dependence, or mixtures of these."[118]

The best example of the role offered to women is that played by Dolores

del Río as one half of the "Adam and Eve" of the Mexican aesthetic, the "Primordial Couple" she composed with Pedro Armendáriz in five films they made together with Fernández and Figueroa: *Flor silvestre*, *María Candelaria*, *Las abandonadas* (1944), *Bugambilia* (1944), and *La malquerida* (1949).[119] The exaggerated machismo of Armendáriz leaves del Río with little room to maneuver; the only persona left her is that of the docile effaced femininity of the *mujercita* (little woman). The public persona constructed by María Félix is more complex, embodying an androgyny similar to that allowed Pedro Infante as a male actor. For example, in *Enamorada*, she begins by challenging the notion that gender roles must be complementary, instead entering into a symmetrical, competitive battle with Armendáriz. Nonetheless, in this and all her films, Félix ends up submitting to male authority. The mother, played most often by Sara García, is situated in a relationship that is naturally complementary to the men of her life, as there is no symmetrical struggle for power between matron and son.

A magnificent illustration of the complementary gender roles fomented in Mexican movies and the sort of female characters available, was provided in an interview with a woman by Julia Tuñon:

> The cinema was pure suffering and crying. I look at it now and I say, "Oh, my God!" How they suffered before! And that was the style everybody followed, because they copied it from there. The men wanted to be like Pedro Infante, drunk and fighting, and they copied that. The women as well—so long-suffering. I say it because my mother was long-suffering, she never questioned anything, nothing, nothing. If the man was a wife-beater and authoritarian, well the woman was self-effacing, because that's the way Sara García and the others were. It was the life style. . . . It feels like an exaggeration, but life was just like those movies: the long-suffering mothers, the fathers in love with and beating their wives, and the well-behaved daughters.[120]

Mexico's mother and grandmother on stage and screen for sixty-seven years, Sara García made her career in the only role that allowed women to show strength.[121] She began to develop her matronly characterizations when she was asked at age twenty to play a mother of forty. Offered a bit part in an insignificant play, a still-young García had fourteen teeth pulled in order to collapse her gums to look convincingly aged in the hopes of expanding the

role in this drama. She appeared in silent films but then returned to the stage until 1933, when she went back to making movies. She was a talented comedian, but the success she enjoyed in *No basta ser madre* (It's not enough to be a mother, 1937), where she was given her first starring role as the self-denying matron, was definitive. The daughter of Spanish immigrants, and educated in schools run by Spaniards, García constructed her homage to motherhood with an exaggerated sentimentalism that she had learned from what Emilio García Riera described as "the most detestable Spanish theater."[122] She endowed her characters with a peninsular tone, embodying Spanishness through her expressions of anger as well as her accent, thus adding *hispanismo* to the reigning ideology of *indigenismo* (Indianism) as an element of *mexicanidad*.[123]

The degree to which García was typecast as a matron can be appreciated in the title of some films: *Mi madre adorada* (My beloved mother, 1948), *Mi madrecita* (My little mother, 1940), *Cuando los hijos se van* (When the children leave home, 1940), *Mamá Inés* (1945), and *Bello recuerdo—así era mi madre* (Beautiful memory—this was my mother, 1961). She was also featured as a grandmother in *La abuelita* (The little grandmother, 1942) and *Mis abuelitas . . . no más* (My grandmothers, that's all, 1959). In line with the self-sacrificing spirit of maternal abnegation, García appeared as characters such as Doña Martirio (Mrs. Martyr—twice!) and Doña Socorro (Mrs. Succor), thus securing her hold on the self-flagellating core of the melodrama.

In Mexico, motherhood and media go hand in hand. The Mexican celebration of Mother's Day was initiated by the newspaper *Excelsior* in 1922 as a response to the progressive reforms instituted in Yucatán by Felipe Carrillo Puerto's socialist government. That administration had provided information about sex and birth prevention, as well as promulgating the need for divorce and women's suffrage, measures that *Excelsior* described as a "suicidal and criminal campaign against maternity, the woman's highest function."[124] The newspaper settled on May 10 as the day "to render homage to the saintly and self-denying mothers that have contributed to prolonging the Mexican family," following the precedent set in the United States.[125] The first film evidently oriented toward the mother market, *Madre querida* (Dear beloved mother, 1935), premiered on 10 May 1935. Sara García did not act in that film, but once she began to develop her star text, she acquired a

large following who seemed to find meaning in masochism: "Her most fervent public, made up in the majority by all the mothers and grandmothers of Mexico, prefer to see her suffering the unpleasant bitterness of maternity, in personages that highlight the sublimity of a woman when she acquires the venerable title of mother."[126]

García's impersonation combines strength and tenderness. She is capable of killing a drunken Indian who threatens her children—although it must occur off-camera. She encourages her young to leave home when the time for that painful separation comes. She scolds her rent collector for inefficiency, but—replacing him—she distributes money to her indigent tenants and overlooks their debts. This dual character is most manifest in relations to her male partners, for (when present) they are treated with the same blend of bossiness and affection as her children. In García's world, men *are* children—weak, sentimental, irresponsible—and they look to her as a mother who dominates them rather than as a partner with whom they can share a sexual relationship, among other things.

Perhaps the culmination of García's matronly melodramas was reached in Fernando de Fuentes's *La gallina clueca* (The mother hen, 1941). There, the matriarchy is absolute; as García Riera remarked, "Character, setting, and universe are the same thing; the mother."[127] Sara's suitor is kept at a distance, mooning nostalgically for the impossible return to the womb, while she tends to her "chicks." The sexual and intellectual suffocation of the subgenre is matched only by its widespread popularity in Mexico. This apparent irony can perhaps be explained by combining two well-known Mexican sayings: "Como México no hay dos" and "Madre sólo una." Just as there is only one Mexico or one mother, so too was there only one Sara García.

Dolores del Río was a well-known Hollywood film actress during the 1920s and 1930s, rejecting offers to appear in Mexican films. When her career began to decline as she approached forty, she returned to her country, where her star text underwent a dramatic transformation. In Hollywood, her public persona was that of an international aristocrat who came from a wealthy Mexican family of "Spanish blood" and spoke five languages.[128] Publicists emphasized her class status, and one writer's observations would later seem ironic: "There is not a feature nor a line in all of del Rio's physical and mental make-up suggestive of the peasant. . . . Every line and curve of her slender, lithe, beautifully proportioned, dainty body and queenly little

head is the perfect essence of many generations of aristocratic breeding."[129] Her age, genotype, and prior film personality notwithstanding, she was converted into a young humble *campesina* and an impoverished Indian girl in her first two Mexican productions, *Flor silvestre* and *María Candelaria*.

A fine actress, she was typecast in Mexican cinema as the embodiment of sacrifice, submission, passivity, and self-effacement (curiously, her media text always remained that of a modern, sophisticated celebrity). Hence, in *Las abandonadas*, she played a woman who, seduced and abandoned, gives up her own life for that of her son. *Bugambilia* presents her in the role of a child-woman who desires only to be dominated by a man whose strength gives him the right to take what he wants; a dramatic cut to stallions snorting and pawing in their stalls shows that this is the law of nature. In *La casa chica* (1949), she is the long-suffering lover of a man married to the blond, rich, young, and European Miroslava, but who maintains del Río in that monument to machismo, the second house and family. *La Cucaracha* (1958) offered a microcosm of her transition from aristocratic to effaced: she begins as the cultured wife of the town's teacher and ends up as a lowly *soldadera* following Emilio Fernández (as did María Félix in this and other films).

Del Río plays the title role in *María Candelaria*, a lachrymose melodrama set in 1909 about the plight of an Indian couple who have been ostracized by their own community. Both she and Pedro Armendáriz, her husband-never-to-be, assume the childlike, puerile mannerisms of *inditos* in Mexican film during this period, including her subservience to him. Indianism (*indigenismo*) was a cornerstone of nationalist reconstruction, as the revolutionary governments sought to celebrate the ancient past and incorporate living Indians into modern Mexico.[130] The numerous manifestations of this ideological configuration permeated Mexican culture, which may be the reason that *María Candelaria* seems to be one of the more remembered of Golden Age films.[131] The movie presents a Manichaean vision of the Indian as idealized past and demonized present. María Candelaria is a paragon of pre-Columbian royalty: she is said by the artist who paints the fatal picture to have the "beauty of ancient Indian princesses," and this is underscored by the star's extrafilmic regal aura. Hence, del Río essentially plays the film in a sort of racial cross-dressing, "Mexicanizing" Indians by incorporating them into the nation through her aristocratic portrayal; I am reminded of

32. Dolores del Río in blackface. Frame enlargement, *María Candelaria*, 1943. Filmoteca de la Universidad Nacional Autónoma de México.

such nineteenth-century paintings replete with natives dressed as Athenian lords as *The Tlaxcalan Senate* by Rodrigo Gutiérrez and *The Discovery of Pulque* by José Obregón. At times del Río literally uses blackface, as when she offers to rub mud on her visage so that other men will not be attracted to her (see figure 32). On arriving in Hollywood, the actress had hoped to introduce U.S. culture to a cosmopolitan Mexican woman who nonetheless maintained national culture, asserting, "The vulgar types are picturesque and almost always fictitious; they falsify our image and will disappear naturally with the rise of new actresses capable of reproducing civilized life in Mexican settings."[132] Those hopes had been left behind in the parts she was offered.

In *María Candelaria*, contemporary Indians are pictured as being the very antithesis, the enemy, of the ancient splendors. The community rejects María, eventually stoning her to death as it did her mother, and its members are shown to be resentful, jealous, untrusting, ignorant, arbitrary, full of hate and rancor, savage, superstitious, and completely resistant to change, as well as embodying the generalized infantilism utilized for portraying

Indians. This representation owes much more to prerevolutionary attitudes than to those of the *indigenistas*, who described the qualities of contemporary Indians as including "bravery, fidelity, frugality, virtue, moral character, and most significantly, their ability to adapt to change,"[133] The image of Indian hordes attacking defenseless individuals who had somehow violated their customs had been introduced in *Janitzio*, and Fernández repeated the theme in *Maclovia* (1948); the fear and loathing of "deep Mexico" would later find its bloodiest representation in *Canoa* (1976).[134]

"María Félix is the most important star to emerge from Latin America and the principal myth produced by Mexican cinema," according to Paulo Antonio Paranaguá.[135] Félix was one of Golden Age culture's greatest celebrities; her physical beauty and personal life were a fetish of the era. She was painted by Diego Rivera, Leonora Carrington, and Jean Cocteau. Agustín Lara, among Mexico's most prolific composers, was one of Félix's husbands and wrote many songs for her, including "María bonita," which then became one of her sobriquets. Poems about her *mestiza* beauty were composed by Efraín Huerta and Renato Leduc. Her gowns were designed by Dior. Even a master such as Jean Renoir rendered homage to her pulchritude by filming her differently—in "Matisse's style"—from the other actors in *French Can-can* (1954). When she decided to spread her international wings, she looked to Europe, working with Renoir, Luis Buñuel, and Juan Antonio Bardem. That she never appeared in U.S. cinema was a source of pride: "The fact that María Félix has become the biggest movie star in Latin America and Spain, without having had to pass through Hollywood, demonstrates Mexico's vitality."[136]

Her third film, *Doña Bárbara* (1943), was a box-office smash that was definitive in both establishing her public persona and making her career.[137] She appeared in the title role of Fernando de Fuentes's screen adaptation of the Rómulo Gallegos novel where, as Octavio Paz asserted, "She invented herself": a strong-willed, independent woman, with a mind and an appetite for sex and power, which ran counter to typically self-sacrificing wives and mothers.[138] Her character won her a place as one of Mexican cinema's biggest stars—within two years she was its highest paid actor—and earned her a lifelong nickname: "La Doña."[139] The film opens with a boatman warning the male lead, Santos Luzardo, that he is entering the lair of Doña Bárbara, a "tiger's feeding trough." We then see a flashback of what happened to her as

a young woman—her gang rape and the murder of her lover—while a man's omniscient voice-over tells of the events that made her into a "devourer of men," a phrase heard repeatedly. In general, it is men's voices, both in dialogue and voice-over, that define her character, but she also participates: when her ex-husband asks that she help with their daughter (product of the rape), she refuses, sneering: "I take men when I need them, and throw the wretches [*guiñapos*] away when they bother me."

Doña Bárbara wears pants and rides horses as men do, a contrast shown when her daughter mounts sidesaddle. Hence, she embodies the archetype of the *cacica-hacendada-charra* (more properly, a *llanera*), a figure associated with barbarism in Latin American literature: she loves a fight, believes that she is above the law, and uses all the arms available, honest and otherwise, to expand her empire.[140] These are the attitudes typical of a strong man, but because she is a woman, the fear she inspires is enhanced by sexuality and witchery. María Félix's complex character imposes itself upon all in this drama, especially her daughter, Marisela. However, any demonstration of female power must necessarily include a mechanism of male containment. Hence, Doña Bárbara becomes infatuated with Santos, who loves Marisela; her mature charms—Félix is playing a woman some years older than her actual age—are no match for her daughter's youth, and she is left alone, abandoned not only by Santos but by all the other men on her hacienda.

"The most beautiful face in the history of Mexican cinema," said one critic of Félix.[141] However, despite working with several of Mexico's most renowned directors—de Fuentes, Fernández, Julio Bracho, Ismael Rodríguez—and some of Europe's, Félix rarely rose above her typecasting as a vamp.[142] She was a mediocre actress with poor diction, who evidently had to overcome problems of stuttering.[143] Her dramatic range was limited, though the raising of a Félix eyebrow and her fixed stare were cinematic events. These techniques drew attention to her large, luminous eyes, especially when photographed by Gabriel Figueroa (see figure 33). However, her thespian shortcomings were most effectively disguised by her powerful stage presence, an enormous projection of personality similar to that of Pedro Infante. From early in her career, the theme of a María Félix film was Félix herself, and her movies elevated her public image, often at the expense of story line or acting. The title of some Félix vehicles bespeak her femme

33. The camera of Gabriel Figueroa closes in on the face and eyes of María Félix. Frame enlargement, *Enamorada*, 1946. Filmoteca de la Universidad Nacional Autónoma de México.

fatale character: *La mujer sin alma* (Woman without a soul, 1943), *La mujer de todos* (Everybody's woman, 1945), *Doña Diabla* (Mrs. Devil, 1949), and—in her preeminent characterization—*La devoradora* (The devourer, 1945), promoted with this advertising pitch: "Three men burned in this woman's flame, this devourer of lives."[144]

Félix's portrayed consumption of men, however, must be understood as part of machismo. Her beauty threatened social convention and stability, for, as one of her suitors says in *Doña Diabla*, "A beautiful woman can't be the property of just one man." Buffeted by the storms unleashed by her smoldering sexuality, the Félix character developed the *image* of a strong woman and, as if to prove the force of her character, her later screen appearances were in roles usually considered to be masculine. In a series of lavishly produced paeans to the revolution, as empty of history as they are full of color—*La Cucaracha* (1958), *Juana Gallo* (1959), *La Bandida* (1962), *La Valentina* (1965), and *La Generala* (1970)—she attempted to personify that process through a series of manly *soldaderas*. The androgyny always

present in her media text was made explicit, for as she had said on one occasion, "I am a woman with a man's heart."[145] In a sense, the personas of Félix and Infante represent a certain abandonment of the rigid gender roles offered by the classical models of Armendáriz and del Río, and it is tempting to imagine what they might have offered had they appeared together in a film other than *Tizoc*, in which Infante played a humble Indian.

Félix's cinematic combativeness was designed to make more appetizing her eventual subjugation. The role she played time and again was essentially that of the "tamed shrew." In *Enamorada*, *El rapto*, *Canasta de cuentos mexicanos* (1954), *La Cucaracha*, and *La Valentina*, Félix begins as a willful and independent woman, sure of herself and of the direction she has given to her life. By the end of these films, Félix trails along after her man, obedient to his wishes and attendant to his needs. However, if the scripts written for Félix's screen rebellions tried to prove the futility of such resistance, the power she projected made her the preeminent personification of a strong Mexican woman and a celebrity until her death. Further, though she was politically conservative, she also often voiced criticism of the media's portrayal of Mexican women as docile, stupid, and obedient, insisting instead that they ought to be represented as powerful and brave, and with the courage to struggle. Her last great (dis)appearance was her death, which occurred, coincidentally, on her birthday. As someone who had made herself, she surely must have had no doubts about who had the rights over her creation.

ILLUSTRATED MAGAZINES,

PHOTOJOURNALISM, AND *HISTORIA GRÁFICA*

(1940–1968)

C elebrity-stars were touted on the pages of illustrated magazines that from the mid-1930s to the mid-1950s were the latest fad of modern visual culture, taking the place occupied by former transient booms— daguerreotypes, *tarjetas de visita*, and picture postcards—while sharing the ocular space with the more long-lived cinema. A number of periodicals opened up new opportunities for photography in the press, but *Hoy, Mañana*, and *Siempre!* seem to have been the most important, and they were probably as popular as their U.S. and European counterparts, *Life, Picture Post*, and *Vu*.[1] The first to develop the photoessay and photoreportage genres in Mexico, these magazines employed top image makers, including Enrique Díaz, the Hermanos Mayo, Ismael Casasola, Walter Reuter, Nacho López, Héctor García, Juan Guzmán, Rodrigo Moya, and, infrequently, Manuel Álvarez Bravo. They also published articles written by well-known international and Mexican intellectuals. By the mid-1950s, television was beginning to provide on-the-spot coverage, in motion and with sound; the magazines steadily lost advertising revenue to the new media and were displaced by it in Mexico and the rest of the world.

Though the picture supplements of Porfirian newspapers such as *El Mundo Ilustrado* are in some sense antecedents, the modern illustrated magazines begin during the administration of Lázaro Cárdenas.[2] The Mexican press's master editor of graphic publications, José Pagés Llergo, founded the most important of this genre: *Hoy, Rotofoto, Mañana*, and *Siempre!*.[3]

He was personally conservative, a devout Catholic, and an idolizer of "the three great caudillos of Europe": Hitler, Mussolini, and Franco.[4] Nonetheless, he was probably the period's most honest editor, and he seems to have really believed in press freedom—as long as the president and the Virgen of Guadalupe remained untouched. He founded *Hoy* in 1937 along with his cousin, Regino Hernández Llergo, and modeled it on *Life*, which had started up the year before. Cárdenas centralized political power, but his rule was not marked by the unquestioning complicity of the press with the presidency that came increasingly to be the case after 1940. Rather, the pluralism of his regime can be appreciated in the fact that *Hoy* was the periodical preferred by the private sector, and the most important supporter of the opposition.[5] Hence, though this weekly began during Cárdenas's regime, its political leanings are more at home in the post-1940 period when, like its baby brother, *Mañana*, it became an almost unconditional ally of a government that moved ever to the right.

As early as 1941, *Hoy* advertised itself as "the magazine of the continent," meaning the entire Western Hemisphere.[6] By the 1950s, it was said to be among the top ten magazines in the world: "The only weekly in Latin America to have achieved this category."[7] *Life* apparently identified *Hoy* as "the most influential periodical in the Spanish-speaking world."[8] The magazine asserted that it had "always offered collaborations by writers of the most diverse and opposite tendencies," and the novelist Carlos Fuentes agreed in a letter sent to the periodical: "*Hoy* has been the Knight Bayard of Mexican journalism; it has been the synonym of courage and the only magazine that has known how to reflect all the tendencies of Mexican thought."[9] Whether the magazine was as "without reproach" as the famous *Chevalier* is debatable; Herón Proal, leader of the 1920s Veracruz rent strikes, certainly had a different take on it. He was photographed looking at a copy of *Hoy* held up by a reporter but commented, "Make it clear that you are photographing me in this way at your instance, and that I do not read *Hoy* because its tendency and price make it exclusive to the bourgeoisie."[10]

Pagés Llergo was forced out of *Hoy* in 1941 by the U.S. State Department because of his fascist sympathies, but he founded *Mañana* two years later.[11] A glance at the first twelve issues demonstrates how the interests of the editor materialized in his new creation. As usual, presidential activities dominated the scene: Manuel Ávila Camacho was shown inaugurating

public works and giving the annual *Informe* (State of the Union Address), as well as attending banquets and military parades. Less common were two appearances by Maximino Ávila Camacho: a photoessay of his saint's day party was published in the first issue, and he was seen again in a photo playing with his son, which the magazine said "demonstrates his tenderness."[12] Among the most reactionary, corrupt, and authoritarian of *caciques*, Maximino connected with *Hoy* while serving as secretary of communications during his brother's regime, and he intended to use it as a media springboard in his attempt to succeed Manuel; obviously, Pagés Llergo opened the pages of *Mañana* for him from its very beginning. The Axis leaders were out of bounds for Pagés Llergo, now that Mexico had declared war against them. However, the editor's insistent attraction to fascism expressed itself in an article advocating recognition of Franco's Spain and an interview with Manuel Torres Bueno, the "Supreme Chief" of Mexican Sinarquistas, shown in a photo with his hand on the bible.[13] The magazine's attacks on the working class were a corollary of its support for the extreme right: labor leaders Vicente Lombardo Toledano and Fidel Velázquez were accused of being communists, and an extended critique was published of what it described as "the absurd politics that have reigned for many years: everything for the workers."[14] The United States was referenced in several articles on *braceros* and by photographs of Hollywood stars who appeared to be reading the magazine, hence validating it for the Mexican public. María Félix wrote an article for *Mañana*, and other Mexican stars were pictured. Women were addressed in the sections on fashion, hairdos, and social gatherings, as well as in an article on feminism that called its ideas "unhealthy doctrines and corrupting examples that attempt to destroy the ancestral virtues that made women a paradigm of beauty and abnegation."[15] Photojournalism was represented by the extremes of dramatic coverage and picturesque platitude: Paco Mayo demonstrated his gift for aerial photography in some wonderful images of the eruption of the volcano, Paricutín, while Enrique Díaz manifested his proclivity for the exotic in a bucolic image of fisher people.[16]

The founding of *Siempre!* in 1953 resulted from a visual scandal involving nudity and presidentialism.[17] The daughter of Miguel Alemán, Beatriz, was honeymooning in Paris when a photo was taken of her and her husband, Carlos Girón, in a cabaret that made it look as if her mate was more interested in a nude dancer than his new wife. The picture was published in *Hoy*,

then under Pagés Llergo. The magazine's owners were frightened by such a challenge to a former president who still wielded great power and informed Pagés Llergo that they would insist on revising everything before the issue went to press. He resigned, and quickly created *Siempre!* with collaborators who abandoned *Hoy* and other publications to participate in one of the most pluralist periodicals in the hemisphere. In his opening editorial, Pagés Llergo made it clear that he was engaged in a battle for Mexican hearts and minds, as well as the larger readership of Latin America:

> The countries of our America have been invaded by foreignist [*extranjerizantes*] magazines and periodicals, poorly translated to Spanish but attractive. The convenience of reinforcing our nationality has become a patriotic imperative. It is necessary to face these invaders, in order to reaffirm Mexican thought and convert it into an arm for this battle in which we are running the danger of losing—not, for the moment, more national territory—but rather the best, the eternal, of Mexico: the consciousness of our own being. Faithful to our origins and to the community of interests in danger, this battle has continental projections. *Siempre!* aspires to present the most mature fruits that have been produced by the cultivation of *mexicanidad*, and has no dogma beyond its fidelity to Mexico.[18]

While these magazines represented some of the best journalism in the Americas, above all *Siempre!*, it is important to bear in mind the degree to which they were co-opted, from top to bottom, by government payoffs. The stick was rarely needed—*Rotofoto* and *Presente* are the only two obvious cases of repression—because the carrots were so handily dispensed. One of the more recognized writers, Renato Leduc, commented on the experience he had when publishing a small cartoon periodical, *El apretado*, which he—together with Jorge Piñó Sandoval and the cartoonist Antonio Arias Bernal—brought out to ridicule the efforts of Alemán to re-elect himself.[19] The president's secretary, Rogerio de la Selva, went to Leduc's house, where he offered him whatever he wanted to "quiet his mouth."[20] As Leduc was protected by his personal friendship with Alemán, as well as his own prestige, he told the emissary that he preferred to live from his journalism.

Rodrigo Moya, a maverick photojournalist who worked for the maga-

zines in the 1950s, provides a glimpse into some details of the corruption that reigned:

> During the presidencies of Miguel Alemán and Adolfo Ruiz Cortines, the relation between the press and the state was almost idyllic. The manna of pesos destined to periodicals flowed through strange sewers and circled the pyramid of directors, columnists, reporters, and assimilated intellectuals. Not that the money provided by the government to control the press permitted higher salaries for journalists; rather, they received gifts in a thousand different ways, the better to control them individually. In this complacent picture, the photojournalists also got theirs: closed envelopes in important political acts; air fare, good hotels, and comforts on federal and state government accounts; gratifications at year's end, and houses acquired at easy credits when they belonged to associations that placed paid announcements supporting the regime. It was the height of the *embute* [bribe]: the hand of power holding bills extended from behind the backdrop; the trips with everything paid; the open bar and the procured girls. The periodical's salary was the least important consideration.[21]

The presidents were at the marrow of *Hoy* and *Mañana*, and roughly a quarter of all the illustrated articles featured them. The adulation shown the "First-in-Command" (*Primer Mandatario*) was unconditional, at times reaching extremes, as when Pagés Llergo compared Ávila Camacho to Jesus Christ in an editorial he wrote in the form of a letter to him: "I have wanted to come before you clean and good. I wish to direct myself to you, *señor*, in whom I recognize all the virtues that I lack. The faithful leave at the temple door all our falsities in order to talk with Jesus Christ. I too have wanted to leave at my office door all my human passions and torments so that my prayer reaches a purer soul than mine."[22] Despite their nearly absolute support for the status quo, at times the magazines critiqued the PRI and bemoaned the lack of political plurality. Pagés Llergo felt that the PRI would have to cede some ground: in a published letter to Adolfo Ruiz Cortines (1952–58) he argued, "It is necessary that the PRI learn to lose, to consider itself a party, and not 'the Party.' For public health, and even political aesthetics, the PRI should leave some [electoral results] to the people's

decision."[23] Given his conservatism, the editor was no doubt hoping that PAN (Partido de Acción Nacional), the right-wing party, would be allowed to accede to those political positions its candidates had won in the north, but his stance also maintained credibility with his readers.

Although the magazines made intermittent calls for real congressional elections, their true colors showed at the moment a solid challenge to the party dictatorship appeared. This was the case with Miguel Henríquez's candidacy in 1952, when the periodicals published one photoessay after another on the campaign of Ruiz Cortines, but almost nothing whatsoever on his opponent. Instead they emphasized the press's responsibility to "stop the mud-slinging" and "tranquilize the contest," calls essentially designed to quiet democracy's noisy voices.[24] They attempted to present themselves as critics of the powerful, including even the presidents they fawned over, while asserting the leaders had "granted an unrestricted freedom of press, but many of the leading national media have not wanted or known how to use that liberty."[25]

The magazines collaborated enthusiastically in the search for *mexicanidad*. Ruiz Cortines praised them for their contributions to "homogenizing the national consciousness," and the editors applauded their own role in constructing "the consolidation of a truly national consciousness."[26] Writers such as the Catalonian, Víctor Alba (Pere Pagés i Elies), were struck by the widespread interest in identity issues: "As soon as one begins to talk with Mexicans, you notice that in all conversations, in the periodicals, even in political discourses, appear and re-appear three themes that can be resumed as questions: What are Mexico and *lo mexicano?* What was the Revolution and what is it today? What is the relation between contemporary Mexico and the country found by the conquistadores in 1523?"[27] *Hoy* sent Rosa Castro to cover the series of conferences on the analysis of *lo mexicano* that were taking place in 1951 at the Universidad Nacional Autónoma de México (UNAM)'s Faculty of Philosophy and Letters. There, she interviewed Samuel Ramos, Leopoldo Zea, Arturo Arnaiz y Freg, Emilio Uranga, Juan Hernández Luna, José Alvarado, and Juan José Arreola.[28] Most agreed that the search had been opened up by the revolution and had begun intellectually with Samuel Ramos's *Profile of Man and Culture in Mexico*, though some pointed to earlier thinkers such as Julio Guerrero, Antonio Caso,

and José Vasconcelos. They also cited the importance of the "Hyperión" group, as well as individuals such as Octavio Paz. Uranga cautioned against the exotic tone interjected by the investigation itself and its investigators: "Everybody wants to act very Mexican when it comes to researching *lo mexicano*, and that gives it a picturesque note."[29] José Alvarado warned of the images reflected by "foreign mirrors that are neither very clean nor very true, which fabricate a Mexico as false as the *charros* imagined by the panting [*anhelantes*] U.S. women that visit us."[30] And Alvarado critiqued the promulgation of these stereotypes in mass culture: "I must note a very important error, which consists in considering the dregs of Mexico City as the prime material of *lo mexicano*; having served as a model for Cantinflas, they now imitate him."[31]

Discussions around national identity ranged between the extremes of self-denigration and autocelebration. Samuel Ramos himself wondered whether the "inferiority complex" he introduced as a touchstone of Mexican character had not received too much attention, something that could be seen in articles such as those by José Natividad Rosales on the "Ugly Mexican."[32] *Mañana* was moved to organize a roundtable, "Why does the Mexican denigrate himself?," which included Leopoldo Zea, who felt that one motive was "having been born in the fearful vicinity of the United States."[33] At the pole opposite was a patriotic self-worship that made Alberto Domingo fear that it was impossible to articulate a critical conception of the nation: "Many Mexicans, precisely because of their spiritual confusion and cultural debility, attribute all the best, most beautiful, and strongest to their nation. Tequila is the best drink, the best music is the Mariachi, the most beautiful woman is María Félix, no painter greater than Diego Rivera, and no man more *macho* than the Mexican."[34] The extremes of exclusion that this position reached were expressed by Roberto Blanco Moheno, who refused to recognize the citizenship of those compatriots who had been imprisoned as a preventative measure when John F. Kennedy visited in 1962: "It is one thing to be born in Mexico, and another, very distinct, to be Mexican."[35] No doubt it was this sort of reactionary chauvinism that led to the situation Antonio Rodríguez observed in 1967: "Lately Mexican nationalism has been talked about with such alarm that some might think it was on the verge of a hysteria capable of launching adventures of conquest." He hastened to assure

Mexicans that the patriotism requiring censure was not that of "threatened and oppressed peoples" but "the imperialist nationalism of threatening and oppressing countries."[36]

The magazines displayed a variety of positions in dealing with the great empire to the north. The poles of sentiment are most easily demonstrated in the two themes that were recurrently addressed. On the one hand, Hollywood and its stars made constant appearances, producing an identification that must have stimulated Mexicans to frequent U.S. movies while flaunting lives of conspicuous consumption. On the other hand, the periodicals continually commented on the *braceros*: advising Mexicans about the program, documenting its manifold aspects, reporting the misadventures suffered, and warning their countrymen about the hazards awaiting them. At times the magazines critiqued the racism to which Mexicans were subject in the United States, while at others they seemed to push facets of U.S. life, showing West Point cadets marching and smiling *gringas* in their summer courses at the UNAM. The weeklies promoted consumerism by extensively advertising U.S. products—among them, Golden Gate Mayonnaise, Italian Swiss Colony wine, 7Up, Coca Cola, General Electric, Simmons mattresses, Elgin watches, Goodrich tires, General Motors, Lincoln, Hudson, Remington Rand, American Airlines, Palmolive, and Motorola televisions—but writers warned about aping the "American way of life."[37] With contributors from both right and left, *Siempre!* demonstrated its pluralism through a plurality of voices. Unfortunately, the U.S. government wanted to hear only praise: when José Natividad Rosales attempted to return to Mexico from France via the United States, he was arrested because he worked for the "communist" magazine—"one of the greatest enemies the USA has in Mexico"—and returned to France.[38]

The one point where the periodicals appeared to be univocal was in resisting the "imperialist penetration" of U.S. competitors, an expression of the period's nationalist fervor, as well as of financial benefit.[39] When it was announced in mid-1952 that *Life* would begin publishing a Spanish edition the next year, the Mexican magazines began a lengthy protest against "the pernicious infiltration of foreign publications."[40] Daniel Morales, editorial director of *Mañana*, wanted to make it clear that this was "not because *Mañana* is against the freedom of the press, but because those magazines represent a danger more than imminent for the spiritual independence of

Mexico"; the editor warned that U.S. magazines intended "to conquer our thought, our ideologies, and our customs."[41] Pagés Llergo felt that the U.S. magazines were a "challenge to *mexicanidad*" and that one of the duties of Mexicans—whom he defined more by their distinctive stance toward life than geography—was "to resist the invasion of creeds, customs, slang, and mental attitudes that destroy the harmony of Mexican originality."[42] The Mexican editors insisted that they were not afraid of competition but that the economic power of the U.S. periodicals gave them an unfair advantage.[43] They feared the political effect of U.S. magazines and felt that the press ought to remain in Mexican hands. Although Pagés Llergo noted that the U.S. government had prohibited the circulation of Soviet magazines, he was not asking that the Mexican government impose such censorship against U.S. periodicals; he desired only that it "adopt some convenient measures" to protect national publications.[44] Nevertheless, the love/hate relationship that Mexicans often seem to have with their neighbors—and the contradictions wrought by competition—can be seen in the fact that, sandwiched between its editorials against U.S. periodicals, *Hoy* cited *Life* magazine as the authority that declared the Mexican magazine to be an exceptional publication.[45]

Presente: In the Mexican Style

Mexicanidad was at the heart of the period's most important media challenge to presidentialism and the party dictatorship, *Presente: Un semanario a la mexicana* (Present: A Weekly in the Mexican Style), in which the editor ended all his collaborations with the insistent reminder, "Es por México." This magazine was founded in 1948 by Jorge Piñó Sandoval, who had been writing a column, "Presente," in the newspaper *Novedades*, until its owner, the millionaire Jorge Pasquel, decided that it was too threatening to the administration of his friend, Miguel Alemán. Piñó Sandoval was evidently offered a trip around the world and, on his return, the direction of a new magazine Pasquel was to create, as well as a notable salary increase. Visited by two lawyers and a military officer, Piñó Sandoval ended up in a violent argument when, "I could not convince them that our motive was not money, but a clean Mexico."[46] He evidently founded the new publication with a tardy separation payment he was given by the newspaper *Excelsior*, as well as his final check from *Novedades*. He was joined by some of the

most critical journalists in Mexico, including Renato Leduc, Tomás Per-
rín, Magdalena Mondragón, René Avilés, and Luis del Toro, as well as the
recognized cartoonist Arias Bernal; all apparently worked without salaries
in order to "serve the people."[47] Photographs were fundamental to the peri-
odical's project, as devastatingly contrasting images of grinding poverty and
outrageous wealth were provided by Legorreta and Arvizu, relatively un-
known photojournalists, who were joined infrequently by more established
figures such as Héctor García, as well as the collectives of Casasola and the
Hermanos Mayo.[48] The magazine's format was unusual, measuring fifteen
by eleven inches and comprising only sixteen pages. *Presente* contained no
advertising, and it seems to have survived through what were said to be the
greatest sales of a periodical in Mexican history.[49]

Other magazines had assumed short-lived postures of opposition to the
revolution's rightward course, the most important of which were *Tricolor*
and *Más*.[50] The former had been founded by communists Hernán Laborde
and Efraín Huerta and included contributions by such radicals as José Re-
vueltas and the lithographer Leopoldo Méndez; it lasted four months dur-
ing 1944. The latter is notable principally for the Hermanos Mayo's critical
photoessays on slums and police corruption; its lifespan was a bit longer,
from September 1947 to January 1948. Although *Presente* denounced the
poverty in Mexico, it was explicitly directed toward the new middle class:
"Who do we serve? Which readers sustain us? The answer is easy: we serve
the most exploited and misunderstood class, which is diffuse and without
a voice. We are at the service of Mexico's middle class, ever disposed to
foment any approach with those from below, which are the majority, and in
open battle with the powerful from above who betray their role, whether as
functionaries drunk with power or as exploiters of the people's hunger and
necessities. We raise our banner higher than ever: *Es por MEXICO*."[51]

Presente is often coupled together with *Rotofoto* as the two prime ex-
amples of critical periodicals destroyed by official repression. Nonetheless,
there are significant differences between them. *Rotofoto* launched its barbs
against Lázaro Cárdenas and ferociously battered Vicente Lombardo Tole-
dano: though it was witty and iconoclastic, it was also a right-wing publica-
tion attacking a leftist regime. More plodding and committed, *Presente* was
almost exactly the opposite of *Rotofoto*, a moderate periodical criticizing

a corrupt and increasingly reactionary administration. In the beginning, *Presente* concentrated on Alemán's collaborators, following the old Spanish tradition of *"¡Viva el rey, muera el mal gobierno!"* (Long live the king, death to bad government). In a tactic that had not been seen before in bringing home Mexico's social injustice, the mansions of Ramón Beteta and Enrique Parra Hernández were revealed in photographs, accompanied by cutlines that made it clear these images were far from the becharmed visits to the homes of the wealthy featured in other illustrated magazines. Hence, below a photo of "Palace Beteta," it was noted dryly of the house built by the treasury secretary and director of the National Bank, "With this work is reborn in 1948 the Porfirian style of palatial architectonic proportions."[52] The publication was more explicitly condemnatory in describing the abode and living style of Parra Hernández, Alemán's lawyer, who was in the innermost circle of the president's economic and amorous affairs: "Another case before which the whole of Mexico asks: So soon? This is the residence of *Licenciado* Enrique Parra Hernández, the Minister without a portfolio. Its cost is estimated at three million pesos, including the furniture. Twenty months ago Parra Hernández was considered the 'poor guy' among the Alemanistas. What will happen when he is rich?"[53]

The critique of Alemán's cabinet was widened to include his friendships (*amigazos*). The cover of the 18 August 1948 issue showed a group rushing toward the president, arms outstretched to embrace him . . . or to help themselves to the national budget he holds in his hand. All resemble Jorge Pasquel, to whom Piñó Sandoval dedicated a lengthy letter in which he accused the powerful entrepreneur of raising the cost of living through his management of the customs offices and control of the wheat market.[54] Piñó Sandoval had witnessed, and testified to, the personal favors provided for Pasquel by the government, such as having members of the armed services fly his planes and drive his vehicles, despite that fact that he had not achieved these privileges through popular election. The editor concluded by declaring that Pasquel should leave Mexico or remove himself from public life as proof of his patriotism. In the same issue, Renato Leduc cited the example of Luis Cabrera, one of the leading intellectuals in the struggle against the Porfiriato, who stated that the first thing he would do when appointed secretary of treasury by Venustiano Carranza would be to carry out

a "radical de-friending" within the department. Leduc closed his column by reminding Alemán, "While you are president you have the right to only one friend: the people you are governing."[55]

Five days later, on 23 August 1948, the press that printed *Presente* was destroyed by twenty armed goons. The magazine asserted that "important figures" of Alemán's regime had directed the attack, whose names had been revealed to the authorities, and a cover cartoon called upon the president to choose between gangsters and the people in his anticipated *Informe* (State of the Union Address) of 1 September.[56] *Presente* attested to its survival by showing photos in which Mexicans of all ages and classes read the publication, as well as other periodicals that demanded an investigation of the attack. It also covered public acts of repudiation, such as a demonstration at a bullfight photographed by the Hermanos Mayo, and noted that it had received more than three thousand letters and telegrams in its support. However, the government had set in motion its defense mechanisms. The president's secretary, Rogerio de la Selva, evidently began by questioning the nationality of Piñó Sandoval and Leduc, leading the latter to wonder whether Article 33 would be applied to them as "Frenchmen."[57] And while the initial response of other periodicals was a condemnation of the assault, some journalists felt that the violent and rude attacks of the magazine that defamed "so many" would make it impossible to determine who had been responsible.[58] Uncertainty was expressed about whether the destruction really took place.[59] Evidently, some in the media felt that it had been occasioned by *Presente*'s attempt to "win an easy applause" with its criticism of the government; but, as Margarita Michelena argued forcefully, "What is easy to win here is a bullet."[60]

Two months later, the issue of 19 October 1948 was subject to "new and 'delicate' forms of repression" as the government used its control of paper through PIPSA (Productora e Importador de Papel, S.A.) to deny the magazine access to affordable material; the Finnish paper it was offered cost almost twice as much as regular newsprint.[61] *Presente* published an issue with half its usual pages, on very cheap paper, which contained an open letter to Alemán from the Mexican Association of Journalists that detailed the many acts of repression to which the magazine and other periodicals had been subjected.[62] On its cover of that issue, a cartoon by Arias Bernal showed a Mexican (dressed as a *charro*) arriving at heaven where he is asked by Saint

Peter how things are in Mexico; the response: "Well . . . well . . . we CAN'T complain."[63]

Despite *Presente*'s assertion that complaints were not allowed, it boldly continued to make them. In one issue, seven collaborators in Alemán's government were pictured and accused of being inept as well as so notoriously corrupt that they thought only of advancing their own businesses; their arrogance was said to be causing the president to lose popularity.[64] Frequent references were made to "thieving functionaries," and photos of the penitentiary were shown as "very appropriate, although insufficient, sites to house these criminals."[65] The magazine exposed the extensive corruption in the "provinces," detailing how certain governors were becoming the virtual owners of their states, while others had appointed "forty brothers, cousins, uncles, nephews, and in-laws to manage the finances."[66] The cover of one issue showed a greedily grinning policeman threatening the Good Kings that they would not be allowed to distribute their gifts because they lacked the proper permission to circulate; in another, *Presente* proposed a "national campaign against bribery."[67] The PRI's role in fomenting corruption was identified, and it was described as a "one-eyed, one-armed, and lame party" that was a "PRIvileged representative of the dictatorial reality that so lacerates the nation."[68] Photographs were published of *campesinos* who were forced or coerced with trinkets to participate in PRI demonstrations (*acarreados*); a cutline admonished, "You rent yourself for all the farces." The accompanying article set up a conversation between an Indian and the motherland in which the latter bemoaned the dependence on tourism: "I have to feel sad and dirty, without faith—without even my braids!—in front of the giant blond that chews gum and enjoys himself by giving me pittances."[69]

The magazine edged ever closer to questioning the untouchable president. After Alemán's *Informe* of 1 September 1948, Piñó Sandoval expressed his disappointment by writing, "Silence was not the medicine."[70] From October to December of that year, *Presente* contrasted the "Program of Government" that Alemán had produced for his 1945 campaign—a work somehow "very difficult to find"—with the reigning reality; in later issues it simply cited the program on the back cover as a way of pointing to its lack of implementation.[71] In one of the strongest articles published in the Mexican press against presidentialism, Luis del Toro called for returning power to con-

gress and the courts, "Liquidating the Presidential Regime that handcuffs Mexico."[72] In February 1949, *Presente* directly confronted the president by identifying him as the origin of authoritarianism and illegality. Alemán was pictured by Arias Bernal on the cover as the jailor of the 1917 Constitution, which—ragged and patched but beautiful—is locked up behind bars on which are written "Attacks on periodicals," "Monopolies," "Gangsters," "No democracy," and "The PRI"; a poor Mexican asks the smiling president, who holds the keys in his hands, "Why don't you free her?"[73] In what may have been its last censure of a presidential decision, *Presente* protested against the appointment to a lucrative post of a former governor under investigation for the assassination of Vicente Villasana, director of newspapers in San Luis Potosí and Tampico.[74]

Presente's critique of corruption went hand in hand with the denunciation of the poverty that was its result. In a devastating photoessay, "Millionaires of Misery," Legorreta provided pictures of men sleeping in the street that were accompanied by Carrera Gil's unambiguous cutlines: "This is the only inviolable liberty of the people . . . , the freedom to die of hunger together with that of lying in the street. The liberty for the parasites to devour the blood of a people degraded by misery. Pictures like this make even grander the great lies of the propaganda that speaks to the sound of gold."[75] In another image, Legorreta portrayed a group of blind street venders, while Carrera Gil pointed to the discrepancy between their contribution to the national budget and that of the wealthy and influential: "All are blind. In spite of their precarious situation, they daily pay the State a 50 cent tax in order to be allowed to sell their insignificant merchandise. If the big monopolies and great friends [*amigazos*] paid their taxes in the same proportion, Mexico would be the most prosperous of nations. But, let Mexico's blind pay!" A photo of a child in rags in front of tumbledown shacks, their roofs were held on by stones, was accompanied by a cutline asserting that such marginality worked against making a nation: "What concept will those who live in such squalid huts have of 'the fatherland,' of 'the government,' of 'social justice'?" (see figure 34). Such images must surely have brought to mind the mansions of Alemán's closest collaborators, but in case they didn't, the cartoon by Alí México on the back cover pictured the sumptuous estate of Fernando Casas Alemán, regent of Mexico City, who explained to a

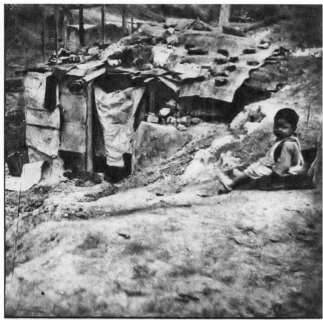

¿Qué concepto tendrán de "la patria", "del gobierno", de "la justicia social" quienes viven en in mundas barracas como ésta. En la República el 41 y medio por ciento de las casas son de adobe más del 15 de varas y palma y apenas un 12 por ciento de mampostería y ladrillo. Sin agua ni albañales hay un 62: con agua, únicamente el 30; y con agua y albañales, alrededor del 7. En cambio, hay siete mil nuevos enriquecidos, todos millonarios.

34. Legorreta. Poor child and huts, *Presente*, 21 September 1948. Collection of Armando Bartra.

poor Mexican that he had been able to build it by "saving . . . saving [myself from giving any] explanations."[76]

The photojournalist Arvizu collaborated with René Avilés to produce several photoessays critical of child labor, which they considered to be "Mexico's number one problem."[77] They argued eloquently that it destroyed children's intelligence and caused them to become "deformed slaves"; the solutions were complex, but the most important was the recognition that no advance was possible without education; as the cutline to one photo notes, "He's not ten yet, and he's left school to solve his problems by himself" (see figure 35).[78]

Geared toward the middle class, *Presente* promoted participatory citizenship. Although it defended the poor and denounced official corruption, it was anticommunist and often attacked Vicente Lombardo Toledano, the Marxist labor leader. Hence, it was common to find articles announcing the communist threat to the Mexican oil industry, as well as those that

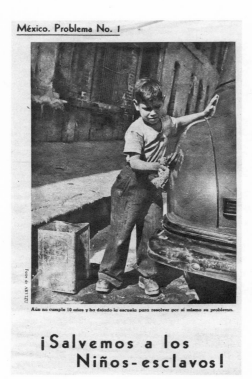

México. Problema No. 1

Aún no cumple 10 años y ha dejado la escuela para resolver por sí mismo su problema.

¡Salvemos a los
Niños-esclavos!

35. Arvizu. Poor boy washing car,
Presente, 6 January 1949. Collection
of Armando Bartra.

described "how the Communist destruction of Mexico is planned," and asserted that leftists were bringing about the "Russianization" of the country.[79] The sort of community consciousness that *Presente* looked to create can be found in its call for people to better their local situation by reporting streets in disrepair.[80] It also rose in defense of Mexico's ecology long before this was an issue. Different writers described how the uncontrolled cutting of trees in Mexico City and Milpa Alta, encouraged by corruption in the Forest Department, was leading to the country's "assassination."[81] And one columnist linked the destruction of Mexico's forest to the introduction of Christmas: "Based on Protestantism, the *pocha* custom of Christmas trees has increased the cutting of our woods in an alarming form."[82]

The end of *Presente* seems to have come with more of a whimper than a bang. Although the editor promised that the magazine "will continue," his editorial in the issue that marked a year of publication concludes with the words "¡Fue por México" (It was for Mexico) instead of the usual ending, "Es por México."[83] Hence, there is a sense of closure in which the front cover

illustration notes how the periodical "*resistió* (lasted) thirty-seven weeks" but, more importantly, "it resisted the temptation to sell out." On the back cover, the little Mexican figure created by the cartoonist Alí México also plays with double meanings when he tells Casas Alemán that the publication "broke, but did not bend," which translates more adequately into "It went broke, but it was not subdued."[84] The conservative journalist Roberto Blanco Moheno wrote that Carlos Serrano, one of Alemán's inner circle, gave Piñó Sandoval 150,000 pesos to absent himself from the country for a while.[85] If that is true, he reappeared in time to collaborate again with Renato Leduc and Arias Bernal in *El apretado*, a publication which may have been instrumental in discouraging Alemán's pretensions to reelection.

Photojournalism

The development of slick picture magazines and small cameras coincided with the Spanish Civil War and World War II to make photojournalists into major celebrities. The heroic image(s) of individuals such as Robert Capa—a daredevil who hopped from battle to battle and hobnobbed with stars—created a cult of photojournalism; in the United States it became the "mirror" and "showcase" of postwar culture.[86] This was also true of Mexico, where photojournalists moved (back) to center stage from the 1940s on. The first exhibit of news photography had been held in 1911 by Agustín Víctor Casasola, when he created the original Association of Press Photographers in the country. This link of organizing and exhibiting was repeated in 1947, when a new guild was created—Asociación Mexicana de Fotógrafos de Prensa—and an exposition opened in the Palace of Fine Arts, the most important exhibit space in Mexico, giving graphic reporters an unaccustomed place in the cultural world.[87] As might have been expected, presidentialism was at the origin of the guild's founding: the photographers felt that they had been treated with disrespect by a member of the presidential staff, and they threatened to cease covering official activities. Ávila Camacho called a meeting with them, addressed their grievances, and agreed to accept their invitation to establish a Press Photographers Day. According to Enrique Díaz, that banquet provided the occasion for the president's suggestion that they form an association.[88]

Achieving recognition for photojournalists produced a creative ferment in which Antonio Rodríguez collaborated with Enrique Díaz and Regino

Hernández Llergo, *Mañana*'s editor, to organize the exhibit "Palpitaciones de la vida nacional: México visto por los fotógrafos de prensa" (Palpitations of national life:. Mexico seen by press photographers), which was accompanied by a long-running series of interviews with press photographers.[89] In 1951, an attempt was made to repeat the success of 1947, and though another long series of interviews with photojournalists were published in *Mañana*, the exhibition was never held.[90] Nonetheless, that decade would see it become increasingly acceptable for those who worked in periodicals to show their images in expositions, which seem often to have centered on the issue of national identity. In 1951, the government produced a traveling exhibit of seven hundred photographs, "Así es México" (Such is Mexico), which included works of the Hermanos Mayo, Enrique Díaz, and the Casasola Archive.[91] Nacho López presented "Nacho López, Fotógrafo de México," which was uncontroversial in Mexico City (1955) but polemical in Washington (1956).[92] In 1958 López participated in the collective exhibit "Risas y lagrimas de México" (Mexican smiles and tears) together with five others: Héctor García, Bernice Kolko, Rodrigo Moya, Antonio Reynoso, and Manuel Álvarez Bravo.[93] Héctor García mounted "Rostros de México" (Faces of Mexico) in the Excélsior Gallery in 1960.

The expansion of photojournalism into the larger cultural sphere was related to the broadening definition of what it meant to be a photographer for periodicals. Hence, while Enrique Díaz was ensconced as the "star" of *Hoy* and *Mañana*, he also directed the agency Fotografías de Actualidad, in which participated Enrique Delgado and Luis Zendejas. The Hermanos Mayo cultivated all of photojournalism's genres in their agency, Foto Mayo, working for dailies such as *El Popular* and *La Prensa*, collaborating in magazines—among them, *Hoy*, *Mañana*, and *Tiempo*—and making a seemingly infinite number of exposures while traveling to and from assignments. Nacho López was essentially a freelancer who provided photoessays on themes of his interest to the weeklies *Hoy*, *Mañana*, and *Siempre!* Héctor García worked for the newspaper *Excélsior*, and contributed to illustrated periodicals; however, he also practiced a sort of subsidized documentary photography during the period he was taking pictures for the president and the national oil company, PEMEX. All were photojournalists, but they had amplified the concept of their calling by mounting exhibits and partici-

pating in books where their images survived beyond the usual twenty-four hours of the newspaper (or one week for a magazine) for which they had been taken. This was only possible because these photographers maintained control of their negatives rather than giving them to the media for which they worked, something that allowed them to take pictures unrelated to their duties and to employ them as they saw fit.

Hence, though the periodicals usually assured that photojournalism was safe for the regime, some photographers could explore their interests and commitments because they owned their negatives and utilized them in other media, including magazines that they founded. While critical imagery was produced, the most important genre that developed in this period was the photography of daily life activities. Focusing on the unexceptional and quotidian was not exclusive to Mexico. Of the British magazine *Picture Post* it has been said, "From the start, attention was to be concentrated on ordinary people, doing ordinary things."[94] In the United States, photographers such as Eugene Smith focused on this theme, most effectively in his documentation of a country doctor's life.[95] The Hermanos Mayo had evidently been drawn to this subject very early, and they made photoessays on the lives of bureaucrats, factory workers, teachers, and students, as well as poor and middle-class families; their interest in the quotidian can be gauged by their collection of some 500,000 negatives (approximately one-tenth of their archive) that were taken in the to-and-fro of covering metropolitan events and which are classified in the section "Imágenes de la ciudad" (Images of the city). Nacho López rarely photographed news events, dedicating himself instead to documenting (and directing) the activities of ordinary individuals in the street. Héctor García opened up a space for this genre in *Excélsior*, creating a new section, "F 2.8: La vida en el instante," where he published "a chronicle of the common people's daily activities."[96] García argued that the quotidian revealed "the most intimate of our idiosyncrasies," and for these photographers, as for Álvarez Bravo, *lo mexicano* was to be found largely in the everyday acts of ordinary beings.[97]

While photoessays on the unexceptional were often articulate encapsulations of identities, explicit representations of *mexicanidad* were infrequent. Only Nacho López seems to have explored the issue with any degree of success, producing at least two on the country, "México: Dolor y sangre,

pasión y alma" (Mexico: Pain and blood, passion and soul), and "México místico" (Mystic Mexico).[98] He made another three on Mexico City, which was often conceived as a synthesis of the country; its centrality in the construction of national identity was articulately addressed by Seth Fein: "Just as the presidency was the nation's political metonym, Mexico City was its geocultural synecdoche."[99] The fatherland's essence was embodied in the commander-in-chief by Enrique Díaz's "Suave patria," a lengthy and picturesque photoessay inspired by Ramon López Velarde's poem that portrayed beautiful women, children at play, and classical landscapes of which Hugo Brehme would have been proud.[100] Hugo's son, Arno Brehme, contributed a superficial photoessay about Mexicans to an issue of *Mañana* in 1951, which came out on Independence Day and contained a lengthy section dedicated to "El mexicano."[101] His photos are of an exotic rural environment, including a low-angle shot of a *charro* with a *hacienda* behind him, folkloric Indians, and an old woman with a cigar; in one image allusive of the revolution, a *campesino* is pictured with a gun on back, with the cutline "Sangre de rebeldía late en las venas de la raza" (Blood of rebellion beats in the race's veins). Two photoessays by German immigrants also focused on the characteristically Mexican: Juan Guzmán's "México típico y progresista" and that by Walter Reuter, "México es así: Un reportaje de Walter Reuter sobre el México típico."[102]

There was always a market for folkloric representations of Mexico, but maverick photojournalists looked for other ways to depict their nation. Rodrigo Moya reflected on this process:

Photoreportages could describe the picturesque, the exotic, the ingenious, the undoubtedly national, but never the inevitably real: the poverty, the growing disparity between the country's inhabitants. . . . Nonetheless, a group of ill-adapted photographers dared to photograph what they saw and were interested in, rather than what was assigned. Those free-lance photographers (at times not quite so independent) began to see, with Nacho López as the pioneer, a Mexico beyond plastic in bulk or impenetrable Indian faces or risk-free surrealism everywhere. Their images were full of workers and *campesinos*, clusters of women, subhuman living spaces, lumpen-proletarians and Otomis and Tarahumaras in prehistoric dress. The press let down its guard in search of

modernization, or an originality that could not be exercised because the directors lacked talent, and this select group began to stick in (*meter*) images like scorpions.[103]

The social consciousness awakened by Cardenist education (as in the case of Nacho López), the experience of growing up miserably poor (as did Héctor García), and the commitment expressed in fighting for democracy (as had the Hermanos Mayo) led these photographers to make critical imagery that contested the carefully constructed façade of the revolution, as the persistence of injustice led to events that demonstrated the limits of the "Mexican Miracle."[104] López, García, and the Hermanos Mayo took pictures that documented the misery that reigned in the shanty towns of Mexico City, though only García attempted to contrast that to the wealth enjoyed by others. The Mayo Brothers and García (and Enrique Bordes Mangel) were the photographers who best captured the 1958–59 strikes, one of the most prominent instances of dissent and social upheaval in Mexico since the armed struggle of 1910–17. Railroad and oil workers, teachers and telegraphers clashed with the police and army for almost two years in an attempt to rid their unions of government-appointed leaders and regain the right to elect their own representatives. Finally, García and the Hermanos Mayo produced the most powerful pictures of the 1968 student movement, which became the watershed of contemporary Mexican history when the official mask of the regime was torn aside by the massacre of its youth. These photojournalists provided a window—if infrequently—onto the country's real state, in the midst of a modern visual culture that was marked by wish-fulfillment cinema that avoided reality as carefully as did the nascent television, while the newsreels shown at the movies were controlled by the United States Information Agency (USIA), which projected "gray propaganda" that was covertly produced and not attributed to the Central Intelligence Agency.[105]

The exceptional contributions by some iconoclasts notwithstanding, the periodicals were of a predominantly officialist tone, and photojournalists toed their lines. Enrique Díaz represents the epitome of an "entrenched" press photographer who unquestioningly followed the dictates of president and party. The "star" of Mexican photojournalists from the mid-1930s to 1951, his entrepreneurial attitude and political position of center-right

placed him squarely in concert with the ruling party.[106] However, Díaz took adulation of the president to new levels. He presumed to have dined with Francisco León de la Barra in 1911, when the old Porfirian functionary was then interim president (and Díaz would have been sixteen!).[107] Díaz evidently then had little personal relationship with succeeding presidents, until the right took power in 1940, when he became the photojournalist who most appeared in images with the commander-in-chief. Díaz's preferences were made clear in a 1949 interview: "My General Manuel Ávila Camacho is a man so good that he gets scared if people speak well of him. My leader (*cabecilla*) Miguel Alemán is a great guy; a great guy. I loved General Maximino Ávila Camacho as I have few people; he was a great friend. General Cárdenas: What? What?"[108] Under Alemán, the photographer's age, advancing diabetes, and conservative tendencies led him to go to extremes, documenting "Alemán's route" on several occasions, composing a poetic photoessay to the president, and constructing a photographic collage to show "what a president does."[109] During one of his incessant national tours, Alemán gave Díaz one of the arrangements of flowers draped around his neck; they were the photojournalist's "greatest satisfaction," and he swore to guard them like jewels.[110]

The great "scoop" of Díaz's career—which acquired such mythical proportions that even Antonio Rodríguez considered it "the most daring feat of Mexican journalism"—reflects his political commitment.[111] In the spring of 1938, the *caudillo* of San Luis Potosí and the last of the revolution's great military leaders, Saturnino Cedillo, rose up against the Cárdenas government. Cedillo was a warlord with private forces who had founded a highly personal system of *cacicazgo* in his state, based on family ties and individual loyalty. This clashed with the new Mexican nation being constructed by Cárdenas, which called for a professional army, corporatist labor and peasant organizations, and the development of a bureaucratized system for resolving differences. The rebellion seems to have been a half-hearted, almost suicidal effort to defend local identity against an emerging nationalism. Cedillo had served as Cárdenas's secretary of agriculture; with little interest in killing him, the president had extended many amnesty offers.

The magazines of Pagés Llergo made the revolt into news by sending Díaz to cover it over four months, at a time that most periodicals had correctly measured the lack of support for the uprising.[112] To *Hoy* and *Rotofoto*,

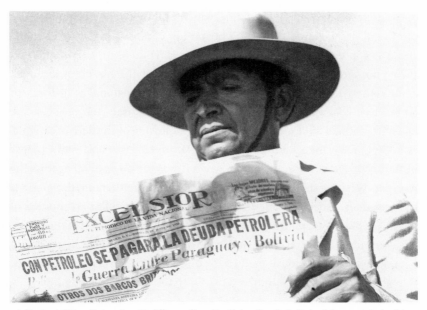

36. Enrique Díaz. Saturnino Cedillo reading *Excélsior*, San Luis Potosí, June 1938. Archivo General de la Nación, Fondo Díaz y Delgado, sobre 6516.

Cedillo was a paladin of the Mexican right, and they gave him a forum to denounce the "Sovietization" that he believed Cárdenas was carrying out.[113] The magazines celebrated Díaz's feat, linking him to the hallowed sphere of the war correspondent by noting that he had "walked desperately for four days, defying the inclement weather and facing great dangers"; Cedillo himself said to the reporter, "Friend, you are a risk-taker. Don't you know that this could cost you your life? How did you get here?"[114] Díaz had the presence of mind to portray Cedillo reading a newspaper, *Excélsior*, from 28 June 1938, to create a document testifying to the date on which he was photographed; the *caudillo* was empowered by the low angle Díaz employed (see figure 36).[115] Cedillo expressed gratitude to the magazines for rescuing him from the defeat to which he seemed consigned by other media: "Here I am again in the mountains. Have you read the newspapers? Well then, look at me carefully, because I am neither dead nor crazy."[116]

Enrique Díaz was evidently a man of few words who let his camera do the talking. When pressed to reflect on whether a unique national photography existed, he replied, "I couldn't say that we have a real school of photography, but would rather speak about the sensitivity of the Mexican's in-

terpretive eye, sharp and penetrating, which captures what is peculiar about our life."[117] He believed that the contribution of photographers to Mexico could be appreciated in publications such as *Hoy* and *Mañana*, which "send their photographers around the country to cover the march of industry, agrarian activities, and the diverse customs of the regions."[118] It does not appear that Díaz spent much time portraying industrial triumphs; instead, he photographed folkloric scenes such as the blessing of animals, cockfights, families of fishermen, and the Day of the Dead. He also took many images of the army, above all in the 1930s, when it was set up as a foil against the workers. What he seems to have photographed more than anything else is the president, especially Miguel Alemán. Hence, in the last six months of 1951, Díaz published photoessays on Alemán in more than half of the issues. His commitment to the commanders-in-chief paid off: when he retired in 1954, he was given a house paid for by donations from former presidents, though evidently finally purchased thanks to the current office holder, Ruiz Cortines.[119]

The Hermanos Mayo offered (at times) a more critical view than Díaz and other officialist graphic reporters.[120] This photojournalist collective played a pivotal role in redefining Mexico's graphic reportage since 1939, but their story began in one of the modern world's great conflagrations: the Spanish Civil War.[121] There, the five "brothers"—Francisco (Paco), Faustino, Julio, Cándido, and Pablo—placed their cameras and guns at the service of the Republic, until the fascist victory obligated them to flee to France and, eventually, migrate to Mexico.[122] Hermanos Mayo is the nom de guerre by which they have been known in their adopted country, where their archive of some five million negatives, and collaboration in some forty publications, has made them the most prolific photojournalists in the history of Latin America.

Their extraordinary productivity is a result of collective labor. They could buy large quantities of 35mm film that they then cut into rolls for the Leica cameras, which they introduced to Mexican photojournalism. This allowed them to shoot extensively the orders they were given to cover, as well as take photos in the street during and between assignments. Their collaboration also enabled them to maintain control of their negatives, as well as to catalogue them so that prints could later be located and sold for illustrative purposes. Their enormous archive also reflects a vision of the

uses of photojournalistic imagery in constructing the history of modern Mexico, as well as a decision to document the country of their refuge. The Mayo Brothers were acutely conscious of their situation as political exiles, and they distinguished themselves clearly from the *Gachupines*, Spaniards who have dedicated themselves to commerce in the New World. Like the other Republican refugees, the Hermanos Mayo fiercely rejected being confused with those Spanish immigrants who had come for economic gain. More than forty years after arriving in Mexico, Faustino expressed these sentiments when, on giving his book *Testimonios sobre México* to President Miguel de la Madrid, he underlined his position, "From a *refugee*." De la Madrid asked Faustino why he had written that, and Faustino explained that it was a great honor for him to be a political émigré. As Julio Mayo delineated, "We weren't the typical 'bread and onion' immigrants who had come here to plant fields or put up a whore house or see who we could exploit. Our circumstances were very different from those Spaniards with whom Mexicans were familiar before the Republicans arrived. So, there was a great distance between the two Spanish societies. For us, it was an honor to say: 'I am a refugee.' We were proud of that, and we objected if they called us *Gachupines*; that was an insult, given the fact that *Gachupines* came to exploit people and make money."[123]

As refugees cast adrift in a society that was not accustomed to receiving immigrants, the Mayo were thrown on their own resources in a situation that they had not chosen but within which they had to create themselves anew. This experience coupled well with the Mexican capacity for improvisation, a constant necessity in a poor and underdeveloped nation. It is from this confluence that the Mayo developed what I would argue is their particular contribution to defining *mexicanidad*: a largely intuitive photographic discourse which insists that identity is forged in the process of people making something out of what is being made of them. Obviously, an archive of five million images offers an almost infinite number of possible readings. The Hermanos Mayo covered *everything*, and their imagery of Indians, for example, could be said to offer an essentialist vision. Nonetheless, what I find noteworthy in their work is not only that, as photojournalists, they covered history-in-the-making but that they infused their imagery with a dialectical perspective.

One example is offered by a photo of autoworkers in a Ford factory in

37. Hermanos Mayo. Ford Company assembly plant, Hermosillo, Sonora, 1952. Archivo General de la Nación, Fondo Hermanos Mayo, concentrados sobre 5827.

Hermosillo during 1952 (see figure 37). In observing the assembly line, we see how the workers are trapped in a situation that reduces them to the level of both the machinery with which they work and the motors they manufacture. Converted into simply another inanimate element of the process, they are a faithful reflection of the reality of labor in modern factories. Everything that surrounds the workers functions to make them into parts of the mechanism, to submerge them in the "inevitable laws" of industrialism. However, though the Mayo have articulately depicted the "force of circumstances," they also captured the response: a laborer's face looks out from among the machines and returns the camera's gaze, portrayed in a way that recognizes and honors the human spirit that confronts and battles against such a delimited condition.

Social struggles during the 1950s and 1960s offered the Mayo many opportunities for constructing their visual dialectic, and I believe their images to be the best taken of the 1958–59 strikes. The Mayos' spontaneous images of newsworthy events demonstrate an acute visual complexity, although members of the Mexican photographic aristocracy have disdained them as mere photojournalists.[124] For example, a picture of the army's occupation of the telegraph offices utilizes three planes to express a trenchant

38. Hermanos Mayo. Army occupation of telegraph offices, Mexico City, 8 February 1958. Archivo General de la Nación, Fondo Hermanos Mayo, cronológicos sobre 12040.

analysis of government control of the labor movement (see figure 38). The foreground is dominated by a bayonet-wielding soldier. In the midground, Mayo captured the outrage evident on a telegrapher's face as he glared at the intruder, visually resisting such an abuse of the fundamental prerogative to choose the leaders of one's union. Finally, in the background, Mayo locates the source of the repression by framing between the soldier's helmet and bayonet a portrait of Álvaro Obregón, president from 1920 to 1924 and creator of the New Order that was to reign for the rest of the twentieth century. Through this strategy, Mayo demonstrates the complicity of presidentialism in the oppression of the working class in a country where it has been typical to excuse the maximum authority from responsibility.

The violent repression of the 1968 movement was not confined to students, and the Mayo were in the front line. Julio Mayo described how, because the police and soldiers would stop photojournalists in the street and expose the film they carried in their cameras, he began to remove and hide

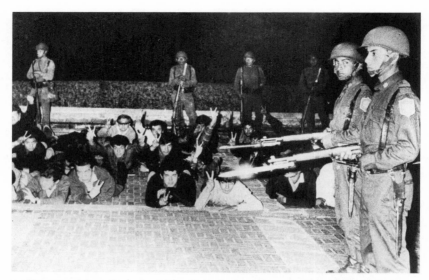

39. Hermanos Mayo. Students and faculty under arrest by army, Universidad Nacional Autónoma de México, Mexico City, 18 September 1968. Archivo General de la Nación, Fondo Hermanos Mayo, cronológicos sobre 24588.

his film in the minute he felt he had made a good image.[125] Perhaps one such photo is of students and faculty captured during the army's invasion of UNAM on 18 September and forced to lie on the cold ground in the night, surrounded by armed soldiers (see figure 39). In spite of the immediate danger they face, they persist in their pursuit of free expression by flashing the sign of "*Venceremos*" (We shall overcome), even under the reflected glare of the bayonets that threaten them, and which Mayo so expertly displayed by bouncing his flash off their drawn blades. Gilberto Guevara believes that this well-known symbol (which dates at least since its use by Winston Churchill during World War II) had acquired a particular significance in this moment, when the government violated the university's guaranteed autonomy from intromission.[126] However, Luis González de Alba traces its recent incorporation in Mexican history to five days before the UNAM invasion, during the "Silent March," when the protestors paraded under the self-imposed decision to avoid their usual chanting and shouting, as a representation of the smothering of free speech. There the "V" appeared and soon covered the city, painted on telephones, buses, and fences, as well as sneaking into public acts, the television, and official ceremonies. Made with fingers and formed by marching contingents, this icon of resistance appeared in the

most unexpected places; as González de Alba declared, "Nothing seemed capable of extinguishing it."[127]

The Tlatelolco massacre on 2 October ended the effervescence of the movement and alienated an important sector of Mexican intellectuals forever from the PRI dictatorship. The cold-blooded execution of unarmed civilians had to be hidden from view, so government agents were sent to all the periodicals and agencies with orders to confiscate all images revealing the atrocities, as well as any that could be useful in identifying participants in the movement. The Mayo Brothers were not exempt from this sweep, and many of their negatives of Tlaltelolco were seized. One of the surviving Mayo pictures offers an intriguing reflection on the history of Mexico. In a photo taken on 3 October, we look down from an apartment (Chihuahua building) high above Tlatelolco Plaza, where, the night before, the greatest massacre of unarmed civilians in modern Mexico had taken place.[128] However, the picture is not full of blood and bodies; in fact, no human figures appear: it is instead a metaphor for the role of violence in forging Mexico. From the window onto Tlatelolco, also known as the "Plaza of Three Cultures," we see three distinct societies represented: the pyramids of the Aztecs where they made their last stand against the Spanish conquest; the colonial church, religious arm of the often barbarous colonizing process; and the modern apartment buildings which surround the plaza, constructed as a sop for the working class. In the foreground and framing the scene, we are confronted with the holes made by the soldiers' bullets in the window through which we look, graphic evidence of the brutality unchained by the government. Octavio Paz comes to mind: "Past epochs never vanish completely, and blood still drips from all their wounds, even the most ancient."[129]

If the Mayos' representation of *mexicanidad* is encapsulated largely through the depiction of resistance to oppression, the collective also constructed their idea of what Mexico is by demonstrating what it is *not*: the United States. The U.S. presence in the Mayos' photography takes on a wide variety of forms, but they appear to have been somewhat skeptical about that nation's commitment to democracy. Certainly, they experienced firsthand the disappointing performance of the United States in relation to Spanish fascism. Despite the fact that Franco's forces received massive military aid and advisors from Hitler's Germany and Mussolini's Italy, the United States not only failed to aid the cause of the democratically elected Republicans

but had tried to prohibit its citizens from participating in the International Brigades by making U.S. passports invalid for travel in Spain.[130] Further, few Republican refugees were admitted to the United States after the defeat. Finally, those refugees who maintained any illusions about the United States had them definitively quashed by the official recognition given Franco's regime in 1951 (Mexico did not renew diplomatic ties to Spain until 1977). The Mayo opinion about the United States can be discerned in the remarks written in their catalogue and on the negative envelopes. There, they commented sarcastically on U.S. air bases in Franco's Spain: "Yankee invasion in Spain to defend imperialist democracy and to protect the Spanish people from liberty. If the Spanish were not defended by Yankee democracy, they would be free. YANKEES GO HOME THE [sic] SPAIN."[131]

This perspective in their photography is demonstrated in the extensive coverage of the many Mexican demonstrations against U.S. interventions in Latin America. They photographed protests in which Mexicans pasted posters on the U.S. embassy demanding "Gringos fuera de México" (Gringos, get out of Mexico).[132] They also covered, on at least two occasions, protest marches in opposition to the U.S. role in the overthrow of Guatemala's democratically elected president, Jacobo Arbenz.[133] Guatemala continued to be a touchstone: in an 18 April 1961 march against the U.S.–sponsored attack on Cuba at the Bay of Pigs, banners read "Cuba will not be another Guatemala," and the Mayo photographed at least eight protest meetings and marches against the U.S. policies in relation to Cuba.[134] The Mayo Brothers seem to have photographed all Mexican dissent against the United States: they documented the 11 May 1965 gathering at the Juárez Hemicycle remonstrating against the U.S. invasion of the Dominican Republic, in which a prominent banner alluded to the fabled relationship of Juárez and Lincoln, "Lincoln has died. Johnson killed him in the Dominican Republic."[135] The Vietnam War also provoked Mexicans to take to the streets in protest, and the Hermanos Mayo photographed the myriad of times that the local authorities took this opportunity to abuse young nonconformists, beginning as early as 1965.[136] When the United States intervened to overthrow Chile's elected president, Salvador Allende, the Mayo captured an eloquent moment in which one participant of the 14 September 1973 march kicked at the burning U.S. flag (see figure 40).[137] Some protests documented by the Mayo had a lighter tone: in a photograph from 14 March 1957, we see young men

40. Hermanos Mayo.
Protestor kicking at
burning U.S. flag, Mexico
City, 14 September 1973.
Archivo General de la
Nación, Fondo Hermanos
Mayo, cronológicos sobre
29589.

holding up a clearly bewildered dog with a sign reading "Death to Presley" hanging around its neck, presumably in response to an alleged racial slur by Elvis, "I'd rather kiss three black girls than a Mexican."[138]

I sense that the Mayo were personally quite critical of the imperial power and hence defined *mexicanidad* in terms of the differences between that culture and the United States.[139] They took photos of "ridiculous gringo tourists buying Mexican curios," of poor women cooking outside the caves provided by Westinghouse Corporation for its workers in Tlanepantla, and of a car bumper with two stickers: the store-bought sticker asserted "All the world is good," but the car's owner had accompanied that with a hand-written note, "Except Nixon and Truman (Hiroshima)."[140] Whatever the personal sympathies of the Mayo may have been, they were nonetheless photojournalists assigned to cover events in Mexico, and these included visits from and reunions with U.S .presidents; the meeting of international

commissions on border policies, drug containment and sanitary control; the arrival of Shriners and American Legionnaires by train; the appearance of Hollywood celebrities; and relations between Mexican and U.S. workers' unions, among many other themes. They certainly documented the "Americanization" of Mexico: long lines of people waiting to see *Peter Pan* and *Lassie*; the opening of Sears and Woolworth stores; the television programs copied from the United States, such as *Reina por un día* (*Queen for a day*), or sponsored by Canada Dry and Nestle; the encroachment of Santa Claus on the more traditional celebration of Noche de Reyes; baseball scoreboards dominated by Pepsi Cola ads, and young Mexican boys playing U.S. football, dressed in expensive gear.

The Mayo also photographed people who, like them, had been forced to emigrate, though for different reasons from theirs: the *braceros* who went legally to the United States to work between 1942 and 1964, as well as undocumented migrants on the border.[141] Some of their more moving photographs are of the farewells in the Mexico City train station. Obviously, there is no shortage of images that reflect the sharp pain of separation: women crying as they say goodbye to a loved one on his way to seek his "fortune" in a strange world, fathers lifting their children for a last hug, clasped hands and interlocked eyes of couples as the train pulls out. How could it have been otherwise? The Hermanos Mayo knew only too well the tearful partings of the Spanish Civil War, families who separated and were never again reunited. But the grace and power of the Mayo Brothers lies in their refusal to succumb to such bitter nostalgia; they see and show in smiling faces and returned gazes the rapport they established with *braceros* as fellow-émigrés with whom they shared the energies liberated by the apparently infinite possibilities that new lands offer.[142]

Héctor García was among the thousands of Mexicans who migrated legally to the United States as *braceros*. In fact, he traces his decision to seriously study photography to an experience he had there in the early 1940s. He was working in Maryland with other migrant laborers to clear railroad tracks of snow when a train roared through and killed one of them, leaving his remains in bloody patches against the white background. García attempted to photograph the scene, but the snow's reflection was too much for his little camera, and the images were blank. The next week he went to New York and began taking lessons in photography.[143] Given the destitution

from which he came, García had little hope of ending up a photographer when he was born in one of Mexico City's poorest barrios, Candelaria de los Patos, and he grew up as if he were a character in Luis Buñuel's *Los olvidados* (1951).[144] He was an unquiet child, so his mother used to leave him tied to the bed while she went to work. Soon he became involved in the rough street life and stole bread to eat; he was arrested and ended up in a reformatory, whose director gave him his first camera.

Although he was accepted to study at the National Polytechnic Institute, he preferred the adventure of seeking his fortune as a *bracero*. With the war's end, García was sent back to Mexico and joined the film magazine *Celuloide*, where famous intellectuals such as the director, Edmundo Valadés, and the writers Salvador Novo, José Revueltas, and Efraín Huerta were his "daily experience."[145] Valadés recognized the photographer's calling and sent him to study with Manuel Álvarez Bravo and Gabriel Figueroa in the Mexican Cinematographic Institute. In the 1950s, García decided to dedicate himself to still photography, and he worked for periodicals that included *Mañana, Siempre!,* and *Excélsior*, publishing the section "F 2.8" in the latter from 1958 to 1960, with a focus on Mexico City's poor. There, one of his most devastating images was that of a ragged, barefooted young man squeezed in a fetal position into a wall niche, his home to avoid the flooded streets. The French minister of culture André Malraux baptized the image "Boy sleeping in a concrete womb" and described it as "one of our time's cruelest testimonies."[146] García was given his first National Award of Photojournalism for this image.

When the strikes of 1958 filled the streets with protests against government control of unions that permitted the constant lowering of real wages, García documented the battles. He was promised by *Excélsior* that the photos would be published, but the well-known dilatory tactic of "Sí, cómo no" (Yes, but of course) seemed destined to go nowhere, and García was eager that his images participate in a movement that promised to bring a measure of democracy to Mexico. Horacio Quiñones, an audacious journalist, liked García's photos, and he convinced the photographer that they would never appear in the official press. García got some money together and published the pictures in a magazine he created, *Ojo, una revista que ve* (Eye, a Magazine That Sees), printing five thousand copies. Because all of the existing channels of distribution were closed to him, a friend took charge of

circulation. Given the thirst Mexicans had for a real photojournalism, the magazine sold out within a day and was often marketed at prices higher than that which appeared on the cover. García decided to run more copies and called Quiñones to order another ten thousand. Quiñones responded: "It would be better that you look for some place to hide, because the police just came to the print shop and took the plates."[147] García went underground until the storm passed; soon thereafter, he was given the 1959 National Award of Photojournalism for these very images. With the worker's movement smashed, and its leaders imprisoned, the government bestowed a prize for photographs that had been censored. News that was converted into art allowed it to reconstruct its façade of democratic tolerance.

The photographer developed a particular aesthetic to document the 1968 student rebellion, which gives the appearance of having been born out of the experience itself: he incorporated movement within the frame as a tactic to register the energy and excitement of a civic uprising that redefined Mexico. For example, when García captured the "Silent March" entering into the Zócalo, he appears to have left the diaphragm open for a slightly longer time than necessary, creating the sensation of marchers streaming into the plaza.[148] One might ask whether this did not result from having to allow enough light to enter for a nighttime photograph, but this same strategy can be seen in other images from 1968, including one in which the blurry store signs indicate that García moved the camera to create a similar effect.[149] He had experimented with this strategy in images prior to 1968, including one of his most famous, *The Ghosts of the Palace* (1963), which reduced to blotches the dolled-up dignitaries that strolled through the National Palace.[150]

The tactic of infusing motion into a still photo reached its maximum expression in García's icon of the Tlatelolco massacre (see figure 41). The photo of a soldier apparently pointing his weapon at a family that flees from the plaza with child in arms portrays an attack on the family, cornerstone of Mexican society, by a government determined to give protestors a definitive lesson about power. The family is in flight, but this does not appear to satisfy the forces of repression, and the blind panic and absolute terror of finding oneself under fire is reflected in faces blurred by movement: we are invited to fill that vacuum with the visages of our beloved.[151] In Tlatelolco, the people who had gathered peacefully attempted to leave the plaza

41. Héctor García. Tlaltelolco massacre, Mexico City, 2 October 1968. Héctor García Archive.

under a merciless fire of more than an hour, only to find the exits blocked. Margarita Nolasco described what she saw from her hiding place: "Sheltered behind a pillar, we saw how the people came toward us, shouting and howling; they were shot at and went running away, and then suddenly they came back toward us, falling; they ran away, and they came back, and they kept falling. It was a mass of people who ran here and fell, and then they ran there, and then they ran back toward us, falling all the time. I thought that the most logical thing would be to go where there were no bullets, but they kept coming back. Now I understand that they were shooting at them from both sides."[152]

García received a third National Award of Photojournalism for his photos of 1968, and they circulated widely; published at the time in *Siempre!*'s supplement, *La cultura en México*, as well as the UNAM's *Revista de la universidad*, they were consecrated upon appearing in Elena Poniatowska's famous reconstruction, *La noche de Tlatelolco*, and Carlos Monsiváis's *Días de guardar*.[153] Hence, it is ironic that he went to work shortly after the massacre for the man who is today considered to have orchestrated it, President Luis Echeverría (1970–76). García maintains that, having become convinced of Echeverría's sincerity and capacity, he accepted his offer to be

the presidential photographer because he was given independence and the right to his negatives.[154] The president facilitated an exposition of García in New York in 1971, "Mexico," but the photographer utilized his position to make several images critical of the dictatorship. One was inspired by Álvarez Bravo's *Sed pública* (Public thirst): García photographed a young girl who was leaning over to drink water from an open spigot supported by a rough cement base, while holding a sign that urges, "Vote PRI." The photojournalist titled this image *Sed política*, in an obvious reference to the thirst of Mexicans for real elections and explained his intention: "Campaigners kissing babies is a form of sentimental blackmail: I denounced these tricks with photographs rather than words."[155]

García has been described as "the photographer of the national essence," and his images of misery have become "signs of identity."[156] He rejects the picturesque and the superficial: "What I try to do is go beyond the frontier of the facile, the epidermic and folkloric, to penetrate with a profound analysis of the reasons behind the event."[157] Hence, his vision of Mexico is not limited to documenting poverty but goes beyond that to provide a dialectical perspective that insists upon critiquing the extreme class differences that produce such destitution. For example, in photographing the celebration of Mexican independence on the night of 15 September, which culminates with the president's invocation of Hidalgo's "cry"—"¡Viva México!"—he captured a complex image that incorporates the poles of society (see figure 42). The poor carry goods they hope to sell at the festivities, the rich stroll along in their tuxedos and gowns. In titling the image *Cada quien su grito* (Each with their own cry), García commented on the way in which social injustice individualizes fate and eats away at a national consensus. Conscious of the way in which the press curried the favor of the wealthy—García once commented that Mexican photojournalism would win a world contest of society pages—he was the only photographer from this period that dared to take on the powerful.[158] He pilloried them in famous photos such as *Nuestra señora sociedad* (Our noble society), in which a bemedaled dignitary awkwardly lifts his toes to free the train of the gown worn by the bejeweled woman in front of him, and *El charro de la rosa*, which depicts a man dressed in a ridiculously ornate *charro* outfit covered with roses, in the midst of Echeverría's campaign propaganda.[159]

García also constructed or encountered scenes that point to the contra-

42. Héctor García. *Cada quien su grito* (Each with his own cry), Mexico City, 15 September 1965. Héctor García Archive.

dictions between official ideology and reality. One is *Inocencia burlada* (Innocence mocked), in which Indian girls with faces that reflect their difficult lives—or the bother caused by having been brought to pose for Echeverría's campaign—hold up government pamphlets with images of Benito Juárez.[160] The revolutionary mask comes under fire as well: in *Niño cañero* (Boy sugarcane cutter), García placed a young lad, filthy from his labors in the field, in front of a mural depicting the Spanish mistreatment of sugar workers. By printing the image in exaggerated gray tones, García makes the boy appear as if he were part of the mural, thus insisting that such oppression did not end with a revolution that financed wall paintings to celebrate its achievements (and disguise its shortcomings).[161] One of his photographs documenting the 1958–59 strikes also referenced that heritage: oil workers march in the street, while in the background the Monument to the Revolution is made small by their torches.[162] The end of the revolution is also depicted in his picture of an old man dressed as a Zapatista, his cartridge belt empty.[163] Rejecting the picturesque as superficial, he photographed a man burdened with a load of henequen as if the plants behind formed part

43. Héctor García. *Muñecas* (Dolls), Mexico City, 17 December 1952. Héctor García Archive.

of the cargo, creating a "crown of thorns" that attests to the crucifixion of *campesinos* by the modern Mexican state.[164]

The impact of U.S. culture on Mexican identity was explored by García in several images. The most published of these, *Muñecas* (Dolls), portrays a poor little girl who is selling newspapers around Christmas time, while begging for donations to her piggybank (see figure 43). Face pressed against the glass, the girl gazes desirously into a shop window at a blond doll; a cruel contrast is offered between her black hair and her skin made even darker by dirt when compared with the immaculate plaything to which she can only aspire. A powerful rendition of neocolonial longing, the image was almost certainly directed by García to achieve this juxtaposition, although he sharply rejected that idea.[165] In reflecting on one of Mexico City's most important monuments, García photographed the statue of Charles V, the Spanish king who directed the conquest of the New World, with a Coca Cola sign behind, thereby creating a synthesis of two major imperial powers.[166]

García had a personal experience with U.S. media that left him feeling

exploited. In 1959, *U.S. News and World Report* had used some of his images to illustrate the article "Is the World Going American? How the U.S. is Being Imitated Abroad," and a year later they asked for more to portray Mexico's development.[167] He provided some that he had made while working for PEMEX, but they were not used until 1961, when they were employed to represent "a panorama completely contrary" to García's intention, demonstrating instead the "very unhealthy condition" of Mexico's economy.[168] The photojournalist protested, but the editors told him, "We reserve, and will continue reserving, the right to use the photos as we see fit."[169]

Given his relations with artists and intellectuals, García must have felt a particular malaise about such a cavalier violation of his copyright. He refers often to the effect muralism had on him, stating that, when he searched for his country's face, he always kept in mind the visages painted by Orozco in Guadalajara; curiously, but effectively, his portrait of Orozco, in which the focus falls on the foreground hand, left the muralist's face a blur.[170] The influence of Siqueiros appears to have been even greater. Some Siqueiros paintings bring to mind García photos: *The Flight* (*Huyendo*, 1964), in which a woman with baby in arms flees during the revolution, bears a striking resemblance to the effect García achieved in the photo of the family in Tlatelolco, while in *Proletarian Mother* (*Madre proletaria*, 1933), the way in which the mother is trapped within gray bricks is reminiscent of García's boy in the cement womb. Given that García's photos are not posed, these are happy coincidences that testify to the photojournalist's aesthetic power. The collaboration between Siqueiros and García in making another photo, that of the painter in Lecumberri prison for the crime of "social dissolution," was instrumental in creating another version of Siqueiros's self-portrait *El coronelazo* (1945); in both the painter's hand is thrust dramatically into the foreground.[171] García was visiting Siqueiros when the painter "extended his hand out of the bars, and I obeyed the magisterial lesson of General Pancho Villa, 'Shoot first and ask questions later' [*Dispara y después virigua*]. Of all the photos of Siqueiros, this is the one that became famous and was on the poster of the world campaign to free him."[172] In the 1960s, García was adopted by the "Mafia," as Carlos Fuentes, José Luis Cuevas, Fernando Benítez, and Carlos Monsiváis, among others, were known, and in 1967 he collaborated with Salvador Novo to illustrate the writer's famous book *New Mexican Grandeur*.[173] Later, in 1972, García worked directly with the artist

Alberto Gironella to create, among other works, *La Verónica*, a photomontage that represents the martyrdom of Emiliano Zapata and, by extension, that of all *campesinos*.[174] Despite his relations with artists, García has often stated that photojournalists must forget about art while they work, and one of his favorite metaphors is that of a dog who, unable to choose between two sandwiches, eats neither: "If one is preoccupied with aesthetics—for example, capturing a particular angle—the news gets away."[175]

Visualizing Mexico's Past

Gustavo Casasola Zapata, eldest son of Agustín Víctor, realized his father's project of constructing a master photohistory of the nation, and in the process, this medium acquired a unique importance in Mexico.[176] From the 1940s on, Gustavo, aided principally by his uncle, Miguel, and sister, Piedad—and by other family members—published and steadily reprinted many illustrated works, as well as providing images for others. The most important of these are two monumental series, *Historia gráfica de la Revolución Mexicana* and *Seis siglos de historia gráfica de México*.[177] The first appeared in 1942, under the title *Historia gráfica de la Revolución*, and covered the period 1900–40. This series was then republished in 1946 and in 1947 and continued to grow in the 1950s. Riding the nationalist wave fomented around the fiftieth anniversary of the revolution's onset, the fatherland was incorporated into the new title, *Historia gráfica de la Revolución Mexicana*, when it was published in a greatly expanded format in 1960 and then reprinted in 1962, 1964, and 1967, ultimately reaching 3,760 pages, with approximately 11,500 photos. The other mammoth series, *Seis siglos de historia gráfica de México*, was first published by Gustavo Casasola in 1962 and must have found an equally enthusiastic acceptance, because it was amplified in 1964, 1966, 1967, 1968, and 1969, eventually arriving at 3,248 pages, and some 18,000 photos.

The Casasolas were the first to systematically explore the uses of and demand for printed visual history.[178] While their books leave much to be desired as models for how to use photographs in reconstructing the past, the sheer number of images makes them obligatory references for anyone interested in Mexico's visible yesteryears, even though the poor reproduction and large grain render imperceptible elements that are visible in books of higher quality.[179] Whatever the aesthetic (and photohistorical) limits

imposed by technical shortcomings, the series must have been costly to produce, with a narrow market among the small educated middle class. It is not yet clear exactly how these expensive works were financed, but the close connections the Casasolas always enjoyed as a dynasty that could be counted on to follow the party line—coupled with the highly officialist history promulgated by the series—leads me to believe that the federal governments subsidized them.[180] It appears that Ávila Camacho helped Gustavo to publish the first pamphlets (*cuadernos*) of the *Historia gráfica de la Revolución*, although the financial strain of producing the series later led to the mortgaging of the Casasola home.[181] The decision of President Adolfo López Mateos (1958–64) to provide free textbooks to public schools was a boon for publishers, and the Editorial Trillas applied some of their surplus to produce a commemorative issue of the *Historia gráfica de la Revolución Mexicana* in 1960. The secretary of the treasury, Antonio Ortiz Mena, directly subsidized the Casasola project through Nacional Financiera in 1962.

The works of the Casasola are not really history but chronicles composed of thousands of images that appear together with a dry and conservative recitation of "facts." The discourse created by the almanac-like prose and the multitude of photographs is eminently Positivistic, expressive of Gustavo's belief in his own capacity for "objective observation."[182] Gustavo stated that he initially attempted to solicit the aid of historians, perhaps following in the footsteps of his father, who had invited prestigious historiographers to participate in the *Albúm histórico gráfico*. However, Gustavo decided that they were "too partial and tendentious," and he determined to write all the texts himself, guided "by a documentary rather than a political idea" and "without accepting advice or ideas from anybody."[183] In a book on his father that Gustavo later published, the articles he commissioned refer time and again to the "objectivity" of the Casasola project.[184] The original intention of Agustín Víctor in collecting such a vast archive is said to have been that of producing "an objective history of the country," and it is argued that the very nature of photographs offers an "equilibrium" that is beyond the "destructive" historiographic battles over the meaning of the revolution, because they cannot be manipulated like words![185] Technical advances (and perhaps greater financing) allowed Gustavo to heighten photography's power: he abandoned the crude retouching of Agustín Víctor's *Albúm histórico gráfico*, leaving behind a nineteenth-century model of illustrationism to

adopt a modern format in which photographs appear as windows onto the past, a transparency that purports to speak for itself, although—as always—the context created by the image choice and texts determine the pictures' meanings.

The Casasola photohistories do not appear to have attracted the attention of Mexican academics.[186] It may well be that their opinion was expressed in the familiar *ninguneo* for, when Gustavo Casasola solicited testimonies about the worth of *Historia gráfica de la Revolución* in 1947, the published responses came from politicians, lawyers, journalists, and generals.[187] No historian was cited, a void Gustavo attempted to fill with Aureliano Urrutia, a medical doctor who had been close to the Porfirian regime, and a *compadre* of Victoriano Huerta. Said to have cut out the tongue of Belisario Dominguéz (who had valiantly resisted Huerta's closure of the Mexican congress and is today the hero of Mexican journalism), Urrutia fled Mexico following Huerta's defeat and lived out his life in San Antonio, Texas. That Gustavo Casasola would have to recur to a figure of such notoriety and lack of historical expertise speaks volumes about both his "objectivity" and his political leanings. Urrutia himself seems surprised at being asked his opinion, given that Gustavo had available "historians of recognized superiority."[188]

However, if historians may have had their doubts, commentators from the broader society attested to the project's importance in the construction of the New Order.[189] Hence, Miguel Alemán endorsed the Casasola enterprise, believing that they permitted "future generations to know objectively ... all those events that have national characteristics."[190] The Casasola family doctor, Francisco Olivares, was called upon to encapsulate the aim of Agustín Víctor and Gustavo; he felt that the *Historia gráfica de la Revolución* was "without doubt a great objective lesson for the new and future generations," because it "gathers the diffuse streams of individual opinions and tends not only to form the collective soul of the people, but the very consciousness of nationality and Fatherland."[191] The testimonies abound with references to the work's "veracity," and frequent mention is made of the Casasola's "impartiality" and "equanimity." One commentary makes it clear that photography itself is at the source of this credibility: the Casasola's history is "incorruptible," because their images are as exact as numbers.[192] The most important journalist of the period, Jacobo Zabludovsky, always closely

aligned with the party dictatorship, later contributed his iota to constructing the façade of neutrality by describing Casasola's as the "only authentic history of the Mexican Revolution," while alleging, "It is not adventurous to affirm that the Casasola Archive is the most objective history of Mexico in this century."[193]

Despite the pretense of photography's exactitude, Gustavo Casasola used it at his whim: even famous images were recruited and turned into whatever was convenient for the theme at hand.[194] A striking example is the appropriation of Paco Mayo's picture of a literacy campaign, perhaps the best known the collective's enormous archive. Paco's photo won the Extraordinary Prize in the important exhibit of photojournalism organized by Antonio Rodríguez in 1947 and was moving if sentimental: illuminated by candlelight, an old woman struggles to learn how to read with the help of children, her brow furrowed as her gnarled hand follows the letters on a page.[195] Despite its being so widely known, Gustavo placed the image in *Seis siglos* among photographs documenting "The House of the Indian Student" and "The Rural Schools" in the period 1926–38, and no credit was given for it. Thus, the identifications of the photos in the Casasola series cannot be trusted, and the fact that we don't know who took the pictures leads to difficulties in determining what is really occurring in them. This makes the Casasola photohistories problematic even as catalogues, for one would have to find the original publications of the images in order to be able to use them with any rigor.

Historia gráfica de la Revolución (and its successor, *Historia gráfica de la Revolución Mexicana*) feature political leaders, above all Mexico's presidents. The series was originally published in five volumes, made up of twenty *cuadernos*, which must have been sold separately and later bound together. Ads for *Historia gráfica de la Revolución* emphasized presidentialism, one with the subtitle "From Porfirio Díaz to Miguel Alemán," and chief executives dominate the covers of twenty-one *cuadernos*; moreover, the eighteen men who governed the country between 1900 and 1946 are prominently portrayed on the back cover of the first pamphlet, despite the brevity of some in office. The volumes on the Porfiriato and the armed struggle headline the chief executives and their ministers, as well as warlords, *caudillos*, and *caciques*. The tomes picturing the postwar periods are largely calendars of official acts—presidential reunions with other politicians or foreign

diplomats, ceremonies, banquets, breakfasts, parades; they are dominated by images of men in suits: presidents, often accompanied by their collaborators, as well as governors, functionaries, bankers, entrepreneurs, and labor bosses. The composition of *Cuaderno No. 25* offers a case in point: Ávila Camacho, hand extended as he takes the oath of office at the presidium, is headlined on the cover of a work in which he and Lázaro Cárdenas appear in 42 percent of the images. The series' birth was attended by presidentialism, for it was presented at the 1942 Book and Journalism Fair, which was inaugurated by Ávila Camacho; the president appears in several photographs with Gustavo, Piedad, and Miguel Casasola at the stand set up to sell their books at the fair.[196] This emphasis on authority figures is consistent with the work's focus on Great Men, who are present in 75 percent of the photographs in *Cuaderno No. 25*.

Women are largely incorporated into the revolution as a touch of the exotic: "There is nothing so picturesque as railroad cars full of *soldaderas*."[197] Though images of women testify to their presence in a history from which they have often been excluded and silenced in written texts, the role they are assigned is revealing. Almost all the published pictures are posed in the Mexico City train station, where the women appear next to the federal soldiers they accompany, emphasizing their role as camp followers. And though their work in supplying soldiers with food was their most important contribution, making them into a "semiofficial quartermaster corps for the lower ranks," only two pictures reflect this activity by showing women with baskets, and none portrays them preparing nutriments or providing any of the other services they rendered, for example, nursing the wounded.[198] Moreover, while Casasola avoids the typical heavily romanticized images of women draped with cartridge belts, none of the published pictures indicates that *soldaderas* were often involved in combat.[199] Thus, if he critiques the widely accepted notion that women were an impediment to troop movements, Gustavo Casasola nonetheless reduces them to mere appendages of the soldiers to whom they are visually attached.

The success of *Historia gráfica de la Revolución* in the 1940s—either in terms of receiving government subsidies or in the sales it generated—made Gustavo Casasola increasingly conscious of the market for picture histories. He advertised the impending publication of several supplements to the series, which are revealing in terms of the topics covered and the order

in which they were listed.[200] Gustavo had began the *Historia gráfica* with a biography of Porfirio Díaz, and this preference was ratified in his desire to give priority among the announced books to a *Biografía ilustrada del general Porfirio Díaz*. The nightmarish memories of the revolutionary cataclysm had evidently begun to recede, and the volumes that were to follow the panegyric on Díaz would include illustrated biographies of Francisco Villa and of "men and Great Men of the Revolution" (hombres y pro-hombres de la Revolución), as well as of combat, troop mobilizations, camp scenes, *soldaderas*, and a history of the Colegio Militar.[201] The emphasis on Great Men and warriors can also be seen in books that Gustavo Casasola began to publish, and for which he made photographs, such as *Polvos de aquellos lodos: Unas cuantas verdades!* (Dust from that mud: Some truths!) by General Gabriel Gavira, which was full of portraits of revolutionary leaders.[202]

Gustavo's decision to dedicate a volume to Pancho Villa (the sole revolutionary leader to be so honored until the 1970s) indicates that mercantile forces were often as important a consideration as official backing, a familiar feature of modern Mexican culture. Villa was largely ignored by the regime until the 1960s, the only major figure not to be incorporated into the campaigns for revolutionary accord of 1929–30 or Ávila Camacho's call for National Unity in the 1940s. Ilene O'Malley believes that the government resented Villa's popularity and, since an outright attack would only provoke sympathy, thus resorted to the familiar *ninguneo*, "the greatest insult that could be meted out to his memory."[203] However, Villa's mass appeal attracted Gustavo Casasola, who, for precisely that reason, placed him on four of the covers of the *cuadernos* of the *Historia gráfica de la Revolución* (a number equaled only by Álvaro Obregón) and planned the biography of him. Villa might not be "in" with the regime, but the machismo he embodied as a virile "stud" with several wives, and the nationalism he inspired by attacking the United States, made him an indispensable player on the stage of *mexicanidad*.

Gustavo may have been more attracted to Porfirian patriarchalism than Agustín Víctor: he increased the space for representing that period by pushing the beginning date of the *Historia gráfica de la Revolución* back to 1900, rather than the 1908 Creelman interview chosen by his father in the *Album histórico gráfico*. However, Gustavo's yearnings for yesteryear were also clearly expressed in a series that he advertised constantly at the end of the

1940s, *Efemérides ilustradas del México de ayer*, in which he incorporated images that had been left over from the *Historia gráfica de la Revolución*.[204] This series may well have embodied not only the Casasola inclination to idealize the Belle Epoch but a generalized sentiment projected by the mass media in this era, to judge by films such as *¡Ay, qué tiempos, señor Don Simón!* (1941) and *Yo bailé con Don Porfirio* (1942). Nostalgia is always a negation of history, an unrealizable fantasy to return to a fetishized past. Susan Sontag might have been commenting on the imagistic wistfulness of Casasola's pictured Porfiriato when she wrote, "Photographs turn the past into an object of tender regard, scrambling moral distinctions and disarming historical judgments by the generalized pathos of looking at time past."[205]

The narrative offered by *Efemérides ilustradas del México de ayer* began on the first day of 1900, and the pictures of daily life activities were "shoehorned" into a chronology that had little to do with the dates on which the photographs had actually been taken. The imagery was centered in Mexico City, illustrating the modernity and cosmopolitanism facilitated by the Pax Porfiriana: stylishly dressed women sashay down a boulevard in the latest Victorian gowns and clutch their full skirts as they enter horse-drawn cabs that will take them to the year's first communion; "distinguished families of the metropolitan society" file out of churches, the women in flowered bonnets and the men wearing spats; employees talk on telephones and stand behind the counter of the sumptuous pastry shop "El Globo"; coachmen in top hats await their employers; elegant carriages and fancy restaurants are featured in cityscapes. The underside of the Porfiriato is represented in the familiar form of "popular types": an Indian woman kneels in the street offering her products, a carpenter stands next to a work in process, soldiers pose with swords and artillery.

It is difficult to know whether *Efemérides ilustradas* fell short of Gustavo Casasola's commercial expectations. Perhaps the Porfiriato did not have the popular appeal he thought it would, or the design of the series may have been unnecessarily awkward, with a volume for every "year." At any rate, *Efemérides ilustradas* seems to have petered out around 1951 after arriving at the year 1904. Gustavo's first attempt to produce a more panoramic approach to Mexican history was the *Enciclopedia Histórica Ilustrada de México, 1325–1958*, which he dedicated to "ignored, forgotten and abandoned heroes," but the series does not appear to have prospered.[206] Instead,

he decided in 1962 to enlarge the focus under a new title: *Seis siglos de historia gráfica de México*. Here, the focus on the politically powerful is expanded to include activities of the upper class: society news about "distinguished matrimonies," high fashion, and cultural events such as the opera. Fawning over the wealthy, the pages of *Seis siglos* present us with women in fancy dresses who promenade around the Condesa Racetrack, their faces shielded from the sun by parasols and huge flowered chapeaus, and tuxedo-clad men wearing silk top hats who gather in front of their favorite watering hole, evidence of the leisure afforded by modernity. We are also shown functionaries that preside over the openings of public works, offering proof of Porfirian progress.

An expression of his longing for the days when class relations were easier, Casasola encounters docile workers as the counterpart of his Belle Epoch aristocracy. Hence, in the section on "Asuntos obreros, 1900–1910" (Workers' affairs), photographs feature well-behaved employees and members of a variety of mutual-aid societies: the men neatly dressed in coats and ties, the women in clean white frocks and seated with their hands held primly in front of them.[207] The strikes at Cananea and Río Blanco are mentioned, but the ocular focus falls on Mexico City's governor, Don Guillermo Landa y Escandón, "protector and friend of the working class," who is shown receiving decorations from workers and speaking to women who stand obediently to listen. The text is an eloquent tribute to Porfirian order: "At the invitation of the 'Mutual-aid and Moralizing Society of Mexico City,' Don Guillermo Landa y Escandón dedicated himself to visiting workers in the factories that are under his jurisdiction, during the last months of 1909. In all the factories, the owners or the administrative councils received him with great ceremonies. He toured the workshops and listened to the workers' speeches, ending his visit with a champagne lunch, where he drank a toast to General Porfirio Díaz and the country's peace."[208]

When they do not fit into the neat image of a modernizing proletariat— and are not being excoriated for engaging in "antisocial" activities—the lower classes are often represented as something picturesque, "popular types" who hang out and drink in *piqueras*, where they celebrate "Saint Monday" rather than going to their jobs.[209] If they are shown working, it is sometimes as performing disgusting tasks, such as digging through trash, an enterprise made palatable by Casasola's reference to the possibility of

extracting "Treasures from the garbage." The cutline that accompanied an image of a humble individual carrying a more wealthy man across a flooded Mexico City street is illustrative of the Casasola history's ideological bent: "The carriers' abuses were terrible. When they reached the middle of the street they asked for more money, if the client didn't agree they let him fall into the water."[210] What a revealing instance of how pictures can say such different things to different people—as well as demonstrating how dependent they are on titles! Where I see Mexico's extreme class differences reflected in the fact that some people have to carry others on their backs, Casasola saw only the "abuses" by the underdogs. He would bring the same sort of perspective to representing the 1968 student movement in his next, and final, version of the *Historia gráfica de la Revolución Mexicana*, where he inveighs against the "aggression" of the students against the police and army.[211]

NEW OCULAR CULTURES AND THE OLD

BATTLE TO VISUALIZE THE PAST AND PRESENT

(1968–2007)

The 1968 student movement was documented by cineastes on both sides of the struggle and was later recreated in different fictional forms. The vast majority of footage was taken by government filmmakers such as Demetrio Bilbatúa and Servando González; it was never edited into films and has only recently become available.[1] However, students enrolled in the Universidad Nacional Autónoma de México (UNAM)'s newly created film school (CUEC; Centro Universitario de Estudios Cinematográficos) decided that the screen was their battleground, and they took over the CUEC to produce what is considered to be "the most faithful portrait" of this period, *El grito* (The shout/scream/cry) directed by Leobardo López Arretche, with Alfredo Joskowicz (assistant director), and José Rovirosa (producer).[2] Although *El grito* became a fabled, almost mythical work, other documentarians were also producing pictures. Paul Leduc directed three of the four *Communications of the National Strike Council*, while Oscar Menéndez was making shorts, including *Únete pueblo* (People unite) and *Dos de octubre, aquí México* (2 October, Mexico here). Fictional films incorporating the experience also began to appear, including three directed by Joskowicz, *Crates* (1970), *El cambio* (The change, 1971), and *Meridiano 100* (1974), and one by Gabriel Retes, *Los años duros* (The hard years, 1973). Nonetheless, two powerful movies stand out in recreating the events of 1968: *Canoa*, directed by Felipe Cazals in 1975, and *Rojo amanecer*, which Jorge Fons made in 1989.

The acclaimed *El grito* grew out of the collective decision of the fifty to sixty students enrolled in the CUEC to provide an alternative source of information to the distortions of the news media, particularly those of Televisa.[3] Utilizing the CUEC's equipment and material, around twenty young men shared the three or four 16mm Reflex cameras to cover the most important events, but only one was powered with an electric drive, while the others required continual winding.[4] Leobardo López and Roberto Sánchez Martínez were the most active and experienced of the photographers, but among those who shot the eight hours of film that would eventually be edited into an hour and forty minutes were others who went on to become important names in independent cinema, including Rovirosa, Joskowicz, Francisco Bojórquez, Raúl Kamffer, and Juan Mora; Paul Leduc participated in taping some of the more than forty hours of sound collected for the documentary. Carrying the camera into the fray was not without its dangers, because the police treated the photographers as members of the movement, while some students were hostile because they suspected the crew of being officialist media.[5] One inventive way to hide the camera was created by Leobardo López and Roberto Sánchez to film the army's occupation of the UNAM in September 1968. Aware of the importance of documenting the violation of university autonomy—which is of great importance in Latin America, where the police and army are generally prohibited from entering campuses—they removed the rear lights from a car, and Sánchez drove around University City "like a lost tourist" while López filmed the occupying army from the trunk through the holes.[6] López was arrested while filming at Tlatelolco on 2 October but released two months later when he was not identified as one of the principal leaders.

In the beginning of 1969, the CUEC's director, Manuel González Casanova, called a meeting with Leobardo López, Roberto Sánchez, and Alfredo Joskowicz, in which he proposed that they make the material into a film. Joskowicz bowed out in favor of López; he believed that López had been closer to the movement as CUEC's representative to the National Strike Council, and he feared that Sánchez had developed "very special, legalistic" notions that blamed the youthful rebels for the repression; it would appear that the majority of CUEC students supported López over Sánchez.[7] The filmmaker Marcela Fernández Violante, then Sánchez's wife, has a different story: she affirms that González Casanova flipped a coin to resolve the differences

between the two leading cineastes.[8] A professional editor, Ramón Aupart, offered to work without pay in the edition, believing that it would take a month.[9] However, the equipment was old and clumsy, and it took them a year, working daily from seven to ten in the morning and from nine at night until one in the morning, the time Aupart could spare from his job. The right wing was exhilarated by the repression and mobilized to finish off any remnants of the movement. One of their organizations, "El muro" (The wall) attempted to destroy the footage but failed. *El grito* was finished around the end of 1969 but was not shown publicly until 1975, when a copy that López (who committed suicide in 1970) had given to the Cuban embassy was recovered by a CUEC student, who presented it in the National Polytechnic Institute and then at the UNAM (where González Casanova appears to have blocked its exhibition).[10] The first feature-length movie produced by the CUEC, it became a regular feature in university cinema clubs, schools, and unions, though the government evidently prohibited its transmission on television as late as the 1990s.[11]

Composed of four parts that move in a strict chronological sequence — "July," "August," "September," and "October" — *El grito* hovers between newreel-like neutrality and agit-prop commitment. The moving footage often appears to limit itself to simply presenting events, a result no doubt of the participation of so many different cameramen with greatly varying experience. However, the edition of still photographs and the soundtrack are a searing indictment of the army and police, as well as the president and ruling class, for their role in the repression. There is little omniscient narration after an early description of the movement's origin in the overreaction of the police to a fight between student groups. Instead, the text is largely composed of speeches given at rallies and marches — which seem to have been the organizing principle for López — along with the testimony of the Italian journalist Oriana Fallaci.[12] Although the track is never in sync with the image, the constant incorporation of source sounds — chants, speeches, singing, shouts, screams, sirens, helicopters, and gunshots — usually gives the appearance of respecting a documentary time-space continuum, though it is unclear whether this is a result of the filmmaker's attempt to infuse the material with the "neutral" look of newsreels, his inexperience in directing documentaries, or the influence of the "direct cinema" that was developing in the United States and Europe, made possible by increasingly lightweight

equipment.[13] This pretense of objectivity is carried to its extreme in a seven-minute sequence that begins "September," in which the president's speech is accompanied by illustrative imagery that makes no attempt to contradict the spoken.

At times, however, *El grito* seems to move more in the direction of revolutionary Cuban documentary, as when it creates collages reminiscent of Santiago Alvarez's dynamic shorts: photos of soldiers marching are accompanied by the drum of boots; cries and muffled sounds of pain are heard during scenes of students being beaten.[14] The incorporation of still photos—some by the Hermanos Mayo and Héctor García (see, for example, figures 39 and 41)—gives the film a visual edge that was not captured by the moving footage. Often employed in the 1960s and 1970s by young leftist filmmakers, this aesthetic strategy also allowed the director to include much poster art, cartoons, and murals from the movement, including the frequent appearance of Che Guevara effigies, once accompanied by the chant "Fidel, Fidel, ¿qué tiene Fidel que los americanos no pueden con él? (What is it about Fidel that the Americans can't deal with?).[15]

Although notions such as *la mexicanidad* or *lo mexicano* had taken on an old-fashioned scent, the issue of national identity is explored through the juxtaposition of sound and image in two telling sequences. The first is considered by the editor to be "one of the film's most emotional scenes," that in which the national anthem is sung by protestors.[16] The Zócalo—which had previously been strictly reserved for official activities and prohibited to protestors—is full of people, but as the anthem begins, the film cuts to the police forming to attack, and sirens are heard as we see faces of participants looking threatened. Tanks roll through the crowd, and people rush to vacate the plaza as soldiers with bayonets appear in both still and moving images. The anthem is increasingly covered over by women's screams, and cries of "Viva México" mix with the sound of ambulance sirens. Finally, the anthem is replaced by an interview with Professor Heberto Castillo, hospitalized after a beating, who maintains, "I have no weapons other than my ideas." The nation has been submerged in blood, and President Gustavo Díaz Ordaz (1964–70) is clearly identified as the author in posters describing him as an "assassin." The movie ends with a sequence about the Olympic games, which initially appears to be a curious decision. However, the images are presented together with the somber and repetitive beat of a single drum,

alluding to Indian musical forms. The rulers may well have prided themselves on being the first developing country to organize an Olympics, but the death knell sounded by the indigenous cadence signals the beginning of the dictatorship's end.

The film is certainly more an emotional remembrance than a political analysis.[17] Emilio García Riera criticized *El grito* for what he felt was its pretense at being "rigorously historical," arguing that it was "falsely objective" and "sentimental," as well as that it reflected the lack of a documentary tradition in Mexico.[18] The underdevelopment of documentary cinema is perhaps that which most affected López, for the "objectivist" approach may have been influenced by some immediate visual antecedents in recounting the national past, among them the officialist compilation film, *Memorias de un mexicano* (1960) and the fawningly presidentialist *historias gráficas* produced by the Casasolas. López's decision to allow the protagonists' speeches to determine the narrative (with poor unsynced sound and without dates to orient his viewers) and to include a great amount of imagery photographed by sometimes unskilled cameramen created a film that appears to register the events as they were (to those with experience of them). It also makes for a frustrating sensation of disorientation that is sometimes tedious. Despite its shortcomings, *El grito* was considered by Carlos Mendoza, today's leading documentarian, as "a live testimony, if very imperfect, with much vitality, much freshness, much responsibility, and of great value."[19] The fact that it was included among the fifty best Mexican films speaks to its transcendence in initiating a documentary sensibility in the country.[20]

The influence of *El grito* can be observed in the documentary effects Felipe Cazals utilizes throughout the fictional *Canoa* as a tactic to buttress its credibility and remind viewers that it is based on a real occurrence. The most apparent of these are the newsreel-like titles that appear identifying the dates and times of the events in which young workers from the University of Puebla (UAP-Universidad Autónoma de Puebla) were brutally attacked by townspeople egged on by a rabidly anticommunist and paranoiac priest. *Canoa* was a product of the cultural policies promoted by President Luis Echeverría (1970–76), who sought to put Mexico on the map—and make himself a leader of the Third World—by displaying its uniqueness: for example, he and his functionaries often wore *guayaberas*, the loose-fitting embroidered shirts that can be formal wear in the Yucatán, as well

as in Cuba, which allowed the president to visually, if obliquely, assert an anti–U.S. sentiment. Film was central to Echeverría's "Democratic aperture," because creating a cinema of "authors" offered a way for him to reestablish his legitimacy with intellectuals and artists disaffected by the Tlatelolco massacre. He was evidently taken with a phrase coined by respected filmmaker-intellectual Alberto Isaac: "A people without cinema is a people without an image."[21]

The president appointed his brother, Rodolfo Echeverría, to head up the state's efforts to produce a cinema worthy of the leader's aspirations and different from the wretched fare that commercial producers had provided in the 1960s. Rodolfo articulated his conception of what Mexican film ought to be: "Before, cinema was empty, escapist, completely apart from the national entrails; it had nothing to do with our history, although they made historical films; it had nothing to do with our land, although they made so-called moves about the countryside; it had nothing to do with our emerging middle class, even when they made movies with these people. I wanted another cinema, a cinema the size of Mexico."[22] The new mode for making movies was to be that of "package" pictures, which were funded through a novel combination: the Banco Cinematográfico paid the production costs, and the film's workers postponed their salaries in the hopes of receiving benefits when the pictures prospered. The Echeverrías' efforts and the participants' patience produced a number of films that stand out in Mexican cinema: Luis Alcoriza's *Mecánica nacional* (1971), Felipe Cazals's *El apando* (Isolation cell, 1975, based on a work by José Revueltas), Miguel Littin's *Actas de Marusia* (1975), Jorge Fons's *Los albañiles* (Construction workers, 1976), and Paul Leduc's documentary *Ethnocidio: Notas sobre el Mezquital* (1976, based on the research of Roger Bartra).

Canoa was the first "package picture," and it tells a horrifyingly blood-splattered tale of an ill-fated mountain-climbing expedition by five UAP workers. They had intended to scale the tallest peak closest to Puebla, "El Malinche," a popular sport among the city's young athletes. However, a storm forced them to take refuge in the village of San Miguel Canoa, where a corrupt and fanatical priest uses his religious influence, economic control, and political power to drive the villagers into a frenzy that eventually leads them to attack the group, and their fellow townsman who had sheltered them, with machetes and rifles. Two are killed, and the other three are badly

cut up before the police arrive to save them. The film's form is a version of the fictional documentaries made during the 1960s, such as *Memories of Underdevelopment* (Gutiérrez Alea, 1967, Cuba) and *The Battle of Algiers* (Pontecorvo, 1966, Italy), depicting an unstable time that moves back and forth between past and present. Suspense as to the outcome is eliminated by revealing the end at the very beginning, one of the work's distantiation techniques; as the scriptwriter Tomás Pérez Turrent described, "It's as if we 'cool down' the spectator when he's hottest. It's like saying, 'Wait, don't let yourself be pulled along by the action and only your emotions.'"[23]

Canoa was born from the pen of Pérez Turrent, a cinema critic and investigator in the UNAM Filmoteca, who carried out research around the incident on which the movie is based. His script was selected by the Banco Cinematográfico, and Jorge Fons was offered the opportunity to direct it; Cazals entered when Fons backed out. Cazals used unknown actors in order not to distract from "our fundamental proposition: to remind the spectators that in 1968 anyone who looked like a student could be lynched."[24] He was also concerned to make Mexican audiences look at ordinary faces, "the antithesis of those venerated national stars, never forgotten and eternally overacted."[25] The use of unrecognized actors also contributed to the documentary feel, as did the incorporation of the survivors. Pérez Turrent had contacted the surviving UAP workers, and they collaborated in writing the script; as one remarked, "You could say that we did the story together; the whole script is our information, is our Stations of the Cross (*via crucis*)."[26] One is reminded of the film by the Bolivian director Jorge Sanjinés, *Courage of the People* (1971), in which he reconstructed the army's massacre of miners by having the very people who had lived the tragedy proudly act it out for his cameras. Nonetheless, Cazals's commitment to the participative ethos of the New Latin American Cinema was limited. The survivors wanted to appear in the film and were finally given bit parts. However, they felt that they had been poorly paid; moreover they were not mentioned in the credits nor were they invited to the premiere.[27] Moreover, *Canoa* could not be filmed in the town where it took place, because the attempt might have led to a genuinely documentary coverage of a (second) bloodletting![28]

Canoa begins with a curious title: "This did happen" (*Esto sí sucedió*), a text that could be an assertion positioning the film in opposition to the

familiar Hollywood legend "Based on a true story" or might be read as if raising doubts about the reality of other repressions during 1968. The film opens with a reporter telephoning information about the killings to his Mexico City newspaper; that some of the information is later determined to have been mistaken is part of Cazals's criticism of the media. The film then moves to what I would describe as a red herring that references the memory of the army's participation in the Tlatelolco massacre to anticipate what the audience expects will be the movie's story. Two simultaneous marches in Puebla's center appear to be headed for a collision: from left to right soldiers tramp, their boots resounding on the colonial stones; from right to left students walk mutely in mourning for their dead comrades, a reference to the famous "Silent March" in Mexico City. The tense and increasingly rapid cross-cutting between the groups is intended to signal their imminent confrontation, a metonym for Tlatelolco that was certainly on every audience member's mind. However, at the very last split cinematic second, the army swerves to the left, eschewing a clash. The expected battle of students and soldiers has been avoided thanks to the state's planning, which has foreseen that eventuality and designed the marches' routes so that they would not run into one another. Hence, the film establishes that neither the army nor the state was to blame for the unavoidable referent—the Tlatelolco massacre—as the movie's titles appear over black-and-white, ill-lit, hand-held images of bloodied bodies and *campesinos* held back by police (see figure 44). The documentary assertion, which convinced some critics that the film was "objective," continues with a voice-over that provides some history about the region, followed by an on-camera narrator who describes the priest's iron lock on the villagers' lives and economies.[29] The truth-claim of documentary is utilized throughout the film, which provides a chilling if scintillating reconstruction of the butchery caused by the priest's manipulation of the villagers; the carnage is stopped only by the arrival of the police.

Well attended and much commented upon, *Canoa* was even sometimes front page news. One contemporary reviewer felt that it wanted to be "denunciatory" but "fell into the tremendous abyss of leftist indoctrination"; another thought it was a "virile and valiant denunciation that shakes up consciences" about injustice.[30] Carlos Monsiváis found it to be an "exceptional film with an excellent script" and called for more such movies of the

44. The documentary feel of *Canoa* is conveyed in the beginning with a struggle between police and *campesinos*. Frame enlargement, *Canoa*, 1975. Filmoteca de la Universidad Nacional Autónoma de México.

"testimonial genre," "to re-examine the killings and murders of dissidents."[31] The Catholic Church rushed to the priest's defense, saying that the film "deformed the facts," and in 1981 the bishops of the Latin American Episcopal Council went to the Canoa church to sing the Mexican national anthem.[32] The priest, who appears to have been exactly as the film depicted him, cooperated reservedly with interviewers but assured them that he had been declared innocent. He did, however, continue to claim, as he had in San Miguel Canoa, that "they" had come to kill him: "I'm no saintlier nor better than other priests who have died for the faith; if you want to, shoot me."[33] Inhabitants of San Miguel Canoa felt that the film "damaged the image of all Mexico"; however, they were particularly concerned about its effect on their youth, who seemed to feel that being portrayed in such a critical way gave them the license to act it out: "They make us look like savages, and groups of young people from San Miguel Canoa that have seen the film do their best to act like savages."[34]

Some have attempted to deny that the film is a metaphor for '68 and the Tlatelolco massacre, beginning with the director and script-writer. Pérez Turrent asserted: "*Canoa* is not and never pretended to be a movie on the events of '68. . . . Years later a friend said to me that he read *Canoa* as a metaphor for 1968: a climate of hysteria, the massacre, and some days later the

great party, as if nothing had happened. Delirium of interpretation? In any case, I never thought that nor did it occur to me to script it out that way."[35] Others assume the obvious: it is ingenuous to believe that a movie about students, communism, police, and bloodletting would not immediately and incessantly thereafter be seen as a synecdoche for that period's strife. Carl Mora was among the most effusive in finding it a direct reference to '68, as well as critical of the government's repression: "It is nothing short of miraculous that the regime would permit, much less produce, such a statement on the events of 1968, especially so since at the time the incumbent president was widely thought to have been directly responsible for the army's attack on the demonstrators."[36] A contemporary critic praised *Canoa* for "destroying the myth that '68 couldn't be mentioned in our cinema," and he felt it was "representative of the 'democratic aperture' in our film."[37]

Some critics felt that *Canoa* led audiences astray. The novelist Jorge Ibargüengoitia closed his review thus: "Take note: a film of denunciation related to the events of 1968 presents a village priest as the guilty party, and the police as the salvation."[38] To Jorge Ayala Blanco, the film was "very irritating" as an allegory of '68, because it "inverted" the real situation.[39] In responding to this much-voiced opinion, Pérez Turrent insisted that it was "absurd," because the police really did rescue the workers: "I have no fear of narrating things as they actually happened."[40] Nonetheless, his argument ignores the fact that the real event he *chose* to write about depicted the Mexican people as savages who can be held in check only by government force. One wonders whether Pérez Turrent would have represented the *pueblo* as the aggressors at Tlatelolco. However, despite the dissatisfaction of some, Cazals's luck in having *Canoa* be the first "package" film was confirmed when the movie was selected in 1997 to be the primary work to be restored and redigitalized by the Mexican Film Institute.[41]

I would describe *Canoa* in terms of a ploy that has often been used by the Mexican government in its relations with the working class: when it wishes to bust a union, it creates a "phantom syndicate" that it supports while it attacks the original union until it has been destroyed. For example, this was the strategy Echeverría carried out in creating an alternative group within *Excelsior* that then forced the editor, Julio Scherer, to resign.[42] In the case of *Canoa*, the Echeverrías (Luis and Rodolfo), together with Pérez Turrent and Cazals, created a "phantom memory" of '68. The wounds of Tlatelolco

were so deep that they had to be addressed, hence the government financed a film that appeared to be telling that story. Consequently, *Canoa* killed two birds with a single stone. On the one hand, it stood Tlatelolco on its head by asserting that the Mexican people are barbaric; as in *María Candelaria*, the brutal, ignorant, blood-thirsty *pueblo* requires the patriarchal control of police and army. On the other hand, *Canoa* filled the cinematic space for '68—once a fictional movie had been made about those events, it would be some time before funding for another could be found.

It was not until 1989 that the Tlatelolco massacre was brought to the screen with *Rojo amanecer* (Red dawn), directed by Jorge Fons. He accepted this project because it met his precondition: Fons must be enamored of a script in order to be able to make the movie. "The only guide I have in choosing a film is that I must be completely in love with the work I am going to take on, if not I'd rather wait another year, or ten, or fifteen, as I did between *Los albañiles* and *Rojo amanecer*."[43] The script was written by Xavier Robles and Guadalupe Ortega Vargas, with funding from the Banco Cinematográfico, but to receive a subsidy for filming it was necessary to send it to the Script Supervisory Council of the Secretariat of Gobernación, and the secretary himself had indicated that no film on the massacre of 2 October would be allowed.[44] A friend within the council told them how their work would be dealt with: "They'll put it in the most hidden of boxes, and they will tell you neither yes nor no; think of another project."[45] However, government bureaucrats had not counted on the tenacity of the actor who was to play the lead, Héctor Bonilla, who broke his "piggybank" and put up 45,000 pesos (around $15,000) to begin production. Fons assembled friends as actors—María Rojo, Bruno and Demián Bichir, Eduardo Palomo—and they worked without pay, providing their own clothes for costumes. After a week, Bonilla's money was gone, and nobody wanted to back the film once they heard it was about Tlatelolco—except one acquaintance who brought Fons 25,000 pesos in a bread bag and told him: "Take this, don't sign anything, I don't want to know anything, you're crazy, I don't want to be mentioned, and I don't even want this money back."[46] The movie was filmed clandestinely at night in a warehouse on a set the participants constructed that was furnished from their own homes, under difficult conditions—roosting pigeons cooed constantly and had to be frightened into silence when a scene was being shot. The director and actors also lived with

the fear that they would be discovered and arrested, the film destroyed and the production stopped. It was a cooperative, almost artisanal work until a producer, Valentín Trujillo, entered the scene; though he was able to provide the funding to finish the work, it appears that he slowed the film's international distribution.[47]

Once it was made, government censors would not allow the film to be released, until Fons and cast members brought up the problem at a meeting of the General Society of Mexican Writers (SOGEM). The intellectuals mobilized; the timing was good because Carlos Salinas de Gortari (1988–94) had entered office a weakened president, having won the 1988 election by fraud. As a Harvard-educated neoliberal, he saw no reason to continue with the charade of the revolutionary heritage. In allowing *Rojo amanecer* to be shown, and in releasing the long-censored *La sombra del caudillo* (a film made in 1960 by Julio Bracho), he distanced himself from former PRI regimes. The government entered into a series of negotiations with Fons and eventually required him to remove the film's references to the army.[48] However, by the time the censored version was finally released, pirated copies (evidently made from the original in the censors' hands) were available on Mexico City streets. Fons says he considers it a unique case in which he celebrates video piracy, which has allowed the original version of *Rojo amanecer* to be seen in many parts of the world.[49]

The screenwriters recognized from the beginning that a film on the Tlatelolco massacre would have to be a very cheap one made with a limited number of actors. When they contemplated what would have been the typical scenario for such a movie if made commercially—a "cast of thousands" that would be required to fill Tlatelolco Plaza with protestors, plus the police and soldiers, whose participation would require official permission—they knew that he would have to find an innovative solution to portraying the events. Focusing on one family, and their experience of 2 October, was the answer.[50] In a certain sense, the director and scriptwriters were recreating a version of daily-life photojournalism, in which meaning is developed in the relation to the larger whole; as Fons explained, "*Rojo amanecer* could have been a meaningless film because there is nothing interesting about a family eating, or the children going to school, or the father being a bureaucrat, or the mother being a housewife—their stories are nothing in the face of the massacre; what makes it interesting is that it reflects what is going

on outside."[51] One could argue that it is precisely the very ordinariness of the personas that brings home to the public the idea that the film's events could just as easily have happened to them.

The film begins on the morning of 2 October, with a typical Mexican family—father, mother, grandfather, and four children, two in the university and two younger—carrying out their daily routines. Political discussions occur of the kind that must have been taking place in households all over Mexico: the grandfather defends the revolutionary government for which he fought and was wounded in 1917; the students express the repulsion for the dictatorship they have developed as part of the UNAM movement; the father warns of the gossip at his office that a repression is in store as a way of scaring the students into submission; and the mother tries to maintain domestic peace. The sense of normalcy that Fons establishes—and reestablishes time and again—is crucial, for the state's violence is then seen to be all the more outrageous. In this sense, *Rojo amanecer* is a much more textured film than *Canoa*, which is one long nightmare. Instead, Fons creates a sense of normality that is suddenly violated by the massacre, which occurs between six and seven in the evening—the constant visual and audio references to clocks add to the film's tension. However, after an hour of gunfire, the worst appears over; the family is safe, although endangered because the sons have brought with them some young people fleeing the plaza, including one who is wounded. An hour later, danger resurfaces when soldiers bang on the door, only to be dissolved as the grandfather shows them his military credentials. Normalcy is again established, as electricity and telephone service—which had been cut by the government to isolate Tlatelolco—return. Abruptly, bursts of machine-gun fire break out, and all huddle in fear; after thirty minutes, the firing stops. The family returns to domestic things: bedding is prepared for the visitors, and then all eat a late dinner after the father's delayed return. These quotidian activities give the impression that the repression has ended, and plans are made for the departure of the guests in the morning. However, with a dawn that could have brought peace and reconciliation, the real nightmare begins: paramilitaries dressed in civilian clothing enter the apartment, discover the students hiding, and massacre the entire family when they attempt to flee (an encapsulation of what occurred in the plaza). The youngest boy is the only survivor.

The domestic situation is a synecdoche for Mexico and the revolution.

Family values are seen to be predominant: even in disagreeing, the young display respect for their elders. For instance, the wounded student is less preoccupied with his injuries than with the fate of his younger sister, who was lost in the plaza and with what his father will say about his irresponsibility. The family around which the film turns incarnates the revolution. The grandfather fought in it, something his allusions and his limp remind us of constantly; his daughter shows her affection to her revolutionary father by the way she lovingly dusts the photos of him in uniform. The father is a bureaucrat for the PRI government, evidently of some influence (although the gunman who kills him observes that it is now the pistol that is determinant). The children are in the public school system constructed by the revolution. Hence, the killing of the family represents the destruction of the revolution, and of Mexico itself. It is replaced by stark violence, and the lies of the media, particularly television.

Rojo amanecer is a taut condemnation of official repression, with an extraordinary rhythm; it is one of the finest examples I know of what the Cuban filmmaker and theorist Julio García Espinosa described as "imperfect cinema," costing only 310,000 pesos (around $100,000) to make.[52] It was generally very well received and was seen by more viewers than any other film in Mexico during the last months of 1990, beating out *Pretty Woman* (Marshall, 1990) at the box office.[53] An important critic, Gustavo García, was less positive, feeling that it pandered to a culture of fear.[54] One criticism that has been leveled at the film is that it appears to exonerate the army. The scene with the lieutenant who comes to the apartment gives that impression, for he does not persecute the family (once it is established that the grandfather is a veteran), and he tells the paramilitaries to stop torturing some captured youth. However, that impression would have been balanced in part by other scenes that linked the military to the massacre but whose censoring was crucial to obtaining the film's release; those short sequences and expressions (around two minutes total) can still be seen in the original pirated version.[55] The Mexican army has been as untouchable as the president or the Church: as Xavier Robles remarked: "It is almost impossible, even today, to show a film that speaks openly against the army's position."[56] That would not change until almost twenty years after *Rojo amanecer* was made.

Photographing Mexico

Social movements in the late 1960s and early 1970s brought new actors to the fore as representers and representatives of national identity in photography; nonetheless, the genres were familiar: independent photojournalism and the documentary picturesque. The massacre in Tlatelolco Plaza was a watershed in Mexican history: the governments that followed this tragic event recognized the necessity of opening spaces for the freedom of expression. Julio Scherer was editor of *Excelsior* in 1968, which he had made into the most important newspaper in Latin America. He refused to accede to the official line that the rest of the Mexican press trumpeted unquestioningly; in a typical conflation of president and *pueblo*, Díaz Ordaz screamed demagogically at Scherer, "When are you going to stop betraying this country!"[57] Díaz Ordaz's successor, Luis Echeverría, created a group within the newspaper that permitted him to carry out a coup to remove Scherer and his principal collaborators. They left *Excelsior* and founded *Proceso* in 1976, the first lasting independent periodical, which was soon followed by more visual media, the newspapers *Unomásuno* and *La Jornada*, where the New Photojournalism of Mexico took root. The feminist movement of the 1970s also contributed novel perspectives, as women such as Graciela Iturbide and Flor Garduño became internationally recognized photographers largely because of their imagery that portrayed women as the new national essence.

The New Photojournalists, and their impulse to represent Mexico in a different way, were made possible by the founding of periodicals whose critical perspective had long been wanting in the country's press.[58] The magazine *Proceso* had opened the door to contestatory journalism in 1976, but the link to photography was not firmly established until the 1977 birth of the newspaper *Unomásuno*; with the founding in 1984 of *La Jornada*, the most critical of Mexican dailies, imagery became a fundamental element. These newspapers offered opportunities unique for graphic reporters: photojournalists participated in the editorial process, could sometimes propose their own assignments, and retained the rights to their negatives. At the same time, the dailies' pages were opened to pictures not directly related to hard news, and the papers published images of daily life activities such as those Álvarez Bravo, Nacho López, Héctor García, and the Hermanos Mayo had

explored in earlier periods, although those photographers rarely had the opportunities to see them appear in print. By allowing for the publication of photography not immediately tied to illustrating "newsworthy" events, and in permitting photojournalists to develop their own themes as well as keep their negatives, these publications led to the development of a documentary style within a daily format, a highly unusual situation that resulted in the flowering of a unique realist aesthetic.[59]

"Inclusivity" is the concept that seems to best encapsulate the New Photojournalists. Their emphasis on the quotidian allowed the common people of Mexico to appear in the media alongside male politicians. Their visual questioning of presidential authority brought the formerly all-powerful—and untouchable—figure down to earth, while their rejection of the PRI's monopoly inaugurated spaces for a political pluralism that eventually led to the end of the party dictatorship in 2000.[60] Their search for personal expression links photojournalism to the broader art world, and they have exhibited their imagery in photo galleries as well as published them in book-length photoessays, placed them on posters, and even seen them reproduced in murals.[61] Finally, the entrance of women has redefined what was formerly an exclusively male environment and perspective.

An image by Elsa Medina (1988) in which hands reach out from all sides to grab onto a subway pole introduces us to some of the elements that are novel about the New Photojournalism of Mexico (see figure 45). The focus on daily life and ordinary people is neither picturesquely condescending nor judgmentally tabloid. Documenting the straitened conditions of public transportation is an implicit criticism of the way the city and the country were governed under the PRI. In addition, the aesthetic approach ignores the classic rules of composition by using the space outside the frame to denote that this photograph is simply one thin slice of a scene that is repeated infinitely throughout the thousand square kilometers of Mexico's megacity. People grasp desperately onto a cold vertical pole in their crowded comings and goings between jobs, family obligations, and engagements—proverbial sardines packed on top of one another in subway cars. This microcosm of the effort required to survive in the great metropolis is presented in a document of subway life that is also a metaphor for contemporary urban existence: crowded, stressful, and competitive. The photo encompasses

45. Elsa Medina. Hands in
subway, Mexico City, 1988.
Elsa Medina Archive.

Mexico in a jumbled pyramid of arms and bodies that form around a woman
wearing the traditional striped *rebozo*—a metaphor for the Indian base of
Mesoamerican civilization—while at the top a man's baseball cap attests to
the pervasive U.S. presence in today's society.[62] A newspaper intrudes into
the frame, a reminder of minutes grabbed while rushing to work (as well as
a subtly self-reflexive reference to where the photo will appear).

The imagery of daily life produced by the New Photojournalists is nei-
ther folkloric nor officialist, neither sentimental nor sensationalist. Rather,
it attempts to discover and represent Mexico's reality in photographs that
insistently document the class differences that define the country. Instead
of disguising extreme social injustice with a nationalist formula that insists
that all Mexicans are somehow equal, its eloquent images go straight to the
contradictions. One example of this is a photo taken by Marco Antonio

Cruz in 1985 in which a humble street organist extends his hand, asking for money from elegantly attired women leaving the fine arts concert hall.[63] With great dexterity, Cruz captured the women's fearful look on being confronted by poverty and by the camera. This was a significant accomplishment, for it is very difficult to photograph the Mexican upper classes in any way other than as they want it done, and even more complicated to capture the rich and the poor in the same image. Another photo that alludes more elliptically to Mexico's profound class distinctions is Francisco Mata's *Belly Flop* (*Panzazo*, 1986) an image of a fat man diving into a crowded swimming pool that offers a humorous testimony to the city's overcrowding as incisive as Elsa Medina's.[64] Easter Week is a time to escape Mexico City's crowds, if you have the money to do so; if not, then you may find yourself among the multitudes at a packed public pool.

The New Photojournalists have engaged with the representation of their nation's history.[65] A primary strategy has been to comment on the porosity between the past and the present in Mexico; and in documenting those coexisting worlds they reject the essentialism that has characterized official forms of *mexicanidad*. Hence, Francisco Mata fuses the pre-Columbian and colonial past with the present in his 1989 photograph *Mictlán* (the Aztec god of death), picturing a man dressed in a skeleton costume for the Day of the Dead—a quintessentially Mexican celebration—as he walked up the subway stairs in front of the National Palace built by the Spanish.[66] In a powerful picture taken at the closure of Carlos Salinas's campaign during 1988, Elsa Medina recontextualized the PRI propaganda intended to legitimate him. She shot the scene in such a way that the enormous painted effigies of Francisco I. Madero and Emiliano Zapata dwarf the official candidate; hence, the historical icons called upon by the PRI to canonize its power seem to question whether Salinas is of their stature.[67]

The PRI's manipulation of Zapata's image was critiqued by Medina in another photo, when she caught Salinas as he was making a face at her in Los Pinos, the presidential residence.[68] Unfortunately for the president, he was unaware that she had framed his grotesque expression in front of a painting of the *guerrillero*.[69] The picture was taken during the dismantling of article 27 of the 1917 constitution, the cornerstone of agrarian reform that was a fundamental program of the Mexican Revolution. Hence, the relationship

Medina created between the elements within the photo leads to a clearly critical reading: the president ridicules the Zapatista heritage, even though the myth of the revolution, incarnated in the gigantic portrait of the *campesino* hero, served to legitimate PRI rule as heir to that social struggle.

The Chiapas rebellion represents an effort to redefine the nation. When the neo-Zapatista army entered into San Cristobal de las Casas on 1 January 1994, Antonio Turok was present to photograph them.[70] In the image of the rebel who points his rifle at the camera (and, by extension, at all who gaze upon the photo), Turok seems to embody visually an argument that Sub-commander Marcos would later articulate: "The Indians of the Mexican southeast—Tzotziles, Tzeltales, Choles, Tojolabales, Zoques, Mames—used to appear only in museum images, tourist guides and handicraft ads. The camera's eye sought them out as anthropological curiosities or the colorful detail of a long-ago past. The rifle's eye has made the cameras see them in a different way."[71]

Although photographing in the midst of combat, the New Photojournalists nonetheless took the opportunity to create images that link Chiapas to national, and Latin American, identity. Francisco Mata reworked a version of Manuel Alvarez Bravo's classic image *Striking Worker, Assassinated* in his photo of two neo-Zapatistas killed during the first days of the fighting.[72] The photo's center is bisected by rivulets of blood that stream across the road, while the head of one guerrilla and the feet of another barely enter at the margins of the picture, the space beyond the frame becoming an eloquent reference to other Mexicans who have given (and will yet give) their lives in a struggle for the most elemental human rights. Raúl Ortega is the photographer who best portrayed the first year of the neo-Zapatista rebellion, a period during which he spent much time in Chiapas and established personal relations with Marcos. His portrait of the subcommander in the act of lighting his pipe became a defining icon of the struggle, most of all as a best-selling poster.[73] It is an image which fits clearly into the visual culture of Latin American revolution, for the fire in the midst of darkness immediately brings to mind one of the most important documentary films produced in this area, *The Hour of the Furnaces* (1968). That movie's directors had taken their title from a statement by José Martí, Cuba's "Apostle of Independence": "Now is the hour of the furnaces, and only light should be

46. Pedro Valtierra. Indian women resist the entrance of soldiers into their communities, X'oyep, Chiapas, 3 January 1998. Pedro Valtierra/Cuartoscuro.com.

seen."[74] Later incorporated as the introductory statement of Che Guevara's most famous address, "Message to the Tricontinental," in 1967, it became a call for unity among the oppressed.

The contest over what Mexico has been, is, and is to become—in terms of both how it is represented as well as what it really is—may be encapsulated in the photo by Pedro Valtierra of the hand-to-hand battle between Indian women and soldiers (see figure 46). The most famous picture to come out of this rebellion, and one that has now been incorporated in neo-Zapatista murals, it portrays the base of *mexicanidad*—the Indians—rising up against the impositions to which they have been subject in reality and, as well, in the systems of representation with which the state has legitimized itself. They push back and seem to be winning the age-old struggle to define their culture in ways that differ sharply from the picturesque terms in which they have too often been depicted.

According to Patricia Mendoza, "La mirada inquieta" was the most polemical exhibit during the ten years that she directed the Centro de la Imagen, a period of great effervescence for the institution created in 1994 to be the nucleus of Mexico's photographic universe.[75] The controversies derived in part from the resentment of those who had themselves aspired to organize an exhibition on what was clearly a new form of press photography, as well as from those photojournalists and media that were not included, although nationalism may have also been a factor.[76] Even the review in *La Jornada* was chilly, as the reporter assigned by Braulio Peralta focused on the centralism of an exhibit confined almost entirely to Mexico City photojournalists, the inclusion of genres such as portraits that he did not consider journalistic, the lack of research in the periodicals, and the emphasis on certain publications, particularly *La Jornada* itself.[77] The newspaper visually underscored the message it wanted to give about the public's reception by showing a person at the opening looking away from one of the photographs on the wall as if censuring the exhibition.

Other mediums entered the fray in defense of their image makers. Humberto Musacchio flung the heaviest gauntlet in a three-part harangue that hammered away at the failure to include imagery from all the nation's newspapers and magazines, while other critics bemoaned the fact that the exhibit was not "representative" of Mexican photojournalism during the period covered.[78] What most detractors failed to recognize was that the exhibit was never intended to provide either an overview of the photography in Mexican periodicals or a visual history covering the most important events of the previous twenty years. Instead, the inspiration for "La mirada inquieta" came from the examples offered by the New Latin American Cinema, a project that began in the 1960s and is defined by very particular attributes that include the decision to use the medium to stimulate social change, the insistence on rescuing hidden episodes in order to revise national histories, the determination to make good movies with few resources, and, perhaps most importantly, the search for a Latin American cinematography.

In Mexico, the new cinema began with *Reed: México insurgente* (1970), directed by Paul Leduc, and includes such pictures as *El apando* and *Canoa*, both directed by Felipe Cazals in 1975, as well as Jorge Fons's masterworks, *Los albañiles* and *Rojo amanecer*. The concept could be extended to include recent movies, among them *La ley de Herodes* (Estrada, 1999), *Amores perros*

(González Iñárritu, 2000), *Perfume de violetas* (Sistach, 2001), *Y tu mamá también* (Cuarón, 2001), *Babel* (González Iñárritu, 2006), and *El violín* (Vargas, 2006). In this sense, "new" is not synonymous with "recent," and those who have studied the NLAC focus on the work of directors who are really authors in the true sense of the word, such as Tomás Gutiérrez Alea, Fernando Solanas, Glauber Rocha, and Jorge Fons, among others. Thus, one with such an interest would choose to analyze *Rojo amanecer*, for example, rather than the innumerable remakes of *La risa loca en vacaciones*, because the endless stream of wretched movies (known in Mexico as *churros*) produced by Mexican cinematic hacks are not really "new," even if they are recent. This was the sense in which I attempted to use the word in my study of "New Photojournalism," and the concept has become widely accepted as a form of referring to this style of photography, which probably reached its apex in the years 1984–88.[79] Although it has today practically disappeared from the periodicals, the most important photographers continue to produce innovative imagery while working freelance or as the directors of their own agencies.[80]

While the New Photojournalists express identity in historical terms, other image makers follow the familiar road of folkloric essentialism. Among the leading Mexican practitioners of the picturesque are Flor Garduño and Graciela Iturbide. Though they have necessarily abandoned such outmoded characterizations as cactus and clouds or the *charro* and *china poblana*, their strategy has been to reconfigure *mexicanidad* in the guise of women, particularly Isthmus Zapotec Indians, the most recent example of turning a local stereotype into a national archetype. The decision to focus on women could be interpreted as a result of these photographers exploring their own gender issues as part of feminism's impact; the influence of Bernice Kolko, the first to have explored the theme in her exhibit "Mujeres de México" (1955), which was mounted in the Palace of Bellas Artes; or simply having discovered a ready-made market.[81]

The Mexican most given to the stereotypical representation of her culture is Flor Garduño.[82] Her mode of operating is illustrated by a story told in Mexican photography circles, where it is said that Marianna Yampolsky, confused by the clothing worn by a person in a Garduño photo, asked her to which indigenous group the fellow belonged.[83] Garduño evidently replied, "Oh Marianna, you're so naive. I just grabbed those old rags out of my closet

and dressed him up in them."[84] Garduño's imagery confirms the suspicion that the story is true. For example, consider the staging of *Angustia* (Anguish, 1984): a woman with strong Indian features has been wrapped in a patterned robe and seated, fully clothed, in the midst of a pond, her lower body hidden in the water; the rocks behind her and adjacent shrubs allege that she is in a rural setting.[85] Her hair streams down into her face enough to convey anguished dishevelment, though it does not hide the pretty features that will make her sympathetic and marketable. The essayist for Garduño's first exhibit remarked that it was "disconcerting" that a young city dweller had chosen to focus on rural life but felt that Garduño would be successful because she had "assimilated the collective subconscious"![86]

In another image, *La mujer que sueña* (The woman that dreams, 1991), we are presented with an Indian lying on the typical *petate*, which she shares with two iguanas whose feet and mouths are bound. Garduño has carried on the traditional use of Indian women as a source of soft-core porn, posing her with blouse open so that her breasts are on view.[87] However, the woman is wrapped in an exotic skirt which functions to provide indigenous dress, as well as to cover the rest of her body, for full frontal nudity might reduce Garduño's clientele. This image would appear to "borrow" from two classic Mexican photographs. One was produced by Manuel Alvarez Bravo in 1938–39, *La buena fama durmiendo* (The good reputation sleeping), an elaborately composed photo of a nude that André Breton requested for a surrealist exhibit in Paris but which could not be included because the woman was completely naked.[88] The other is from 1979, when Graciela Iturbide posed a woman with iguanas on her head to create her famous work *Nuestra Señora de las iguanas* (Our Lady of the iguanas).[89]

Graciela Iturbide's much-circulated photo initiated the picturesque relationship of Indian women and this exotic symbol of Isthmus Zapotec identity, but it is probably unfair to place her in the same camp as Flor Garduño, for the latter is all too obviously motivated by immediate commercial concerns.[90] Iturbide makes complex and sophisticated imagery, "encountering the incredible in the quotidian, and the extraordinary in the ordinary."[91] Nonetheless, much of Iturbide's photography revolves around folkloric themes, and I believe that foreign audiences are attracted to her work because it is obviously exotic and different from what they see in their own lands.[92]

Although it is often reproduced outside its original context, *Nuestra Se-ñora de las iguanas* is actually part of a documentary project on the city of Juchitán, Oaxaca. Iturbide and the renowned Mexican writer Elena Poni-atowska collaborated to produce the book *Juchitán de las mujeres*, a paean to a mythical matriarchal society.[93] The women essentially recreate the nar-rative that outsiders have been constructing since the sixteenth century, whose "representations of Isthmus Zapotec women, while not monolithic, have tended to reproduce a common discourse that emphasizes women's strength, untamed sexuality, and exoticism."[94] Iturbide has asserted that she photographs "Mexican reality," and she feels that "Juchitán is a very strong and solid matriarchy."[95] However, Poniatowska and Iturbide appear to have followed the usual course in failing to consult with the Zapotec women, who evidently do not see themselves as matriarchs or believe that it would be the ideal state.[96] One Zapotec anthropologist, Edaena Saynes-Vázquez, argued that such a portrayal made her "angry," explaining, "There is a great differ-ence between self-identification as a Zapotec and descriptions of Zapotec culture provided by outsiders. Whereas outsiders argue for an egalitarian Zapotec society or for a society ruled by women, Zapotec women say: '*galán pa dxani*' (that would be great if it were true)."[97] U.S. commentators have accepted Iturbide's as a documentary, even anthropological, approach, and one praised the photographs' power to produce "a suspension of disbelief" that permits readers to accept the "fantastically exotic and unusual juxta-position" of *Nuestra Señora de las iguanas* "as the everyday occurrence that it is."[98] However, the book was not received with enthusiasm by all; some Zapotec women feel that the imagery is a nostalgic glance at a Juchitán long past, and they affirm that "the photos do not represent them, and they do not identify with the photos."[99]

Iturbide has explicitly critiqued photographers who "present a tour-isty and folkloric Mexico," although she ratcheted her exotic portrayal of the nation up another level in her following project, *In the Name of the Father*.[100] There, she presents us with what I would call the "grotesque-picturesque," in photos of the rather ghastly, though traditional, slaughter of goats brought down from the Oaxacan highlands by Mixtec shepherds at the end of the rainy season. Focusing on dead goats piled up on textured *petates* or whose bloated corpses lie next to sleeping babies, she visually portrayed her "fascination" with the butchery, finding it "erotic," as well as

expressive of the Mexican approach to death.[101] It should be noted that Iturbide is a wonderful photographer when she chooses to photograph her own society, and she has also demonstrated the capacity to capture the cultural blending that is so typical of today, as in *Mujer ángel* (1980), a picture that shows a Seri Indian woman in traditional raiment running into the infinite desert, a portable radio-cassette player in hand. Here, Iturbide created a synecdoche for the very process that she had observed of the Seris' dramatic adjustment from a life of nomadic artisanal production to their integration into commercial capitalism.[102] However, if you want to sell to foreign audiences (including agencies such as the Guggenheim Foundation, from whom Iturbide received a grant 1988), you must give them a Mexico that is dramatically different from their own countries, a Mexico that they have come to expect to see, thanks to image makers such as Hugo Brehme, Luis Márquez, Emilio Fernández, Gabriel Figueroa, and Bernice Kolko, among others, as well as in publications such as *National Geographic*.

While Iturbide and Garduño have made women into a metaphor for Mexico, some U.S. photographers have continued in a more typically picturesque fashion. Though we are accustomed to this in coffee table books, it is disappointing when U.S. academic presses follow the traditional route rather than seeking out innovative approaches. For example, David Burckhalter's *La vida norteña* is a work whose cover photo encapsulates its folkloric treatment: a cowboy from Sonora in a large white hat hugs a pretty little thing in a party dress; both smile salaciously for the camera while his horse waits calmly behind, occupying half of the frame.[103] An old car barely protrudes into the side of the image opposite the horse, situating the *norteño* society between two transportation modes, both archaic, and two eras. The photo's title, *Cowboy Love*, underlines the libidinous exoticism and offers one pole of "The Visual Celebrations and Laments of David Burckhalter" (as the essay by Gary Nabhan is titled). Within the book, the opposite extreme is provided immediately by the first image: an old couple stares sadly into the camera, holding a portrait of themselves when they were young. The strategy of creating a metaphoto that constrasts the vigor and beauty of a past youth with a weathered and tired present is well known, and the apparent self-reflexivity of this photo does not save it from being a pale copy of the sort of sentimentalism that made Sebastião Salgado famous for his book *Other Americas* (1986).[104]

Though we are insistently told that Burckhalter has spent the last twenty-five years photographing Sonora, there is little in the imagery to substantiate that claim. The culture is often seen from a distance, and there is no evidence of the rapport which would customarily accompany such an extended relationship. When close-ups are employed, they fall into the quickly exhausted formula of "celebrations and laments": children grin for the camera, while the aged look pensive and sad. Burckhalter's photography has little power or expressivity, and the quality of the essays can be judged by the assertion of one writer that a photograph of an *"ejidatario* standing beside a portrait of Emiliano Zapata conveys the failure of the Mexican Revolution and the betrayal of agrarian reform better than any analysis."[105] The image lacks the punch to carry the weight of this assertion but even if it were a forceful picture, it would still leave this reader surprised at finding such a claim in a book published by a university press.

Historia gráfica: Old Pictures, Familiar Frames

In 1973, Gustavo Casasola authored what would be the final version of the *Historia gráfica de la Revolución Mexicana*, continuing his collaboration with Editorial Trillas to produce a ten-volume set, with a very large printing of 25,000.[106] As always, he included recent photos, implicitly extending *La Revolución* into the present and thus aligning himself with the PRI's self-representation as the continuation, and legitimate heir, of the nation forged in the crucible of 1910–17. The last volume is filled with what seems to be an infinite number of photographs (1,482) made between 1965 and 1970 of presidential activities and reunions, government functionaries, official parades, and the armed forces.

The endless cavalcade of Great Men is briefly interrupted only by the student movement of 1968, when anonymous individuals abruptly replace official icons for some fourteen pages and seventy photos. Casasola's history of the Tlatelolco massacre provides a trenchant example of his much-professed "objectivity": according to him, mutinous agitators, armed with "automatic weapons of foreign manufacture," assaulted the police, which simply repelled their aggression.[107] Photographs are used to provide evidence of "subversive" activities: Molotov cocktails and buckets of paint that were going to be used by the "rebels." Casasola was confident enough about being able to determine the readings of images that he included one or

47. Rodrigo Moya. *Pinche comunista* (Fuckin' communist), striking worker beaten by police, Mexico City, 1958. Rodrigo Moya Archive.

another that witness police brutality: three officers beat a worker unmercifully, and the cutline makes it appear to have been necessary: "Agitators were subdued with rifle butts and night sticks" (see figure 47).[108]

The concluding pages of *Historia gráfica de la Revolución Mexicana* document the appointment of President Luis Echeverría's cabinet, presenting bureaucrats—gray men in dark suits—as if they constituted some sort of "revolutionary" government. The fact that all of Echeverría's cabinet members are male is expressive of a major metatext in this, and almost all *historias gráficas*, that is even more meaningful and pernicious: Great Men made Mexico, and they continue to make it. A familiar focus in picture histories within and without Mexico, male political leaders make up some 70 percent of all the photographs published in the *Historia gráfica de la Revolución Mexicana*.[109] As the Greatest of the Great Men, presidents appear in 52 percent of the pictures in volume 10, with Gustavo Díaz Ordaz, president during the Tlatelolco massacre, present in some 43 percent. Gustavo Casasola's insistence in documenting leaders can also be seen in his pub-

lications during this period of works such as *Hechos y hombres de México, anales gráficos de la historia militar de México, 1810–1980,* as well as illustrated biographies of Pancho Villa, Venustiano Carranza, Álvaro Obregón, Emiliano Zapata, Lázaro Cárdenas, and Plutarco Elías Calles.[110] This emphasis on headmen is consonant with the percentages found of them in the *historias gráficas* that would follow: *Biografía del poder* (75 percent), *Así fue la Revolución Mexicana* (60 percent), and *Historia gráfica de México* (50 percent).[111] The utilization of so many portraits makes me ask what we really learn from photographs of politicians, for their physiognomy tells us little about the past.[112] Instead, the real object of such imagery is to situate male chieftains as if they were *mexicanidad* incarnate, the sum total of national identity encapsulated in the effigy of a headman.[113]

The golden age of subsidized *historia gráfica* was the reign of Miguel de la Madrid (1982–88). This is appropriate, for his rule was the last gasp of "Revolutionary Nationalism," the PRI's strategy for co-opting cultural expression; in this case, it was employed as his campaign slogan to conceal the neoliberal transformation he was to introduce. At the same time that *La Revolución* began to be replaced by privatizations, de la Madrid's government paid for the writing, visual research, and mass printings of several voluminous series: *Así fue la Revolución Mexicana*, a sumptuously produced paean to revolutionary warfare; *Biografía del poder*, gossipy hagiographies of the New Order's heroes; and *Historia gráfica de México*, the obligatorily titled series hurriedly thrown together to take advantage of funds remaining in the *sexenio*'s final year.[114] Because the writing was usually farmed out to specialists, the history recounted in the texts of these works is markedly better than that of the Casasola albums, though the series are essentially illustrated histories, in which the essays have been constructed completely apart from the (sometimes limited) research undertaken for the imagery. With these works, Mexican historians were finally incorporated into the process of producing *historias gráficas*. In general, they have shown little interest in analyzing the country's extraordinary production of picture histories, a reticence that probably stems from two factors. On the one hand, those with some recognition are usually invited to participate in them, which can provide a supplement to their salaries; on the other, they fear alienating the powerful historians who often are the editors.[115]

Revolution, nation, and gender were intertwined in the series *Así fue la*

Revolución Mexicana (1985), which was produced by the Senate and the secretary of public education in celebration of 175 years of independence and the revolution's seventy-fifth anniversary. The government spared no expense: around 40,000 copies of each of the eight hard-bound volumes were published (a large print run in Mexico), on expensive paper, with texts provided by a significant number of established Mexican scholars. The series' officialism, and its recourse to history in defining the nation, were made clear immediately in the introduction provided by de la Madrid:

> In moments of uncertainty we Mexicans reflect on the principles, ideals, and successes of the project that brought us life as an independent nation. For the Mexican people, history is more than an inert image of the past; it is fundamental to national construction, and a guide for future action. One of the events that have most transformed our country's life is the 1910 Revolution, the great social movement that gave a new orientation to Mexico's historical development. This great historical turnaround, in which all social groups, all political currents, and all the country's regions participated, integrated the nation into one conduit of preoccupations and projects. Paradoxically, at the same time that it was a battle of groups and factions, this struggle unified the efforts of Mexicans to construct a nation . . . integrated geographically, socially, culturally, and politically, in a single national project.[116]

De la Madrid's magnificent distillation of official history is reinforced by the series' imagery, for "national integration" is effected fundamentally through pictures of the Great Men who made the revolution. However, in this fabrication, leaders who actually fought to the death against one another are instead portrayed as somehow constructing a unity: Zapata together with Madero (who betrayed Zapata) and Carranza (who had Zapata killed), Villa together with Obregón (who probably ordered Villa's death). If this were true, it would indeed be the paradox of which the president spoke. However, the "single national project" did not result from the armed struggle but rather was a concoction of the party dictatorship that controlled the postrevolutionary state.

Women's role in constructing the new nation is usually limited in the *historias gráficas* to being the unnamed wives of Great Men, the *Señora* of so-and-so.[117] However, they are allowed rare appearances when they can

be recruited to testify to the transformations wrought by the revolution. Hence, a photo of a woman working in a *nixtamal* (corn meal) mill was included in this series, where it was accompanied by a cutline designed to incorporate it into official history: "The workers' debts would not affect their families."[118] The image was situated within a discussion of "the problem of the workers," embedded in a text reproducing the provisions of article 123, the section of the 1917 constitution that "constituted the most enlightened statement of labor protective principles in the world to that date."[119] Placed in this context, the picture appears to illustrate the article's stipulation that a worker's debts could not be passed on to family members. Hence, the photo was presumably taken before the revolution that would cure social ills such as usury and thus *evidently* presents us with a middle-aged woman who had been forced to work at menial labor, because she had apparently inherited her husband's obligations at his death. Eliminating any reference to the date of the photo enabled the series' authors to give the impression that the woman suffered from the vulnerability of workers under the Porfiriato.

Nevertheless, this picture was taken in 1919, and the good intentions of article 123—printed around the photo and on the facing page—stand in shocking juxtaposition to the reality of this woman's condition and that of her fellow *nixtamaleras*. For example, the article contained far-reaching reforms related to women and childbirth: mothers were to be given a month of rest with full pay (and other benefits) after giving birth, including two extra breaks a day to nurse. When interviewed by Juan de Bereza (an investigator from the Secretariat of Industry, Commerce, and Labor), the woman in this image, Luz Duani (a widow with six children), asserted that the company "didn't give them anything."[120] Article 123 legislated an eight-hour workday and forbade women to work overtime. The women de Bereza talked to usually labored from 4 a.m. until 5 p.m., "without considering the time they spend liquidating accounts, which usually lasts until seven or eight at night." For a workday of thirteen to sixteen hours, the women received the "miserable salary" of from $.62 to $1.50, when the cost of living in Mexico City was around $2.50 a day, and despite article 123's requirement that the minimum salary be sufficient to satisfy the normal necessities of the worker's life, education, and honest pleasures. Although this article obliged owners to pay a legal salary, de Bereza wrote, "They pay them nothing for the sale of the company's corn meal, which averages 1000 kilograms daily. The

salaries must come out of the *maquila* [the corn brought in by clients to be ground], and if there's no *maquila* they pay them nothing." Article 123 stipulated that indemnification be provided for accidents or work-related illness; the women told de Bereza that not only did they receive no aid or compensation but, moreover, they lost their jobs and were replaced immediately. The women were virtual prisoners in the *nixtamal* mills and complained of sexual harassment by their "coarse and despotic" boss. De Bereza summed up their condition: they were treated "like slaves," a very different situation for women workers than that imagined through the use made of the picture by *Así fue la Revolución Mexicana*.

Biografía del poder was authored by Enrique Krauze, funded by the secretary of agriculture, and published by the prestigious Fondo de Cultura Económica in 1987, in a large print run: 40,000 copies were produced of each of the eight volumes that focus on Mexican leaders from Porfirio Díaz to Lázaro Cárdenas.[121] The series' very title predicts the anticipated emphasis on Great Men in picture histories. However, here the familiar strategy of reproducing images of political leaders is carried out ad nauseam: three out of every four photographs are of male political leaders, who are the work's be-all and end-all. Although the only visages in sight are those of History's Makers, the series was advertised on television as presenting "history's human face." This appeal attempted to benefit from the supposed "democracy" of photographs, as well as appearing to be based upon one of the real contributions photography can make to history writing by "personalizing the past": on seeing individual human beings, we remember that it is people who live out the realities of analytic abstractions such as class, race, and gender. Nonetheless, utilizing photographs as a way to bring into view individuals from the underside who have been largely excluded from dominant historiography is quite different from employing images of heroes to feed into the celebrity culture that is itself largely a product of modern visual media.

Biografía del poder demonstrates neoliberalism's transformation of Mexican culture under Miguel de la Madrid, which each succeeding president took at least one step further. De la Madrid was evidently convinced of the series' importance, and he communicated this on more than one occasion to the director of the Fondo de Cultura Económica.[122] Further, it was accompanied by an extraordinary publicity campaign that included

videotape productions on the eight heroes that were widely transmitted on Televisa. The tapes were realized in the typical compilation-film format of illustrative footage and photographs accompanied by interminable narrations, which resulted in movies that are aesthetically flat and of little interest as filmic history. Despite his failings as a visual historian, Krauze's relation with governmental agencies enabled him to accumulate an enormous corpus of Mexican images: the doors to the national archives were opened, and the pictures were paid for with public monies.[123] Krauze has used this mass of images to manufacture books (for his press, Clío) and television programs (for Televisa), which are far from the rigor one expects of history, even *historia gráfica*. However, the process by which he acquired the cultural clout he wields today was articulately analyzed by Claudio Lomnitz: "Krauze's power was amassed in a moment in which the government turned its back on public education and research and subsidized a process of cultural privatization that had similar characteristics to other privatizations: enormous concentration of power in very few hands, and the formation of a new elite."[124]

Historia gráfica de México also reflects the allure of Great Men. This series was published by Instituto Nacional de Antropología e Historia in 1988, with a print run of 11,000 of each of the ten volumes, and was profusely illustrated with poorly reproduced images on expensive paper. Though historical celebrities were not its thematic center (as they are in *Biografía del poder*), they are certainly the ocular core. For example, volume 8 opens with photographs of Adolfo de la Huerta, Woodrow Wilson, and Albert Fall; the insistence with which political leaders are featured is illustrated by the repetition of the same photographs of Lázaro Cárdenas (pp. 82, 154) and of Plutarco Elías Calles (pp. 70, 151). Volume 9 provides another take on presidentialism: the inauguration in 1970 of Luis Echeverría is shown in two different photographs, both of which are equally meaningless in terms of historical information (pp. 125, 154), because the only things that appear in the images are Echeverría and out-going president Gustavo Díaz Ordaz in suits, one of whom wears the presidential sash.

The participation of women, anonymous or identified, is extremely limited in *Historia gráfica de México*: they appear in some 2 percent of the photos. However, the editors did conscript for the cause one of the key revolutionary icons: that of the archetypical camp follower, whom they decided to

call "Adelita." For Mexican picture histories, the photograph of the woman who grips the handrails of a train car and leans forward to peer intently up the tracks has become "the paradigmatic image of the *soldadera*, the Mexican soldier's faithful companion."[125] However, without identifications that anchor photographs to their reality, their aesthetic force generates myths, decontextualized symbols that disfigure our understanding of the past. *Historia gráfica de México* provided the following cutline for this image: "Adelita-the-*soldadera*, a photo taken by Agustín V. Casasola in 1910, which would very soon become one of the emblems of the Revolution, just like the famous song with almost the same name, 'La Adelita.'"[126] This can only be described as a condensed comedy of errors. Although it should have been clear that the photo was not taken in 1910, because there were few troop movements in that year, revolutionary chronology led the authors to assign that date. Recent research has determined that the picture was published on 6 April 1912 and depicted the troop movements sent by Madero to the north to put down the rebellion of Pascual Orozco; the author was almost certainly Jerónimo Hernández.[127] Finally, it appears to have been the very editors of *Historia gráfica de México* who named this woman "Adelita," and it was almost certainly derived precisely from the corrido "La Adelita," the best-known of the songs celebrating *soldaderas*.[128]

The authors of *Historia gráfica de México* followed the usual practice of cropping the negative wherein appears "Adelita," removing the right half of the image (see figure 48). That part of the glass plate is broken in the original negative, but we can still see a group of women standing on the platforms of the train cars. When we ask who Adelita was, her location in the train may provide an important clue. *Soldaderas* of the rank and file usually traveled on top of, or underneath, the cars.[129] The women who were inside the cars were probably the privileged followers of federal officers.[130] The ragged clothing of this woman would seem to preclude her being an officer's *soldadera*; instead, she may well be a food seller (note the baskets) who has simply grabbed the train for a short ride.[131] Analyzed as a whole, the image could contribute to our historical knowledge about life during the armed struggle, for it provides clues about the living conditions of some women. The cropped version of "Adelita" only serves as another revolutionary myth, because the vitality evinced by this woman makes her a repository for, and symbol of, the attributes of the legendary *soldaderas*. One commentator on

48. Jerónimo Hernández. *Soldadera* or food seller, Mexico City, April, 1912. Inv. # 5760, Fondo Casasola, SINAFO-Fototeca Nacional del INAH.

the myth described it as being the "feminine version of the Revolutionary hero," in which women were portrayed as embodying the "attitude of indiscriminately following their men, whether they were right or not"; she asked whether it might not be preferable for women to develop their own criteria, thus "abolishing the 'sublime' concepts of Adelita and the *soldadera*, as well as the never sufficiently praised 'values' that are attributed to them."[132] In the 1980s, the image of "Adelita" became a centerpiece for women in struggle, as the seamstress union "September 19th"—created because of their manifold deaths in the 1985 earthquake—incorporated it in the large banners they carried as they marched demanding the right to organize.

In that same era, the officialist impulse given visual history led to the creation of a new icon that joined "Adelita" (and the images of Villa and Zapata described in chapter 2) in the revolutionary ocular pantheon. A picture of Victoriano Huerta and his general staff was featured prominently in the *historias gráficas* of the 1980s and became the signature image of the National Fototeca's exhibit on the armed struggle, "Insurgent Mexico."[133] This photo offers a fascinating story of technological failure and revolutionary rescue. It is evidently the result of a magnesium flash-powder that

malfunctioned, leaving Huerta and his officers illuminated only by the light that enters from a window to the side.[134] The effect is reminiscent of the expressive illumination that characterized film noir movies in the United States, in which "small areas of light seem on the verge of being completely overwhelmed by the darkness that threatens them from all sides," and the strange highlights that were produced often represented "the faces of the sinister or demented."[135] In this way, Huerta embodies the role of the heavy in the revolutionary picture, the visual incarnation of the counterrevolution that "whitens" the reputation of the other leaders. At the same time, this photo's rescue reflects the concern with photograph aesthetics, and with promoting research, of the Fototeca's director in that period, Eleazar López Zamora, for an image was discovered that could only be reproduced with fine printing techniques. In fact, the picture's impact depends completely upon its faulty lighting, because the "successful" photo of Huerta and his staff is of so little interest that Gustavo Casasola did not include it in the seventy pages dedicated to the Huerta regime in the *Historia gráfica de la Revolución Mexicana.*

Fictionalizing Frida: History and Transcultural Identities

Frida Kahlo's most famous picture, *The Two Fridas* (1939), offers a point of departure from which to interrogate the fiction films that have been made about the artist, Paul Leduc's *Frida, naturaleza viva* (1983), and *Frida* (2002), directed by Julie Taymor and produced through the efforts of its star, Salma Hayek.[136] This painting doubles the self-portraits that constitute much of this artist's oeuvre, confronting the question of identity head on. Two Fridas sit holding hands: one is clothed in the traditional Mexican attire the painter often affected, the other wears a white Victorian-era dress. The women's hands touch, and their material link is represented in the artery that originates in the exposed healthy heart of the Mexican Frida and runs to the also revealed, but diseased, heart of the European Frida; a severed vein that extends from the Victorian heart drips blood onto the white dress. The painting clearly represents a confrontation of societies, but it is not really "transcultural," if by that term we mean the energy produced by symbiotic interpenetration. Rather, "authentic" Mexico is represented as the source of life, which a strait-laced Europe bleeds off. The painting stands as a metaphor for the intertwined histories of Frida Kahlo, Mexico, and the

developed world, a visual rendering of what Eduardo Galeano would years later describe as the "Open Veins of Latin America."[137]

Interfacing different sets of "two Fridas" may provide depth to an analysis of her representation, somewhat akin to the way that the overlap of binocular vision furnishes information of a different logical type than that supplied by either eye alone.[138] The most immediate contrast is between the Taymor-Hayek movie and that made by Leduc. The former is a commercial film with a twelve million dollar budget, international distribution, and a flock of awards, including two Oscars. Leduc's is an independent Mexican film shot in 16mm and marked by the director's radical experimentation with temporal fragmentation and an almost total absence of dialogue; the recognition it has received includes the Gran Coral as the Best Picture of the 1984 Havana Film Festival of New Latin American Cinema (NCLA), where Ofelia Medina received a Coral as the Best Actress.[139] The stars of these films—another "two Fridas"—are among the most accomplished of today's Mexican actresses. Medina might well be considered Mexico's Jane Fonda, having consistently placed herself at the service of progressive causes such as the Neo-Zapatista rebellion in Chiapas. As Salma Hayek has taken control of her cinematic career, she has shown a desire to place rebellious women at the center of the big screen. After appearing in a number of insipid Hollywood movies, Hayek produced and starred in the film *In the Time of the Butterflies* (2001), an articulate denunciation of the Mirabal sisters' assassination in 1960 for resisting the dictator of the Dominican Republic, Rafael Trujillo.

The sexual politics of the Leduc-Medina and Taymor-Hayek movies differ significantly. In Leduc's film, Kahlo is always portrayed as an invalid, seated in a wheelchair, lying on her bed, or supporting herself with crutches.[140] Her sexuality is, in the main, limited to expressions of jealousy and rage over Diego Rivera's affairs. Conversely, the Frida of Taymor-Hayek is empowered through her sexual energy. While the missing leg of Leduc's Frida is signaled by the white sock worn on the remaining limb (see figure 49), Taymor's persona hardly limps, something many Mexican critics of the film pointed to as simply one of the movie's historical inaccuracies. However, representing a limp on film runs the risk of symbolically overdetermining a character; a limp in reality does not have the same connotation as it does on the screen.[141] Though the Frida constructed by Taymor and Hayek is

49. Frame enlargement, *Frida, naturaleza viva*, 1983. Filmoteca de la Universidad Nacional Autónoma de México.

based on Hayden Herrera's biography, it transcends that book's lachrymose harping upon Kahlo's physical and emotional pain.[142] Tears come easily in U.S. media; Taymor and Hayek's *Frida* is more Mexican, showing that life is a process of finding ways to live within the possibilities given us, rather than whining about its deprivations.

The Frida constructed by Taymor and Hayek is as sexual as the *Mexicana* in *The Two Fridas*. The sexuality that Kahlo emphasized in depicting her Mexican self with open legs was replicated by Salma Hayek in the image modeled on the painting that was reproduced on the invitation to the film's premiere in Mexico City, and in an opening scene of the film, in which a young Frida leads her group surreptitiously to watch Rivera paint a nude model (following the opening flash-forward of Frida near the end of her life).[143] The scene has a strong erotic charge that is immediately thereafter addressed by the love scene between Frida and her first boyfriend, Alejandro Gómez Arias (Diego Luna). In spite of her horrible accident (brilliantly rendered through an animated sequence), Frida is not reduced to asexual invalidism. When Alejandro comes to visit her, she attempts to seduce him,

though he rejects her advances. Moreover, Frida's accident is not shown to be a "punishment" for her eroticism, a strategy unfortunately too familiar in U.S. cinema. The acknowledgment of female sexuality in *Frida* stands in sharp contrast with Hollywood, where even good films such as *The Life of David Gale* (2002) and *The Unsaid* (2001) continue to represent women's desire as the fount of tragedy, which inexorably pushes the narrative to its disastrous ending.

Though *Frida* is a love story about the passionate relationship between two great artist-celebrities, the romantic saga is nevertheless impelled by material forces. Frida is the daughter of an artisan, Guillermo Kahlo, a photographer who has to scramble in order to provide the money for her expensive medical treatments. Hence, Frida knows that she must eventually earn her living, and the relationship with Rivera begins with her interrogating him as to whether he believes her work is good enough to provide that. Diego's need (or desire) for money is what leads him to accept a commission to paint the (subsequently destroyed) mural for the Rockefeller Center. He paid highly for his miscalculation, because the magnate's argument was decisive: though the mural may well be Rivera's creation, the wall belonged to Rockefeller. By contrast, almost all contemporary U.S. cinema is placed in luxurious settings: fabulous houses, exquisite interiors, expensive cars, first-class airplane seats, and clothing in the latest fashions.[144] Most importantly, this conspicuous consumption is often divorced from the labor required to attain such goods; prosperity, like manna, is heaven sent. Instead, *Frida* is shot in realistic settings and insists that even famous artists have to work for a living, as well as pay a price for selling themselves to the highest bidder.[145]

The fact that these films are about people who really existed requires that they be compared to what happened in "reality," that the Fridas of Leduc-Medina and Taymor-Hayek be interfaced with the "real" Frida. In avoiding an explicit declaration of their veracity, both movies differ from most biographical films, a genre about which George Custen observed, "Almost all biopics are prefaced by written or spoken declarations that assert the realities of their narratives."[146] Of course, the story of Frida Kahlo is so well known to Leduc's audience as to make such an assertion unnecessary for his picture. The fact that Taymor notes in the beginning credits that her film is "based on the book by Hayden Herrera" introduces a certain subjectivity

that is distinct from the credibility extended a work that is "based on a true story." In any case, contrasting filmic representations with reality—that is, what is constructed from written histories, personal memories, or accepted folklore—is not a simple issue of asserting that "it wasn't that way." Rather, the contradictions between what we know as reality and what we see on the screen must be interrogated. Which are the omissions and the errors? More importantly, what do they mean?

While the team of Taymor and Hayek is clearly attuned to the sexual politics of the real Frida, they seem less attentive to her politics in general. Certainly, it is an enormous advance to depict a member of the Communist Party as a human being, and *Reds* (1981) may be the only Hollywood film since the beginning of the Cold War to have found a communist to be an "acceptable subject" for a biographical picture.[147] Nonetheless, the artist's real participation in the Mexican Communist Party (PCM) is veiled in *Frida*. Time and again, Diego's political commitment is accented, while Frida's is minimized and portrayed as derivative; she is not shown to be the autonomous and self-motivated political individual that she seems to have been. Frida's entry into the party did not result from her relationship with Rivera, and she remained in the PCM long after Rivera resigned or was expelled. Her devotion to the cause is apparent in her last painting, an unfinished portrait of Stalin, which is absent from both films. Nonetheless, Leduc incorporates her political commitment by beginning his movie with a scene around her coffin, draped with the PCM flag in the Palace of Fine Arts.

Perhaps the political restraints of the Taymor-Hayek film are shown most clearly in what it chooses to depict as Frida Kahlo's last public act. The movie opens (as does the Herrera book) with a flashback that will be the film's finale: confined to her bed, Frida is carried from her home to the opening of her only exhibit in Mexico City. The agonies she suffered to attend are much underscored. Nonetheless, the actual last public appearance of Frida Kahlo took place more than a year later, and only eleven days before her death, when she must have withstood much greater pain to protest, in her wheelchair, the U.S. overthrow of the democratically elected regime of Jacobo Arbenz in Guatemala (see figure 50). Taymor and Hayek chose to emphasize personal gratification, making Kahlo into a prototypical bourgeois artiste, rather than depicting the courage and commitment of a dying leftist. Although it is understandable that such a representation

50. Hermanos Mayo. Frida Kahlo and Diego Rivera in a march protesting the involvement of the CIA in the overthrow of democratically elected Guatemalan president, Jacobo Arbenz, Mexico City, 2 July 1954. Archivo General de la Nación, Fondo Hermanos Mayo, cronológicos sobre 7937.

would have gone down poorly among audiences in Latin America's "Good Neighbor," the fact that Leduc does allude to this episode by having Frida pushed through the streets by Rivera, carrying a placard demanding "Peace," indicates how different the ideological constraints are within the United States and outside it.

Although the character of Frida appears to transcend cultural boundaries, it poses the risk of fitting readily into a typically "American" pattern. Hence, though both parents (the German father and the Oaxacan mother) are present, the artist is seen to be more a product of her own invention than a synthesis of Germanic and Mexican cultures. This is a very "American" idea, created by a society within which people are constantly inventing and reinventing themselves; and the fact that Frida Kahlo is represented in this way may have a distinct relation to the popularity her figure has achieved in the United States and the development of her persona as a new version of *lo mexicano*, feminized and transcultural. This penchant for autoconstruc-

51. On the way to the pyramids, the car passes among majestic magueys. Frame enlargement, *Frida*, 2002. Filmoteca de la Universidad Nacional Autónoma de México.

tion is typical of U.S. biopics: as Custen has pointed out, "In place of the family as a model of causality, Hollywood inserted self-invention, that most characteristic American form of personality construction."[148]

Identity formation within the United States is sharply bounded by the hegemony of capitalist ideology: if it is a country that accepts immigrants of many races and religions, they are all required to kneel before the altar of the all-powerful Mammon. For someone with Kahlo's uncompromising social commitment, the United States must have seemed suffocatingly materialistic. In *Frida*, Kahlo rejects it as a place in which "ambition" is the only thing that interests people; and the issue is played out in the relationship with Rivera, when she insists on returning to Mexico: "We don't belong here. I'm tired of *gringos*, and I'm tired of who you are when you are around them." Diego, the Mexican immigrant who recognizes the economic benefits of the United States, would rather stay, but Frida finds it to be a cold country, and the blue tones in which it is filmed convey that impression (just as the extensive interior scenes leave one with a sense of claustrophobia). On the other hand, Mexico is full of color (and luscious orange tones): folk art appears constantly in Judas figures and clay pots, boats adorned with flowers glide through the Xochimilco canals, the Day of the Dead makes its picturesque appearance, and exterior scenes shot at the pyramids incorporate the majestic magueys (see figure 51). Mexico is also shown to be a culture of song, and one singer in particular, Lila Downs (the daughter of a

gringo and a Oaxacan woman), provides an element of transculturalism as well as serving as yet another "Frida," given her physical resemblance to the artist.

Although the film may flirt with Mexico's innate exoticism, *Frida* is a healthy antidote to the way in which U.S. cinema has usually portrayed its southern neighbor. For example, classic films such as *Touch of Evil* (1958) represent Mexico as dark, dangerous, and chaotic, while in *Hud* (1963) it is the source of iniquity, the place from whence comes the dreaded hoof-and-mouth disease that threatens the family's ranch. Before *Frida*, U.S. films denied Mexican heroes autonomy and independence of decision. In *Juarez* (1939), Abraham Lincoln's portrait is fallaciously made into a protagonist and interlocutor; Benito Juárez, Mexico's greatest statesman, is reduced to carrying the portrait about, as he flees the invading French army, so that he will later be able to consult it over the decision of whether to execute the defeated Emperor Maximilian.[149] When Elia Kazan was planning to make *Viva Zapata!* (1952) for Twentieth-Century Fox, Darryl F. Zanuck (vice-president in charge of production) instructed script writers to fabricate a fable of U.S. influence over Emiliano Zapata: "Pablo [a fictitious character] must have told Zapata about a little country known as the United States of America. . . . It seems to me that Zapata must have heard about free elections and a government run by the people, for the people. . . . I am sure that Zapata must have asked the question many times: 'How do they do it in the United States?'"[150] In placing a Mexican mestizo communist woman—who, moreover, drinks heavily, takes drugs, and has lesbian relations—at the center of the story, *Frida* has gone against the grain of biopics, where history is "male, white, and American."[151]

Frida's greatest accomplishment could be that its very transculturality, which violates norms of U.S. and Mexican cinemas, may open doors most viewers don't realize are closed. The film was not received well by the "cultural establishment" of Mexico, and the press mistreated both Taymor and Hayek, despite the fact the film was popular enough to remain in exhibition several months.[152] A leading reviewer summed up a reiterative theme: *Frida* is "afflicted by historical inaccuracies."[153] Among the errors mentioned by Raquel Tibol, a pillar of leftist art criticism in Mexico and a friend of Rivera and Kahlo, is that of Frida drinking tequila: "Frida didn't drink tequila; when she got drunk, she did it with cognac, because she didn't

like tequila."[154] Although the example may appear trivial, it is complex: Frida probably drank the best that was available at any given moment but, given her insistent displays of *mexicanidad*, one imagines that she would have preferred to be portrayed as drinking tequila. A deeper critique was that voiced by the writer Guadalupe Loaeza, who objected to the film's failure to capture the postrevolutionary effervescence: "Those years of an intense search for national identity in which everything seemed possible."[155] It is a criticism that could also be applied to Leduc's film.

The real problem in the Mexican reception of Taymor and Hayek's *Frida* is that it was "made in Hollywood."[156] As one reviewer remarked, "It is an imperial film, and it is spoken in the empire's language."[157] Hence, for some critics, it reproduces the typically "superficial image of *lo mexicano*, in which abound drunken tequila parties, Judas figures, the pyramids, a piñata market, and a Coyoacán of artificial nostalgia."[158] However, another factor is the deep resentment felt by Mexicans against those they perceive as "sell-outs" (*vendidos*), who go to make their fortune in the United States. Certainly, the film invites the rejection Mexicans express against *pochos*, and one could hear people in the audience react vociferously to the previews: "Bah. It's in English. I'm not going to see that. Salma Hayek, yuk."[159] Hayek addressed that issue directly: "There is already an excellent picture on Frida in Spanish and with Mexican actors, that by Paul Leduc with Ofelia Medina. I wanted to show Frida to the world, and to do that I needed an expensive production that would attract attention."[160] It is somehow appropriate that the movie about a woman who was a "half-breed" was made by a *gringa* and a *mexicana*.

In some ways, *Frida* is a very "American" film: the classically closed and linear narrative foments identification with the onscreen celebrities, rather than engaging in a search for new ways to do historical cinema. In an insightful review, Seth Fein argued that the distantiation embedded in Leduc's movie was the preferable strategy, because it reminded viewers that it was a film about history rather than history itself: "Leduc's film is better history than Taymor's neither because it is factually more accurate nor essentially more Mexican, but because it is methodologically more compelling."[161] Nonetheless, although Leduc's distantiation may appear to be the more appropriate tactic to our postmodern eyes, his was a search for artistic innovation rather than historical experimentation, and his good intentions were

overwhelmed by the force of the legendary protagonists, whose mute representation simply feeds into and reinforces the all-too-familiar stereotypes. Hence, Juan José Gurrola's Diego cannot rise above the caricature of a fat, charmless, loutish toad.[162] In contrast, Alfredo Molina's portrayal of Rivera conveys the sensitivity this womanizer must necessarily have demonstrated toward the opposite sex in order to have been so successful in his conquests; his ex-wife, Lupe Marín, tells Frida that he finds all women "perfect," and when he finally sees the scar Frida had so feared him discovering, he tells her that it is "beautiful."

Frida effects identification with its celebrity artists, largely because it is exquisitely lit, well photographed, and with excellent stage direction. Nonetheless, the movie is also punctuated with Brechtian ruptures that are far more subtle and enjoyable than are Leduc's strategies of distantiation and temporal fragmentation; special effects are foregrounded, rather than being hidden as a realist ploy: a cartoon sequence creatively depicts Kahlo's accident, an inventive photomontage introduces their trip to the United States, paintings are animated, turning into scenes with actors. Further, notwithstanding the limitations imposed by *Frida*'s Hollywoodian form, the film is profoundly Mexican in its contrast to the U.S. cinema formula that "all ills can be cured."[163] For *Frida*—as it must certainly have been as well for Frida herself—life should be lived well rather than long.

Postmodern Digitalization and the Tenacity of the Real

The invention of digital imagery would seem to mark a watershed in visual culture because the credibility in the veracity of photographs, what Barthes called the "That-has-been," is threatened by the fact that they can now be easily created in computers without the necessity of the referent having ever really existed.[164] The images of Pedro Meyer, for example, often raise doubts about the act of representation, calling attention to the fact that they are constructed and putting into question the notion of photography as a window onto the real world. They are postmodern in fomenting incredulity in opposition to the believability that was the ideological bedrock of technical images since their invention in 1839. Hence, they might be said to initiate the beginnings of a *postmodern* visual culture, although the massification and the manufacture of celebrities that begin with modernity continue unabated. However, Mexico is a country in which neocolonialism

and its attendant underdevelopment assure that, in Leopoldo Zea's words, "the past is always present."[165] That is, the extremely unequal distribution of wealth and contemporary technology creates multiple worlds in which people live in what almost appear to be vastly different historical periods: isolated Indian groups subsisting in infrahuman conditions, and country people with burros and wooden plows exist together with city dwellers and cutting-edge gadgetry. This extraordinary asymmetry was recently addressed by Francisco Vargas Quevedo in the powerful "neorealist" film *El violín* (2006), a fictional work that utilizes the certainties of the documentary style to portray the reality it wishes to disclose: the clash between highland *campesinos* in rebellion against an oppressive government and the modern army it has sent to eradicate them.

Pedro Meyer is a prototype of postmodern mutation. A transcultural figure, he was born in Spain (1935) but was taken two years later to Mexico, where he lives, though he also spends time at his U.S. residence. Having devoted himself to photography since 1974, Meyer became the pioneer of digital imagery in Mexico, creating the bilingual site "Zonezero: From Documentary to Digital Photography" in 1993.[166] In 1987, Meyer was awarded a Guggenheim fellowship for a project designed specifically to capture in photographs his vision of the United States. Conscious of the reverberations between Mexican and U.S. culture, Meyer commented: "As one observes images about the United States one could, in many ways, also relate them to our Mexican reality. There are inevitable echoes and resonances given off by our mutual proximity."[167] Notwithstanding his interest in the ways the United States and Mexico reflect one another, Meyer seems to focus more on the differences between the cultures, defining Latin American identity in contradistinction to the United States. A photograph taken in 1979 of a young Nicaraguan *guerrillero*, his legs blown off by bombs probably provided by the United States, is in tune with the sentiments Meyer expressed about the invasion of Panama ten years later: "Let's review a very recent 'spectacle' well orchestrated by the entertainment industry in the United States (today even the news is handled as entertainment): the invasion of Panama. They even came up with a well-thought-out theme: 'Operation Just Cause.' What could be more 'just' than another invasion of one of our nations with that splendid desire to install 'democracy' (can one really *install* democracy?)."[168]

52. Pedro Meyer. *Mexican serenade*, 1985 (photograph); 1992 (collage). Pedro Meyer Archive.

A major theme of Meyer's digital imagery addresses the interface of the United States and Mexico.[169] In the image, *Mexican Serenade* (1985/1992), Meyer created a metaphor for neocolonialist tourism: a *gringa* sits in a collapsible aluminum chair, reduced to the size of the tiny caricaturesque figurines of the Mexican musicians to whom she listens, in a trailer park that, reproduced on a completely different scale, overwhelms them (see figure 52). Another digital image, *Mexican Migrant Workers, California Highway* (1986/1990), shows men laboring at agricultural tasks, stooped over in a field beneath a billboard advertising "Caesars," an inn which offers "Free Luxury Service from Your Motel;" in the sign, a Roman gladiator opens the door of a fancy private taxi for prospective customers who, presumably, will not include the poor souls straining below.[170]

In other pictures, Meyer focuses upon dissimilarities between the countries. He remarks upon the gun fetish that dominates the United States: *You're Dead* (1988/1990) is a powerful image in which young boys play joyously with arms, pointing them with great glee at the photographer (and his public).[171] He also comments sharply on the extraordinary overconsumption and waste of resources in the United States. Photographs such as *Cadillac Ranch* (1991) document the conspicuous destruction of goods

that would have been put to some purpose in the Third World.[172] The image of Cadillacs buried, noses-down, to their half-way point has a particular effect on a viewer from almost any other country, for it is difficult to imagine a situation of such surplus value that expensive cars, which apparently were functional, could be so wantonly destroyed.[173] Another picture, *Social Commentary* (1990/1993), is a high-contrast rendering of a typical activity at "American" fairs—destroying cars with sledgehammers—and conveys the same message of flagrant waste.[174] The effect of such overconsumption, and its contradiction of the media images that rule U.S. culture, is registered with irony by *Astronauts* (1990), in which perfect specimens of U.S. obesity are seated below a painting celebrating the well-fit men engaged in space exploration.[175] Perhaps Meyer's view of the United States is encapsulated in the image *Cardboard People* (1988); here, real individuals pose among cardboard reproductions of Ronald Reagan and the latest sexual attraction offered by Hollywood, making it difficult to distinguish between them.[176]

While Pedro Meyer uses digitalization to reveal the reality of image construction, Francisco Vargas employs a documentary style in *El violín* to uncover a Mexico that really exists: "The hand-held camera, the non-professional actors, the lack of special effects, and the form in which it is narrated are all resources to make it look like a documentary, with the end in mind that people don't think this occurred in the past, but that it is occurring right now."[177] The stark black-and-white work is usually illuminated with natural light and brings to mind fictional documentaries such as *The Battle of Algiers*; European critics "baptized it as Mexican neorealism."[178] Vargas began work on what would eventually become *El violín* as his thesis to graduate from the Center for Cinematic Studies (Centro de Capacitación Cinematográfica, CCC), the major film production school along with the CUEC in Mexico City. The director had made a documentary with his star, Ángel Tavira, a one-handed violinist in his eighties from a tiny village in the state of Guerrero, and then focused on him in his first version of *El violín*, a thirty-minute short that both served as his CCC thesis and won him an Ariel, the Mexican Oscar. With that recognition, he was able to get minimal funding from the Mexican Film Institute and put together a project in which many worked without pay to make a ninety-minute movie about the war between *campesino* guerrillas and the army, of which he is producer, director, and scriptwriter.[179] Because it deals with the controversial theme

of military repression, the film had won thirty-three international awards before it was released in Mexico.[180] Once distribution was undertaken by Canana Films—the company created by the actors Gael García Bernal and Diego Luna—in collaboration with *Proceso* magazine, the film became an immediate draw in those Mexican theaters where it was shown, and it was often applauded. In fact, it attracted the greatest number of viewers in relation to the amount of copies being shown.[181]

El violín is a moving depiction of the clash between two cultures that seem to come from different times and, in fact, almost appear to belong to dissimilar countries. The film opens with a wrenching depiction of torture and rape (shot from the *campesinos'* point of view), in which the army is as foreign and heartless an occupying force as the Nazis in Paris or the United States in Iraq. Genaro, the son of Don Plutarco (Ángel Tavira), is a member of the guerrilla contingent, and the aging musician attempts to aid him by rescuing arms that were buried in an area now controlled by the army. He is intercepted, and the commanding officer decides to keep his violin—simply one of the daily humiliations to which the *campesinos* are subjected—forcing him to come and play it at the military camp. A relationship develops in which each wants what the other has: "One of the paradoxes that the picture plants is that the old man who has music wants arms to change his life, while the captain, who has the arms, wants to change his life with music."[182] Eventually, Plutarco's real mission is discovered and, when the captain attempts to make him play the violin again, unholstering his pistol to underline the threat, the musician—in an agonizingly drawn-out sequence—finally refuses in the face of the death that awaits him and the other captured guerrillas, including his son; he meticulously puts away the bow, carefully closes the case, and informs him with enormous dignity: "The music is over" (La música se acabó). The movie cuts to black, but the last scene of the Plutarco's young grandson, Lucio, singing protest songs and carrying a concealed pistol, indicates that the struggle is still underway.

Vargas and Tavira impose a strict rhythm in *El violín* that seems to be one with that of the aging *campesino*. Violin music and silence dominate the soundtrack while words are used with great economy. The visuals underscore this structure. Plutarco appears on a burro riding back and forth through the Mexican countryside of mountains, cornfields, and magueys,

53. Elements of classic Mexican film style are incorporated in *El violín*, as Ángel Tavira rides his burro next to a maguey, a *guerrillero* looking down from above. Frame enlargement, *El violin*, 2006. Filmoteca de la Universidad Nacional Autónoma de México.

under overhanging clouds that the cinematographer, Martín Boege Paré, has photographed in a style that is a tribute to and a reworking of Gabriel Figueroa's legacy (see figure 53). Further, the camera often lingers on the faces of Plutarco, Genaro, and Lucio, sometimes expressively illuminated by campfire light, forcing the audience to adapt to the unhurried, paused, considered pace of the *campesino* mentality.

Tavira had never really acted in a film before, but he is so convincing that he was awarded the Best Actor Award of the section "A Certain Look" at the 2006 Cannes Film Festival. He has been very clear about his reasons for participating in the film: "To project the music of Guerrero around the world."[183] His character exudes such charisma that few criticisms have been made of the film, though the journalist Hermann Bellinghausen felt that it portrayed the guerrillas as hopelessly inexperienced and the *campesinos* as naive.[184] Nonetheless, the movie became an immediate reference when photographs were published of Oaxacan police torturing kneeling protestors in positions "that appear to be taken from *El violín*."[185] The contemporary Mexican films that have received the most recognition in the United States with Oscar nominations are internationalist, transcultural productions: *Pan's Labyrinth* (del Toro, 2006) and *Babel* (González Iñárritu, 2006), but

El violín tenaciously searches for solutions within the national reality that insistently asserts itself; as some audience members observed, "It is a profoundly and painfully Mexican film."[186]

Over the past 150 years or so, modern visual culture has increasingly become the site where Mexican identities have been constructed, deconstructed, and reconstructed. In this process, the credibility generated by technical images, their massive distribution, and their construction of celebrities has been fundamental. The believability introduced by the daguerreotypes was soon joined to mass consumption with the *tarjetas de visita*, and this coupling led almost immediately to the appearance of celebrities, who would become important as models for *mexicanidad*. Technical images entered into ever-wider circulation as photographs came to be printed on postcards, and then in the newspapers, illustrated magazines, and picture histories, where Great Men were celebrated as the makers of Mexico. The birth of cinema was fundamental in adding voices to the visual and in creating celebrity-stars, who offered their own examples of *lo mexicano*.

A central bifurcation in the representation of Mexico has been that of the picturesque and the antipicturesque. Followers of the former tendency depict Mexicans as a product of nature and an expression of the "vestiges" left by pre-Columbian civilizations, the colony, and underdevelopment; for them, national identity is an essence that has been made once and for all time. Those who are opposed to such essentialism choose instead to posit that *lo mexicano* is a product of historical experiences; they assert that Mexicans have made themselves through struggle, and that the story of these efforts is in fact how *mexicanidad* has been, and continues to be, created and recreated endlessly.

NOTES

Introduction

1. I moved to Mexico in 1981, voting with my feet after Ronald Reagan was elected president. Since arriving, I have been a "player" in its modern visual culture, curating controversial photo exhibits, directing films, and writing books, as well as critiquing the production of Mexicans in those enterprises. Throughout this work, I employ the terms "U.S." and "United States," rather than "American" and "America." All the inhabitants of the Western Hemisphere are "Americans," because the single continent, as it is perceived by Latin Americans, is described as *América*. A Cuban cineaste, Manuel Pereira, commented that he had learned about the "Americans" in school, "Like that, Americans and not North Americans, as if they were the owners of the continent, not just the coldest part of it" ("El cine cubano: Espejo y escuela," *Cine cubano* 100 [ca. 1980]: 65–66). The documentarian Michael Moore is preoccupied that those who live in the United States are the only national group without a proper name; he proposed that it be adapted from the title he conceived for the country in his film *The Big One* (1997), although the problem remains of what to call the inhabitants (the big ones?). In Mexico, we are often called *gringos*, a term whose origin has been much discussed. An important clue is provided by the fact that in several South American countries it refers to any foreigner. Hence, it would appear to be a deformation of *griego* (Greek), which was used in the colonial period for foreign travelers.

2. I have passed rather lightly over some Europeans who have had a marked influence on the construction of national identity, including Sergei Eisenstein, Henri Cartier-Bresson, and Luis Buñuel, to mention only some of the most obvious.

3. I thank Ryan Long for this observation.

4. Hall, "Cultural Identity and Cinematic Representation," 68. See also Hall and du Gay, eds., *Questions of Cultural Identity*.

5. Anderson, *Imagined Communities*, 25.

6. Benjamin, *La Revolución*, 14.

7. Casanova and Debroise note that the "photo-graph" of the Virgin imprinted on Juan Diego's cloak was what proved the miracle to the episcopal court; *Sobre la superficie bruñida de un espejo*, 10.

8. On the invention of technical images, see Flusser, *Towards a Philosophy of Photography*, 5.

9. Edward Said is the foremost analyst of Orientalism; see Bayoumi and Rubin, *The Edward Said Reader*.

10. Hall, "Cultural Identity and Cinematic Representation," 68.

11. By Great Men, I refer to leaders who are provided with a name and surname. This category does not include nameless soldiers, *campesinos* or workers, or identified men who are not in a leadership capacity, for example, individuals that are being executed for forgery or desertion.

12. García and Maciel, eds., *El cine mexicano a través de la crítica*, 11.

13. See the "Visual Culture Questionnaire," *October* 77 (1996): 25–70.

14. The best collection of readings on this issue is Bartra, ed., *Anatomía del mexicano*. In English, a useful compilation, "The Search for '*Lo Mexicano*,'" can be found in Joseph and Henderson, eds., *The Mexico Reader*, 9–54.

15. See, for example, the extensive documentation provided by García Cantú, *Las invasiones norteamericanas en México*.

16. See Lomnitz, "Fissures in Contemporary Mexican Nationalism," *Deep Mexico, Silent Mexico*, 110–22.

1. War, Portraits, Mexican Types

1. See in Sandweiss, Stewart, and Huseman, *Eyewitness to War*, 35, 346.

2. Sandweiss et al., *Eyewitness to War*, argue that Nebel's version "sticks closer to the truth," 346; see in Sandweiss et al., 98. It is unclear whether Nebel (or any other foreign lithographer) was present at the moment of Scott's entry into the Zócalo. See García Rubio, *La entrada de las tropas estadunidenses a la ciudad de México*, 69–72.

3. Stewart, "Artists and Printmakers of the Mexican War," 17.

4. Ibid., 38, citing a contemporary review in the *Knickerbocker*, found among the Kendall family papers.

5. García Rubio, *La entrada de las tropas estadunidenses a la ciudad de México*, 108.

6. El Fisgón, "Plan Mexico," *La Jornada*, 22 August 2007, 5.

7. See in *Nación de imágenes*, 73, 214–16.

8. See in Sandweiss et al., *Eyewitness to War*, 316.

9. See in ibid., 353.

10. Trachtenberg, *Reading American Photographs*, 46.

11. Sandweiss et al., *Eyewitness to War*, 216–17.

12. This image can be seen at its best in Debroise, *Mexican Suite*, 166, which also provides a translation of part of Vander Linden's text. Its current state of decomposition can be appreciated in García Krinsky, ed., *Imaginarios y fotografía en México, 1839–1970*, 5. It was first published before it had deteriorated so greatly in *Imagen histórica de la fotografía en México*, 39. It can be seen (reconstructed) in Casanova and Debroise, *Sobre la superficie bruñida de un espejo*, 32–33. On directed photojournalism, see the chapter "Thinking about Documentary," in Mraz, *Nacho López, Mexican Photographer*, 169–89. Another version of this discussion can be found in Mraz, "What's Documentary about Photography? From Directed to Digital Photojournalism," *Zonezero Magazine*, www.zonezero.com, 2002.

13. Pedro Vander Linden, "Ejercito de Oriente-cuerpo médico militar," *Diario del gobierno de la República Mexicana*, 30 April 1847, 2–3.

14. Ibid., my translation and condensation.

15. Debroise, *Mexican Suite*, 165–66.

16. Vander Linden was born in Belgium. He returned from the United States to Mexico in 1852 and founded the Military Hospital in Mexico City.

17. A Mexican writer of 1843 described the daguerreotype as "the simplest and most truthful medium for portraying nature with . . . a prodigious exactitude." Casanova, "Ingenioso descubrimiento," 10.

18. Casanova, "Un nuevo modo de representar," 195.

19. Cited by González Rodríguez, "Cuerpo, control y mercancía," 74.

20. Debroise, *Mexican Suite*, 22, affirms the cost of the daguerreotypes and compares them to salaries cited by Fanny Calderon de la Barca. However, the salaries paid by the latter appear to have been excessive. See Fisher and Fisher, eds., *Life in Mexico*, 157, and 722, n. 6.

21. See these individual exceptions in Casanova and Debroise, *Sobre la superficie bruñida de un espejo*, 85, 86, back cover, 87.

22. Patricia Massé refers to a Venezuelan photographer who hid a servant under a sheet, leaving her hands free to hold the child; see Massé Zendejas, *Simulacro y elegancia en tarjetas de visita*, 89. A Mexican maid holding a child in an ambrotype portrait can be seen in Casanova and Debroise, *Sobre la superficie bruñida de un espejo*, 108.

23. Aguilar Ochoa, *La fotografía durante el imperio de Maximiliano*, 27; Casanova, "Las fotografías se vuelven historia, 216.

24. Casanova, "Las fotografías se vuelven historia," 216.

25. See in Aguilar Ochoa, *La fotografía durante el imperio de Maximiliano*, 87; Massé Zendejas, "Photographs of Mexican Prostitutes in 1865."

26. Debroise, *Mexican Suite*, 27.

27. *Galería de personas que han ejercido el mando supremo de México con título legal o por medio de la usurpación.*

28. Aguilar Ochoa, *La fotografía durante el imperio de Maximiliano*, 96.

29. Massé Zendejas, *Simulacro y elegancia en tarjetas de visita*, 45.

30. See Jeffrey, *Photography*, 56.

31. Massé Zendejas, *Cruces y Campa*. For a study of another studio, see Negrete Álvarez, *Valleto Hermanos*.

32. Massé Zendejas, *Simulacro y elegancia en tarjetas de visita*, 99, 86.

33. Fernández Ledesma, *La gracia de los retratos antiguos*, 54.

34. Sange, "All Kinds of Portraits," 112.

35. Massé Zendejas, *Simulacro y elegancia en tarjetas de visita*, 93.

36. Vania Carneiro de Carvalho and Solange Ferraz de Lima note of nineteenth-century Sao Paulo that, though the great majority of men were manual workers, tools of their trades rarely appear, for their portraits were made in suits and vests in order to mark their social distance from the real poor. See "Individuo, género y ornamento en los retratos fotográficos, 1870–1920," 283.

37. A useful collection of *tarjetas de visita* representing the national types can be found in *¡Las once y serenooo!* That models were employed can be determined by the selection made available in this book: the same individual is identified as a seller of *jícaras* (laquered bowls from Uruapan) and of rope, 51 and 119. This book is an interesting example of photohistory in Mexico, for the pictures are accompanied by selections from travelers' accounts, cookbooks, and the reflections of Mexican writers on different work activities.

38. The fireman carries a rifle, *¡Las once y serenooo!*, 96. Such details open possibilities in relation to the use of the *tarjetas* of the Mexican types in reconstructing ordinary people's daily lives and work. Among the more fascinating bits of the past we have lost is the practice of selling roasted lamb heads in the street; see the image of such vendors in *¡Las once y serenooo!*, 39.

39. Massé Zendejas, *Simulacro y elegancia en tarjetas de visita*, 48.

40. Ibid., 56.

41. José Antonio Navarrete noted the appearance of "Indian types" (and "negro types") in parts of Latin America during the 1860s and 1870s, but Mexican Indians seem to have been incorporated more as pre-Columbian archeology than as contemporaries. See his "Del tipo al arquetipo," 36–37; and Chávez, "La sensibilidad del mexicano," in Bartra, ed., *Anatomía del mexicano*, 32, 44 (from an article originally published in 1901 under a different title).

42. Debroise, *Mexican Suite*, 117; Sange, "All Kinds of Portraits," 117. It should be noted that Sange's essay is illustrated with a full-page advertisement offering images of "Tipos Españoles," which were sold in Madrid (116). Spain is often considered to be among the more picturesque European countries; see Calvo Serraller, "La imagen romántica de España."

43. For other instances, see Prochaska, "The Archive of *Algérie Imaginaire*"; Poole, *Vision, Race, and Modernity*.

44. See the analysis of the *Street Cries* series set in London and Paris in Rosen, "Posed as Rogues," 29, 38.

45. Ramírez, "La visión europea de la América Tropical," 1383.

46. Ramírez, "El arte del siglo XIX," 1230; Moyssén, "Pintura popular y costumbrista del siglo XIX," 21.

47. Moyssén, "Pintura popular y costumbrista del siglo XIX," 22.

48. Carole Naggar, "The Fascination for the Other," in Naggar and Ritchin, eds., *México through Foreign Eyes*, 44.

49. Ramírez, "La visión europea de la América Tropical," 1368.

50. Among others, see Rugendas's "Picturesque Voyage through Brazil" (1827), Alcide d'Orbigny's "Picturesque Trip to the Two Americas" (1836), and Désiré Charnay, "Picturesque America" (1894). "Picturesque Mexico" is a common title for books on the country. Perhaps the first is by Marie Robinson Wright, and dates from 1897. In the early 1920s, Hugo Brehme consecrated this image of the country with a book published in Spanish, English, and German. See chapter 2.

51. Navarrete, "Del tipo al arquetipo," 34.

52. Pratt, *Imperial Eyes*, 23.

53. See "Fotolibros en México"; Rodríguez, "Vamos a México," 35.

54. Casanova, "Las fotografías se vuelvan historia," 222.

55. Casanova, "De vistas y retratos," 11.

56. Though Aubert was not the official photographer, he created the enterprise Aubert y Compañía, for which Julio de Maria y Campos worked. The photographs of both men bear the imperial eagle and the same address on their back.

57. Deborah Dorotinsky argues for "close relationship" between Aubert's photographic types and *costumbrismo*, and she backs up her claim with several images (although she does not include the photos mentioned here); "Los tipos sociales desde la austeridad del estudio," 17.

58. See in Aguilar Ochoa, *La fotografía durante el imperio de Maximiliano*, 126, 125.

59. See Ramírez and Rodríguez, *La manera en que fuimos*, 44–49; Aguilar Ochoa, *La fotografía durante el imperio de Maximiliano*, 45; Debroise, *Mexican Suite*, 168–70; Casanova, "Las fotografías se vuelvan historia," 218.

60. Yeager, "Porfirian Commercial Propaganda," 231–32.

61. Riguzzi, "México próspero," 147.

62. See Vanderwood and Sampanaro, *Border Fury*.

63. "Tarjetas postales," *El Mundo: Seminario Ilustrado* (5 July 1903): 13.

64. Vanderwood and Sampanaro, *Border Fury*, 6–7.

65. Fernández Tejedo, *Recuerdo de México*, 14. Postcards were preceded by stereo-

scopes, a format in which some of the first images of Mexico circulated; according to Carlos Córdova, "*Mexicanidad* was resumed in the exotic countryside, the surprise at the archeological sites, and urban modernity"; *Arqueología de la imagen*, 54.

66. Fernández Tejedo, *Recuerdo de México*, 39.

67. Ibid., 14; del Castillo, "La historia de la fotografía en México, 1890–1920," 67. See the Waite photo of a store selling "Curiosities" in the train station of Torreón, in Montellano, *C. B. Waite, Fotógrafo*, 79.

68. Hales, *William Henry Jackson and the Transformation of the American Landscape*, 175.

69. Aguayo, *Estampas ferrocarrileras*, 19–25.

70. Malagón Girón, "La fotografía de Winfield Scott." Malagón's study is an important step in differentiating between the work of Scott and Waite, as the latter incorporated the photos of the former without giving him credit. The relationship between the men is still unclear.

71. Aguayo commented on the bridge photography, *Estampas ferrocarrileras*, 117.

72. The Archivo General de la Nación and the Fototeca Nacional have hundreds of photographs that are registered to Waite, although many were taken by Scott. Published images can be seen in Malagón, "La fotografía de Winfield Scott"; Montellano, *C. B. Waite, Fotógrafo*; Debroise, *Mexican Suite*; and García Krinsky, *Imaginarios y fotografía en México*.

73. Montellano, *C. B. Waite, Fotógrafo*, 42–44, 81. On Jackson's picturing of "extreme poverty," see Debroise, *Mexican Suite*, 79. Deborah Poole published four *tarjetas de visita* of "Lice-pickers" in the Andean region, *Vision, Race, and Modernity*, 122.

74. Debroise, *Mexican Suite*, 82; Rodríguez Hernández, "Niños desnudos en el porfiriato," 46.

75. "Las hazañas de un fotógrafo," *El Imparcial*, 5 June 1901, 2.

76. "El asunto del fotógrafo Waite," *El Imparcial*, 8 June 1901, 2.

77. Aguayo, *Estampas ferrocarrileras*, 60.

78. "Las hazañas de un fotógrafo," 2.

79. Ibid.

80. Malagón Girón, "La fotografía de Winfield Scott," 279–85.

81. See Edwards, "Pretty Babies," 39.

82. See images of nude Mexican children by Scott in Rodríguez Hernández, "Niños desnudos en el porfiriato," and Montellano, *C. B. Waite, Fotógrafo* (though they are attributed to Waite), as well as García Krinsky, *Imaginarios y fotografía en México*. The young girl in figure 6 appears in at least three published photos.

83. Cited in Montellano, *C. B. Waite, Fotógrafo*, 123.

84. Turner, *Barbarous Mexico*.

85. According to Sinclair Snow, Introduction to Turner, *Barbarous Mexico*, xviii. It should be noted that this edition does not reproduce the original photos.

86. Cited in Hart, *Empire and Revolution*, 167.

87. See "Mr. Hearst envía al periodista Mr. Stevens a México," *El Imparcial*, 25 November 1909, 1, and "Entrevista con Mr. Stevens," *El Imparcial*, 26 November 1909, 8.

88. Turner, *Barbarous Mexico*, 70.

89. Ibid., 334.

90. Ibid., 119.

91. See Turner's 1913 letter in Snow, introduction to Turner, *Barbarous Mexico*, xxvi.

92. Chico Buarque is one of the most popular of contemporary Brazilian songwriters and singers.

93. See Franger and Huhle, eds., *Fridas Vater*.

94. See Coronel Rivera, "Guillermo Kahlo," 31–38. He died in Coyoacán in 1941.

95. On the Casa Boker, see Buchenau, *Tools of Progress*.

96. See his ad reproduced from *El Mundo Ilustrado* in Coronel Rivera, "Guillermo Kahlo," 47.

97. The Mexican photohistorian Juan Carlos Valdez stated that Kahlo erased people who appeared in his photographs of the colonial churches. Personal communication, 2006.

98. See the reprinted version, Kahlo, *Mexiko 1904*.

99. Manrique, "Guillermo Kahlo," 12–13.

100. Vera Trejo, "Guillermo Kahlo," 142.

101. See Cuevas-Wolf, "Guillermo Kahlo and Casasola."

102. Cited in ibid., 202.

103. No serious biography of Agustín Víctor Casasola or any of the family members has been carried out. Information can be gleaned from two compilations: *Agustín Víctor Casasola: El hombre que retrató una época, 1900–1938* and *Agustín Víctor Casasola*, as well as other works mentioned below. The Casasola Archive was acquired by the Instituto Nacional de Antropología e Historia in 1976, and according to Sergio Raúl Arroyo, "The Fondo Casasola of the Fototeca Nacional of INAH is presently made up of 483,993 images, taken between 1895 and 1972, of which 411,904 are negatives and 72,089 are positives only. Of the images, 427,418 have been catalogued, and 199,018 are digitalized and available through the automated catalogue of the Sistema Nacional de Fototecas," "The Casasola Archive in the INAH National Photo Library," 11.

104. See Luis G. Moreno Irázabal, "Figuras del periodismo mexicano: Don Agustín Víctor Casasola," *El Demócrata*, 11 April 1926, magazine section, 6.

105. His daughter, Dolores Casasola Zapata, said that he was "very Catholic"; Adriana

Malvido, "Archivo Casasola: 100 años de historia fotográfica en México," *La Jornada*, 19 November 1991, 36.

106. "Periodismo," *Mañana*, 12 May 1951, 318.

107. Alan Knight comments on "the end of ideology" during the Porfiriato; see *The Mexican Revolution*, vol. 1, *Porfirians, Liberals and Peasants*, 15.

108. See Carlebach, *American Photojournalism Comes of Age.*

109. Manuel Gutiérrez Nájera, cited in del Castillo, *Conceptos, imágenes y representaciones de la niñez en la ciudad de México, 1880–1920*, 142.

110. Cited in García, *El periódico "El Imparcial,"* 91.

111. Ibid., 23.

112. Ibid., 148–49.

113. The subtitle was removed two years later; ibid., 31.

114. Saborit, *"El Mundo Ilustrado" de Rafael Reyes Espíndola*, 57.

115. Argudín, *Historia del periodismo en México*, notes that there were 300 periodicals in 1883, and only 200 by 1891 (97). The amount of the subsidy seems correct, and other papers received much less (García, *El periódico "El Imparcial,"* 59). However, its importance is in some debate. Clara García believes that Reyes Espíndola was not dependent on the subsidy (59), and Saborit argues that the editor attempted to reject it many times, but was not allowed to (*"El Mundo Ilustrado" de Rafael Reyes Espíndola*, 29). I think it is clear that the subsidy was pivotal in allowing him to establish his preeminence and near monopoly.

116. García, *El periódico "El Imparcial,"* 59–61. Limantour made his comments in a book of recollections written in 1921 but published in 1965; Reyes Espíndola published his in the daily during 1911, in response to his critics.

117. See del Castillo, "Prensa, poder y criminalidad a finales del siglo XIX en la Ciudad de México," 32–36; García, *El periódico "El Imparcial,"* 168.

118. See García, *El periódico "El Imparcial,"* 207–19.

119. Alberto del Castillo remarked on the paradox of the notable rise in preoccupations about crime, at the same time that crime itself remained stable and reduced; see "El surgimiento del reportaje policiaco en México," 163. However, Pablo Piccato believes that there was a growing crime rate in Mexico City; *City of Suspects*, 53.

120. The *nota roja* sometimes decontextualizes historical images, converting them into essentialist exemplifications of Mexicans' brutality; see my discussion of the transformation of an Hermanos Mayo photo in "Today, Tomorrow and Always," 140–41.

121. Quoted in García, *El periódico "El Imparcial,"* 148.

122. Cited in de los Reyes, "El cine, la fotografía y los magazines ilustrados," 185.

123. Del Castillo, "El surgimiento del reportaje policiaco en México," 167–69.

124. This list is compiled from the description provided by Francisco Mejía in Saborit, *"El Mundo Ilustrado" de Rafael Reyes Espíndola*, 245–73.

125. De la Torre Rendón, "Las imágenes fotográficas de la sociedad mexicana en la prensa gráfica del porfiriato," 354.
126. Del Castillo, "El surgimiento del reportaje policiaco en México," 186.
127. De la Torre Rendón, "Las imágenes fotográficas de la sociedad mexicana en la prensa gráfica del porfiriato," 360. One or another of the "picturesque poor" must have been included, to judge from the reproduction of some photos by José María Lupercio in Saborit, *"El Mundo Ilustrado" de Rafael Reyes Espíndola*, 196.
128. For an overview of the unofficial press, see Smith, "Contentious Voices amid the Order," and Díaz, "The Satiric Penny Press for Workers in Mexico, 1900–1910." On cartoons, see Aurrecoechea and Bartra, *Puros cuentos*, as well as recent books by Rafael Barajas Durán (El Fisgón).
129. De la Torre Rendón, "Las imágenes fotográficas de la sociedad mexicana en la prensa gráfica del porfiriato," 357.
130. Quoted in ibid., 352.
131. Saborit, *"El Mundo Ilustrado" de Rafael Reyes Espíndola*, 265.
132. Escorza Rodríguez dates his entrance into *El Imparcial* as 1906, "Los inicios de Agustín V. Casasola como *reporter-fotógrafo*," 31.
133. Dolores Casasola Zapata remembered, "My father never let go of his camera . . . getting the photo was his true passion." Malvido, "Archivo Casasola," 36.
134. Casasola was evidently providing images to two illustrated magazines during the transition to becoming a full-time photojournalist, *El Tiempo Ilustrado* and *El Mundo Ilustrado* (Moreno Irázabal, "Figuras del periodismo mexicano," 6). Escorza Rodríguez asserts that he was working for *El Tiempo* and the *Seminario Literario Ilustrado* in this period ("Las fotografías de Casasola publicadas en diarios capitalinos durante 1913," 26). Agustín Víctor's son, Gustavo Casasola, attributes the bonus to having constructed a platform that Agustín Víctor attached to a telephone pole in order to take photos of an execution in 1907 from which photojournalists had been barred (*Historia gráfica de la Revolución Mexicana*, 4: 2321–323), and this story is repeated in *Agustín Víctor Casasola: El hombre que retrató una época, 1900–1938*, 28, as well as in Arroyo and Casanova, "The Casasolas," 205. However, the photographer is identified as José Soriano in the article "Fusilamiento de los asesinos del Gral. Barillas," *El Imparcial*, 10 September 1907, 1. The true story of the bonus can be found in Moreno Irázabal, 6, and the receipt, dated 31 October 1910, can be seen in *Historia gráfica de la Revolución Mexicana*, 4: 2323. It is at least curious that Gustavo was so eager to link this recognition to *nota roja* rather than sports.
135. Ignacio Gutiérrez Ruvalcaba has found the work of more than 480 photographers in the Archivo Casasola, noting that "Agustín Víctor Casasola erased names from the emulsion of many thousands of negatives"; see "A Fresh Look at the Casasola Archive," 191. At this point, only those images on which the

handwriting of Agustín Víctor enables an identification are considered to have been taken by him; the others are classified as "Archivo Casasola" in the Fototeca Nacional.

136. See Flora Lara Klahr, "Agustín Casasola & Cia. México a través de las fotos," *La Cultura en México, Siempre!*, 21 November 1984, 40. See also an anonymous text with many of Lara Klahr's ideas, "Agustín Casasola: An Unknown Photographer," and Ehrenberg's aptly titled essay "The Style of the File. . . ."

137. *Mexico: The Revolution and Beyond*, 40–41; *¡Tierra y Libertad!*, 14–15. Andrea Noble has carried out an analysis in "Photography and Vision in Porfirian Mexico."

138. *Jefes, héroes y caudillos*, 8.

139. Gutiérrez Ruvalcaba, "Los Casasola durante la posrevolución," 194.

140. I discuss Modotti's oft-reproduced photomontage, *Los de arriba y los de abajo*, in chapter 2; see in Debroise, *Mexican Suite*, 223.

141. *Jefes, héroes y caudillos*, 16; *Mexico: The Revolution and Beyond*, 38; *El poder de la imagen y la imagen del poder*, 28.

142. Debroise, *Mexican Suite*, 184. Gutiérrez Ruvalcaba questions the idea that Porfirian photography is dominated by conventional poses ("Los Casasola durante la posrevolución," 191), as does Escorza Rodríguez, who published a 1902 picture of Díaz that is clearly not posed ("Las fotografías de Casasola publicadas en diarios capitalinos durante 1913," 27).

143. See the execution and the coup de grace in *Jefes, héroes y caudillos*, 14–15; *¡Tierra y Libertad!*, 24–25. To judge from the handwriting on the negative, this photo was made by Agustín V. Casasola.

144. Escorza Rodríguez, "Las fotografías de Casasola publicadas en diarios capitalinos durante 1913," 27; Gutiérrez Ruvalcaba, "Los Casasola durante la posrevolución," 194. Agustín Víctor was evidently arrested when he photographed Taft because he did not understand the Secret Service officers when they told him in English not to get so near the U.S. president (Moreno Irázabal, "Figuras del periodismo mexicano," 6).

145. "Se cumplió en Chalco la pena de muerte impuesta a los reos Arcadio Jiménez y sus camaradas," *El País*, 30 April 1909, 1. Whether the crime and punishment had social origins is difficult to determine. The trial lasted almost two years, and neither it nor the execution was covered in the main opposition paper, *El Diario del Hogar*. Nonetheless, one can well imagine that in Mexico of 1909 the conflict must have had a history, as well as a sequel.

146. "En el mismo lugar que cometieron su crimen lo expiaran," *El Imparcial*, 29 April 1909, 1; the reporter for *El Tiempo* stated that "thousands" witnessed the execution, "Tres ejecuciones capitales en Chalco," *El Tiempo*, 1 May 1909, 3.

147. "Se forma el cuadro," *El Imparcial*, 30 April 1909, 1.

148. Ignacio Gutiérrez Ruvalcaba, one of the most rigorous of the researchers who

have worked on the Archivo Casasola, has argued otherwise in "A Fresh Look at the Casasola Archive," 193–94.

149. Mexico's long and destructive war for independence from Spain began in 1810 with the revolt led by Miguel Hidalgo, but it was not attained until 1821, under the leadership of Agustín de Iturbide.

150. Tenorio, "1910 Mexico City," 79.

151. García, ed., *Crónica oficial de las fiestas del primer centenario de la independencia de México*, 1.

152. A list of the participating photographers can be found in Ancira, "Fotógrafos de la luz aprisionada," 347.

153. A description of the photographs in the Genaro García collection can be seen online through the University of Texas library, the current owner. Among the photographers mentioned in García's introduction are Antonio Carrillo, Manuel Ramos, Antonio Garduño, and Juan Echeverría. Several other picture books were also produced in conjunction with the Centenario, including Espino Barros, *México en el centenario de su independencia*; a sumptuous *Albúm Oficial del Comité Nacional del Comercio*, which boasted of costing 52,000 pesos to print 10,000 copies and contained photos made by Guillermo Kahlo, Manuel Ramos, and F. Clarke; and a work dedicated to foreigners, *México y las colonias extranjeras en el Centenario de la Independencia*. However, García's work appears to be the only one directly commissioned by the government.

154. García, *Crónica oficial*, 138.

155. Ibid., 138; Tenorio, "1910 Mexico City," 99; Reese and Reese, "Revolutionary Urban Legacies," 371. One newspaper remarked upon the "many details of authenticity"; "El desfile histórico de ayer resultó brillante y sugestivo," *El País*, 16 September 1910, 1.

156. Conversely, the revolutionary centennial of 1921 would focus on Miguel Hidalgo. See chapter 2.

157. Cited in Tenorio, "1910 Mexico City," 99.

158. García, *Crónica oficial*, 140. Press accounts varied greatly: the reactionary daily *El País* declared that 500,000 had attended, while *El Tiempo* estimated that some 100,000 had witnessed the parade. See "El desfile histórico de ayer resultó brillante y sugestivo," *El País*, 1; and "Cien mil personas presenciaron hoy el desfile histórico," *El Tiempo*, 15 September 1910, 1.

159. See comparative images of the Zócalo in *Entre portales, palacios y jardines*, especially pp. 140 and 161. Some photos of the Centenario published in 1974 may show denser crowds, but it is unclear which events are being witnessed; Alberto Domingo, "Fiestas del Centenario," *Siempre!*, 3 July 1974, 46–53.

160. "The event itself was not so well attended by locals as the official pamphlet claimed." Bloch and Ortoll, "'¡Viva México! ¡Mueran los yanquis!,'" 198.

161. This was not the original plan. It was to have begun with a study of "Mexico's

progress from 1810 to our days" and then describe the festivities in the capital and the states. García, *Crónica oficial*, vii.

162. On the racism of the papers, see Tenorio, "1910 Mexico City," 100. The First Indianist Congress represented another of the Centenario's activities designed to integrate Indians into the nation.

163. A photo of the banquet of the attendees in the *gruta* can be seen in García, *Crónica oficial*, 230.

164. De los Reyes, *Cine y sociedad en México*, 102; Tenorio analyzes the construction of an "ideal" city along Reforma and asserts that "during the centennial celebration, all the monuments, events and parades appeared within (and were part of the making of) this ideal city" ("1910 Mexico City," 83). On the separation of classes required by this ideal construction, see Lear, "Mexico City."

165. García, *Crónica oficial*, 109.

166. Díaz's son, Porfirio Díaz Jr., was the engineer in charge of constructing both the Mental Hospital and the Teacher's College. Nonetheless, nepotism was evidently not conceivable: he simply had "formulated the most acceptable propositions." García, *Crónica oficial*, 110.

167. See Morales, "Luces y sombras del Centenario I."

168. García, *Crónica oficial* 150–51; pp. 148–65 show some thirty-three buildings and houses strung extensively with lights.

169. Ibid., 150.

170. García, "In Quest of a National Cinema," 8.

171. De los Reyes, *Cine y sociedad en México*, 54, 93.

172. García Riera, *Breve historia del cine mexicano*, 26. The film was produced by the American Amusement Company, a Mexican firm that evidently wished to appear otherwise. Mora reproduces a negative review of the film in *Mexican Cinema*, 11–12.

173. Tenorio, "1910 Mexico City," 102.

174. De los Reyes, *Cine y sociedad en México*, 103.

175. Tenorio, "1910 Mexico City," 76.

2. Revolution and Culture

1. See *La Semana Ilustrada*, 24 November 1911, which documents the strike, "uncommon in Mexico City," and the protests in Huatusco.

2. Cited in MacLachlan and Beezley, *El Gran Pueblo*, 208. See the U.S. onlookers in Vanderwood and Samponaro, *Border Fury*, 18, 130, 131.

3. Leyda, *Films Beget Films*, 113.

4. See de Orellano, *La mirada circular*.

5. Ibid., 169.

6. Vanderwood and Samponaro, *Border Fury*, ix.

7. Jablonska and Leal, *La revolución mexicana en el cine nacional, 1911–1917*, 23.

8. Miquel, *Salvador Toscano*, 72, paraphrasing and citing from a letter by Toscano dated 29 September 1915. Salvador's daughter, Carmen Toscano, edited his footage together in *Memorias de un mexicano*, which was released in 1950.

9. Toscano, letter of 24 November 1910, cited in Miquel, *Salvador Toscano*, 54.

10. See Miquel, "El registro de Jesús H. Abitia de las campañas constitucionalistas," 7–27.

11. See his remembrances in Jesús H. Abitia, "Memorias de un fotógrafo constitucionalista," *Revista de la Semana de El Universal*, 22 February 1959, 5–8.

12. Guzmán, *El aguila y la serpiente*, 338.

13. Evidently two pictures were made with this title, one edited by Fernando Marcos at an undetermined date, and the other by Gustavo Carrero in 1961; see Miquel, *Salvador Toscano*, 17–21.

14. Jablonska and Leal, *La revolución mexicana en el cine nacional, 1911–1917*, 27.

15. Jimenéz and Villela, *Los Salmerón*.

16. See Zapata's letter in ibid., 43.

17. See this photo in ibid., 52. Abitia also documented Indian soldiers in Obregón's forces with bows and arrows; see Miquel, *Acercamientos al cine silente mexicano*, 88–89.

18. See de los Reyes, *Con Villa en México*; de Orellano, "Pancho Villa."

19. See the definitive study of Villa by Katz, *The Life and Times of Pancho Villa*.

20. See Berumen, *Pancho Villa: La construcción del mito*, 54–60. This photo has been much reproduced; see Brenner, *The Wind That Swept Mexico*, number 86; Naggar and Ritchin, eds., *Mexico through Foreign Eyes*, 136.

21. A decent film about this, *And Starring Pancho Villa as Himself*, was directed by Bruce Beresford in 2003 for HBO Television, with Antonio Banderas as Pancho.

22. Jablonska and Leal, *La revolución mexicana en el cine nacional, 1911–1917*, 19. Mexicans describe the barracks revolt carried out by Victoriano Huerta as "*La decena trágica*" (February 9–19, 1913), in which the complicity of U.S. ambassador Henry Lane Wilson was pivotal.

23. Rosenblum, *A World History of Photography*; Trachtenberg, *Reading American Photographs*, 33.

24. Debroise, *Mexican Suite*, 185; Arroyo and Casanova, "The Casasolas," 207.

25. Casasola, *Albúm histórico gráfico*. Ignacio Gutiérrez states that he "affirmed in the prologue of the *Albúm* that he was the photographer of the Mexican Revolution"; Gutiérrez Rubalcava, "Los Casasola durante la posrevolución," 37. However, none of the copies of the album that I have seen substantiate this.

26. Luis G. Moreno Irázabal, "Figuras del periodismo mexicano: Don Agustín Víctor Casasola," *El Demócrata*, 11 April 1926, magazine section, 6. Of course, by

the time of the Queretaro congress, the fighting was largely over, and the Constitutionalists had won.

27. *Agustín Víctor Casasola*, 12.
28. Ibid., 11; Gustavo Casasola, *Historia gráfica de la Revolución Mexicana*, 4: 2323.
29. "Don Agustín Casasola Velasco," *Siempre!*, 31 July 1974, 67.
30. Cited in *Agustín Víctor Casasola*, 11.
31. Gutiérrez Rubalcava, "Los Casasola durante la posrevolución," 37.
32. Arroyo and Casanova, "The Casasolas," 205; Gutiérrez Ruvalcaba, "A Fresh Look at the Casasola Archive," 193–94.
33. Adriana Malvido, "Relata la familia Casasola el devenir de su archivo de fotos," *La Jornada*, 21 November 1991, 24.
34. See Gutiérrez Ruvalcaba, "A Fresh Look at the Casasola Archive," 193; Marion Gautreau, "El Archivo Casasola y la representación de la Revolución Mexicana," unpublished manuscript, 2006. See Gautreau, "Questionnement d'un symbole: Agustin Victor Casasola, photographe de la Révolution Mexicaine."
35. See Gould and Greffe, *Photojournalist*, 100–115. More recently, Berumen has analyzed the photography of this combat, see *1911*.
36. "Casasola," *Siempre!*, 3 July 1974, 100. "The Casasola Archive is that . . . which is most filtrated in national identity"; Ochoa Sandy, "Historia de un archivo," 11.
37. Casasola's speech was published in *La Semana Ilustrada*, 3 November 1911, where it is accompanied by a photo of Casasola standing next to the president. It is reproduced in *Agustín Víctor Casasola: El hombre que retrató una época, 1900–1938*, 61, and Ancira, "Fotógrafos de la luz aprisionada," 347.
38. Moreno Irázabal, "Figuras del periodismo mexicano," 15.
39. See the photo of Agustín Víctor with the banner in the center of the protest in *Agustín Víctor Casasola: El hombre que retrató una época, 1900–1938*, 63.
40. Known as Korda, Alejandro Díaz Gutiérrez was one of the greatest photographers of revolutionary Cuba.
41. Although it is now attributed to Hugo Brehme, Agustín Víctor claimed authorship, at least implicitly, as early as 1921, when he published the image in the *Albúm histórico gráfico* as if it were his. See Blanca Ruiz, "Brehme, autor del Zapata de Casasola," *Reforma*, 4 October 1995, 12.
42. *José Guadalupe Posada*, 395. It is difficult to say how Posada was introduced to the photo, but he must have seen it before it was published because he died in January 1913, and the photo was published in April of that year.
43. See Arnal, "La fotografía del zapatismo en la prensa de la Cudad de México 1910–1915," and "Construyendo símbolos."
44. See the photograph of Zapata and Asúnsolo, the latter still with the sash and sword, in Arnal, "Construyendo símbolos," 69. On the incident, see Womack,

Zapata and the Mexican Revolution, 81–96. I am grateful to John Womack for helping me understand this situation.

45. Arnal, "La fotografía del zapatismo," 45.

46. Escorza Rodríguez, "Las fotografías de Casasola publicadas en diarios capitalinos durante 1913."

47. The image appeared in the magazine *La Ilustración Semanal*, 7 December 1914, 4, and in the newspaper *El Monitor*, 7 December 1914, 3. At least two photos of this scene exist, one apparently made by A. V. Casasola and the other credited to Antonio Garduño; both have been published often. Among those that reproduce the Garduño image are Brenner, *The Wind That Swept Mexico*, number 108; Katz, *Imágenes de Pancho Villa*, 45; and Berumen, *Pancho Villa*, 133. Works with the photo by Casasola include *Mexico: The Revolution and Beyond*, 59; *The World of Agustín Víctor Casasola*, 47; *¡Tierra y Libertad!*, 60; *Jefes, héroes y caudillos*, 51.

48. José E. Ortiz, "Villa jugando a la presidencia," *El Pueblo*, 14 March 1915, 3.

49. *Agustín Víctor Casasola*, 13.

50. Hart, *Revolutionary Mexico*, 298.

51. The script was written by Abitia, and the film was directed by the Alva brothers; Cineteca Nacional, Expediente A-03088.

52. This text appeared in a large ad for the film in *El Imparcial*, 3 June 1914, 7, that was reprinted in *El Imparcial*, 8 June 1914, 7.

53. Many photographs of Melhado and Flores Pérez are published in Martínez, *La intervención norteamericana*. I have carried out an analysis of the negatives of P. Flores Pérez and Eduardo Melhado found in the Archivo General de la Nación (AGN). The seventy-three negatives by P. Flores Pérez are in G1-E2, "Intervención norteamericana," Fondo Propiedad Artística y Literaria, AGN. The thirty-three negatives by Eduardo Melhado are in G1-E4, "Intervención norteamericana," Fondo Propiedad Artística y Literaria, AGN. For other images of the invasion, mostly taken by U.S. military photographers, see Vanderwood and Samponaro, *Border Fury*, 144–53.

54. On Melhado, see Debroise, *Mexican Suite*. My belief that P. Flores Pérez was a Veracruzan is based on the fact that some of his photographs are the property of a port resident, José Pérez de León; see García Díaz, *Puerto de Veracruz*.

55. See this and other photos of the invasion in Mraz, "Representing the Mexican Revolution." This photograph offers an interesting lesson in the difficulties of determining authorship. It is a regular in the Casasola picture histories, where the lack of credit would seem to assert that it was made by Agustín Víctor, although the grain indicates that it was copied from a published image. It appeared in Brenner, *The Wind That Swept Mexico*, number 97, where the photo is credited to Brown Bros. and the left-hand side is cropped. In Martínez, *La*

intervención norteamericana, 53, the left side of the photo is occupied by the annotation of Flores Pérez: "Muertos in Diligencias [Dead in Diligencias], Abril 21, 1914. P. Flores Perez, Fot." According to García Díaz, Diligencias was an area "where one of the strongest nuclei to the invador was concentrated," *Puerto de Veracruz*, 157, and the historian reproduces the same photo but with the following inscription written on the left side: "Hadsell. Veracruz. 3371. Killed in Front of Hotel Diligencias," which would seemingly establish a "Hadsell" as the author. The screw has yet another turn: both the Hadsell picture and the Flores Pérez image are housed in the AGN.

56. The vast majority of photos made during the Mexican Revolution that purport to show combat are directed, as a glance at Casasola's *historias gráficas* confirms.

57. See Mraz, "Representing the Mexican Revolution," 30–31.

58. Martínez did not include this photo in *La intervención norteamericana*, perhaps because she could not locate it in the AGN (a problem I faced as well). The photo can be seen in García Díaz, *Puerto de Veracruz*, 154. Martínez seems unaware of the difference between photographers she employs merely to illustrate a straight history of the invasion.

59. This image was published in Mraz, "Representing the Mexican Revolution," 28.

60. See Novelo, ed., *Album conmemorativo de la visita del Sr. General de División D. Pablo González, a la Ciudad de Toluca*.

61. Gustavo Casasola noted that the *Albúm histórico gráfico* "no tuviera el éxito apetecido"; *Historia gráfica de la Revolución Mexicana*, 4: 2324. Perhaps Jesús Abitia anticipated this problem and for that reason did not bring out a picture history on the revolution that he had envisioned, despite his close friendship with Álvaro Obregón. See Abitia's expressed intention to make a *historia gráfica* about the struggle in Abitia, "Memorias de un fotógrafo constitucionalista," 5.

62. Benjamin, *La Revolución*, 72.

63. Lempériere, "Los dos centenarios de la independencia mexicana (1910–1921)," 33.

64. His representation as the photographer of the revolution is implicit in the fact that he gives no credit to any others. However, the different handwriting on the published images and the inclusion of photos now known to be taken by others (for example, Brehme's picture of Zapata) make it evident that he had assembled an archive from a variety of sources.

65. This is based on an analysis of volume 2, in which Great Men appear in sixty-one of the eighty-six total photos, and current or future presidents appear in thirty-four.

66. This photograph was evidently posed as a way of counteracting the reputa-

tion that the revolutionary armies had for abducting the young women in the towns they occupied. Young, dashing, and handsome, Ramón Iturbe was particularly vulnerable to such suspicions. When he took Topia, Durango, women who had initially taken refuge in the U.S. consulate evidently later asked to pose with him, creating the legend of his "female General Staff." Conversation with Mireya Iturbide, daughter of General Ramón Iturbe, 2008.

67. See his opening remarks (Proemio) in volume 1, *Albúm histórico gráfico*. Commissioned by Gustavo Casasola in the 1980s, Mario Luis Altúzar asserted, "There are those who criticize the semi-official tone of the work. Nonetheless, the task of selecting the images was faithful to the original idea of the journalist: Objectivity before all"; *Agustín Víctor Casasola: El hombre que retrató una época, 1900–1938*, 34. This will be a recurring claim of future Casasola publications.

68. Strauss Neuman, *El reconocimiento de Álvaro Obregón*, 57–88.

69. The English is passable but was clearly not written by a native speaker.

70. Casanova, "El primer ensayo editorial de los Casasola," 31.

71. Wilson appears in volume 2, on the occasion of wishing Díaz a happy new year in 1911. There, the Spanish text refers to his "meddlesome interference" in 1913, though the English translation limits itself to observing that his "interference was lamentable."

72. No such volumes have been found.

73. See "Unidad e imitación," taken from two of Caso's articles, in Bartra, ed., *Anatomía del mexicano*, 60. On the association of *lo mexicano* with nationalism in the 1920s and 1930s, see Schmidt, *The Roots of* Lo Mexicano, 102.

74. A Mexican critic described them as "pictorialist" and "objectivist"; Galindo, "¿Objetivismo o pictorialismo?," 13.

75. The clothing of both was adopted as the "typical Mexican image" for the official Nationalist Campaigns in 1930, and the *china* was named the National Archetype for women in 1941. See Pérez Montfort, "Indigenismo, hispanismo y panamericanismo," 349; Gillespie, "The Case of the *China Poblana*," 19. See as well Pérez Montfort, *Expresiones populares y estereotipos culturales en México*; *Estampas de nacionalismo popular mexicano*; and *Avatares del nacionalismo cultural*. Márquez is considered the "pioneer" among Mexican folklorists; see Sánchez Estevez, "Luis Márquez Romay y su obra; and "El imaginario de Luis Márquez."

76. Rubén Gallo argues that Modotti was more interested in picturing modernity than Weston, who "refused to photograph scenes relating to Mexico's modernization, which he blamed for 'spoiling' the country"; *Mexican Modernity*, 50. Nonetheless, the toilet that Weston so assiduously photographed was certainly modern.

77. See in Vélez Storey, *El ojo de vidrio*, 165.

78. See in *Hugo Brehme: Fotograf-Fotógrafo*, 131.

79. See in Lowe, *Tina Modotti*, plate 66. Lavrentiev, *Alexander Rodchenko*.

80. Conger, *Edward Weston in Mexico, 1923–1926*, 56.

81. The references to Brehme's importance in constructing a visual nationalism are numerous. See Rodríguez, "La construcción de un imaginario," 39; Lerner, "La exportación de lo mexicano: Hugo Brehme en casa y en el extranjero," and Mendoza Áviles, "La colección Hugo Brehme," 43, as well as Garduño Pulido, "Mexico's Enduring Images," 15.

82. See Brehme's photography in *México pintoresco*; *Hugo Brehme: Pueblos y paisajes de México*; *México: una nación persistente*; *Hugo Brehme: Fotograf-Fotógrafo*; and "Hugo Brehme: Los prototipos mexicanistas."

83. See in Naggar and Ritchin, eds., *México through Foreign Eyes*, 92.

84. See in *Hugo Brehme: Pueblos y paisajes*, 202.

85. Rodríguez, "La construcción de un imaginario," Michael Nungesser, "El México de Brehme en libros y revistas," and Dennis Brehme, "Hugo Brehme: Una vida entre la tradición y la modernidad," in *Hugo Brehme: Fotograf-Fotógrafo*.

86. See Lutz and Collins, *Reading National Geographic*, 89–93.

87. These included *Das malerische Mexiko* and the Spanish translation, *México pintoresco*, both in 1923, as well as, in 1925, *Mexiko: Baukunst, Landschaft, Volksleben*, translated into English as *Picturesque Mexico: The Country, the People, and the Architecture*. See details in *Hugo Brehme: Fotograf-Fotógrafo*, 202–3.

88. "El artista fotógrafo Hugo Brehme," *Nuestra Ciudad*, 4 July 1930, 57; Rodríguez, "La construcción de un imaginario."

89. See Gallo, *Mexican Modernity*, 46–47, for an anecdote about the 1924 defacing of an exhibited Weston print by Gustavo Silva; the pictorialist clawed it with his fingernails.

90. "Algo sobre la exposición de La Tolteca," *Helios* 18 (1932): 2–3.

91. See the references to the Jews as the "enemy in common" of Mexican photographers, and a "damned race," in "Editorial," *Helios* 9 (1931): 1. References to blacks occur in the last lines of the diatribe about the Tolteca Exposition, which refer to modernist photographers as "ridiculous crazies who fatuously believe that they are making art with disgusting *monos* [literally, monkeys or figuratively, ludicrous figures] and the noise of negroes"; "Algo sobre la exposición de La Tolteca," 3.

92. See my discussion of Weston and Modotti's position in Mraz, *Nacho López, Mexican Photographer*, 5. Weston referred to his irritation with the picturesque while shipbound for Mexico in 1923, and then again in his article "Fotografía, no pintura," *Helios* 16 (1931): 5.

93. Tina Modotti to Edward Weston, 17 September 1929. In Stark, "The Letters from Tina Modotti to Edward Weston," 67–68.

94. See Delpar, *The Enormous Vogue of Things Mexican*, 62, 78.

95. According to an unpublished interview with Rosa Luján, widow of Traven, by John Mraz and Reinhard Schultz, Mexico City, 1988. See González Cruz, *Tina Modotti y el muralismo mexicano*.

96. Siqueiros, *Me llamaban El Coronelazo*, 216–17.

97. See in Hooks, *Tina Modotti*, 145. Hereafter cited in the notes as Hooks, with page numbers.

98. On "internal colonialism" and "*ladinos*," see the classic essay by Rodolfo Stavenhagen, "Seven Fallacies about Latin America." Often reprinted, it can be found in James Petras and Maurice Zeitlin, eds., *Latin America. Reform or Revolution?* (New York: Fawcett, 1968), 13–31.

99. See in Hooks, 149, and *El Machete*, 6 April 1929, 1.

100. See my remarks on the first photo in Mraz, *Nacho López, Mexican Photographer*, 5–6. See these pictures in Hooks, 153, 150, and in *El Machete*, 1 September 1928, 1, and 15 September 1928, 1.

101. See in Hooks, 150, and *El Machete*, 28 July 1928, 1.

102. Modotti, "On Photography," 196. Modotti also violated her own injunctions against picturesque photography, most notably in the *tehuana* who carries a painted gourd on her head, an image published in this article and often reproduced; see in Hooks, 181.

103. See in Lowe, *Tina Modotti*, plate 81.

104. See this photo on the cover of *Tina Modotti*.

105. See in Hooks, 154; Lowe, *Tina Modotti*, plate 90. This image is often identified as a woman with an "anarcho-syndicalist flag"; it would have been inconceivable for a communist such as Modotti to have placed that in her hands. It is also worth observing here that the woman is not Benita Galeana, the famous social combatant who is sometimes named as its subject. As Marianna Figarella has established, she is almost certainly a maid, Luz Jiménez, who posed for Diego Rivera, Weston, and Modotti; see *Edward Weston y Tina Modotti en México*, 184.

106. See in Lowe, *Tina Modotti*, plate 71.

107. Figarella makes a convincing case for Weston's influence. See also Rodríguez, "La mirada de la ruptura."

108. Víctor Flores Olea, "Manuel Álvarez Bravo, un artista mexicano del siglo xx," *La Jornada*, 4 February 1992, 38.

109. Elena Poniatowska, "Manuel Álvarez Bravo (Quinta y última parte)," *La Jornada*, 26 July 1990, 11.

110. Elena Poniatowska, "Manuel Álvarez Bravo (Segunda parte)," *La Jornada*, 23 July 1990, 12. Modotti was expelled from Mexico in 1930 under Article 33 of the constitution, which prohibits foreigners participating in Mexican politics.

111. Taylor, "Manuel Alvarez Bravo," 28.

112. Cristina Pacheco, "En los 80 años de Manuel Álvarez Bravo: 'Solo hay que mirar hacia el futuro,'" *Sábado*, supplement of *Unomásuno*, 6 February 1982, 7.

113. Moyssén, ed., *Diego Rivera*, 327.

114. See in Kismaric, *Manuel Alvarez Bravo*, 87.

115. The reference is to Roland Barthes's concept of "punctum"; see *Camera Lucida*, 27.

116. See in Kismaric, *Manuel Alvarez Bravo*, 88. I have discussed this photo in *Nacho López, Mexican Photographer*, 6. I am here distinguishing between "Indianist" photography, which is that made of Indians by non-Indians, and "Indian" photography, which is that they would take of themselves.

117. See in Kismaric, *Manuel Alvarez Bravo*, 49.

118. In a 1976 interview with Jane Livingstone, Álvarez Bravo described the influence of Pictorialism and the Japanese printmaker Hokusai during the early 1920s; Livingstone, *M. Alvarez Bravo*, x–xi.

119. See in Livingstone, *M. Alvarez Bravo*, plate 77.

120. See in Kismaric, *Manuel Alvarez Bravo*, 203.

121. See in Parker, *Manuel Alvarez Bravo*, 25.

122. As Jean-Paul Sartre reflected, "What the drama of the war gave me, as it did everyone else who participated in it, was the experience of heroism . . . which is a false experience. After the war came the true experience, that of society," "An Interview with Sartre," *New York Review of Books*, 26 March 1970, 22.

123. See in Kismaric, *Manuel Alvarez Bravo*, 78. Unpublished interview with Álvarez Bravo by John Mraz, 1988.

124. Álvarez Bravo commented on his photography while in LEAR, in Manuel García, "Encuentro con el fotógrafo Manuel Álvarez Bravo," *Sábado*, supplement of *Unomásuno*, 3 January 1998, 3.

125. Coleman, "The Indigenous Vision of Manuel Álvarez Bravo," 222.

126. Taylor, "Manuel Alvarez Bravo," 28.

127. Benjamin, *La Revolución*, 14, 165.

128. Florescano, *El nuevo pasado mexicano*, 71.

129. See Gilly, "Memoria y olvido, razon y esperanza"; Benjamin makes reference to the "Revolutionary Family," *La Revolución*, 21.

130. See "La revolución mexicana: Filmografía básica," 120–25, which lists sixty films in a special issue of *Filmoteca* in 1979.

131. It is not clear to what extent De Fuentes conceived of these three films as a trilogy. Because they deal with a common theme and were made very closely together—and as De Fuentes did not return to the subject of the revolution at a later date—I have taken the liberty of denominating them as such. They are, at any rate, more of a trilogy than the three films that Mora attempts to identify in this way—*El compadre Mendoza*, *¡Vámonos con Pancho Villa!*, and *Allá en*

el Rancho Grande (1936)—in *Mexican Cinema*, 43. With *Rancho Grande*, De Fuentes abandoned definitively any attempts to make serious cinema; henceforth, he dedicated himself to genre films about folkloric subjects such as the singing *charro* (*Rancho Grande*), and the self-sacrificing mother (*La gallina clueca*, 1941). See my essay on him at www.filmreference.com, and an earlier article with sixteen frame enlargements, "How Real Is Reel?"

132. García Riera, *Historia documental del cine mexicano*, 1: 32.

133. It appears that Lázaro Cárdenas, minister of war under Abelardo L. Rodríguez (1932–34), ordered the film withdrawn from circulation because he considered it denigrating to the army; see de los Reyes, *Medio siglo de cine mexicano*, 158. Emma Roldán, who appears in the film as the mother of the freed son—and who was the real-life wife of Alfredo del Diestro, who played Carrasco—stated, "The film was shown to Cárdenas, who said that the ending had to be changed"; Eugenia Meyer, ed., *Cuadernos de la Cineteca Nacional*, 6: 18–19. Apparently, neither a script nor copies exist of what must have been the original version.

134. Luz Alba, *Ilustrado*, 8 June 1933, and Denegri, *Filmográfico* (1933); cited in García Riera, *Fernando de Fuentes*, 93, 95.

135. See Knight, *The Mexican Revolution*, 2: 91–93.

136. O'Shaughnessy, *A Diplomat's Wife in Mexico*, 48.

137. See Florescano, ed., *Así fue la Revolución Mexicana*, 4: 606; on the myths surrounding Huerta, see Rutherford, *Mexican Society during the Revolution*, 177.

138. On bribery under Huerta, see Katz, *The Secret War in Mexico*, 119.

139. See Sherman and Greenleaf, *Victoriano Huerta*, and Meyer, *Huerta*.

140. Juan Bustillo Oro, *Ilustrado*, 22 June 1933; cited in García Riera, *Fernando de Fuentes*, 95.

141. A. F. B., *Filmográfico* (1934); cited in García Riera, *Fernando de Fuentes*, 103.

142. *El Redondel*, 8 April 1934; cited in García Riera, *Fernando de Fuentes*, 104.

143. Anonymous interview, "Lo que piensa Fernando de Fuentes de su película *El compadre Mendoza*," *El Universal*, 6 April 1934; cited in García Riera, *Fernando de Fuentes*, 28.

144. Anonymous reviews in *El Cine Gráfico*, 1 April 1934, and in the section "Cinefonías," *Ilustrado*, April 1934, where it was said to be "undoubtedly the best Mexican film made up to now"; cited in García Riera, *Fernando de Fuentes*, 104.

145. It was named number 3 among the hundred best Mexican films in a 1994 poll published by *Somos* magazine; see "100 mejores películas mexicanas," *Somos*, 16 July 1994.

146. See Lukács, *The Historical Novel*, 37.

147. On the different filmed ending, which has been shown several times on Mexican television, and the original script, see García Riera, *Fernando de Fuentes*,

38–40. The alternative ending of the script can be found in its entirety in Serrano, *¡Vámonos con Pancho Villa!*, 60–64.

148. On the production costs and the equipment utilized, see García Riera, *Fernando de Fuentes*, 33–34, 120–21. The producer, Salvador Elizondo, says that the film was a commercial failure, ibid., 34. The film was voted number 1 in the *Somos* poll; see note 145.

149. The fact that he chose to dress his *federales* in 1930s uniforms despite his funding indicates that he either still suffered from shortages or was unconcerned about such details.

150. Given the participation of foreigners such as Fred Zinnemann and Paul Strand, the *mexicanidad* of *Redes* is somewhat problematic. See my essay on this film at www.filmreference.com.

151. I say "evidently" because, although it is generally agreed among those who write on Mexican cinema that Cárdenas was responsible for the creation of CLASA, one of CLASA's founders, Salvador Elizondo, stated that it "operated entirely with private capital" (cited in García Riera, *Fernando de Fuentes*, 33–34). García Riera believes that the Cárdenas government was deeply involved in CLASA; see García Riera, *Historia documental del cine mexicano*, 1: 90. Among those who have accepted García Riera's version are Mora, *Mexican Cinema*, 43, and Sánchez, *Crónica antisolemne del cine mexicano*, 35.

152. Salvador Elizondo, "Fernando de Fuentes," *Nuevo cine* 1, no. 2 (1961): 10; cited in García Riera, *Fernando de Fuentes*, 121.

153. The director José Bohr said, "The Cárdenas government never influenced the tendencies of productions; it never utilized censorship nor counter-censorship"; cited in Mora, *Mexican Cinema*, 246. José de la Colina refers to the "amplia libertad" of the Cardenist period, *Política* (15 March 1961); cited in García Riera, *Fernando de Fuentes*, 119. However, Emilio Gómez Muriel—who worked in the cinema industry in the 1930s and was involved in *Redes*—stated that though de Fuentes had "treated the Revolution in a very interesting manner" in *El compadre Mendoza*, he "no longer treated the themes with such liberty" in *Vámonos*; cited in O'Malley, *The Myth of the Revolution*, 173.

154. See de Luna, *La batalla y su sombra*, 228; Serrano, "*¡Vámonos con Pancho Villa!*" 59, and Jorge Ayala Blanco, "La Cultura en México," *Siempre!*, 22 September 1982, also attribute it to "official censorship"; cited in García Riera, *Fernando de Fuentes*, 38–39.

155. Gilly, "Memoria y olvido, razon y esperanza," 10.

156. O'Malley, *The Myth of the Revolution*, 111–12; Mayer, "El proceso de recuperación simbólica de cuatro héroes de la Revolución mexicana de 1910 a través de la prensa nacional," 375.

157. This may be the most convincing explanation, for one feels "beat over the head" by the excessive cruelty of the eliminated scene.

158. See Knight, *The Mexican Revolution*, 2: 35; Ruíz, *The Great Rebellion*, 193; and Katz, *The Life and Times of Pancho Villa*, 286, 473–74.

159. Villa's charisma has been commented on by many writers, among them, Knight, *The Mexican Revolution*, 2: 34; Katz, *The Secret War*, 145, and *The Life and Times of Pancho Villa*, 286, 473–74; Rutherford, *Mexican Society during the Revolution*, 155.

160. Soler stated: "Pancho Villa is the most difficult role that has ever been interpreted by anybody in our cinema. . . . For that reason, I've dedicated myself to studying with great zeal, not only the part I've been given in the film, or that which is in the Muñoz novel [the source of the film script], but also the guerrilla evoked in other novels, in biografies, anecdotes, periodical articles, fantasies, and even in corridos." Mario Galán interview with Soler, *Ilustrado*, 21 November 1935; cited in García Riera, *Fernando de Fuentes*, 35.

161. Ayala Blanco, *La aventura del cine mexicano*, 27.

162. Writing in 1937, Alfonso de Icaza expressed his disappointment at discovering the "defect" that Villa was a secondary character; cited in García Riera, *Fernando de Fuentes*, 119.

163. Katz, *The Secret War*, 141, and *The Life and Times of Pancho Villa*, 210, 239; Knight, *The Mexican Revolution*, 2: 35.

164. Knight says that disease was the "single biggest killer" of the revolutionary struggle and notes the importance of smallpox among the debilitating illnesses; 2: 420–421. It may be worth noting that Miguel Ángel's malady has often been misidentified: some authors have claimed it was cholera—García Riera, *Fernando de Fuentes*, 119, and *Historia documental del cine mexicano*, 1: 92; de Luna, *La batalla y su sombra*, 228; Mora, *Mexican Cinema*, 44—other writers think it was malaria (Jean Allard) or plague (Gustavo García); cited in García Riera, *Fernando de Fuentes*, 126–27.

165. According to Gustavo García, as of 1974 there had been more than twenty films made in which Villa appeared in some form; cited by Gustavo Montiel Pagés, who observed that these films were inevitably epics. See Montiel Pagés, "Pancho Villa: El mito y el cine," *Filmoteca*, 103–4.

166. José de la Colina, "Diorama de la Cultura," *Excelsior*, 28 October 1973; cited in García Riera, *Fernando de Fuentes*, 126. Although it seems to me that wider takes with greater depth of field would be generally preferable in historical cinema for the greater amount of detail they could include, I am also in agreement with Natalie Zemon Davis, who has argued, "There is no automatic privileging of the 'realistic' or naturalistic film as the mode for representing the past"; see "'Any Resemblance to Persons Living or Dead,'" 273.

167. So states the old railroader, Guillermo Treviño, in the opening interview of my videotape *Made on Rails: A History of the Mexican Railroad Workers* (1987), distributed by the Cinema Guild.

3. Cinema and Celebrities in the Golden Age

1. See Niblo, *Mexico in the 1940s*, 75, 183–251.
2. Knight, "The Rise and Fall of Cardenismo," 315.
3. The phrase is Héctor Aguilar Camín's description of education under Alemán; see *Saldos de la Revolución*, 126.
4. Tuñon, "Femininity, 'Indigenismo,' and Nation," 82; on Golden Age culture, see Joseph, Rubenstein, and Zolov, eds., *Fragments of a Golden Age*.
5. Quoted in Reyes Nevares, *The Mexican Cinema*, 14.
6. Dennis Brehme, in "Hugo Brehme" in *Hugo Brehme: Fotograf-Fotógrafo*, 19, writes that when Figueroa began to make still photographs, he used to pass by his grandfather's studio, "examining the photos that Hugo exhibited in a window that looked out on the street." He finds Figueroa's style "very similar to Hugo's."
7. See Taibo, *El Indio Fernández*, 55. On arriving at the border, Eisenstein's car was searched and the negatives were discovered; it was only with luck that he escaped arrest and confiscation of the film. He was given a thirty-day pass to get from Texas to New York and leave for Moscow.
8. Tuñon, *En su propio espejo*, 24–25. Fernández may later have deliberately imitated Eisenstein in *Una cita de amor* (1956).
9. Sánchez Estevez, "Luis Márquez Romay y su obra," 16.
10. See the issue of *Alquima* titled "El imaginario de Luis Márquez."
11. Interview with Márquez, in Tibol, *Episodios fotográficos*, 119; Sánchez Estevez, "Luis Márquez Romay y su obra," 52.
12. Alfonso de Medina, "*Janitzio*, la primera gran cinta de espíritu mexicano," *El Universal Ilustrado*, 27 December 1934, 8–9.
13. Letter from Fernández to Márquez, cited in Sánchez Estevez, "Luis Márquez Romay y su obra," 53.
14. Tuñon, *En su propio espejo*, 30. Strand is the author of *Redes*, as well as its cinematographer, and he is listed as such in the credits. The direction is assigned to Fred Zinnemann (later to direct *High Noon*, among other works) and Emilio Gómez Muriel. Narciso Bassols and Carlos Chávez are given credit for producing the film, and they enlisted Silvestre Revueltas, a composer of note, to create the music. At another point in the Tuñon interview, Fernández described the director John Ford, with whom he worked as codirector on *The Fugitive* (1946), as his maestro. His description of what he took from Ford is more convincing than his references to Eisenstein and Strand: "John Ford is the greatest cinematic poet, with his violent conception of landscape," 51.
15. See my essay on *Redes* available at www.filmreference.com. On Strand's photography in Mexico and *Redes*, see Krippner, "Traces, Images and Fictions."

16. Strand, cited in Alexander, "Paul Strand as Filmmaker, 1933–1942," 151.

17. See Isaac, *Conversaciones con Gabriel Figueroa*, 25; de Orellano, "Palabras sobre imágenes," 40; *Gabriel Figueroa y la pintura mexicana*.

18. Feder, "A Reckoning," 13.

19. See Ramírez Berg, "Figueroa's Skies and Oblique Perspective." Figueroa refers to his perspective as "curvilinear" rather than "oblique," in Feder, "A Reckoning," 5.

20. The state appears to have supported film production in one form or another between 1931 and 1970, according to Ramírez Berg, *Cinema of Solitude*, 6.

21. Tuñon, *En su propio espejo*, 72.

22. Ibid., 77.

23. Ibid., 56.

24. "After the Revolution," *Films and Filming* (June 1963): 20.

25. See Mistron's take on this form, "A Hybrid Subgenre."

26. Recounted in Taibo, *El Indio Fernández*, 93.

27. See Colina and Torres, "Ideología del melodrama en el viejo cine latinoamericano."

28. See Burton-Carvajal, "Mexican Melodramas of Patriarchy."

29. See my discussion of an individual trapped within his bourgeois forms of perception while living in a revolutionary situation, Mraz, "*Memories of Underdevelopment*."

30. *Novelas de Pantalla* (8 May 1943); cited in García Riera, *Emilio Fernández*, 40.

31. Education is a reiterative concern in Fernández's interviews, although his "institutionalism" is apparent in the credit he gives to Ávila Camacho, rather than Cárdenas; see Tuñon, *En su propio espejo*, 84; see also Tuñon, "Una escuela en celuloide."

32. See my discussion of the *pelado* below in relation to Cantinflas.

33. See Tuñon, *Los rostros de un mito*, 98.

34. See the book-length interview with Figueroa, in Poniatowska, *Todo México*, 196.

35. Fernando Morales Ortiz, *Esto*, 27 December 1946; cited in García Riera, *Emilio Fernández*, 93. On the reception of *Enamorada* in Spain, see Tuñon, "*Enamorada en Madrid*."

36. See chapter 2. I have reflected more widely on historical representation in Mraz, "The Revolution Is History."

37. On the importance of eyes, see Tuñon, *En su propio espejo*; Taibo, *El Indio Fernández*, 159.

38. Taibo, *El Indio Fernández*, 109.

39. Tuñon, *En su propio espejo*, 71–72.

40. Taibo, *El Indio Fernández*, 58, 51.

41. "El cine de Emilio Fernández no es mexicano ni extraordinario, dice el director Julio Bracho," *Hoy*, 26 September 1951, 27.

42. Carlos Monsiváis comments on the appearance of celebrities in "Sociedad y cultura," 274; and "Los Hermanos Mayo: . . . y en una reconquista feliz de otra inocencia," *La cultura en México*, supplement of *Siempre!*, 12 August 1981, iv.

43. Vicente Vila, "El macho mexicano, obra del cine," *Siempre!*, 28 January 1959, 52.

44. Vicente Vila, "Falsificación del mexicanismo en el cine," *Mañana*, 15 September 1951, 195; Vila "El macho," 52.

45. Alejandro Carrillo, "El cine y una leyenda negra," *Mañana*, 20 March 1954, 11.

46. Vila, "El macho," 53.

47. Vicente Lombardo Toledano, "La crisis del cine mexicano," *Siempre!*, 18 August 1954, 12.

48. Vila, "Falsificación," 193.

49. Vila, "Falsificación," 194. Curiously, Vila does not mention Pedro Infante.

50. See Dyer, *Stars*. Although the star text and the media text will usually coincide, there are cases where they differ; for example, see the cases of Dolores del Río and María Félix discussed below.

51. Monsiváis, "Las mitologías del cine mexicano," 13.

52. One trenchant example of declaring class struggle at an end can be seen in the fact that the CTM (Confederación de Trabajadores Mexicanos), the main coalition of unions, transformed its slogan in the 1940s from "For a classless society" to "For the emancipation of Mexico." Of course, the PRI retains a corporate structure, maintaining clientelistic relations with groups, but social problems are increasingly privatized.

53. Ayala Blanco, *La aventura del cine mexicano*, 82.

54. Antonio Rodríguez, "Cantinflas, el fenómeno: un símbolo mexicano," *Siempre!*, 20 March 1957, 32. The mentions of Cantinflas incarnating *lo mexicano* are innumerable; for example, in 1946 César Garizurieta asserted, "Without any doubt, the Mexican is represented by Cantinflas. . . . He represents, very very much, the various ways of being Mexican"; "Catarsis del mexicano," in Bartra, *Anatomía del mexicano*, 124.

55. Moreno, "Retrato de 'Cantinflas,'" 70. For an overview in English, see Pilcher, *Cantinflas and the Chaos of Mexican Modernity*.

56. Ramos, *Profile of Man and Culture in Mexico*, 57–63. The word "pelado" was used by Ezequiel Chávez in 1901; see "La sensibilidad del mexicano," in Bartra, *Anatomía del mexicano*, 41.

57. Jesús Romo y de la O, "Cantinflas y el peladito," *Mañana*, 15 September 1951, 232.

58. Moreno, "Retrato de 'Cantinflas,'" 65.

59. Ibid., 69.

60. This observation was made articulately by my student, Alejandra López Camacho, in discussing this sequence.

61. Pedro Ferriz, "El habla del mexicano: El mejor espejo de su alma," *Siempre!*, 13 June 1962, 40.

62. See Brading, "Manuel Gamio and Official Indigenismo in Mexico," and Gamio, *Forjando Patria*.

63. Paulita Brook, "Carta abierta a Cantinflas," *México Cinema*, 15 March 1952; cited in García Riera, *Historia documental del cine mexicano*, 4: 378.

64. See Luis G. Basurto, "Mario Moreno continúa hundiendo a Cantinflas," *Hoy*, 3 October 1953, 50–51; José Alvarado, "Entre su director y su argumentista están destruyendo a Cantinflas," *Siempre!*, 6 October 1954, 60. Carlo Coccioli, "¿De dónde sacó Johnson que Cantinflas es México? Sólo en la cabeza de un texano puede madurar esa idea," *Siempre!*, 22 November 1967, 26–27; the Coccioli article produced responses from Cantinflas and a number of letters to the editor, published in subsequent issues.

65. Ayala Blanco, *La aventura del cine mexicano*, 110.

66. Bartra, *La jaula de la melancolía*, 173–81.

67. Ibid., 179.

68. Carlos Monsiváis, "Cantinflas: That's the Point!," in Monsiváis, *Mexican Postcards*, 98–99.

69. Pérez, *Cantinflas*, 44, 42.

70. Antonio Rosete Riverón, "Cantinflas al servicio de intereses antimexicanos?," *Siempre!*, 6 December 1967, 5.

71. Paz, *The Labyrinth of Solitude*, 14.

72. Compare Paz's position to the feelings expressed by Zadie Smith, in her novel about cultural mixing in London: "And underneath it all, there remained an ever-present anger and hurt, the feeling of belonging nowhere that comes to people who belong everywhere"; *White Teeth* (New York: Vintage, 2001), 225.

73. Carlos Monsiváis, "Tin Tan: The Pachuco," in Monsiváis, *Mexican Postcards*, 111.

74. Eglantina Ochoa Sandoval, "Una maldición sobre México: La del pocho!," *Siempre!*, 19 March 1958, 28. Perhaps more empathy was extended toward migrants under Cárdenas; see mention of their "ferocious defense" of "being Mexican" by Rasa Seldi, "La mexicanidad de los 'pochos,'" *Hoy*, 31 December 1938, 71.

75. *Hoy*, 16 February 1952, cover.

76. Fernando Muñoz Castillo, "Tiruliruli," *Sábado*, supplement of *Unomásuno*, 25 June 1994, 1. I thank Ricardo Pérez Montfort for clarifying some of these expressions for me.

77. Emilio García Riera, "Las películas de Tin Tan," *La Jornada Semanal*, 5 December 1999, 4; Muñoz Castillo, "Tiruliruli," 1.

78. Augusto Orea Marin, "Caifanes, pachucos e intelectuales ye ye," *Siempre!*, 21 December 1966, 7. Few letters to the editor were published in magazines, so one imagines that this served a purpose.

79. Interview with José Revueltas, in Meyer, *Cuadernos de la Cineteca Nacional*, 4: 104.

80. Marcelo Cháves was evidently known as an "implacable critic of economic and social questions in Mexico and the world," so he may have been the force pushing the denunciation that he makes at the end of *El rey*, which makes Tin Tan nervous; see Eduardo Septién, "Tin Tan, el cómico que tomó la vida en broma y su carrera en serio," *Nosotros*, 30 June 1973, 42.

81. Paz noted the impracticality of the pachuco's clothing ("Hence its aggressiveness") in *The Labyrinth of Solitude*, 15.

82. The film's title is literally "Tender little squash," but it plays with the rhyme of *"¡Ay qué bonita piernas!* (What beautiful legs), a phrase used in the film and appearing as part of the title of the copy I have from the Filmoteca of the Universidad Nacional Autónoma de México.

83. Ana Milagros Medina argues, in *Tin Tan*, 15, that "producers definitively eliminated his costume and controlled his expressions in English." Nonetheless, this has yet to be documented; Tin Tan's only complaint about his producers registered in his daughter's book relates to their avarice and corruption; see Valdés Julián, *La historia inédita de Tin Tan*, 195–96.

84. *"Buey"* is pronounced very similarly to "way," and is today used constantly in young people's conversations.

85. The personage was here in character with Tin Tan's media text, for his spendthrift ways were well publicized. Although he earned a fortune, he died bankrupt; this is another difference from Cantinflas, who was very careful with his money and died a multimillionaire. A typical Mexican trait was supposedly that of throwing money away; see Rafael Solana, "Tirar el dinero es placer del mexicano," *Siempre!*, 9 November 1966, 34.

86. I discuss *El rey del barrio* in Mraz, *Nacho López, Mexican Photographer*, 30–32.

87. Andres Ortega Aragón, "Muerte de un genio de la comicidad desperdiciado," *Mañana*, 7 July 1973, 43. Other obituaries agree with this number.

88. A. Catani, "Quedó trunco el deseo de Tin Tan películas especiales para niños," *El Heraldo de México*, 30 June 1973, 14c.

89. Gómez Peña, *The New World Border*, 178.

90. Paz saw identity as drawn from the past, asserting that "the *pachuco* has lost his whole inheritance: language, religion, customs, beliefs," *The Labyrinth of Solitude*, 15.

91. Muñoz Castillo argued that Tin Tan was the sole comedian *"vigente"* for young people in 1994 ("Tiruliruli," 1), and I have personally noted his appeal among

them. See Mraz, *Nacho López, Mexican Photographer*, for an extended discussion of nationalism in this period.

92. See Paredes, "Estados Unidos, México y el machismo," 69, 82.

93. At the same time, its appearance as an affirmative concept may be related to presidentialism, because it offered the possibility to rhyme with "Camacho" (Manuel Ávila Camacho, 1940–46), and was evidently incorporated as one of his campaign slogans: "Ca . . . MACHO" (Gutmann, *The Meanings of Macho*, 226). While Guttman has outlined the complexities surrounding the word's meaning, my experiences of drinking with Mexican men leads me to disagree with Anne Rubenstein's assertion that, "the word always describes somebody else," or her contention (based on Alma Guillermoprieto) that "groups of men getting together to get drunk . . . [is] a more or less self-conscious ritual of middle-class men who understand themselves to be playing a slightly ridiculous role," Rubenstein, "Bodies, Cities, Cinema," 226, 233. I sense that, faced with the questions of a U.S. academic, Mexican informants tailor their testimonies to suit their interviewers.

94. Gutmann, *The Meanings of Macho*, 224.

95. See my remarks on "Americanization" in this period, and the reactions to it, in Mraz, *Nacho López, Mexican Photographer*, 28.

96. Moreno Rivas, *Historia de la música popular mexicana*, 200. References to Negrete and Infante as "idols" are constant in the illustrated magazines.

97. Rafael Solana, "Una imagen del México típico se va: Silveti," *Siempre!*, 17 October 1956, 32.

98. See García Riera, *Historia documental del cine mexicano*, 1: 56.

99. Margot Valdés Peza, "10 años después María Félix perdona a Jorge," *Hoy*, 25 December 1952, 11; Efrain Huerta, "Ases y estrellas," *Nosotros*, 19 December 1953, 36.

100. Moreno Rivas, *Historia de la música popular mexicana*, 203.

101. Vicente Vila, "Pedro Armendáriz vivió y murió con la pistola en la mano," *Siempre!*, 10 July 1963, 51. Diagnosed with terminal cancer, and in great pain, Armendáriz finished his part in *From Russia with Love* (1963) to ensure that his family would receive his contracted salary, and then shot himself while in the UCLA Medical Center.

102. Vicente Vila, "Víctima del cine violento," *Siempre!*, 17 July 1963, 48.

103. Ibid.

104. Among other roles that Armendáriz played effectively was that of a labor leader in *Distinto amanecer* (1943); he appeared in many U.S. films, but always in character parts for Latinos.

105. Alvaro Custodio, *Excelsior*, September 1947, cited in García Riera, *Historia documental del cine mexicano*, 3: 70.

106. These comments were made by writer Guadalupe Loaeza and the director of the Cineteca Nacional, Leonardo García Tsao, in interviews made by Televisa and broadcast on 16 April 2007.

107. See the comparison of U.S. and Mexican buddy movies in de la Mora, *Cinemachismo*, 88. De la Mora argues that "the ambiguities in the texts allow spectators to read Infante as a queer icon," 72.

108. On Infante's sexual exploits, see ibid., 74.

109. De la Colina, "Pedro Infante," 3.

110. The critic's reference is to the *héroe agachado*, representative of the defeated *pueblo*; Yépez, "Como leer a Pedro Infante," 8. On this figure, see Bartra, *La jaula de la melancolía*, 96, as well as the application I have made of this concept in Mraz, *Nacho López, Mexican Photographer*, 29, 190.

111. Yépez, "Como leer a Pedro Infante," 7.

112. Pedro Infante, "Creo que soy así," *Siempre!*, 29 June 1955, 49.

113. For an interesting comparison of Infante's acting in different films, see Eduardo Mejía, "El mito Infante: Pedro Malo y Pedro Bueno," *El Financiero*, 17 April 1993, 30–31. For insight into Infante's personal views, see Jaime Morales, "'Mi lema es no meterme en nada': Pedro Infante," *Mañana*, 12 August 1950, 22–23. Richard Dyer contrasts "The Good Joe" and "The Tough Guy" in *Stars*, 48–49.

114. Upon watching Infante's films, I was struck by how his natural exuberance seems to embody a passage from Friedrich Nietzsche, "I want to learn more and more to see as beautiful what is necessary in things: then I shall be one of those who make things beautiful. *Amor fati*: let that be my love henceforth." *The Gay Science*, trans. Walter Kaufmann (New York: Vintage, 1974), 223.

115. Marco Antonio Campos, "Crónica periodística de la muerte y entierro del ídolo," *Confabulario*, 7 April 2007, 9–11; see also Rubenstein, "Bodies, Cities, Cinema."

116. Dever, *Celluloid Nationalism and Other Melodramas*, 12.

117. Tuñon, "Femininity, 'Indigenismo,' and Nation," 95.

118. Bateson, "Morale and National Character," 90–91.

119. See Carlos Monsiváis's references to the del Río–Armendáriz couple in "Dolores del Río: The Face as Institution," in Monsiváis, *Mexican Postcards*, 82.

120. Interview with Isabel Alba, in Tuñon, "Entre lo público y lo privado," 112.

121. References to García as the national mother and grandmother are numerous; José M. Sánchez García describes her as "Madre de México" in "Sara García, la maestra: Entre risas y lágrimas," *Siempre!*, 24 September 1958, 46, while Fernando Muñoz Castillo states that she was "la abuelita del cine nacional" in "Sara García, Mater admirabilis," *Sábado*, supplement of *Unomásuno*, 2 July 1994, 5.

122. García Riera, *Historia documental del cine mexicano*, 1: 153.

123. Ricardo Pérez Montfort has observed that *hispanismo* was often linked to con-

servative tendencies and that the mass media construed it as part of national identity, although official nationalism favored *indigenismo*; "Indigenismo, hispanismo y panamericanismo en la cultura popular mexicana de 1920 a 1940," 365.

124. *Excelsior*, 13 April 1922, cited in Acevedo, *El 10 de mayo*, 9.

125. *Excelsior*, 18 April 1922, cited in Acevedo, *El 10 de mayo*, 23.

126. Sánchez García, "Sara García, la maestra," 46.

127. García Riera, *Historia documental del cine mexicano*, 2: 37.

128. Hershfield, *The Invention of Dolores del Río*, 10.

129. Margery Wilson, cited in ibid.

130. See Dawson, *Indian and Nation in Revolutionary Mexico*.

131. On the film's presence in modern memory, see García Canclini, ed., *Los nuevos espectadores*, 60.

132. "Dolores del Río narra su estancia en los Estados Unidos," *El Universal*, 5 October 1925, 2nd section, 6.

133. Dawson, "From Models for the Nation to Model Citizens," 285.

134. The concept of a "deep Mexico," rooted in traditional Mesoamerican culture, was introduced by Guillermo Bonfil in his book, *México profundo: una civilización negada* (1987), which has been translated by the University of Texas Press as *México Profundo: Reclaiming a Civilization* (1996). See also Lomnitz, *Deep Mexico, Silent Mexico*.

135. Paranaguá, *Tradición y modernidad en el cine de América Latina*, 107. One of the more respected scholars of Latin American cinema, Paranaguá dedicates the chapter titled "Mito" to Félix, 107–20.

136. José Alvarado, "Saludo a María Félix," *Siempre!*, 2 January 1954, 24.

137. Paco Ignacio Taibo I notes that the film's success had few precedents; see his *María Félix*, 36.

138. Paz, "Razón y elogio a María Félix," 11.

139. Taibo, *María Félix*, 74, cites *México Cinema* magazine of June 1945 as listing the earnings per film in this order: María Félix, 250,000 pesos; Cantinflas, 200,000; Jorge Negrete, 75,000; Pedro Armendáriz, 50,000.

140. The film is placed in Venezuela, where cowboys are *llaneros*, plainsmen. Doña Bárbara is referred to as a *llanera* in the film, but in Mexican terms she would be a *cacica* (female *cacique*) and *hacendada* (female hacienda owner). The counterpoint of civilization and barbarism was most pointedly made by the Argentine Domingo Sarmiento, in his 1845 work *Facundo*.

141. Ramón, "Lectura de las imágenes propuestas por el cine mexicano de los años treinta a la fecha," 99.

142. One director, the Spaniard Antonio Momplet, observed, "In some scenes you can't direct María. She directs herself," Taibo, *María Félix*, 81.

143. Ibid., 19.

144. García Riera, *Historia documental del cine mexicano*, 3: 102.

145. Monsiváis, "María Félix," 15.

4. Magazines, Photojournalism, *Historia gráfica*

1. I have analyzed these periodicals at length in Mraz, *Nacho López, Mexican Photographer*, chap. 2; see also Mraz, "Today, Tomorrow and Always." Circulation figures for Mexican periodicals are inexact when not unavailable; see *Nacho López, Mexican Photographer*, 208, and "Today, Tomorrow and Always," 152. On the circulation of *Life*, see Baughman, "Who Read *Life*?

2. An immediate precedent may be the magazine, *Todo*, which began to publish in 1933. See Monroy Nasr, *Historias para ver*.

3. On Pagés Llergo see Mraz, *Nacho López, Mexican Photographer*, 38; on *Rotofoto*, see 38–41.

4. José Pagés Llergo, "El Papa me regañó," *Hoy*, 10 February 1940, 44. See, for example, José Pagés Llergo, "Yo hablé con Hitler," *Hoy*, 18 November 1939, 38–40, in which he describes how he stalked Hitler throughout Germany, attempting to interview him, finally to be admitted to his presence in a conquered Warsaw. The lengthy text contains few of Hitler's words and much of Pagés's acclaim for this "magnificent, extraordinarily sensitive, man who had realized in 10 years what neither Napoleón, nor Julius Caesar nor Carlos V nor Bismarck could in a lifetime."

5. Blanco Moheno, *Memorias de un reportero*, 86.

6. *Hoy*, 5 July 1941, back cover. In Mexico, the Americas (North and South together) are considered to be one continent.

7. "Hay 4,572 revistas en el mundo, pero de ellas sólo 10 destacan: allí está *Hoy*," *Hoy*, 1 March 1952, 141.

8. "*Life* visita a *Hoy*," *Hoy*, 26 July 1952, 8. *Life* had evidently carried out a survey.

9. "*Hoy*: Un periódico libre en un país libre," *Hoy*, 1 March 1952, 6; the Fuentes letter was published in the magazine on 29 March 1952, 4.

10. Luis Manuel Portilla, "Sombras de Herón Proal: Con 70 años reumático y cansado, es una figura pintoresca y agresiva," *Hoy*, 8 April 1950, 27.

11. *Hoy* was blacklisted by the State Department and boycotted by U.S. advertisers until Pagés Llergo resigned; see Ortiz Garza, *México en guerra*, 93, and Niblo, *Mexico in the 1940s*, 321.

12. "El onomástico del General Maximino Ávila Camacho," *Mañana*, 4 September 1943, 46–47; "Vida pública en México," *Mañana*, 20 November 1943, 10. The magazine later gave Maximino even more press, dedicating an entire issue to him, *Mañana*, 16 December 1944.

13. "¿Debe México reconocer al govierno de Franco?," *Mañana*, 2 October 1943, 36–37; the notion of recognizing Franco was so repugnant to the important

Spanish exile community that it would not occur until after the Generalísimo's death in 1976. Manuel Larens, "Habla para *Mañana* el jefe oculto del sinarquismo y descorre el velo de su organización para decir que son ellos y que es lo que quieren," *Mañana*, 23 October 1943, 30–32. A long-running history of Sinarquismo, the Mexican movement promoted by foreign fascist governments, appeared in issues from April through July in 1944.

14. The article was written by Senator Noé Lecona, "No todo ha de ser para los trabajadores," *Mañana*, 16 October 1943, 12. One issue's cover featured a cartoon of a worker appealing to the president to intercede in a strike that does not allow him to work and provide for his family, which watches with anxious eyes, *Mañana*, 30 October 1943.

15. Alfonso Francisco Ramírez, "Feminismo," *Mañana*, 16 October 1943, 35. Ramírez was noted to be a supreme court judge.

16. "Lava y cenizas," *Mañana*, 11 September 1943, 38–42. I discuss Paco Mayo's aerial photography in Mraz and Vélez, *Trasterrados*, 16. The Díaz photograph was published in *Mañana*, 13 November 1943, 47; it is not credited here, but had appeared previously on the cover of *Hoy*.

17. See Mraz, *Nacho López, Mexican Photographer*, 56–59.

18. "*Siempre!* Presencia de México," *Siempre!*, 27 June 1953, 8.

19. *El apretado: Semanario de verídica información y crítica sana para las clases laborantes* was published between 19 May 1951 and 26 January 1952 in thirty-five issues.

20. Garmabella, *Renato por Leduc*, 66, 175. For other instances of bribery, see Mraz, *Nacho López, Mexican Photographer*, 36, 47.

21. Rodrigo Moya, "Las imágenes prohibidas," unpublished manuscript, 2007. Moya has recently been rediscovered by Mexico's photographic community; see *Rodrigo Moya: Foto insurrecta* and del Castillo, *Rodrigo Moya*.

22. José Pagés Llergo, "Carta al presidente," *Mañana*, 11 September 1943, 11.

23. Letter from *Hoy* to Ruiz Cortines, *Hoy*, 20 December 1952, 4.

24. See *Hoy*, 9 February 1952.

25. See the editorial "Señor Presidente," *Hoy*, 17 October 1953, which is directed to Ruiz Cortines and begins, "You know better than anyone that *Hoy* is critical of your government, as it was of those presided by don Lázaro Cárdenas, don Manuel Ávila Camacho and don Miguel Alemán," 14. *Hoy* was certainly critical of Cárdenas, but not of his successors. On freedom of the press, see "5 años de Alemán en el poder," *Hoy*, 1 December 1951, 7, and the editorial in the issue of 1 March, 1952, 6–7.

26. See Ruiz Cortines's answers to José Pagés Llergo, "*Hoy* interroga a Ruiz Cortines," *Hoy*, 1 March 1952, 38–39; "Conjunciones y disperciones," *Hoy*, 14 January 1956, 6.

27. Víctor Alba, "México es asi . . . ," *Siempre!*, 19 June 1963, 39.

28. Rosa Castro, "¿Qué es y cómo es lo mexicano?," *Hoy*, 14 April 1951, 36–39, 66.

29. Ibid., 37.

30. Ibid., 38.

31. Ibid., 39.

32. Samuel Ramos, "Encuentro de sí mismo: Su carácter," *Mañana*, 15 September 1951, 83. José Natividad Rosales, "Para el psiquiatra el mexicano es un costal de vicios, mañas y defectos," *Siempre!*, 1 September 1954, 22–25; José Natividad Rosales, "El mexicano feo!," *Siempre!*, 28 August 1963, 28–29.

33. "*Mañana* presenta: Mesa redonda organizada por Víctor Alba. ¿Porqué se autodenigra el mexicano?," *Mañana*, 29 May 1954, 28–31.

34. Alberto Domingo, "Egolatría patriotera, enfermedad mexicana," *Siempre!*, 30 July 1969, 24.

35. Roberto Blanco Moheno, "Ni entreguista, ni comunista, ni anti-yanki," *Siempre!*, 11 July 1962, 26.

36. Antonio Rodríguez, "Recurso del débil," *Siempre!*, 26 April 1967, 32.

37. Antonio Elizondo, "El rastacuerismo produce un Mexican Way of Life," *Siempre!*, 25 June 1969, 28.

38. José Natividad Rosales, "Expulsado de EU: *Siempre!* Un enemigo?," *Siempre!*, 14 November 1962, 4.

39. Gregorio Ortega, "Prensa: amenaza una penetración imperialista," *Hoy*, 28 June 1952, 14–15.

40. "México en *Mañana*," *Mañana*, 15 November 1952, 12.

41. Daniel Morales, "Carta de *Mañana* a Pagés Llergo," *Hoy*, 16 August 1952, 24–25; "México no es así," *Mañana*, 14 February 1953, 11.

42. José Pagés Llergo, "*Hoy* señala los rumbos de México: Un reto a la mexicanidad la penetración de revistas de EEUU escritas en español," *Hoy*, 2 August 1952, 6.

43. See, for example, Alberto Domingo, "El dumping del papel: El gobierno alienta y protege la invasión de revistas yanquis," *Siempre!*, 14 June 1967, 14.

44. Pagés Llergo, "*Hoy* señala los rumbos de México," 6.

45. Hence, the issues of *Hoy* for 28 June and 2 August 1952 both contain editorials against *Life*, while the issue of 26 July describes *Life*'s visit to and approbation of *Hoy*.

46. Jorge Piñó Sandoval, "Señor Pasquel . . . , ¡vayase!," *Presente*, 18 August 1948, n.p. I am grateful to Armando Bartra for allowing me to consult his collection of *Presente*, a magazine unavailable in any Mexican public archive. ·

47. Mention of working without pay can be found in a note about the increased cost, "Aumento de precio," *Presente*, 18 August 1948, n.p., as well as in the article by Margarita Michelena, "¡En *Presente* no nos pagan!," *Presente*, 13 January 1949, 12.

48. Legorreta and Arvizu are identified only by these names.

49. Blanco Moheno, *Memorias de un reportero*, 292. In *Presente*, 17 March 1949, 9, Joaquín Pérez Saldaña (almost certainly a pseudonym for Jorge Piñó Sandoval) states that the print run for issue 8 (after the assault of August 1948) was 122,000, "the largest ever in Mexico, including dailies" ("Ya con esta me despido pero pronto doy la vuelta").

50. On these periodicals, see Mraz, *Nacho López, Mexican Photographer*, 42–43.

51. Editorial, "Año nuevo," *Presente*, 30 December 1948, 3.

52. *Presente*, 28 July 1948, n.p. In this same issue Renato Leduc referred to the "Porfirian climate" of Alemán's government, "Presentimientos," n.p.

53. Santos Ruiz Haro, "El ministro sin cartera," *Presente*, 4 August 1948, n. p. On Parra Hernández, see Niblo, *Mexico in the 1940s*, 212, 216, 261.

54. Piñó Sandoval, "Señor Pasquel . . . , ¡vayase!," n.p.

55. Renato Leduc, "Presentimientos," *Presente*, 18 August 1948, n.p.

56. Editorial, "Presente," *Presente*, 31 August 1948, n.p.

57. Renato Leduc, "Presentimientos," ibid.

58. See "Asalto al taller donde se imprimía la revista *Presente*," *La Prensa*, 24 August 1948, 34; Bertillon Jr., "Setenta mil pesos perdidos durante el asalto a la imprenta," *Excélsior*, 25 August 1948, 1, 7; "Oscuridad en el atentado: Hablan de otros personajes y de 'Algunas dudas,'" *La Prensa*, 27 August 1948, 2; Rafael A. Pérez, "Carta a Perrín," *Mañana*, 28 August 1948, 9.

59. "*La Prensa* exige plena luz en el caso de la impresora," *La Prensa*, 27 August 1948, 3.

60. Margarita Michelena, "El diablo metido a predicador," *Presente*, 31 August 1948, n.p.

61. Editorial, "Presente," *Presente*, 19 October 1948, 2. *Presente* had already had to raise its price, from twenty to thirty cents, in August because PIPSA had increased the cost of paper by 40 percent, "Aumento de precio." It is unclear if this was the first of several official obstacles to be placed in its path.

62. Asociación Mexicana de Periodistas, "Carta abierta al Presidente Miguel Alemán Valdés, en defensa de libertad de expresión," *Presente*, 19 October 1948, 8.

63. Ibid., cover.

64. "Ante el altar de la libre expresión," *Presente*, 31 August 1948, n.p.

65. Jorge Piñó Sandoval, "Rebeldía o abyección: ¿Sólo es un sarcasmo la Ley de Responsabilidades?," *Presente*, 9 December 1948, 8–9.

66. "Provincia," *Presente*, 21 September 1948, 2.

67. Cover by Arias Bernal, *Presente*, 6 January 1949; Miguel Ángel Mendoza, "La mordida," *Presente*, 7 September 1948, n.p.

68. Jorge Prieto Laurens, "PRI, un partido tuerto, cojo y manco," *Presente*, 10 March 1949, 8–9; Luis del Toro, "Pueblo sin esperanza: Al borde de la revolución," *Presente*, 24 February 1949. 7.

69. Jorge Ferretis, "Esa patria tan mentada," *Presente*, 14 September 1948, 10. With this issue the magazine began numbering its pages.

70. Jorge Piñó Sandoval, "En el silencio no está la medicina," *Presente*, 7 September 1948, n. p.

71. Editorial, "Presente," *Presente*, 26 October 1948, 3; back covers of *Presente*, 23 and 30 December 1948.

72. Luis del Toro, "¡Alto al presidencialismo!," *Presente*, 30 December 1948, 5.

73. *Presente*, 3 February 1949, cover.

74. "Increible nombramiento," *Presente*, 3 March 1949, 3.

75. "Millonarios de miseria," photos by Legorreta, text by Carrera Gil, *Presente*, 21 September 1948, 11.

76. Ibid., back cover. The joke is: "¿Cómo l'hicistes, Casitas? Ahorrando . . . ahorrando explicaciones."

77. René Avilés, "¡Salvemos a los niños-esclavos!" *Presente*, 6 January 1949, 10–11. Other articles by Avilés are more optimistic: "¡Sí es posible redimir a los lobeznos!," 17 February 1949, 6, and "Leve indicio de liberación para los niños esclavos," 24 February 1949, 10, with photos by Héctor García.

78. Avilés, "¡Salvemos a los niños-esclavos!"

79. See, for example, Jorge Piñó Sandoval, "Cómo está planeada la destrucción comunista de México," *Presente*, 19 October 1948, 4–5; Jorge Piñó Sandoval, "Stalin en Tampico," *Presente*, 26 October 1948, 7–9; Jorge Prieto Laurens, "La 'Rusificación' de México," *Presente*, 30 December 1948, 6.

80. See the announcement, "En defensa de la calle," *Presente*, 4 August 1948, n.p.

81. See Carlos Franco Sodja, "Ya se cayó el arbolito," *Presente*, 30 December 1948, 10; and three articles in *Presente*, 17 February 1949: M. Aguirre, "Están asesinando a México!," 7, Dr. Atl, "En defensa del Valle de Méjico," 8–9, and Carlos Franco Sodja, "Cien mil árboles talados en Milpa Alta," 10.

82. Magadalena Mondragón, "Pero México es así . . . ," *Presente*, 30 December 1948, 15.

83. "Continuará," *Presente*, 17 March 1949, back cover; "Hemos cumplido," ibid., 3.

84. The caricature of Casas Alemán asks, "And *Presente?*," to which the figure replies, "¡Quebró, pero no se dobló!"; ibid., back cover.

85. Blanco Moheno, *Memorias de un reportero*, 292.

86. Guimond, *American Photography and the American Dream*, 152.

87. See Monroy Nasr, "Ases de la cámara," 18–29.

88. Anonymous (Antonio Rodríguez), "Ases de la cámara. xix. Enrique Díaz: Fotógrafo admirable, compañero ejemplar, hombre excepcional," *Mañana*, 26 October 1946, 30–31.

89. The exhibit is referred to by other names, including "Primera exposición nacional de la fotografía de prensa" and that used for the catalogue (Antonio

Rodríguez, *Homenaje a los fotógrafos de prensa*). The interviews begin in *Mañana*, 22 June 1946, and run until 26 October 1946. No author is indicated, but they were by Antonio Rodríguez.

90. This series starts off in *Mañana*, 20 October 1951, and continues until 31 May 1952; Rodríguez is identified as the author of the first eight essays, Antoniorrobles is credited with the last twelve. I discuss these interviews and exhibits in more detail in Mraz, *Nacho López, Mexican Photographer*, 59–63.

91. See Jorge Stanford, "Así es México," *Mañana*, 24 April 1954, 48–53.

92. On this exhibition, see Mraz, *Nacho López, Mexican Photographer*, 32–34.

93. "Risas y lagrimas de México," *Siempre!*, 17 December 1958, 44.

94. Kee, *The "Picture Post" Album*, n.p. See also Hall, "The Social Eye of *Picture Post*," 74, 81, 83, 84.

95. "Country Doctor," *Life*, 20 September 1948; see Willumson, *W. Eugene Smith and the Photographic Essay*.

96. Peña, "F 2.8: La vida en el instante," 38–39. The term "F 2.8" refers to a widest lens aperture which permits the most light to enter and allows for the capture of candid scenes, especially when the subjects are in movement.

97. Ibid., 39.

98. "México: Dolor y sangre, pasión y alma," *Siempre!*, 25 May 1955, 22–24; "México místico," *Hoy*, 14 March 1953, 28–35. See Mraz, *Nacho López, Mexican Photographer*, 82, 189–92.

99. Fein, "New Empire into Old," 716. López's essays are "Un día cualquiera en la vida de la ciudad," *Siempre!*, 3 July 1958, 72–79; "Nacho López presenta México, D.F.," *Siempre!*, 5 November 1958, 44–47; and "Las mil caras de la ciudad," *Mañana*, 17 February 1962, 29–43. See Mraz, "Mexico City," *Nacho López, Mexican Photographer*, 150–61.

100. "Suave patria," *Mañana*, 10 September 1949, 78–79.

101. Arno Brehme, "En su identificación con la tierra, crisol de la raza," *Mañana*, 15 September 1951, 176–84. No mention was made of photography in the issue's extended discussion of *mexicanidad*, 83–232.

102. Juan Guzmán, "México, típico y progresista," *Mañana*, 1 April 1950, 44–47. On Guzmán, born Hans Guttman, see Maricela González Cruz, "Juan Guzmán en México." Walter Reuter, "México es así: Un reportaje de Walter Reuter sobre el México típico," *Hoy*, 7 March 1953, 82–90. On Reuter, see *Walter Reuter*.

103. Moya is cited in González Cruz, "Momentos y modelos en la vida diaria," 296.

104. The "Mexican Miracle" is the term used to describe the extraordinary industrialization that begins around 1937 and continues until 1972; see MacLachlan and Beezley, *El Gran Pueblo*, chaps. 10, 11, 12.

105. On the USIA involvement in Mexican newsreels, see Fein, "New Empire into Old," and his forthcoming book, *Transnational Projections: The United States in the Golden Age of Mexican Cinema* (Duke University Press).

106. References to Díaz as the "star photographer" can be found in *Hoy*, 12 March 1938, 31, and *Mañana*, 9 December 1944, 15. Other photojournalists were referred to as "aces," but Díaz was the only one to be named a star; see the remarks by Faustino Mayo in Monroy Nasr, *Historias para ver*, 27. Monroy Nasr refers to his ideology on 33, 31.

107. Antoniorrobles, "Fotos habladas (Enrique Díaz)," *Mañana*, 1 March 1952, 51.

108. Felipe Morales, "Centinela del periodismo: Enrique Díaz, fotógrafo y hombre ejemplar," *Mañana*, 3 September 1949, 34–36.

109. See *Mañana*, 5 August 1950, and 16 December 1951; *Mañana*, 10 September 1949; *Mañana*, 11 November 1950.

110. Antoniorrobles, "Fotos habladas (Enrique Díaz)," 52.

111. Antonio Rodríguez referred to the exploit in "Enrique Díaz: El símbolo," *Siempre!*, 22 September 1954, 32, and it is mentioned in all the articles on Díaz.

112. Monroy Nasr comments that, in June, the newspaper headlines "had begun to circulate news of the movement's defeat," *Historias para ver*, 248. Cedillo was not killed until 11 January 1939.

113. See "*Rotofoto* en la Huasteca con Cedillo," *Rotofoto*, 23 July 1938, n.p.; "Con Cedillo en las montañas potosinas: Fotoreportaje de Enrique Díaz," *Hoy*, 23 July 1938, 28–33.

114. Ibid., 28.

115. Monroy Nasr notes that the periodical is being held for precisely this effect, because Cedillo would be reading the ad that appeared on that back page; *Historias para ver*, 252.

116. *Rotofoto*, 23 July 1938, n.p.

117. Rosa Castro, "Habla a *Hoy* los ases de la fotografía," *Hoy*, 6 January 1951, 30.

118. Ibid.

119. See Felipe Morales, "Una casa para vivir," *Hoy*, 23 October 1954, 34–37; "Gracias señor presidente," *Hoy*, 6 November 1954, 3.

120. The Mayo were not exempt from presidentialism. See the discussion of Faustino Mayo being photographed by Ruiz Cortines in Mraz, *Nacho López, Mexican Photographer*, 53.

121. See Mraz, "Foto Hermanos Mayo"; Mraz and Vélez, *Uprooted*; Mraz, "Close-up." I interviewed Faustino on several occasions and have had an ongoing conversation with Julio Mayo from 1982 to the present.

122. In the course of its history, the collective has been made up of five men from two different families: Francisco (Paco) Souza Fernández (12 August 1912–26 September 1949); Cándido Souza Fernández (23 April 1922–11 November 1985); Julio Souza Fernández (18 October 1917); Faustino del Castillo Cubillo (8 October 1913–28 October 1996); and Pablo del Castillo Cubillo (6 June 1922).

123. Mraz and Vélez, *Uprooted*, 21.

124. For example, Pablo Ortiz Monasterio, editor of the series *Río de luz*, rejected the inclusion of the Hermanos Mayo in a collection that had published works on Nacho López, Héctor García, and Argentine photojournalism. As I showed him the selection of Mayo photos I had brought for his consideration, he argued that they had no aesthetic interest. There has been no exhibit dedicated to the Mayo photography in the Centro de la Imagen, the country's most important site for photographic exhibition.

125. See Mraz, "Fotografiar el 68," where I have discussed the photography of the student movement in greater detail, accompanied by eighteen images. Alberto del Castillo has begun studying the published photojournalism of 1968; see "Fotoperiodismo y representaciones del Movimiento Estudiantil de 1968," and "Historias del 68: La cobertura fotoperiodística del *Excélsior*, 'El periódico de la vida nacional,'" *Anthrosetempo* 3 (2005), www.anthrosetempo.netfirms.com.

126. Bellinghausen, ed., *Pensar el 68*, 65.

127. González de Alba. *Los días y los años*, 119.

128. Mraz and Vélez, *Uprooted*, 77; Mraz, "Foto Hermanos Mayo," 87.

129. Paz, *The Labyrinth of Solitude*, 11.

130. Jackson, *The Spanish Republic and the Civil War*, 354.

131. The Hermanos Mayo stored their negatives in envelopes, which are catalogued in books where they sometimes wrote information about the activities photographed. This comment, from 1961, is one of the longest and most vitriolic in the catalogues and can be found in the thematic areas of both "España" and "Los Estados Unidos," where it is repeated almost exactly; I have translated the first part from Spanish, the last phrase is in English; Chronological Section, 16191–16195, Mayo-AGN (Archivo General de la Nación). I asked Julio Mayo about the author of these phrases, which he attributed to Cándido Mayo, who was official photographer for Jacobo Arbenz, Guatemalan president from 1951 until he was overthrown by a CIA operation in 1954.

132. Negative envelope, Chronological Section, 3290. Other protests against the United States can be found in Negative envelopes, Chronological Section, 5493, 8685, and 14862, Mayo-AGN.

133. Negative envelopes, Chronological Section, 7494 and 7937, Mayo-AGN.

134. Negative envelope, Chronological Section, 15726, Mayo-AGN. In relation to another anti-Yankee, pro-Cuba protest, one Mayo wrote sardonically, "Poor little things, they get blamed for everything. Protest in the Hotel del Prado for the Cuban question. Some pretext! Surely they were damn communists or negroes," "Protestas," Catalogue, Chronological Section, 15829, Mayo-AGN. For other protests, see Negative envelopes, Chronological Section, 14882, 14919, 15792, 19400, 22187, and 25419, Mayo-AGN.

135. Negative envelope, Chronological Section, 20467, Mayo-AGN.

136. Negative envelopes, Chronological Section, 20346, 21705, 22914, 24035, and 24121, Mayo-AGN.

137. Negative envelope, Chronological Section, 29589, Mayo-AGN.

138. Negative envelope, Chronological Section, 11027, Mayo-AGN. On the complex story of Presley's alleged racism, see Zolov, *Refried Elvis*, 40–47. Present at a talk I gave at the 2004 congress of Society for Latin American Studies (SLAS), Zolov inquired whether this coverage of protests against the United States was not simply a result of their photojournalistic activity, instead of demonstrating an intentionality to critique that nation. I responded that such images are not found in the archives of Nacho López or Héctor García. I also elaborated that it is possible that similar photos were made by other graphic reporters, but these are lost in the uncatalogued newspaper "morgues" (as the inaccessible archives are referred to). I asked Julio Mayo about this rather pointed interest in documenting protests against the United States, and he responded that it was simply a case of covering work orders, his usual reply to questions about intentionality in Mayo photographs.

139. I did not touch on this theme in my interviews with Faustino and Julio, but when Faustino dedicated his book *Testimonio sobre México*, he differentiated me from other "*norteamericanos*" by indicating that I was "one of the good ones." The one time I attempted to interview Pablo, he muttered something equating *gringos* with Nazis, and went his way.

140. The first negative is found in an envelope in the Concentrated Section, "Gringos, ridículos comprando," in which images of that theme have been collected; the second is in the Chronological Section, 2763, 12 July 1947; and the third in the large collection entitled "Imagen de la ciudad"; Mayo-AGN.

141. See Mraz and Vélez, *Uprooted*; Mraz and Vélez, *Trasterrados*.

142. I have developed this relationship of the Hermanos Mayo and the *braceros* by comparing their images to those found in the Casasola Archive in Mraz and Vélez, *Trasterrados*, 44–45.

143. See the interviews with García compiled by Mireya B. Matus in "Retratos hablados," and her critical review of the myths he has constructed over the years, 16–17. Several collections of García's photos have been published; the most recent is *Héctor García*, which contains interviews with and articles about him, including a biography, "Héctor García por Francisco Montellano," 193–98. See as well *Escribir con luz*; *Héctor García: México sin retoque*; *Héctor García: Camera oscura*; *Héctor García: Iconos*.

144. See Merry MacMasters, "Soy como un personaje de *Los olvidados* pero con final diferente," *La Jornada*, 25 August 2005, 4a–5a.

145. Marco Lara Klahr, "Héctor García: Mi lenguage en el periodismo es muy cinematográfico," *El Financiero*, 6 January 1993, 45.

146. See the photo as originally published in "Hector García y su tiempo," 55; the conversation with Malraux is recounted in Riley, "Gironella y sus entierros," 264. García described this photo as a "self portrait," John Mraz and Ariel Arnal, unpublished interview with Héctor García, January 1996. It can be seen in *Héctor García*, 10, and *Escribir con luz*, 31.

147. John Mraz, unpublished interview with Héctor García, October 2000.

148. See the photos of 1968 in *Héctor García*, 133–43; see this photo in *Héctor García*, 136.

149. See this photo in ibid., 134.

150. *Héctor García*, 106.

151. This is also a result of not utilizing a flash, which García was afraid would attract unwelcome attention; see Blanch Petrich, "Hector García: Tlatelolco era un infierno donde la muerte te rozaba," *La Jornada*, 3 October 1998, 17.

152. Poniatowska, *La noche de Tlatelolco*, 175.

153. "Lo que se ha visto y lo que se ha dicho; Una versión del movimiento estudiantil," with fifty-nine black-and-white and ten color photographs by García, *La cultura en México*, supplement of *Siempre!*, 25 September 1968, i–xix; Monsiváis, *Días de guardar*.

154. See the unattributed interview in "Hector García y su tiempo," 323; Mraz and Arnal, interview.

155. Mraz and Arnal, interview. This photo is rarely reproduced, but can be seen in *Héctor García: México sin retoque*, 73.

156. "Héctor García y su tiempo," inside front jacket copy and page 51.

157. Enrique Aguilar Resillas, "La fotografía nunca fue romántica: Entrevista con Héctor García," *La Semana de Bellas Artes*, 9 August 1978, 6.

158. See the interview with Garciá in Enrique Ibarra Chavarría, "La situación actual de la fotografía periodística en México," *Licenciatura* thesis, Escuela de Periodismo "Carlos Septién García," 1979, 85.

159. See the first in *Héctor García*, 108, and the second in *Héctor García: México sin retoque*, 69, and *Héctor García: Iconos*, 23.

160. *Héctor García: Iconos*, 24–25. The *burla* is seen as a fundamental part of Mexican identity in works such as Garizurieta, "Catarsis del mexicano," and Uranga, "Ontología del mexicano," in Bartra, ed. *Anatomía del mexicano*.

161. This is one of García's most reproduced photos; see *Héctor García*, 23, *Escribir con luz*, cover. Because this image's printing is so important to its connotation, I was particularly interested in seeing how it had been printed for García's 1998 exhibit in the Museum of Modern Art; the extreme gray tones confirmed my reading.

162. *Escribir con luz*, 40; *Héctor García*, 123. The Hermanos Mayo also incorporated the Monument in their photos of marches during 1968. On this memorial and modern visual culture, see Vásquez Mantecón, "El monumento a la Revolución en el cine."

163. Titled *Cartucho quemado* (Spent Round), this image can be seen in *Escribir con luz*, 53, and *Héctor García*, 18.

164. *Escribir con luz*, 63; *Héctor García*, 42.

165. Mraz and Arnal, interview. The reproduced photos from section "F 2.8" make it clear that the photo is directed; "Héctor García y su tiempo," 42–43. García has consistently denied directing photos or scenes; see Cristina Pacheco, "La cámara fue instrumento para captar mi realidad. El arte de Héctor García," *Siempre!*, 16 January 1980, 44.

166. See this, and other pictures of the statue, in "Héctor García y su tiempo," 198–201.

167. See Gómez Mostajo, "Los grandes timadores," 238–43.

168. Ibid., 241–42.

169. Ibid., 242.

170. García cited by Montellano, *Héctor García*, 197. The portrait is reproduced in *Héctor García*, 157; *Escribir con luz*, 17.

171. See Montes, "Preso No. 46788," 76–81. The photo of Siqueiros can be seen in *Héctor García*, 159; *Escribir con luz*, 19.

172. Montes, "Preso No. 46788," 77.

173. Originally published in 1946, the book was reedited with a new appendix, Novo, *New Mexican Grandeur*.

174. Bartra, "Lo que La Mafia se llevó," 210–17; Riley, "Gironella y sus entierros," 264–75.

175. Marina M. Hernández, unpublished interview with Héctor García, Rufino Tamayo Museum, 1989.

176. Certainly, every culture has produced illustrated histories. Nonetheless, Mexico seems to me to have been particularly prolific in producing totalizing narratives of the country's past. In Brazil, by comparison, photohistories appear to be focused on cities, for example, Rio de Janeiro or Sao Paulo around 1900.

177. See the interview Pacheco, "Gustavo Casasola: todos nuestro ayeres." In the credits for *Historia gráfica de la Revolución*, Gustavo Casasola attributes the collecting of materials and the photography to Agustín Víctor, noting that he (Gustavo) directed and finished it. Upon renaming the series *Historia gráfica de la Revolución Mexicana*, Gustavo assumed full credit as author. Around this same time (1960), Gustavo changed the name of the press from Editorial Archivo Casasola to Editorial Gustavo Casasola. One example, among many, of the multiple uses of the Casasola Archive can be seen in the series of supplements issued by the newspaper *Novedades*, which were published as *Historia gráfica de México* in 1952.

178. The first mention that I have encountered of *historia gráfica* was in relation to a documentary film, *De Porfirio Díaz a Lázaro Cárdenas: Treinta años de historia*

(1940), which was evidently a "parade of presidents." See "30 años de historia gráfica de México," *Hoy*, 29 June 1940, 91.

179. For good reproductions of Casasola imagery, see *Mexico: The Revolution and Beyond*, as well as *Los inicios del México contemporáneo* and *Jefes, héroes y caudillos*. See also *¡Tierra y Libertad!* and *The World of Agustín Víctor Casasola*.

180. Information about the press run of Casasola volumes is spotty. The 1964 edition of *Seis Siglos* asserts that 2,300 were published; that of 1966 says that 5,000 were published. The cost of the series is also variable. The *cuadernos* of *Historia gráfica de la Revolución* (1947) were sold at 3.50 pesos each in a paperback cover, and at 5.50 pesos in "Bristol"; the *Tomos* were sold at 25 pesos (Percalina) and 35 pesos (Keratol), according to an ad published in the series.

181. See the interview with Gustavo Casasola S., son of Gustavo Casasola Zapata, by José Luis Trueba Lara, "Fotografías, libros y desmemorias, 2" *Unomásuno*, 6 November 1993, 28.

182. Gustavo Casasola, "Palabras del autor," in Casasola, *Historia gráfica de la Revolución Mexicana*, 1: vi.

183. Pacheco, "Gustavo Casasola: Todos nuestro ayeres," 123; Casasola, *Historia gráfica de la Revolución Mexicana*, 4: 2324.

184. *Agustín Víctor Casasola: El hombre que retrató una época*. This book was subsidized at least in part by the carmaker Chrysler de México.

185. See the essays by Mario Luis Altúzar and Mario Orozco Rivera, in which these statements can be found on pages 19, 36, and, 78. Altúzar wrote the book's key essay and was undoubtedly little more than Gustavo's mouthpiece because his prior contact with the Casasola Archive came when he first saw its images in Womack's *Zapata and the Mexican Revolution*, 37.

186. The only serious consideration of Mexican picture histories with which I am familiar was carried out by a Brazilian, Carlos Alberto Sampaio Barbosa, in *A fotografia a servico de Clio*. The sole instance I have found by a Mexican historian is a weak and poorly informed essay by Matute, "Memoria e imagen de la revolución mexicana." Conversely, U.S. historians utilized the newly founded American Historical Association to insistently critique popular picture histories, until they were eventually disqualified as serious narratives about the past; see Pfitzer, *Picturing the Past*, 161–243.

187. The responses were eventually published in the 1960 edition of Casasola, *Historia gráfica de la Revolución Mexicana*, 4: 2325–334.

188. Ibid., 4: 2327.

189. Ibid., 4: 2325–334.

190. Ibid., 4: 2326.

191. Ibid., 4: 2328.

192. Ibid., 4: 2330.

193. Jacobo Zabludovsky, "Agustín Casasola: El hombre que escribió la única historia auténtica de la Revolución Mexicana," *Siempre!*, 3 May 1967, 38; this article is reproduced in *Agustín Víctor Casasola: El hombre que retrató una época*.

194. One participant in the revolution complained of inaccuracies: "That was the truth and not what Casasola wrote in the second volume of his *Historia gráfica*." López de Nava Camarena, *Mis hechos de campaña*, 92.

195. See the photo, with the cutline "Mother learning to read" (the advanced age of the woman, and the youth of the children, makes it much more probable that she is a grandmother), of the literacy campaign in Casasola, *Seis siglos de historia gráfica en México*, 5: 2851, and a better reproduction in García Krinsky, ed., *Imaginarios y fotografía en México*, 195. On the photo and the prize, see Pepe Grillo, "Vivir para ver," *Más*, 25 December 1947.

196. See the photograph of Ávila Camacho at the stand in *Agustín Víctor Casasola: El hombre que retrató una época*, 94, and with photojournalists in Casasola, *Seis siglos de historia gráfica de México*, 5: 3122.

197. Casasola, *Historia gráfica de la Revolución*, 2: 664–66.

198. See Salas, *Soldaderas in the Mexican Military*.

199. The best published collection of photos portraying these women is Poniatowska, *Las soldaderas*.

200. The announcement appeared in Casasola, *Historia gráfica de la Revolución*, cuaderno 20, n.p.

201. These works were evidently not published, although the 1970s would see numerous illustrated biographies produced by the Editorial Gustavo Casasola.

202. Gavira, *Polvos de aquellos lodos*.

203. O'Malley, *The Myth of the Revolution*, 98.

204. Pacheco, "Gustavo Casasola: Todos nuestro ayeres," 124.

205. Sontag, *On Photography*, 71.

206. Casasola, *Enciclopedia histórica ilustrada de México*, 2.

207. Casasola, *Seis siglos de historia gráfica en México*, 13: 1450–55.

208. Ibid., 3: 1453.

209. A *piquera* is a bar that sells the cheapest distilled alcohol. "San Lunes" is a common expression in Mexico for celebrating Monday as if it were a saint's day (and thus a holiday). See the pages dedicated to "Las piqueras" and "San Lunes" in Casasola, *Seis siglos de historia gráfica en México*, 3: 1496–97.

210. Ibid., 2: 1119.

211. Casasola, *Historia gráfica de la Revolución Mexicana*, 10: 3497.

5. New Ocular Cultures and the Old Battle

1. See the videotape by Carlos Mendoza, *Tlatelolco: Las claves de la masacre* (Mexico City: La Jornada-Canalseisdejulio, 2002).

2. References to this film as being the most faithful and objective of the movies on '68 are abundant. See the interviews in Rodríguez Cruz, "El retrato más fiel," *El 68 en el cine mexicano*, 17–42. Among other commentaries, see Nelson Carro, "El 68 y el cine: *El grito*," *Tiempo Libre*, supplement of *Unomásuno*, 21 October 1993, 6, where he describes the film as "presenting the events exactly as they were lived." A more recent article, "*El grito*/México 68," asserted that it was the "most objective testimony," *Reforma*, section Primera fila, 20 October 1998, 12. The critic Jorge Ayala Blanco goes further, calling it "the only objective record that exists of any popular movement in the last thirty years," *La búsqueda del cine mexicano*, 328.

3. See the interview with Marcela Fernández Violante in Rodríguez Cruz, *El 68 en el cine mexicano*, 17–19. Hereafter referred to in the notes as Rodríguez Cruz, with page numbers.

4. See the interviews with Fernández Violante and Alfredo Joskowicz in Rodríguez Cruz. The spring-drive Reflexes had to be rewound after thirty to forty-five seconds.

5. See the interview by Jorge Brogno with Alfredo Joskowicz, Carlos González Morantes, and Federico Weingarsthofer in *Cinemateca* 3 (1973): 3–6.

6. Fernández Violante in Rodríguez Cruz, 18.

7. Joskowicz, *Cinemateca*, 4–5.

8. Fernández Violante in Rodríguez Cruz, 20.

9. Aupart in Rodríguez Cruz, 31.

10. The student, Guillermo Díaz Palafox, was evidently expelled for arranging the showing. Several of those interviewed by Rodríguez Cruz mention the resistance of González Casanova to showing *El grito* at the UNAM.

11. Jorge de la Rosa in Rodríguez Cruz, 26.

12. Aupart noted that "Leobardo had a chronological order, and had selected the best of the speeches given during that day, that week, or that month," Rodríguez Cruz, 32.

13. Barnouw, *Documentary*, 231–55.

14. On Álvarez's cinema, see Mraz, "Santiago Alvarez."

15. At the risk of solipsism, my experience as a filmmaker in the early 1970s was that we grabbed anything at hand to make our films, both moving and still. See Chiles and Mraz, "The Historical Film-Essay"; Mraz and Tracy, "Classroom Production of an Historical Film-Essay."

16. Aupart in Rodríguez Cruz, 35.

17. Joskowicz felt that it was more oriented toward a "sentimental question" than "a truly political judgement," *Cinemateca*, 5.

18. García Riera, *Historia documental del cine mexicano*, 2nd ed., 14: 182–83.

19. Carlos Mendoza in Rodríguez Cruz, 55.

20. *El grito* was placed at number 44 of the "100 best Mexican films"; see "100 mejores películas mexicanas," *Somos*, 16 July 1994, 61.

21. Interview with Xavier Robles in Rodríguez Cruz, 85.

22. Cited in Costa, *La "apertura" cinematográfica*, 69.

23. Pérez Turrent, *Canoa*, 78.

24. Felipe Cazals in Rodríguez Cruz, 72.

25. Felipe Cazals, "*Canoa*, 23 años después," *La Jornada*, 15 September 1998, 28.

26. Roberto Rojano, cited in Gabriel Peña Rico, "*Canoa*: Sobrevivientes incómodos," *El Financiero*, 26 February 1999, section Cultura, s2.

27. Ibid.

28. Pérez Turrent estimated that it would require at least a generation before a film dealing with the incident could be shot in San Miguel Canoa, *Canoa*, 67.

29. Antonio Delahameau, "El cura de Canoa—¿nueva inquisición?," *Excélsior*, 12 March 1976, 7a.

30. Carlos González Correa, "*Canoa*, ensalada de golpes y de sangre con naúsea," *Novedades*, section Espectáculos, 10 March 1976, 1, 3; L. Meraz, "Un cine social que sacuda conciencias," *El Universal*, 10 March 1976, 6, 9. Cazals feels that it is a film of "social denunciation"; see Rubén Torres, "Felipe Cazals explica su cambio de técnica al filmar *Canoa*," *El Heraldo de México*, 5 March 1976, 7c.

31. Carlos Monsiváis, "Los linchamientos de Canoa," *Excélsior*, 20 March 1976, 7–8.

32. Ma. Guadalupe Santa Cruz, "Según la *Omi*, del Episcopado, el filme *Canoa* deformó los hechos," *El Sol de México*, section Espectáculos, 23 March 1976, 1; Raquel Peguero, "Impugnar a *Canoa* sería como volver al pasado: Felipe Cazals," *La Jornada*, 15 September 1998, 28.

33. Juan Bustillos Orozco, "Habla el cura de Canoa, 'Soy inocente,' vive temiendo una venganza," *El Universal*, 24 March 1976, 1, 17.

34. "Daña a San Miguel Canoa el filme," *El Universal*, 26 March 1976, 1, 10.

35. Pérez Turrent, *Canoa*, 84–85.

36. Mora, *Mexican Cinema*, 126.

37. Gustavo Arturo de Alba, "*Canoa*," *El Nacional*, 7 March 1976, 18.

38. Jorge Ibargüengoitia, "*Canoa* ¿cine de denuncia?," *Excelsior*, 22 March 1976, 10.

39. Ayala Blanco, *La condición del cine mexicano*, 303.

40. Pérez Turrent, *Canoa*, 79.

41. Julio Cortés, "*Canoa*: La primera 'edición especial' mexicana," *La Crónica Dominical*, supplement of *Crónica*, 20 September 1998. 10.

42. See Granados Chapa, *"Excelsior" y otro temas de comunicación*. I discuss this case below.

43. Raquel Peguero, "No me gusta hacer filmes para pensar, sino para sentir: Fons," *La Jornada*, 6 August 1995, 28.

44. See the interviews with Fons and Robles in Rodríguez Cruz, 90, 81. The script has been published: Robles and Ortega, *Rojo amanecer*.

45. Fons in Rodríguez Cruz, 90.

46. Fons in Rodríguez Cruz, 91, and Raquel Peguero, "*Rojo amanecer* no tendrá distribución mundial: Fons," *La Jornada*, 5 August 1995, 27.

47. Peguero, "*Rojo amanecer* no tendrá distribución mundial," 27.

48. Francisco Sánchez provides a list of the censored scenes in "*Rojo amanecer*: Directo al corazón," *El Nacional*, section Espectáculos, 21 February 1993, 8. Robles and Ortega Vargas state that prior to the cuts required by the government, some twenty references to the army were eliminated by the director and producer, "*Rojo amanecer* no plagia a ningún autor: guionistas," *La Jornada*, 4 December 1990, 40.

49. Fons in Rodríguez Cruz, 93.

50. See Robles's discussion of the script's origin in Héctor Anaya, "*Rojo amanecer* sí fue censurada, dice su guionista Xavier Robles," *Punto*, December 1990, 14.

51. Peguero, "*Rojo amanecer* no tendrá distribución mundial," 27.

52. Julio García Espinosa, "For an Imperfect Cinema," has been reprinted often in Spanish and English; Fons in Rodríguez Cruz, 92.

53. Alejandro Salazar Hernández, "*Rojo amanecer* captó a un millón de espectadores en solo 45 días," *El Heraldo de México*, section Espectáculos, 2 January 1991, 1; José Ver, "*Rojo amanecer* provocó tumultos," *El Nacional*, 17 October 1990, section Espectáculos, 9.

54. "*Rojo amanecer*, una cinta irresponsable: Gustavo García," *Unomásuno*, 26 October 1990, 23.

55. Robles provides a list of the missing in Rodríguez Cruz, 82–84.

56. Robles in Rodríguez Cruz, 83.

57. Leñero, *Los periodistas*, 74.

58. In 1996, I curated the exhibit "La mirada inquieta: Nuevo fotoperiodismo mexicano: 1976–1996" (An Unquiet Gaze) at the invitation of Patricia Mendoza, then director of the Centro de la Imagen. The investigation included interviews with thirty photojournalists, which provided the base for my texts *La mirada inquieta* and "The New Photojournalism of Mexico."

59. Other newspapers also began to appear that were critical of the PRI, of which the most important is the right-wing *Reforma*, founded in 1993. However, the photography of these media is not exceptional. For a conservative account of recent Mexican journalism, see Lawson, *Building the Fourth Estate*.

60. The degree of self-censorship in relation to the presidency can be appreciated in the fact that I have not encountered critical imagery of this personage in the archives of Nacho López, Héctor García, or the Hermanos Mayo. The first photo that I know of which explored this vein in relation to a president in office was that taken by Marco Antonio Cruz of Miguel de la Madrid at a meeting

with official unions in 1984. The president appears to be singing (perhaps the national anthem), for he, and the others, have their mouths ajar. However, a lightning bolt painted on the background propaganda descends directly toward his head from a cloud with the word UNEMPLOYMENT written on it, almost as if the president were a cartoon character with a text bubble. The grave problem of employment in Mexico made it necessary for the PRI to incorporate this theme at a union event, but Cruz gave another turn of the screw to the official message by using his camera to indicate where the blame lay; see *Fotografía de prensa en México*, 33; and Mraz, *La mirada inquieta*, 91.

61. Among the more important books produced by New Photojournalists are Martínez, *Mixtecos*; Cruz, *Cafetaleros*; Hernández-Claire, *De sol a sol*; Castrejón, *Sombras de mi ciudad*; Valtierra, *Zacatecas*; Mata, *México Tenochtitlán*.

62. The temptation to compare the structure of this image with the Cholula pyramid, in the state of Puebla, is overwhelming. There, in the oldest continuously inhabited spot of the Western Hemisphere, every major Indian civilization built a structure atop the one left by the preceding culture. The result is a monument composed of seven pyramids built one over the other. Crowning this structure is a Catholic church built there by the Spanish.

63. Mraz, *La mirada inquieta*, 55; Mraz, "The New Photojournalism of Mexico," 324.

64. Mraz, *La mirada inquieta*, 58; Mraz, "The New Photojournalism of Mexico," 328.

65. Because I felt that introducing a vitiated notion such as "the search for national identity" would affect the rapport with my informants, I did not refer to this issue in the interviews carried out for the exhibition. In a conversation I had in 2005 with Francisco Mata, the most articulate of Mexican photojournalists, he asserted that a photographer's images necessarily reflect his or her individual and national identity.

66. Mraz, *La mirada inquieta*, 60; Mraz, "The New Photojournalism of Mexico," 330.

67. Mraz, *La mirada inquieta*, 167.

68. Mraz, *La mirada inquieta*, 1; Mraz, "The New Photojournalism of Mexico," 343.

69. In fact, the painting is based on the photograph by Hugo Brehme discussed in chapter two (figure 14).

70. Turok, *The End of Silence*, 128–29; Mraz, *La mirada inquieta*, 99.

71. Subcomandante Insurgente Marcos, "Las imágenes fotográficas, arma para combatir el olvido: Marcos," *La Jornada*, 8 February 1996, 13.

72. Mraz, *La mirada inquieta*, 100–101; Mraz, "The New Photojournalism of Mexico," 350. The experimentation engaged in by Mata can be appreciated in comparing his picture of these dead neo-Zapatistas with more conventional

views of them made by Carlos Cisneros and Juan Miranda, found respectively in *Primera Bienal de Fotoperiodismo* (Mexico City: Conculta-INBA-FONCA, 1994), 41, and *Proceso: Edición especial*, 1 January 1999, 21.

73. Mraz, "The New Photojournalism of Mexico," 348.

74. *La hora de los hornos* was directed by Fernando Solanas and Octavio Getino in Argentina and began to circulate clandestinely during 1968. See Stam, "*The Hour of the Furnaces* and the Two Avant-Gardes." The importance of this film in constructing identity was underscored by Tzvi Tal, "Del cine-guerrilla a lo 'grotético.'" Martí's words appeared in a letter that can be found in his *Obras completas*, 275, and Guevara's use of it can be seen in Guevara, *Che*, 170. I am grateful to Ambrosio Fornet for providing information about this phrase.

75. Conversation with Patricia Mendoza, 2004.

76. The criticism began even before the opening, when Braulio Peralta, then editor of *La Jornada*'s culture section, evidently called Mendoza to complain about what he felt was the intromission of a *gringo*, conversation with Patricia Mendoza, 1997.

77. Renato Ravelo, "Mraz: Relevante, vincular la expresividad con la información," *La Jornada*, 13 July 1996, 26.

78. Musacchio is an editorialist for *Reforma*, and his comments appeared in that newspaper on 22 and 29 July, and 5 August 1996. My responses were published on 26 July and 5 August 1996. Among the more bitter critiques of the exhibit's failure to adequately represent the gamma of Mexican photojournalism from 1976 to 1996 were those of (the unincluded) Luis Jorge Gallegos, "La inquieta mirada del investigador," *Milenio*, 24 May 1999, 62. The coeditor of *Milenio*'s culture section, Cecilia Jarero, would not publish my response.

79. See, for example, the reference to "nuevo fotoperiodismo" by Alejandro Castellanos, current director of the Centro de la Imagen, in "Tres realidades tres," *La Jornada Semanal*, 26 March 2000, 14.

80. Pedro Valtierra directs the most successful of these agencies, Cuartoscuro, which has published a fine photography magazine by that name since 1993.

81. Bernice Kolko was a Polish emigré who lived in the United States before moving to Mexico in 1951. Although some of her photos are clearly picturesque, others are interesting documents. See *Rostros de México*; *Semblantes mexicanos*; *Bernice Kolko, fotógrafa/photographer*.

82. See Flor Garduño, *Magia del juego interno*; *Witnesses of Time*; and *Inner Light*. Although her latest book, titled *Flor* in Spanish, is said to represent an "interior voyage" distinct from her former documentary work, it is clear that hers has always been an "internal game." The notion that Garduño had given up traveling to engage in an "interior voyage" was a constant in interviews made with her in June 2002; see, among others, Merry MacMasters, "Flor Garduño asume los desnudos femeninos como 'cuerpos de la vida'," *La Jornada*, 28 June 2002,

6a; Gilberto Rendón, "El erotismo de Garduño, influido por la maternidad," *Unomásuno*, 27 June 2002, 8; Norberto Ángel, "Se presentó el libro de la fotógrafa Garduño," *México Hoy*, 20 July 2002, 16; José Nava, "En cada imagen soy yo mismo: Chaurand," *El Financiero*, 27 June 2002, 55.

83. Marianna Yampolsky was an emigrant photographer from the United States who lived the majority of her long life in Mexico. Her imagery provides interesting documentation of Mexican rural life and is not easily placed within either picturesque or antipicturesque categories.

84. Conversation with Eleazar López Zamora, founding Director of the Instituto Nacional de Antropología e Historia Fototeca, 1990.

85. *Mujer x mujer* (Mexico City: Conaculta-INBA, 1989), 33.

86. De Santiago S., *Flor Garduño*. I have encountered little written criticism of Garduño's work, and the novelist Carlos Fuentes provided the foreword to *Witnesses of Time*. The participation of important Mexican intellectuals in validating picturesque photography raises interesting questions, as in the case of the forewords written for Bernice Kolko's books by the novelist and diplomat Rosario Castellanos, as well as the Instituto Nacional de Antropología e Historia's director, the anthropologist Ignacio Bernal.

87. See in Debroise, *Mexican Suite*, 113.

88. See in Kismaric, *Manuel Alvarez Bravo*, 123.

89. Iturbide, *Graciela Iturbide*, 37. Iturbide stated in a television interview with Cristina Pacheco that the woman arrived at the market with the iguanas on her head but had sat down. She asked the woman to stand up and put the animals back on her head; "Aquí nos tocó vivir," Channel 11, 29 March 2002.

90. Campbell and Green identify the iguana as a key identity element; see "A History of Representations of Isthmus Zapotec Women," 164. Good introductions to Iturbide's photography are offered in Iturbide, *Images of the Spirit*; and Iturbide, *Graciela Iturbide*.

91. Campos, *Graciela Iturbide, Paulina Lavista, Colette Urbajtel*.

92. My experiences in attempting to organize exhibits in Europe and the United States have helped me understand this phenomenon. The directors of prospective venues have shown no interest in my expositions on the New Photojournalism of Mexico or the Hermanos Mayo, nor in potential exhibits on Nacho López, the Casasola Archive, or Tina Modotti (before she became a fad and hence marketable). What they have asked for repeatedly are works by Graciela Iturbide. The only Nacho López exhibition still in circulation features prints of Indians, made in the 1970s.

93. Iturbide and Poniatowska, *Juchitán de las mujeres*, 57. The image of *Nuestra Señora de las iguanas* appears on the cover and first page of this book as well, indicating its centrality to Iturbide's work. See the analysis of this book by the anthropologist Leigh Binford, "Graciela Iturbide." Iturbide has commented on

the circulation of this image, finding it in the houses of Chicano artists and painted in Los Angeles murals; see Merry MacMasters, "La cámara, un pretexto que invoco para descubrir la realidad: Iturbide," *La Jornada*, 20 February 1996, 25.

94. Campbell and Green, "A History of Representations of Isthmus Zapotec Women," 156.

95. Manuel García, "La cámara es un pretexto para descubrir la realidad: Entrevista con Graciela Iturbide," *Sábado*, supplement of *Unomásuno*, 23 April 1994, 7; Manuel García, "Entrevista con Graciela Iturbide," *Sábado*, supplement of *Unomásuno*, 23 April 1991, 6.

96. Campbell and Green, "A History of Representations of Isthmus Zapotec Women," 174.

97. Saynes-Vázquez, "'Galán Pa dxandi,'" 183, 187. Iturbide stated that "one never stops being a foreigner" in Juchitán; see Angélica Abelleyra, "Iturbide: En México no se le brinda apoyo a la fotografía," *La Jornada*, 8 July 1988, 26.

98. Durant, "The Performance of Everyday Life," 6.

99. Saynes-Vázquez, "'Galán Pa dxandi,'" 189.

100. Abelleyra, "Iturbide," 26; Iturbide, *En el nombre del padre*.

101. On the eroticism of the killing, see Elena Poniatowska, "Abracadabra patas de cabra," *La Jornada*, 11 September 1993, 29, and García, "La cámara es un pretexto," 7; Iturbide recounts her interest as related to the Mexican idea of death in Marcia Torresasia, "El ojo y la sorpresa: Entrevista con Graciela Iturbide," *La Jornada Semanal*, 16 January 1994, 28.

102. Iturbide, *Graciela Iturbide*, 70–71. She describes her experiences in photographing the Seris in García, "La cámara es un pretexto," 7.

103. Burckhalter, *La vida norteña*.

104. *Other Americas* was published simultaneously in English, Spanish, and French in 1986. The U.S. publisher was Pantheon Books. On Salgado, see my essay "Sebastião Salgado."

105. Thomas F. Sheridan, "Another Country," *La Vida Norteña*, 30. An *ejidatario* is a member of a community formed around *ejidos*, the communal land-holding structure created under Cárdenas.

106. This would indicate that the expected market was large, or the work was significantly subsidized. Gustavo Casasola Salazar (son of Gustavo) states that the *Historia gráfica de la Revolución Mexicana* enjoyed great success once it began to be sold in self-service stores, José Luis Trueba Lara, "Gustavo Casasola S. Fotografía, libros y desmemorias, 2" *Unomásuno*, 6 November 1993, 28. The Casasolas maintained the copyright of the *Historia gráfica de la Revolución Mexicana*, and it continued to sell well: this edition was republished in 1984 by Trillas and Gustavo Casasola, and in 1992 it was directly subsidized by the government through the Consejo Nacional para la Cultura y las Artes. The

other major series, *Seis siglos de historia gráfica de México*, was republished and expanded in 1971, 1976, and 1978. The last edition, *Seis siglos de historia gráfica de México, 1325–1989*, was the first time the government was openly credited with subsidizing a Casasola publication. It eventually reached a total of 4,628 pages.

107. *Historia gráfica de la Revolución Mexicana*, 10: 3494–499.

108. Ibid., 10: 3497. This photograph also offers another example of Casasola's indiscriminate use of images: it is in fact of policemen beating a worker at the Monument of the Revolution during the 1958 strikes. It was taken by Rodrigo Moya, who titled it *Pinche comunista* (Fuckin' Communist), because that is what the police shouted with every stroke of their clubs.

109. This figure was arrived at by counting the photographs in Gustavo Casasola, *Historia gráfica de la Revolución Mexicana*, vols. 3 and 10. Of the 2,462 total photographs, 1,685 were of Great Men.

110. The Editorial Gustavo Casasola published the biographies in the 1970s and the military history in 1980.

111. Although the predominance of male leaders is clear at a glance, this is not an exhaustive survey: I analyzed one volume from each series, comparing the total number of photos to those that pictured Great Men in some way.

112. One possible use would be to employ those pictures to open up questions about racial attitudes—for example, comparing photos of Porfirio Díaz taken in 1876 with those made in 1910, in order to determine whether he had whitened his skin over that period.

113. A comparison with picture histories from other countries is beyond the scope of this book. However, in one study on these works in the United States, the percentage of Great Men in the reproduced images is around 40 percent; see Pfitzer, *Picturing the Past*.

114. Florescano, ed., *Así fue la Revolución Mexicana*; Krauze, *Biografía del poder*; Aguilar Camín et.al., *Historia gráfica de México*. See my studies of these series and the Casasola works, "Representing the Mexican Revolution" and "Picturing Mexico's Past." A *sexenio* is the six-year presidential term of office.

115. See note 186 in chapter 4. The inhibition of criticism that such cultural figures can inspire is illustrated in my experiences while trying to publish a review of *Historia gráfica de México*. Disappointed with the series, I sent a text to *Nexos*, where it was rejected. When I proposed it to *La Jornada*, the cultural editor, Braulio Peralta, was initially enthusiastic. However, after glancing at the first few sentences, he informed me that the newspaper could not publish a criticism of its founders, Aguilar Camín and Florescano; *Unomásuno* responded in the same way. The review was finally published in the journal of the ITAM (Instituto Tecnológico Autónomo de México), *Estudios* 11 (1987): 137–39.

116. Miguel de la Madrid, introduction to Florescano, ed., *Así fue la Revolución Mexicana*, 1: 5–6.

117. Mexican women usually retain their maiden surnames, so designating a woman as being "of [de] so-and-so" reduces her autonomy.

118. Florescano, ed., *Conjunto de testimonios*, vol. 6 of *Así fue la Revolución Mexicana*, 1207.

119. Cumberland, *Mexican Revolution*, 347.

120. I have analyzed this case in "'En calidad de esclavas'" and "Some Visual Notes toward a Graphic History of the Mexican Working Class." The quotes from the inspector can be found in Expediente 173–12, Ramo del Trabajo, Archivo General de la Nación (AGN).

121. I attempted to determine whether *Biografía del poder* had been reprinted, but was told that information was "confidential." Such taciturnity is unusual, but it may be the case that Krauze does not want public archives to have information about the republication of their images because they are evidently upset at his use of their photos in his books and television productions without paying rights. In 1987, a newspaper article announced that the series had sold 286,000 copies in three months and that the Fondo de Cultura Económica was preparing to reprint it; Angélica Abelleyra, "286 mil ejemplares vendidos de *Biografía del poder*," *La Jornada*, 20 July 1987, 29.

122. See the interview with Jaime García Terrés, Director of the FCE, in Abelleyra, ibid.

123. Krauze managed to involve the Dirección General de Radio, Televisión y Cinematografía and the Dirección General del Instituto Mexicano de Cinematografía, as well as the Secretaría de Agricultura y Recursos Hidráulicos and FCE.

124. Lomnitz, "An Intellectual's Stock in the Factory of Mexico's Ruins: Enrique Krauze's *Mexico: Biography of Power*," in *Deep Mexico, Silent Mexico*, 220.

125. Rodríguez Lapuente, *Breve historia gráfica de la Revolución Mexicana*, 74.

126. This was the caption used in the original fascicle, Héctor Aguilar Camín and Lorenzo Meyer, *Siglo XX*, 7, published in 1987, 100–101. In the series published the next year, the cutline was changed to read "In the lens of Agustín V. Casasola, women were incorporated in the revolutionary disorder," Aguilar Camín and Meyer, *Siglo Veinte I*, vol. 7, *Historia gráfica de México*, 100–101.

127. Morales, "La celebre fotografía de Jerónimo Hernández." As the photograph had been published in the first and all successive *historias gráficas* of the Casasolas, authorship was assigned by default to Agustín Víctor.

128. No reference is made to the name "Adelita" in any other *historia gráfica*, though this photo is invariably reproduced. However, journalists had employed this name previously in referring to *soldaderas*, and coverage of Morales's discovery

makes it clear that it has stuck to this image: see Arturo Jiménez, "Identifican al verdadero autor de la fotografía de la Adelita," *La Jornada*, 16 February 2007, 4a, and Dora Luz Haw, "Prueba que 'Adelita' no es de Casasola," *Reforma*, 16 February 2007, section Cultura, 6.

129. Salas, *Soldaderas in the Mexican Military*, 43.

130. See the photo of a better-dressed woman serving alcohol to federal officers in a train car, *Jefes, heroes y caudillos*, 47.

131. Observation of Alfonso Morales.

132. Juana Armanda Alegría, "Pero, ¿existió La Adelita? Reconsideraciones del mito," *Siempre!*, 26 February 1975, 34.

133. This image appeared in all the picture histories and was also published in the following works: *¡Tierra y Libertad!*, 38–39; *El poder de la imagen y la imagen del poder*, 36; *Jefes, héroes y caudillos*, 39; Debroise, *Mexican Suite*, 185; Rodríguez Lapuente, *Breve historia gráfica de la Revolución Mexicana*, 59.

134. The photo in which the flash worked can be seen in Escorza Rodríguez, "Las fotografías de Casasola publicadas en diarios capitalinos durante 1913," 36–37.

135. Place and Peterson, "Some Visual Motifs of Film Noir," 328–330.

136. Earlier versions of this text were published as Bartra and Mraz, "Las Dos Fridas: History and Transcultural Identities"; "Las Dos Fridas: Historia e identidades transculturales"; and "As duas Fridas." This painting is reproduced on the cover of *Secuencia* 65 (2006).

137. Galeano, *Open Veins of Latin America*.

138. See Bateson, *Mind and Nature: A Necessary Unity*, 69–70.

139. The script has been reproduced in Leduc and Blanco, *Frida*. Leduc's first film, *Reed: Insurgent Mexico* (1972), demonstrated an interest in transcultural issues by centering on the activities of John Reed during the Mexican Revolution. Nonetheless, choosing to focus on a *gringo* was a curious, perhaps iconoclastic, decision for a work made during the effervescence of the New Latin American Cinema (NCLA), a movement dedicated to a tenacious search to develop this region's particular aesthetic.

140. See frame enlargements # 3, 4, 5, 6, and 7 of the 19 published in Bartra and Mraz, "Las dos Fridas: Historia e identidades transcultural," 149–53. Raquel Tibol noted that Frida's use of a wheelchair was "sporadic"; Raquel Tibol, "Una Frida con errores," *Proceso*, 19 November 1984, 56.

141. It should be noted that Frida does limp in the period of recovery after her accident, but she loses the limp as the Taymor-Hayek movie progresses. As José Rabasa observed in a conversation, the absence of the limp may also correspond to Hollywood's demand for physical perfection.

142. Herrera, *Frida*.

143. Those familiar with Kahlo's painting will recognize that the image of Hayek as

Frida utilizes two paintings: *Las dos Fridas* and the self-portrait in which she has lopped off her hair and wears a man's suit, *Cutting my hair with some little scissors* (1940). The invitation can be seen in Bartra and Mraz, "Las Dos Fridas: History and Transcultural Identities," 450; Bartra and Mraz, "Las Dos Fridas: Historia e identidades transculturales," 148; and Bartra and Mraz, "As duas Fridas," 70.

144. It is difficult not to see contemporary Hollywood cinema as the counterpart of the "white telephone" films of Fascist Italy.

145. The absence of dialogue in Leduc's film makes it impossible to compare this issue.

146. Custen, *Bio/Pics*, 8. Custen analyzes the years 1927–60.

147. Custen notes that only certain "lives are acceptable subjects," ibid., 12.

148. Ibid., 149.

149. See the frame enlargements of Benito Juárez (Paul Muni) and Lincoln's portrait in Vanderwood, ed, *Juárez*, 43, 46, and 48.

150. Vanderwood, "The Image of Mexican Heroes in American Films," 234.

151. Custen, *Bio/Pics*, 109.

152. See Ernesto Diezmartinez, "La Frida de Salma," *El Ángel*, supplement of *Reforma*, 16 February 2003, 5.

153. Leonardo García Tsao, "No tan sufrida," *La Jornada*, 29 November 2002, 9a.

154. Angel Vargas, "Degrada *Frida* a los personajes representados en la cinta: Tibol," *La Jornada*, 9 March 2003, 2a.

155. Guadalupe Loaeza, "Salma interpreta a Salma," *Reforma*, 7 November 2002, section Gente, 5.

156. Guadalupe Loaeza, "Frida Made in USA," *Reforma*, 7 November 2002, section Gente, 1; see also Ysabel Gracida, "Cada quien su Frida," *El Universal*, 28 November 2002, section Cultura, 3.

157. Fernando Celin, "Frida en inglés," *Seminario cultural*, supplement of *Novedades*, 15 December 2002, 8.

158. Francisco Hernández, "Las múltiples Fridas," *Milenio*, 6 December 2002, 45.

159. The article on Frida in *Proceso* was ironically titled "Frida returns to Bellas Artes speaking in English": "Frida regresa a Bellas Artes hablando en íngles," *Proceso*, 10 November 2002, 54. See also Gracida, "Cada quien su Frida," 3.

160. Ricardo Hernández, "Que Frida no era lesbiana," *El Sol de México*, 7 November 2002, section Escenario, 1.

161. Seth Fein, review of *Frida*, *American Historical Review* 108, no. 4 (October 2003): 1262.

162. One of Frida's disciples, Arturo García Bustos, felt that Gurrola had been a "caricature" of Rivera; see Mary Carmen Santana, "Le dan tres de calificación," *Milenio*, 8 November 2002, 7. Olivier Debroise, however, asserted that Diego

had been "magistrally interpreted" by Gurrola; "*Frida*, la película," *La Jornada*, 26 November 1984, 25. Reviewers differed on the credibility of Alfredo Molina.

163. Custen notes, "This idea—that all ills can be cured—is precisely the biopic's message," *Bio/Pics*, 189.

164. Barthes, *Camera Lucida*, 80. This is an enormously complex question: for example, nobody appears to doubt the authenticity of the digital images made of torture in the Abu Ghraib prison.

165. Zea, *The Latin American Mind*, 6.

166. www.Zonezero.com. Among the prolific Meyer's works are the book *Espejos de espinas*, the CD-ROM *I Photograph to Remember* (1991), and his exploration in digital imagery, *Verdades y ficciones*, published in English as *Truths and Fictions: A Journey from Documentary to Digital Photography* (New York: Aperture, 1995).

167. Meyer, "Inside the USA," 47.

168. Ibid., 48. The photograph of the Nicaraguan can be seen in Belliter, *Fotografía latinoamericana desde 1860 hasta nuestros días*, 321.

169. Digital images are identified with a dual dating system: the first date refers to the year the straight photograph was made, and the second date is when the digital "collage" was created.

170. Meyer, *Verdades y ficciones*, 19.

171. Ibid., 65.

172. Ibid., 112–13.

173. I chatted with Chip Lord, the curator of "Cadillac Ranch," and he told me that all the cars could be driven into the holes dug for them, indicating that their engines were still functioning.

174. Meyer, *Verdades y ficciones*, 69.

175. Ibid., 46.

176. Ibid., 21.

177. Vargas cited in "Exhibirá Argentina *El violín* antes que México," *El Universal*, 4 April 2007, section Espectáculos, 15.

178. Juan Manuel Badillo, "No tenemos el cine que merecemos," *El Economista*, 21 April 2006, section La Plaza, 7.

179. Vargas mentions the unpaid participation of "many people" in Rogelio Segoviano, "Ese pinche militar me quiere chingar,"*Diariomonitor*, 13 May, 2006, section Entretenimiento, 2. Ángel Tavira stated that he had not been paid a cent for the film; Jesús Pintor Alegre, "No me pagaron ni un peso por hacer *El violín*: Ángel Tavira," *La Jornada Guerrero*, 14 March 2007, section Espectáculos, 8.

180. Dalila Carreño, "Aspiran a dar la mejor nota en México con *El violín*," *Reforma*, 18 April 2007, section Gente, 4.

181. Hence, the twenty copies of *El violín* attracted an average of 1,066 viewers, while the 247 copies of *The Messenger* (2007) were attended by an average of 720 viewers; Dalila Carreño, "Buenas 'notas' en taquilla," *Reforma*, 4 May 2007, section Gente, 24. It is worth pointing out that almost double the number of copies (39) circulated in French theaters. Anne Marie Mergier, "Francia, enamorada de *El violín*," *Proceso*, 13 May 2007, 60–61.

182. "Suena bien *El violín* en San Sebastián," *El Sol de México*, 26 September 2006, section Espectáculos, 4.

183. Pintor Alegre, "No me pagaron ni un peso por hacer *El violín*," 8.

184. Hermann Bellinghausen, "Notas para *El violín*," *La Jornada*, 18 May 2007, 4a.

185. See "Comentan foto publicada," a letter to the editor by Alvaro Carlos Aldama y Luebbert, *La Jornada*, 19 July 2007, 2, in reference to the photographs published in "Vuelve la violencia a Oaxaca," *La Jornada*, 17 July 2007, 3.

186. See "Elogio de *El violín*," letter to the editor by Dionisio Alzaga et al., *La Jornada*, 18 May 2007, 2.

BIBLIOGRAPHY

Acevedo, Marta. *El 10 de mayo*. Mexico City: Martin Casillas Editores, 1982.

Aguayo, Fernando. *Estampas ferrocarrileras: Fotografía y grabado, 1860–1890*. Mexico City: Instituto Mora, 2003.

Aguayo, Fernando, and Lourdes Roca, eds. *Imágenes e investigación social*. Mexico City: Instituto Mora, 2005.

Aguilar Camín, Héctor. *Saldos de la Revolución: Cultura y política de México, 1910–1989*. Mexico City: Editorial Nueva Imagen, 1982.

Aguilar Camín, Héctor, et al. *Historia gráfica de México*. 10 volumes. Mexico City: Editorial Patria, 1988.

Aguilar Ochoa, Arturo. *La fotografía durante el imperio de Maximiliano*. Mexico City: Universidad Nacional Autónoma de México, 1996.

"Agustín Casasola: An Unknown Photographer." In *The World of Agustín Víctor Casasola, Mexico: 1900–1938*, 8–13. Washington, D.C.: Fondo del Sol Visual Arts and Media Center, 1984.

Agustín Víctor Casasola. Mexico City: Partido Revolucionario Institucional, 1988.

"Agustín Víctor Casasola: El archivo, el fotógrafo." Special issue, *Alquimia* 1 (1997).

Agustín Víctor Casasola: El hombre que retrató una época, 1900–1938. Mexico City: Editorial Gustavo Casasola, 1988.

Albúm Oficial del Comité Nacional del Comercio: 1er Centenario de la Independencia de México. Mexico City: n.p., 1910.

Alexander, William. "Paul Strand as Filmmaker, 1933–1942." In *Paul Strand: Essays on his Life and Work*, edited by Maren Stange, 148–60. New York: Aperture, 1990.

Ancira, Eduardo. "Fotógrafos de la luz aprisionada: Asociación de fotógrafos de la prensa metropolitana de la Ciudad de México, octubre-diciembre de 1911." In *Imágenes e investigación social*, edited by Fernando Aguayo and Lourdes Roca, 334–53. Mexico City: Instituto Mora, 2005.

Anderson, Benedict. *Imagined Communities: Reflections on the Origin and Spread of Nationalism*. London: Verso, 1983.

Argudín Yolanda. *Historia del periodismo en México*. Mexico City: Panorama Editorial, 1987.

Arnal Lorenzo, Ariel. "Construyendo símbolos—fotografía política en México: 1865–1911." In "Cultura visual en América Latina," edited by John Mraz. Special issue, *Estudios Interdisciplinarios de América Latina y el Caribe* (Tel Aviv) 9, no. 1 (1998): 55–73.

———. "Fotografía del zapatismo en la prensa de la Ciudad de México, 1910–1915," M.A. thesis, Universidad Iberoamericana, 2002.

Arroyo, Sergio Raúl. "The Casasola Archive in the INAH National Photo Library." In *Mexico: The Revolution and Beyond: Photographs by Agustín Víctor Casasola, 1900–1940*, 11. New York: Aperture, 2003.

Arroyo, Sergio Raúl, and Rosa Casanova. "The Casasolas: An Everyday Epic." In *Mexico: The Revolution and Beyond: Photographs by Agustín Víctor Casasola, 1900–1940*, 203–10. New York: Aperture, 2003.

Aurrecoechea, Juan Manuel, and Armando Bartra. *Puros cuentos: La historia de la historieta en México, 1874–1934*. Mexico City: Conaculta, 1988.

Ayala Blanco, Jorge. *La aventura del cine mexicano*. Mexico City: Ediciones Era, 1979 [1968].

———. *La búsqueda del cine mexicano*. Mexico City: Editorial Posada, 1986 [1974].

———. *La condición del cine mexicano*. Mexico City: Editoral Posada, 1986.

Barbosa, Carlos Alberto Sampaio. *A fotografia a servico de Clio: Uma interpretação da história visual da Revolução Mexicana (1900–1940)*. São Paulo: Editora UNESP, 2006.

Barnouw, Erik. *Documentary: A History of the Non-Fiction Film*. London: Oxford University Press, 1974.

Barthes, Roland. *Camera Lucida*. Translated by Richard Howard. New York: Hill and Wang, 1981.

Bartra, Armando. "Lo que la Mafia se llevó." In "Héctor García y su tiempo." Special issue, *Luna Córnea* 26 (2003): 210–17.

Bartra, Eli, and John Mraz. "As duas Fridas: história e identidades transculturais." *Estudos Feministas* 13, no. 2 (2005): 69–79.

———. "Las Dos Fridas: History and Transcultural Identities." *Rethinking History* 9, no. 4 (2005): 449–57.

———. "Las Dos Fridas: Historia e identidades transculturales." *Secuencia: Revista de historia y ciencias sociales* 65 (2006): 139–65.

Bartra, Roger, ed. *Anatomía del mexicano*. Mexico City: Plaza Janés, 2002.

———. *The Cage of Melancholy: Identity and Metamorphosis in the Mexican Character*. Translated by Christopher J. Hall. New Brunswick, N.J.: Rutgers University Press, 1992.

————. *La jaula de la melancolía: Identidad y metamorfosis del mexicano*. Mexico City: Grijalbo, 1988.

Bateson, Gregory. *Mind and Nature: A Necessary Unity*. New York: E. P. Dutton, 1979.

————. "Morale and National Character." In *Steps to an Ecology of Mind*, 88–106. New York: Ballantine, 1972.

Baughman, James L. "Who Read *Life?* The Circulation of America's Favorite Magazine." In *Looking at "Life" Magazine*, edited by Erika Doss, 41–51. Washington, D.C.: Smithsonian Institution Press, 2001.

Bayoumi, Moustafa, and Andrew Rubin, eds. *The Edward Said Reader*. New York: Vintage Books, 2000.

Bellinghausen, Herman, ed. *Pensar el 68*. Mexico City: Cal y Arena, 1988.

Belliter, Erika. *Fotografía latinoamericana desde 1860 hasta nuestros días*. Barcelona: Ediciones El Viso, 1982.

Benjamin, Thomas. *La Revolución: Mexico's Great Revolution as Memory, Myth, and History*. Austin: University of Texas Press, 2000.

Bernice Kolko, fotógrafa/photographer. Mexico City: Ediciones del Equilibrista, 1996.

Berumen, Miguel Ángel. *1911: La batalla de Ciudad Juárez / II. Las imágenes*. Ciudad Juárez: Cuadro X Cuadro, 2005.

————. *Pancho Villa: La construcción del mito*. Mexico: Cuadro por Cuadro, 2006.

Binford, Leigh, "Graciela Iturbide: Normalizing Juchitán." In "Mexican Photography," edited by John Mraz. Special issue, *History of Photography* 22, no. 4 (1996): 244–48.

Blancarte, Roberto, ed. *Cultura e identidad nacional*. Mexico City: Universidad Nacional Autónoma de México, 1994.

Blanco Moheno, Roberto. *Memorias de un reportero*. Mexico City: Libro Mex Editores, 1965.

Bloch, Avital H., and Servando Ortoll. "'¡Viva México! ¡Mueran los yanquis!' The Guadalajara Riots of 1910." In *Riots in the Cities: Popular Politics and the Urban Poor in Latin America, 1765–1910*, edited by Silvia M. Arron and Servando Ortoll, 195–223. Wilmington, Del.: Scholarly Resources, 1996.

Brading, David A. "Manuel Gamio and Official Indigenismo in Mexico." *Bulletin of Latin American Research* 7, no. 1 (1988): 75–89.

Brehme, Hugo. *México pintoresco*. Mexico City: Porrúa-INAH, 1990 [1923].

Brenner, Anita. *The Wind That Swept Mexico: The History of the Mexican Revolution, 1910–1942*. New York: Harper and Brothers, 1943.

Buchenau, Jurgen. *Tools of Progress: A German Merchant Family in Mexico, 1865–Present*. Albuquerque: University of New Mexico Press, 2004.

Burckhalter, David. *La vida norteña: Photographs of Sonora, México*. Albuquerque: University of New Mexico Press, 1998.

Burton-Carvajal, Julianne. "Mexican Melodramas of Patriarchy: Specificity of a Transcultural Form." In *Framing Latin American Cinema: Contemporary Critical Perspectives*, edited by Ann Marie Stock, 186–234. Minneapolis: University of Minnesota Press, 1997.

Calvo Serraller, Francisco. "La imagen romántica de España." *Cuadernos Hispanoamericanos* 111 (1978): 240–60.

Campbell, Howard, and Susanne Green. "A History of Representations of Isthmus Zapotec Women." *Identities* 3, nos. 1–2 (1996): 155–82.

Campos, Julieta. *Graciela Iturbide, Paulina Lavista, Colette Urbajtel*. Mexico City: Instituto Nacional de Bellas Artes, 1975.

Carlebach, Michael L. *American Photojournalism Comes of Age*. Washington, D.C.: Smithsonian Institution Press, 1997.

Carneiro de Carvalho, Vania, and Solange Ferraz de Lima. "Individuo, género y ornamento en los retratos fotográficos, 1870–1920." In *Imágenes e investigación social*, edited by Fernando Aguayo and Lourdes Roca, 271–91. Mexico City: Instituto Mora, 2005.

Casanova, Rosa. "De vistas y retratos: La construcción de un repertorio fotográfico en México, 1839–1890." In *Imaginarios y fotografía en México, 1839–1970*, edited by Emma Cecilia García Krinsky, 2–57. Mexico City: Lunwerg, 2005.

———. "Las fotografías se vuelven historia: Algunos usos entre 1865 y 1910." In *Los pinceles de la historia: La fabricación del estado, 1864–1910*, 214–241. Mexico City: Museo Nacional de Arte, 2003.

———. "Ingenioso descubrimiento: Apuntes sobre los primeros años de la fotografía en México." In "De plata, vidrio y fierro. Imágenes de cámara del siglo xix." Special issue, *Alquimia* 6 (1999): 6–13.

———. "Un nuevo modo de representar: Fotografía en México, 1839–1861." In *Hacia otra historia del arte en México*, edited by Esther Acevedo, 191–217. Mexico City: Conaculta, 2001.

———. "El primer ensayo editorial de los Casasola." In "Fondo Casasola: relecturas." Special issue, *Alquimia* 25 (2005): 28–34.

Casanova, Rosa, and Olivier Debroise. *Sobre la superficie bruñida de un espejo: Fotógrafos del siglo xix*. Mexico City: Fondo de Cultura Económica, 1989.

[Casasola, Agustín Víctor.] *Albúm histórico gráfico: Contiene los principales sucesos acaecidos durante las épocas de Díaz, de la Barra, Madero, Huerta y Obregón*. 5 volumes. Mexico City: Agustín V. Casasola e Hijos, 1921.

Casasola, Gustavo. *Enciclopedia histórica ilustrada de México, 1325–1958*. Mexico City: Ediciones Archivo Casasola, n.d.

[———.] *Historia gráfica de la Revolución*. 25 cuadernos. Mexico City: Editorial Archivo Casasola, 1942–60.

———. *Historia gráfica de la Revolución Mexicana*. 10 volumes. Mexico City: Editorial Gustavo Casasola and Trillas, 1960–73.

———. *Seis siglos de historia gráfica en México*. 14 volumes. Mexico City: Editorial Gustavo Casasola and Conaculta, 1962–89.

Castrejón, Guillermo. *Sombras de mi ciudad: Campeche*. Campeche: Conaculta, 1999.

Chávez, Ezequiel. "La sensibilidad del mexicano." In *Anatomía del mexicano*, edited by Roger Bartra, 25–45. Mexico City: Plaza Janés, 2002.

Chiles, Frederic, and John Mraz. "The Historical Film-Essay: *Todo es más sabroso con.* . . ." *Proceedings of the Pacific Coast Council on Latin American Studies* 4 (1975): 183–86.

Coleman, A. D. "The Indigenous Vision of Manuel Álvarez Bravo." In *Light Readings: A Photography Critic's Writings, 1968–1978*, 221–28. New York: Oxford University Press, 1979.

Colina, Enrique, and Daniel D. Torres. "Ideología del melodrama en el viejo cine latinoamericano." *Cine Cubano* 73–75 (1972): 14–26.

Conger, Amy. *Edward Weston in Mexico, 1923–1926*. Albuquerque: University of New Mexico Press, 1983.

Córdova, Carlos. *Arqueología de la imagen: México en las vistas estereoscópicas*. Mexico City: Museo de la Historia Mexicana, 2000.

Coronel Rivera, Juan. "Guillermo Kahlo: Fotógrafo 1872–1941." In *Guillermo Kahlo: Vida y obra*, 28–110. Mexico City: Museo Estudio Diego Rivera, 1993.

Costa, Paola. *La "apertura" cinematográfica: México, 1970–1976*. Puebla: Universidad Autónoma de Puebla, 1988.

Cruz, Marco Antonio. *Cafetaleros*. Mexico City: Imagenlatina, 1996.

Cuevas-Wolf, Cristina. "Guillermo Kahlo and Casasola: Architectural Form and Urban Unrest." In "Mexican Photography," edited by John Mraz. Special issue, *History of Photography* 22, no. 4 (1996): 196–207.

Cumberland, Charles. *Mexican Revolution: The Constitutionalist Years*. Austin: University of Texas Press, 1972.

Curiel, Gustavo, et al., eds. *Arte, historia e identidad en América: Visiones comparativas*. Mexico City: Universidad Nacional Autónoma de México, 1994.

Custen, George F. *Bio/Pics: How Hollywood Constructed Public History*. New Brunswick, N.J.: Rutgers University Press, 1992.

Davis, Natalie Zemon. "'Any Resemblance to Persons Living or Dead': Film and the Challenge of Authenticity." *Historical Journal of Film, Radio and Television* 8, no. 3 (1988): 269–83.

Dawson, Alexander S. "From Models for the Nation to Model Citizens: Indigenismo and the 'Revindication' of the Mexican Indian, 1920–40." *Journal of Latin American Studies* 30 (1998): 279–308.

―――. *Indian and Nation in Revolutionary Mexico*. Tucson: University of Arizona Press, 2004.

Debroise, Olivier. *Mexican Suite: A History of Photography in Mexico*. Translated by Stella de Sá Rego. Austin: University of Texas Press, 2001.

de la Colina, José. "Pedro Infante." *Dicine* 21 (1987): 2–3.

de la Mora, Sergio. *Cinemachismo: Masculinities and Sexuality in Mexican Film*. Austin: University of Texas Press, 2006.

de la Torre Rendón, Judith. "Las imágenes fotográficas de la sociedad mexicana en la prensa gráfica del porfiriato." *Historia mexicana* 48, no. 2 (1998): 343–73.

del Castillo, Alberto. *Conceptos, imágenes y representaciones de la niñez en la ciudad de México, 1880–1920*. Mexico City: El Colegio de México, 2006.

―――. "Fotoperiodismo y representaciones del Movimiento Estudiantil de 1968: El caso de *El Heraldo de México*." *Secuencia* 60 (2004): 136–72.

―――. "La historia de la fotografía en México, 1890–1920: La diversidad de los usos de la imagen." In *Imaginarios y fotografía en México, 1839–1970*, edited by Emma Cecilia García Krinsky, 58–117. Mexico City: Lunwerg, 2005.

―――. "Prensa, poder y criminalidad a finales del siglo XIX en la Ciudad de México." In *Hábitos, normas y escándalo: Prensa, criminalidad y drogas durante el porfiriato tardío*, edited by Ricardo Pérez Montfort, 17–73. Mexico City: Plaza y Valdés, 1997.

―――. *Rodrigo Moya: Una visión crítica de la modernidad*. Mexico City: Conaculta, 2006.

―――. "El surgimiento del reportaje policiaco en México: Los inicios de un nuevo lenguaje gráfico (1888–1910)." In "Antropología e imagen." Special issue, *Cuicuilco* 5, no. 13 (1998): 163–94.

de los Reyes, Aurelio. "El cine, la fotografía y los magazines ilustrados." In *Historia del arte mexicano*, edited by Jorge Manrique, 182–200. Mexico City: Secretaría de Educación Pública, 1982.

―――. *Cine y sociedad en México, 1896–1930*. Vol. 1, *Vivir de sueños (1896–1920)*. Mexico City: Universidad Nacional Autónoma de México, 1981.

―――. *Con Villa en México: Testimonios de camarógrafos norteamericanos en la Revolución*. Mexico City: Universidad Nacional Autónoma de México, 1985.

―――. *Medio siglo de cine mexicano (1896–1947)*. Mexico City: Trillas, 1987.

Delpar, Helen. *The Enormous Vogue of Things Mexican: Cultural Relations between the United States and Mexico, 1920–1935*. Tuscaloosa: University of Alabama Press, 1992.

de Luna, Andrés. *La batalla y su sombra (La revolución en el cine mexicano)*. Mexico City: Universidad Autónoma Metropolitana-Xochimilco, 1984.

de Orellano, Margarita. *La mirada circular: El cine norteamericano de la Revolución mexicana, 1911–1917*. Mexico City: Joaquín Mortiz, 1991.

————. "Palabras sobre imágenes. Entrevista con Gabriel Figueroa." In "El arte de Gabriel Figueroa." Special issue, *Artes de México* 2 (1988): 37–53.

————. "Pancho Villa: Primer actor del cine de la Revolución." In *Cine mexicano*, edited by Jorge Alberto Lozoya, 61–62. Mexico City: Instituto Mexicano de Cinematografía-Lunwerg, 1992.

de Santiago S., José. *Flor Garduño: Fotografías*. Mexico City: Instituto Nacional de Bellas Artes, 1982.

Dever, Susan. *Celluloid Nationalism and Other Melodramas: From Post-Revolutionary Mexico to* fin de siglo Mexamérica. Albany: State University of New York Press, 2003.

Díaz, María Elena. "The Satiric Penny Press for Workers in Mexico, 1900–1910." *Journal of Latin American Studies* 22, no. 3 (1990): 497–526.

Dorotinsky, Deborah. "Los tipos sociales desde la austeridad del studio." In "François Aubert en México." Special issue, *Alquimia* 21 (2004): 14–25.

————. "La vida de un archivo. 'México indígena' y la fotografía etnográfica de los años cuarenta en México." Ph.D. Thesis, Universidad Nacional Autónoma de México, 2003.

Durant, Mark Alice. "The Performance of Everyday Life: Reflections on the Photography of Graciela Iturbide." *Afterimage* (September–October 1996): 6–8.

Dyer, Richard. *Stars*. London: British Film Institute, 1998.

Edwards, Susan H. "Pretty Babies: Art, Erotica, or Kiddie Porn?" *History of Photography* 18, no. 1 (1994): 38–46.

Ehrenberg, Felipe. "The Style of the File . . ." In *The World of Agustín Víctor Casasola, Mexico: 1900–1938*, 14–15. Washington, D.C.: Fondo del Sol Visual Arts and Media Center, 1984.

Entre portales, palacios y jardines: El Zócalo de la ciudad de México, 1840–1935. Mexico City: Conaculta, 2004.

Escorza Rodríguez, Daniel. "Las fotografías de Casasola publicadas en diarios capitalinos durante 1913." In "Fondo Casasola: relecturas." Special issue, *Alquimia* 25 (2005): 35–40.

————. "Los inicios de Agustín V. Casasola como *reporter-fotógrafo*." *Alquimia* 27 (2005): 24–35.

Escribir con luz: Héctor García. Mexico City: Fondo de Cultura Económica, 1985.

Espino Barros, Eugenio. *México en el centenario de su independencia: Albúm gráfico de la República mexicana*. Mexico City: Müller Hnos, 1910.

Feder, Elena. "A Reckoning: Interview with Gabriel Figueroa." *Film Quarterly* 49, no. 3 (1996): 2–14.

Fein, Seth. "New Empire into Old: Making Mexican Newsreels the Cold War Way." *Diplomatic History* 28, no. 5 (2004): 703–48.

Fernández Ledesma, Enrique. *La gracia de los retratos antiguos*. Mexico City: Ediciones Mexicanas, 1950.

Fernández Tejedo, Isabel. *Recuerdo de México: La tarjeta postal mexicana, 1882–1930.* Mexico City: Banobras, 1994.

Figarella, Mariana. *Edward Weston y Tina Modotti en México: Su inserción dentro de las estrategias estéticas del arte posrevolucionario.* Mexico City: Universidad Nacional Autónoma de México, 2002.

Fisher, Howard T., and Marion Hall Fisher, eds. *Life in Mexico: The Letters of Fanny Calderon de la Barca.* Garden City: Anchor Books, 1970.

Florescano, Enrique, ed. *Así fue la Revolución Mexicana.* 8 volumes. Mexico City: Senado de la República-Secretaría de Educación Pública, 1985–86.

———. *El nuevo pasado mexicano.* Mexico City: Cal y Arena, 1991.

Flusser, Vilém. *Towards a Philosophy of Photography.* Germany: European Photography, 1984.

Fotografía de prensa en México: 40 reporteros gráficos. Mexico City: Procuraduría General de la República, 1992.

"Fotolibros en México." Special issue of *Alquimia* 29 (2007).

Franger, Gaby, and Rainer Huhle, eds. *Fridas Vater: Der Fotograf Guillermo Kahlo von Pforzheim bis Mexico.* Munich: Chirmer-Mosel, 2005.

Gabriel Figueroa y la pintura mexicana. Mexico City: Conaculta, 1996.

Galeano, Eduardo. *Open Veins of Latin America: Five Centuries of the Pillage of a Continent.* Translated by Cedric Belfrage. New York: Monthly Review Press, 1973.

Galería de personas que han ejercido el mando supremo de México con título legal o por medio de la usurpación. Mexico City, 1874.

Galindo, Enrique. "¿Objetivismo o pictorialismo?" *Foto* 14 (1937): 12–15.

Gallo, Rubén. *Mexican Modernity: The Avant-Garde and the Technological Revolution.* Cambridge: MIT Press, 2005.

Gamio, Manuel. *Forjando Patria: Pro-nacionalismo.* Mexico City: Porrúa, 1960 [1916].

García, Clara Guadalupe. *El periódico "El Imparcial": Primer diario moderno de México (1896–1914).* Mexico City: Centro de Estudios Históricos del Porfiriato, 2003.

García, Genaro, ed. *Crónica oficial de las fiestas del primer centenario de la independencia de México.* Mexico City: Centro de Estudios de Historia de México Condumex, 1991 [1911].

García, Gustavo. "In Quest of a National Cinema: The Silent Era." In *Mexico's Cinema: A Century of Film and Filmmakers*, edited by Joanne Hershfield and David Maciel, 5–16. Wilmington, Del.: Scholarly Resources, 1999.

García, Gustavo, and David R. Maciel, eds. *El cine mexicano a través de la crítica.* Mexico City: Universidad Nacional Autónoma de México, 2001.

García Canclini, Néstor, ed. *Los nuevos espectadores: Cine, televisión y video en México.* Mexico City: Conaculta, 1994.

García Cantú, Gastón. *Las invasiones norteamericanas en México.* Mexico City: Era, 1971.

García Díaz, Bernardo. *Puerto de Veracruz.* Vol. 8, *Veracruz: Imágenes de su historia.* Veracruz: Archivo General del Estado de Veracruz, 1992.

García Krinsky, Emma Cecilia, ed. *Imaginarios y fotografía en México, 1839–1970.* Mexico City: Lunwerg, 2005.

García Riera, Emilio. *Breve historia del cine mexicano.* Mexico City: Instituto Mexicano de Cinematografía, 1998.

———. *Emilio Fernández, 1904–1986.* Mexico: Universidad de Guadalajara-Cineteca Nacional, 1987.

———. *Fernando de Fuentes (1894–1958).* Mexico City: Cineteca Nacional, 1984.

———. *Historia documental del cine mexicano.* 9 volumes. Mexico City: Era, 1969–78.

———. *Historia documental del cine mexicano.* 2nd ed. 18 volumes. Mexico: IMCINE-Universidad de Guadalajara, 1996.

García Rubio, Fabiola. *La entrada de las tropas estadunidenses a la ciudad de México: La mirada de Carl Nebel.* Mexico City: Instituto Mora, 2002.

Garduño, Flor. *Inner Light.* New York: Bulfinch, 2004.

———. *Magia del juego interno.* Juchitán, Oaxaca: Guchachi, 1985.

———. *Witnesses of Time.* New York: Thames and Hudson, 1992.

Garduño Pulido, Blanca. "Mexico's Enduring Images." In *México: Una nación persistente: Hugo Brehme, fotografías,* 13–16. Mexico City: Conaculta-INBA, 1995.

Garizurieta, César. "Catarsis del mexicano." In *Anatomía del mexicano,* edited by Roger Bartra, 121–30. Mexico City: Plaza Janés, 2002.

Garmabella, José Ramón. *Renato por Leduc: Apuntes de una vida singular.* Mexico City: Ediciones Océano, 1983.

Gautreau, Marion. "Questionnement d'un symbole: Agustin Victor Casasola, Photographe de la Revolution Mexicaine." M.A. thesis. Université Paris Sorbonne, 2002.

Gavira, Gabriel. *Polvos de aquellos lodos: Unas cuantas verdades!* Mexico City: Gustavo Casasola, 1949.

Gillespie, Jeanne L. "The Case of the *China Poblana.*" In *Imagination beyond Nation: Latin American Popular Culture,* edited by Eva Bueno and Terry Caesar, 19–37. Pittsburgh: University of Pittsburgh Press, 1998.

Gilly, Adolfo. "Memoria y olvido, razon y esperanza: Sugerencias para el estudio de la historia de las revoluciones." *Brecha* 1 (1986): 7–15.

Gómez Mostajo, Lorena. "Los grandes timadores." In "Héctor García y su tiempo." Special issue, *Luna Córnea* 26 (2003): 238–43.

Gómez Peña, Guillermo. *The New World Border.* San Francisco: City Lights Books, 1996.

González Cruz, Maricela. "Juan Guzmán en México: Fotoperiodismo, modernidad

y desarrollismo en algunos de su reportajes y fotografías de 1940 a 1960." M.A. thesis, Universidad Nacional Autónoma de México, 2003.

————. "Momentos y modelos en la vida diaria: El fotoperiodismo en algunas fotografías de la Ciudad de México, 1940–1969." In *Historia de la vida cotidiana en México, v, Siglo xx: La imagen, ¿espejo de la vida?*, vol. 2, edited by Aurelio de los Reyes, 229–300. Mexico City: El Colegio de México-Fondo de Cultura Económica, 2006.

————. *Tina Modotti y el muralismo mexicano*. Mexico City: Universidad Nacional Autónoma de México, 1999.

González de Alba, Luis. *Los días y los años*. Mexico City: Era, 1971.

González Rodríguez, Sergio. "Cuerpo, control y mercancía: Fotografía prostibularia." *Luna Córnea* 4 (1994): 72–81.

Gould, Lewis, and Richard Greffe. *Photojournalist: The Career of Jimmy Hare*. Austin: University of Texas Press, 1977.

Granados Chapa, Miguel Ángel. *"Excelsior" y otro temas de comunicación*. Mexico City: Ediciones El Caballito, 1980.

Guevara, Che. *Che: Selected Works of Ernesto Guevara*. Edited by Rolando E. Bonachea and Nelson P. Valdés. Cambridge, Mass.: MIT Press, 1969.

Guillermo Kahlo: Fotógrafo oficial de monumentos. Mexico: Casa de las Imágenes, 1992.

Guillermo Kahlo: Vida y obra. Mexico City: Museo Estudio Diego Rivera, 1993.

Guimond, James. *American Photography and the American Dream*. Chapel Hill: University of North Carolina Press, 1991.

Gutiérrez Rubalcava, Ignacio. "Los Casasola durante la posrevolución." In "Agustín Víctor Casasola. El archivo, el fotógrafo." Special issue, *Alquimia* 1 (1997): 37–40.

————. "A Fresh Look at the Casasola Archive." In "Mexican Photography," edited by John Mraz. Special issue, *History of Photography* 22, no. 4 (1996): 191–95.

Gutmann, Matthew C. *The Meanings of Macho: Being a Man in Mexico City*. Berkeley: University of California Press, 1996.

Guzmán, Martín Luis. *El aguila y la serpiente*. Mexico City: Málaga, 1977.

Hales, Peter B. *William Henry Jackson and the Transformation of the American Landscape*. Philadelphia: Temple University Press, 1988.

Hall, Stuart. "Cultural Identity and Cinematic Representation." *Framework* 36 (1989): 68–81.

————. "The Social Eye of *Picture Post*." *Working Paper in Cultural Studies* 2 (1972): 71–119.

————, and Paul du Gay, eds. *Questions of Cultural Identity*. London: Sage Publications, 1996.

Hart, John Mason. *Empire and Revolution: The Americans in Mexico since the Civil War*. Berkeley: University of California Press, 2002.

————. *Revolutionary Mexico: The Coming and Process of the Mexican Revolution.* Berkeley: University of California Press, 1987.

Héctor García. Madrid: Turner; Mexico City: Conaculta, 2004.

Héctor García: Camera oscura. Veracruz: Gobierno del Estado de Veracruz, 1992.

Héctor García: México sin retoque. Mexico City: Universidad Nacional Autónoma de México, 1987.

"Héctor García y su tiempo." Special issue, *Luna Córnea* 26 (2003).

Hernández-Claire, José. *De sol a sol.* Guadalajara: Universidad de Guadalajara, 1997.

Herrera, Hayden. *Frida: A Biography of Frida Kahlo.* New York: Harper and Row, 1983.

Hershfield, Joanne. *The Invention of Dolores del Río.* Minneapolis: University of Minnesota Press, 2000.

Hershfield, Joanne, and David Maciel, eds. *Mexico's Cinema: A Century of Film and Filmmakers.* Wilmington, Del.: Scholarly Resources, 1999.

Hooks, Margaret. *Tina Modotti: Photographer and Revolutionary.* New York: Pandora, 1993.

Hugo Brehme: Fotograf-Fotógrafo. Berlin: Verlag Willmuth Arenhövel, 2004.

"Hugo Brehme: Los prototipos mexicanistas." Special issue, *Alquimia* 16 (2002–2003).

Hugo Brehme: Pueblos y paisajes de México. Mexico City: Porrúa-INAH, 1992.

Imagen histórica de la fotografía en México. Mexico City: Instituto Nacional de Antropología e Historia, 1978.

"El imaginario de Luis Marquéz." Special issue, *Alquimia* 10 (2000).

Los inicios del México contemporáneo: Fotografías Fondo Casasola. Mexico City: Conaculta, 1997.

Isaac, Alberto. *Conversaciones con Gabriel Figueroa.* Guadalajara: Universidad de Guadalajara, 1993.

Iturbide, Graciela. *En el nombre del padre.* Mexico City: Ediciones Toledo, 1993.

————. *Graciela Iturbide: Sueños de papel.* Mexico City: Fondo de Cultura Económica, 1985.

————. *Images of the Spirit.* New York: Aperture, 1996.

Iturbide, Graciela, and Elena Poniatowska. *Juchitán de las mujeres.* Mexico City: Ediciones Toledo, 1989.

Jablonska, Alexandra, and Juan Felipe Leal. *La revolución mexicana en el cine nacional, 1911–1917.* Mexico City: Universidad Pedagógica Nacional, 1997.

Jackson, Gabriel. *The Spanish Republic and the Civil War, 1931–1939.* Princeton, N.J.: Princeton University Press, 1965.

Jefes, héroes y caudillos: Archivo Casasola. Mexico City: Fondo de Cultura Económica, 1986.

Jeffrey, Ian. *Photography: A Concise History.* London: Thames and Hudson, 1981.

Jimenéz, Blanca, and Samuel Villela. *Los Salmerón: Un siglo de fotografía en Guerrero*. Mexico City: Instituto Nacional de Antropología e Historia, 1998.

José Guadalupe Posada: Ilustrador de la vida mexicana. Mexico City: Fondo Editorial de la Plástica Mexicana, 1992.

Joseph, Gilbert M., and Timothy J. Henderson, eds. *The Mexico Reader: History, Culture, Politics*. Durham, N.C.: Duke University Press, 2002.

Joseph, Gilbert M., Anne Rubenstein, and Eric Zolov, eds. *Fragments of a Golden Age: The Politics of Culture in Mexico since 1940*. Durham, N.C.: Duke University Press, 2001.

Kahlo, Guillermo. *Mexiko 1904*. Mexico City: Universidad Iberoamericana, 2002.

Katz, Friedrich. *Imágenes de Pancho Villa*. Mexico City: Era, 1999.

———. *The Life and Times of Pancho Villa*. Stanford, Calif.: Stanford University Press, 1998.

———. *The Secret War in Mexico: Europe, the United States, and the Mexican Revolution*. Chicago: University of Chicago Press, 1981.

Kee, Robert. *The "Picture Post" Album*. London: Barrie and Jenkins, 1989.

Kismaric, Susan. *Manuel Alvarez Bravo*. New York: Museum of Modern Art, 1997.

Knight, Alan. *The Mexican Revolution*. 2 volumes. Lincoln: University of Nebraska Press, 1990.

———. "The Rise and Fall of Cardenismo." In *Mexico since Independence*, edited by Leslie Bethell, 241–320. Cambridge: Cambridge University Press, 1991.

Krauze, Enrique. *Biografía del poder*. 8 volumes. Mexico City: Fondo de Cultura Económica, 1987.

Krippner, James. "Traces, Images and Fictions: Paul Strand in Mexico, 1932–1934." *The Americas* 63, no. 3 (2007): 359–83.

¡Las once y serenooo! Tipos mexicanos. Siglo XIX. Mexico City: Conaculta, 1994.

Lavrentiev, Alexander. *Alexander Rodchenko: Photography, 1924–54*. Edison, N.J.: Knickerbocker Press, 1996.

Lawson, Chappel H. *Building the Fourth Estate: Democratization and the Rise of a Free Press in Mexico*. Berkeley: University of California Press, 2002.

Lear, John. "Mexico City: Space and Class in the Porfirian Capital, 1884–1910." *Journal of Urban History* 22, no. 4 (1996): 454–92.

Leduc, Paul, and José Joaquín Blanco. *Frida: Naturaleza viva*. Puebla: Universidad Autónoma de Puebla, 1992.

Lempériere, Annick. "Los dos centenarios de la independencia mexicana (1910–1921): De la historia patria a la antropología cultural." *Historia mexicana* 45, no. 2 (1995): 317–52.

Leñero, Vicente. *Los periodistas*. Mexico City: Joaquín Mortiz, 1978.

Lerner, Jesse. "La exportación de lo mexicano: Hugo Brehme en casa y en el extranjero." In "Hugo Brehme. Los prototipos mexicanistas." Special issue, *Alquimia* 16 (2002–2003): 30–38.

Leyda, Jay. *Films Beget Films: A Study of the Compilation Film*. New York: Hill and Wang, 1964.

Livingstone, Jane. *M. Alvarez Bravo*. Washington, D.C.: Corcoran Gallery of Art, 1978.

Lomnitz, Claudio. *Deep Mexico, Silent Mexico: An Anthropology of Nationalism*. Minneapolis: University of Minnesota Press, 2001.

López de Nava Camarena, Rodolfo. *Mis hechos de campaña*. Mexico City: Instituto Nacional de Estudios Históricos de la Revolución Mexicana, 1995.

Lowe, Sarah M. *Tina Modotti: Photographs*. New York: Harry Abrams, 1995.

Lukács, George. *The Historical Novel*. Translated by Hannah and Stanley Mitchell. Harmondsworth: Penguin Books, 1969.

Lutz, Catherine A., and Jane L. Collins. *Reading National Geographic*. Chicago: University of Chicago Press, 1993.

MacLachlan, Colin M., and William H. Beezley. *El Gran Pueblo: A History of Greater Mexico*. Englewood Cliffs, N.J.: Prentice Hall, 1994.

Malagón Girón, Beatriz. "La fotografía de Winfield Scott: Entre la producción comercial y la calidad estética de la fotografía." Ph.D. diss., Universidad Nacional Autónoma de México, 2003.

Manrique, Jorge Alberto. "Guillermo Kahlo: Fotógrafo oficial de monumentos." In *Guillermo Kahlo: Fotógrafo oficial de monumentos*, 11–17. Mexico: Casa de las Imágenes, 1992.

Martí, José. *Obras completas*, vol. 1. Havana: Editorial Nacional de Cuba, 1963.

Martínez, Andrea. *La intervención norteamericana: Veracruz, 1914*. Mexico City: Martín Casillas, 1982.

Martínez, Eneac. *Mixtecos: Norte, sur*. Mexico City: Grupo Desea, 1994.

Massé Zendejas, Patricia. *Cruces y Campa: Una experiencia mexicana del retrato tarjeta de visita*. Mexico City: Conaculta, 2000.

———. "Photographs of Mexican Prostitutes in 1865." In "Mexican Photography," edited by John Mraz. Special issue, *History of Photography* 22, no. 4 (1996): 231–34.

———. *Simulacro y elegancia en tarjetas de visita: Fotografías de Cruces y Campa*. Mexico City: Instituto Nacional de Antropología e Historia, 1998.

Mata, Francisco. *México Tenochtitlán*. Mexico City: Conaculta, 2005.

Matus, Mireya B. "Retratos hablados." In "Héctor García y su tiempo." Special issue, *Luna Córnea* 26 (2003): 7–15.

Matute, Álvaro. "Memoria e imagen de la revolución mexicana: Articulación y desarticulación textual." *Estudios de historia moderna y contemporánea de México* 24 (2002): 79–101.

Mayer, Leticia. "El proceso de recuperación simbólica de cuatro héroes de la Revolución mexicana de 1910 a través de la prensa nacional." *Historia Mexicana* 45, no. 2 (1995): 353–81.

Medina, Ana Milagros. "Tin Tan: El pachuco de oro." Special supplement, *Encuadre* (Caracas) 21 (1994): 1–23.

Mendoza Áviles, Mayra. "La colección Hugo Brehme." In "Hugo Brehme: Los prototipos mexicanistas." Special issue, *Alquimia* 16 (2002–2003): 41–43.

México: Una nación persistente. Hugo Brehme, fotografías. Mexico City: Conaculta, 1995.

Mexico: The Revolution and Beyond; Photographs by Agustín Víctor Casasola, 1900–1940. New York: Aperture, 2003.

México y las colonias extranjeras en el Centenario de la Independencia. Mexico City: Bouligny and Schmidt, 1910.

Meyer, Eugenia, ed. *Cuadernos de la Cineteca Nacional: Testimonios para la historia del cine mexicano,* vols. 4 and 6. Mexico City: Secretaría de Gobernación, 1976.

Meyer, Michael C. *Huerta: A Political Portrait.* Lincoln: University of Nebraska Press, 1972.

Meyer, Pedro. *Espejos de espinas.* Mexico City: Fondo de Cultura Económica, 1985.

———. "Inside the USA." In *Between Worlds: Contemporary Mexican Photography,* edited by Trisha Ziff, 46–57. New York: Impressions, 1990.

———. *Verdades y ficciones: Un viaje de la fotografía documental a la digital.* Mexico City: Casa de las Imágenes, 1995.

Miquel, Ángel. *Acercamientos al cine silente mexicano.* Cuernavaca: Universidad Autónoma del Estado de Morelos, 2005.

———. "El registro de Jesús H. Abitia de las campañas constitucionalistas." In Miquel, Pick, and de la Vega Alfaro, *Fotografía, cine y literatura de la Revolución mexicana,* 6–30. Morelos: Universidad Autónoma del Estado de Morelos, 2004.

———. *Salvador Toscano.* Mexico: Universidad de Guadalajara, 1997.

Miquel, Ángel, Zuzana M. Pick, and Eduardo de la Vega Alfaro. *Fotografía, cine y literatura de la Revolución mexicana.* Morelos: Universidad Autónoma del Estado de Morelos, 2004.

Mistron, Deborah. "A Hybrid Subgenre: The Revolutionary Melodrama in the Mexican Cinema." *Studies in Latin American Popular Culture* 3 (1984): 47–56.

Modotti, Tina. "On Photography." *Mexican Folkways* 5, no. 4 (1929): 196–98.

Monroy Nasr, Rebeca. "Ases de la cámara." *Luna Córnea* 26 (2003): 18–29.

———. *Historias para ver: Enrique Díaz, fotorreportero.* Mexico City: Universidad Nacional Autónoma de México, 2003.

Monsiváis, Carlos. *Días de guardar.* Mexico City: Era, 1970.

———. "María Félix: Pabellón de la imagen." *Intermedios* 6 (1993): 12–17.

———. *Mexican Postcards.* Edited by John Kraniaukas. London: Verso, 1997.

———. "Las mitologías del cine mexicano." *Intermedios* 2 (1992): 12–23.

———. "Sociedad y Cultura." In *Entre la guerra y la estabilidad política: El México de los 40,* edited by Rafael Loyola, 259–80. Mexico City: Conaculta, 1990.

Montellano, Francisco. *C. B. Waite, Fotógrafo: Una mirada diversa sobre el México de principios del siglo xx*. Mexico City: Grijalbo, 1994.

Montes, Mónica. "Preso No. 46788." In "Héctor García y su tiempo." Special issue, *Luna Córnea* 26 (2003): 76–81.

Montiel Pagés, Gustavo. "Pancho Villa: el mito y el cine." In "El cine y la revolución mexicana." Special issue, *Filmoteca* 1 (1979): 100–109.

Mora, Carl. *Mexican Cinema: Reflections of a Society, 1896–1980*. Berkeley: University of California Press, 1982.

Morales, Alfonso. "Luces y sombras del Centenario I." *Luna Córnea* 12 (1997): 67–71.

Morales, Miguel Ángel. "La celebre fotografía de Jerónimo Hernández." *Alquimia* 27 (2006): 68–75.

Moreno, Mario. "Retrato de 'Cantinflas.'" In *Cantinflas: Apología de un humilde*, edited by Javier Castelazo, 65–73. Mexico City: Editorial Paralelo, n.d.

Moreno Rivas, Yolanda. *Historia de la música popular mexicana*. Mexico City: Conaculta, 1989.

Moyssén, Xavier, ed. *Diego Rivera: Textos de arte*. Mexico City: Universidad Nacional Autónoma de México, 1986.

———. "Pintura popular y costumbrista del siglo xix." *Artes de México* 61 (1965): 13–26.

Mraz, John. "Close-up: An Interview with the Hermanos Mayo, Spanish-Mexican Photojournalists (1930s-Present)." *Studies in Latin American Popular Culture* 11 (1992): 195–218.

———. "'En calidad de esclavas': Obreras en los molinos de nixtamal, México, diciembre, 1919." *Historia obrera* 24 (1982): 2–14.

———. "Fotografiar el 68." *Política y cultura* 9 (1997): 105–28.

———. "Foto Hermanos Mayo: A Mexican Collective." *History of Photography* 17, no. 1 (1993): 81–89.

———. "How Real Is Reel? Fernando de Fuentes's Revolutionary Trilogy." In *Framing Latin American Cinema: Contemporary Critical Perspectives*, edited by Ann Marie Stock, 92–119. Minneapolis: University of Minnesota Press, 1997.

———. "*Memories of Underdevelopment*: Bourgeois Consciousness/Revolutionary Context." In *Revisioning History: Film and the Construction of a New Past*, edited by Robert Rosenstone, 102–14. Princeton: Princeton University Press, 1995.

———, ed. "Mexican Photography." Special issue, *History of Photography* 22, no. 4 (1996).

———. *La mirada inquieta: Nuevo fotoperiodismo mexicano, 1976–1996*. Mexico City: Conaculta, 1996.

———. *Nacho López, Mexican Photographer*. Minneapolis: University of Minnesota Press, 2003.

―――. "The New Photojournalism of Mexico, 1976–1998." *History of Photography* 22, no. 4 (Winter 1998): 312–65.

―――. "Picturing Mexico's Past: Photography and *Historia Gráfica*." *South Central Review* 21, no. 3 (2004): 24–45.

―――. "Representing the Mexican Revolution: Bending Photographs to the Will of *Historia Gráfica*." In *Photography and Writing in Latin America*, edited by Marcy E. Schwartz and Mary Beth Tierney-Tello, 21–39. Albuquerque: University of New Mexico Press, 2006.

―――. "The Revolution Is History: Filming the Past in Mexico and Cuba." In "Cinema and History in Latin America," edited by John Mraz. Special issue, *Film Historia* 9, no. 2 (1999): 147–67.

―――. "Santiago Alvarez: From Dramatic Form to Direct Cinema." In *The Social Documentary in Latin America*, edited by Julianne Burton, 131–49. Pittsburgh: University of Pittsburgh Press, 1990.

―――. "Sebastião Salgado: Ways of Seeing Latin America." *Third Text* 16, no. 1 (2002): 15–30.

―――. "Some Visual Notes toward a Graphic History of the Mexican Working Class." *Journal of the West* 27, no. 4 (1988): 64–74.

―――. "Today, Tomorrow and Always: The Golden Age of Illustrated Magazines in Mexico, 1937–1960." In *Fragments of a Golden Age: The Politics of Culture in Mexico since 1940*, edited by Gilbert Joseph, Anne Rubenstein, and Eric Zolov, 116–57. Durham, N.C.: Duke University Press, 2001.

Mraz, John, and Raymond Tracy. "Classroom Production of an Historical Film-Essay: Reflections and Guidelines." *History Teacher* 7, no. 4 (1974): 540–51.

Mraz, John, and Jaime Vélez Storey. *Trasterrados: Braceros vistos por los Hermanos Mayo*. Mexico City: Archivo General de la Nación, 2005.

―――. *Uprooted: Braceros in the Hermanos Mayo Lens*. Houston: Arte Público Press, 1996.

Nación de imágenes: La litografía mexicana del siglo XIX. Mexico City: Museo Nacional de Arte, 1994.

Naggar, Carole, and Fred Ritchin, eds. *México through Foreign Eyes*. New York: Norton, 1993.

Navarrete, José Antonio. "Del tipo al arquetipo: Fotografía y tipos nacionales en América Latina." *Extra-Camara* 21 (2003): 34–43.

Negrete Álvarez, Claudia. *Valleto Hermanos: Fotógrafos mexicanos de entresiglos*. Mexico City: Universidad Nacional Autónoma de México, 2006.

Niblo, Stephen R. *Mexico in the 1940s: Modernity, Politics, and Corruption*. Wilmington, Del.: Scholarly Resources, 1999.

Noble, Andrea. *Mexican National Cinema*. London: Routledge, 2005.

―――. "Photography and Vision in Porfirian Mexico." In "Cultura visual en

América Latina," edited by John Mraz. Special issue, *Estudios Interdisciplinarios de América Latina y el Caribe* (Tel Aviv) 9, no. 1 (1998): 121–31.

Novelo, Manuel F., ed. *Album conmemorativo de la visita del Sr. General de División D. Pablo González, a la Ciudad de Toluca*. Toluca: Santiago Galas, 1916.

Novo, Salvador. *New Mexican Grandeur*. Mexico City: Petróleos Mexicanos, 1967.

Ochoa Sandy, Gerardo. "Historia de un archivo." *Luna Córnea* 13 (1997): 10–15.

O'Malley, Ilene V. *The Myth of the Revolution: Hero Cults and the Institutionalization of the Mexican State, 1920–1940*. New York: Greenwood Press, 1986.

Orme, William, ed. *A Culture of Collusion: An Inside Look at the Mexican Press*. Miami: University of Miami, 1997.

Ortiz Garza, José Luis. *México en guerra: La historia secreta de los negocios entre empresarios mexicanos de la comunicación, los nazis y E.U.A.* Mexico City: Planeta, 1989.

O'Shaughnessy, Edith. *A Diplomat's Wife in Mexico*. New York: Harper and Brothers, 1916.

Overmyer-Velázquez, Mark. *Visions of the Emerald City: Modernity, Tradition, and the Formation of Porfirian Oaxaca, Mexico*. Durham, N.C.: Duke University Press, 2006.

Pacheco, Cristina. "Gustavo Casasola: Todos nuestro ayeres." In *La luz de México: Entrevistas con pintores y fotógrafos*, edited by Cristina Pacheco, 116–25. Mexico City: Fondo de Cultura Económica, 1988.

Paranaguá, Paolo Antonio. *Tradición y modernidad en el cine de América Latina*. Mexico City: Fondo de Cultura Económica, 2003.

Paredes, Américo. "Estados Unidos, México y el machismo." *Journal of Inter-American Studies* 9, no. 1 (1967): 65–84.

Parker, Fred L. *Manuel Alvarez Bravo*. Pasadena: Pasadena Art Museum, 1971.

Paz, Octavio. *The Labyrinth of Solitude: Life and Thought in Mexico*. Translated by Lysander Kemp. New York: Grove Press, 1961.

———. "Razón y elogio a María Félix." In *María Félix*, 7–13. Mexico City: Cineteca Nacional, 1992.

Peña, Alejandrina. "F 2.8: La vida en el instante." In "Héctor García y su tiempo." Special issue, *Luna Córnea* 26 (2003): 38–50.

Pérez, Ismael Diego. *Cantinflas: Genio del humor y del absurdo*. Mexico City: Indo-Hispana, 1954.

Pérez Montfort, Ricardo. *Avatares del nacionalismo cultural*. Mexico City: Centro de Investigaciones y Estudios Superiores en Antropología Social, 2000.

———. *Estampas de nacionalismo popular mexicano*. Mexico City: Centro de Investigaciones y Estudios Superiores en Antropología Social, 2003.

———. *Expresiones populares y estereotipos culturales en México: Siglos XIX y XX*. Mexico City: Centro de Investigaciones y Estudios Superiores en Antropología Social, 2007.

————, ed. *Hábitos, normas y escándalo: Prensa, criminalidad y drogas durante el porfiriato tardío*. Mexico City: Plaza y Valdés, 1997.

————. "Indigenismo, hispanismo y panamericanismo en la cultura popular mexicana de 1920 a 1940." In *Cultura e identidad nacional*, edited by Roberto Blancarte, 343–83. Mexico City: Fondo de Cultura Económica, 1994.

Pérez Turrent, Tomás. *Canoa: Memoria de un hecho vergonzoso: La historia, la filmación, el guión*. Puebla: Universidad Autónoma de Puebla, 1984.

Pfitzer, Gregory M. *Picturing the Past: Illustrated Histories and the American Imagination, 1840–1900*. Washington, D.C.: Smithsonian Institution Press, 2002.

Piccato, Pablo. *City of Suspects: Crime in Mexico City, 1900–1931*. Durham, N.C.: Duke University Press, 2001.

Pilcher, Jeffrey. *Cantinflas and the Chaos of Mexican Modernity*. Wilmington, Del.: Scholarly Resources, 2001.

————. *¡Que vivan los tamales! Food and the Making of Mexican Identity*. Albuquerque: University of New Mexico Press, 1998.

Place, J. A., and L. S. Peterson. "Some Visual Motifs of Film Noir." In *Movies and Methods*, edited by Bill Nichols, 325–38. Berkeley: University of California Press, 1976.

El poder de la imagen y la imagen del poder: Fotografías de prensa del porfiriato a la época actual. Chapingo: Universidad Autónoma Chapingo, 1985.

Poniatowska, Elena. *La noche de Tlatelolco*. Mexico City: Era, 1971.

————. *Las soldaderas*. Mexico City: Era, 1999.

————. *Todo México*. Volume 3, *La mirada que limpia*. Mexico City: Editorial Diana, 1996.

Poole, Deborah. "An Image of 'Our Indian': Type Photographs and Racial Sentiments in Oaxaca, 1920–1940." *Hispanic American Historical Review* 84, no. 1 (2004): 37–82.

————. *Vision, Race, and Modernity: A Visual Economy of the Andean Image World*. Princeton, N.J.: Princeton University Press, 1997.

Pratt, Mary Louise. *Imperial Eyes: Travel Writing and Transculturation*. New York: Routledge, 1992.

Prochaska, David. "The Archive of *Algérie Imaginaire*." *History and Anthropology* 4 (1990): 373–420.

Ramírez, Fausto. "El arte del siglo XIX." In *Historia del Arte Mexicano*, vol. 9, edited by Jorge Manrique, 1214–1231. Mexico City: Salvat, 1986.

————. "La visión europea de la América Tropical: Los artistas viajeros." In *Historia del Arte Mexicano*, vol. 10, edited by Jorge Manrique, 1366–91. Mexico City: Salvat, 1986.

Ramírez, Patricia Priego, and José Antonio Rodríguez. *La manera en que fuimos: Fotografía y sociedad en Querétaro: 1840–1930*. Mexico City: Jérico, 1989.

Ramírez Berg, Charles. *Cinema of Solitude: A Critical Study of Mexican Film, 1967–1983.* Austin: University of Texas Press, 1992.

———. "Figueroa's Skies and Oblique Perspective: Notes on the Development of the Classical Mexican Style." *Spectator* 13, no. 1 (1992): 24–41.

Ramón, David. "Lectura de las imágenes propuestas por el cine mexicano de los años treinta a la fecha." In *80 años de cine en México*, edited by Aurelio de los Reyes et al., 93–120. Mexico City: Universidad Nacional Autónoma de México, 1977.

Ramos, Samuel. *Profile of Man and Culture in Mexico.* Translated by Peter G. Earle. Austin: University of Texas Press, 1962.

Reese, Thomas E., and Carol McMichael Reese. "Revolutionary Urban Legacies: Porfirio Díaz's Celebrations of the Centennial of Mexican Independence in 1910." In *Arte, historia e identidad en América: Visiones comparativas*, vol. 2, edited by Gustavo Curiel et al., 361–73. Mexico City: Universidad Nacional Autónoma de México, 1994.

"La revolución mexicana: Filmografía básica." In "El cine y la revolución mexicana." Special issue, *Filmoteca* 1 (1979): 120–25.

Reyes Nevares, Beatrice. *The Mexican Cinema: Interviews with Thirteen Directors.* Albuquerque: University of New Mexico Press, 1976.

Riguzzi, Paolo. "México próspero: Las dimensiones de la imagen nacional en el porfiriato." *Historias* 20 (1988): 137–57.

Riley, Luisa. "Gironella y sus entierros." In "Héctor García y su tiempo." Special issue, *Luna Córnea* 26 (2003): 264–77.

Robles, Xavier, and Guadalupe Ortega. *Rojo amanecer.* Mexico City: Ediciones El Milagro-IMCINE, 1995.

Rodrigo Moya: Foto insurrecta. Mexico City: Ediciones El Milagro, 2004.

Rodríguez, Antonio. *Homenaje a los fotógrafos de prensa (México visto por los Fotógrafos de Prensa).* Mexico City: Asociación Mexicana de Fotógrafos de Prensa, 1947.

Rodríguez, José Antonio. "La construcción de un imaginario." In *Hugo Brehme: Fotograf-Fotógrafo.* Berlin: VerlagWillmuth Arenhövel, 2004.

———. "La mirada de la ruptura." In *Edward Weston: La mirada de la ruptura.* Mexico City: Conaculta, 1994.

———. "Vamos a México." In "El viaje ilustrado. Fotógrafos extranjeros en México." Special issue, *Alquimia* 5 (1999): 32–38.

Rodríguez Castañeda, Rafael. *Prensa vendida: Los periodistas y los presidentes: 40 años de relaciones.* Mexico City: Grijalbo, 1993.

Rodríguez Cruz, Olga. *El 68 en el cine mexicano.* Puebla: Universidad Iberamericana-Plantel Golfo Central, 2000.

Rodríguez Hernández, Georgina. "Niños desnudos en el porfiriato." *Luna Córnea* 9 (1996): 44–49.

Rodríguez Lapuente, Manuel. *Breve historia gráfica de la Revolución Mexicana*. Mexico City: G.Gili, 1987.

Rosen, Jeff. "Posed as Rogues: The Crisis of Photographic Realism in John Thompson's *Street Life in London*." *Image* 36, nos. 3–4 (1993): 17–39.

Rosenblum, Naomi. *A World History of Photography*. New York: Abbeville Press, 1989.

Rostros de México. Fotografías de Bernice Kolko. Mexico City: Universidad Nacional Autónoma de México, 1966.

Rubenstein, Anna. "Bodies, Cities, Cinema: Pedro Infante's Death as Political Spectacle." In *Fragments of a Golden Age: The Politics of Culture in Mexico since 1940*, edited by Gilbert Joseph, Anne Rubenstein, and Eric Zolov, 199–233. Durham, N.C.: Duke University Press, 2001.

Ruíz, Ramón Eduardo. *The Great Rebellion: Mexico, 1905–1924*. New York: Norton, 1980.

Rutherford, John. *Mexican Society during the Revolution: A Literary Approach*. London: Oxford University Press, 1971.

Saborit, Antonio. *"El Mundo Ilustrado" de Rafael Reyes Espíndola*. Mexico City: Centro de Estudios de Historia de México Condumex, 2003.

Salas, Elizabeth. *Soldaderas in the Mexican Military: Myth and History*. Austin: University of Texas Press, 1990.

Sánchez, Francisco. *Crónica antisolemne del cine mexicano*. Veracruz: Universidad Veracruzana, 1989.

Sánchez Estevez, José Luis. "Luis Márquez Romay y su obra: Apuntes sobre la búsqueda del nacionalismo cultural en México." Licenciatura thesis, Centro Universitario de Ciencias Humanas, 1990.

Sandweiss, Martha, Rick Stewart, and Ben Huseman, eds. *Eyewitness to War: Prints and Daguerreotypes of the Mexican War, 1846–1848*. Washington, D.C.: Smithsonian Institution Press, 1989.

Sange, Jean. "All Kinds of Portraits." In *A New History of Photography*, edited by Michel Frizot, 102–29. Cologne: Könemann, 1998.

Saynes-Vázquez, Edaena. "'Galán Pa dxandi: That Would Be Great if it were True': Zapotec Women's Comment on Their Role in Society." *Identities* 3, nos. 1–2 (1996): 183–204.

Schmidt, Henry C. *The Roots of Lo Mexicano: Self and Society in Mexican Thought, 1900–1934*. College Station: Texas A&M University Press, 1978.

Segre, Erica. *Intersected Identities: Strategies of Visualisation in Nineteenth- and Twentieth-Century Mexican Culture*. New York and Oxford: Berghahn Books, 2007.

Semblantes mexicanos de Bernice Kolko. Mexico City: Instituto Nacional de Antropología e Historia, 1968.

Serrano, Francisco. "*¡Vámonos con Pancho Villa!*," *Cine* 8 (1978): 57–64.

Sherman, William, and Richard Greenleaf. *Victoriano Huerta: A Reappraisal.* Mexico City: Mexico City College, 1960.

Siqueiros, David Álfaro. *Me llamaban El Coronelazo.* Mexico City: Grijalbo, 1977.

Smith, Phyllis L. "Contentious Voices amid the Order: The Opposition Press in Mexico City, 1876–1911." *Journalism History* 22, no. 4 (1997):135–45.

Snow, Sinclair. Introduction to *Barbarous Mexico*, by John Kenneth Turner, xi–xxix. Rev. ed. Austin: University of Texas Press, 1969.

Sontag, Susan. *On Photography.* New York: Dell Publishing, 1973.

Stam, Robert. "*The Hour of the Furnaces* and the Two Avant-Gardes." In *The Social Documentary in Latin America*, edited by Julianne Burton, 251–66. Pittsburgh: University of Pittsburgh Press, 1990.

Stark, Amy, ed. "The Letters from Tina Modotti to Edward Weston." Special issue, *The Archive* 22 (1986).

Stewart, Rick. "Artists and Printmakers of the Mexican War." In *Eyewitness to War: Prints and Daguerreotypes of the Mexican War, 1846–1848*, edited by Martha Sandweiss, Rick Stewart, and Ben Huseman, 4–43. Washington, D.C.: Smithsonian Institution Press, 1989.

Strauss Neuman, Martha. *El reconocimiento de Álvaro Obregón: Opinión americana y propaganda mexicana (1921–1923).* Mexico City: Universidad Nacional Autónoma de México, 1983.

Taibo, Paco Ignacio, I. *El Indio Fernández: El cine por mis pistolas.* Mexico City: Joaquín Mortiz, 1986.

———. *María Félix: 47 pasos por el cine.* Mexico City: Joaquin Mortiz-Planeta, 1985.

Tal, Tzvi. "Del cine-guerrilla a lo 'grotético'—La representación cinematográfica del latinoamericanismo en dos films de Fernando Solanas: *La hora de los hornos* y *El viaje.*" In "Cultura visual en América Latina," edited by John Mraz. Special issue, *Estudios Interdisciplinarios de América Latina y el Caribe* (Tel Aviv) 9, no. 1 (1998): 39–54.

Taylor, Liba. "Manuel Alvarez Bravo." *British Journal of Photography* 6751 (1990): 27–31.

Tenorio, Mauricio. "1910 Mexico City: Space and Nation in the City of the Centenario." *Journal of Latin American History* 28, no. 1 (1996): 75–104.

Tibol, Raquel. *Episodios fotográficos.* Mexico City: Libros de *Proceso*, 1989.

¡Tierra y Libertad! Photographs of Mexico, 1900–1935, from the Casasola Archive. Oxford: Museum of Modern Art, Oxford, 1985.

Tina Modotti, with an essay by Margaret Hooks. Köln: Könemann, 1999.

Trachtenberg, Alan. *Reading American Photographs: Images as History: Mathew Brady to Walker Evans.* New York: Hill and Wang, 1989.

Tuñon, Julia. *En su propio espejo: (Entrevista con Emilio "El Indio" Fernández).* Mexico City: Universidad Autónoma Metropolitana-Iztapalapa, 1988.

———. "*Enamorada* en Madrid: La recepción de una película mexicana en la España franquista." In *Imágenes cruzadas: México y España, siglos XIX y XX*, edited by Ángel Miquel, Jesús Nieto Sotelo, and Tomás Pérez Vejo, 114–43. Morelos: Universidad Autónoma del Estado de Morelos, 2005.

———. "Entre lo público y lo privado: El llanto en el cine mexicano de los años cuarenta." *Historias* 34 (1995): 109–18.

———. "Una escuela en celuloide: El cine de Emilio 'Indio' Fernández o la obsesión por la educación." *Historia mexicana* 48, no. 2 (1998): 437–70.

———. "Femininity, 'Indigenismo,' and Nation: Film Representation by Emilio 'El Indio' Fernández." In *Sex in Revolution: Gender, Politics, and Power in Modern Mexico*, edited by Jocelyn Olcott, Mary Kay Vaughan, and Gabriela Cano, 81–96. Durham, N.C.: Duke University Press, 2006.

———. *Los rostros de un mito: Personajes femininos en las películas de Emilio Indio Fernández*. Mexico City: Conaculta, 2000.

Turner, John Kenneth. *Barbarous Mexico*. Chicago: Charles Company Cooperative, 1911.

Turok, Antonio. *The End of Silence*. New York: Aperture, 1998.

Uranga, Emilio. "Ontología del mexicano." In *Anatomía del mexicano*, edited by Roger Bartra, 145–58. Mexico City: Plaza Janés, 2002.

Valdés Julián, Rosalía. *La historia inédita de Tin Tan*. Mexico City: Planeta, 2003.

Valtierra, Pedro. *Zacatecas*. Mexico City and Zacatecas: Universidad de Zacatecas and Cuartoscuro, 1999.

Vanderwood, Paul. "The Image of Mexican Heroes in American Films." *Film Historia* 2, no. 3 (1992): 221–44.

———, ed. *Juárez*. Madison: University of Winconsin Press, 1983.

Vanderwood, Paul, and Frank Sampanaro. *Border Fury: A Picture Postcard Record of Mexico's Revolution and U.S. War Preparedness, 1910–1917*. Albuquerque: University of New Mexico Press, 1988.

Vásquez Mantecón, Álvaro. "El monumento a la Revolución en el cine." *Fuentes humanísticas* 31 (2005): 45–59.

Vaughan, Mary Kay. *Cultural Politics in Revolution: Teachers, Peasants, and Schools in Mexico, 1930–1940*. Tucson: University of Arizona Press, 1997.

Vélez Storey, Jaime, et al. *El ojo de vidrio: Cien años de fotografía del México indio*. Mexico City: Bancomext, 1993.

Vera Trejo, Heladio. "Guillermo Kahlo: Su equipo y su técnica." In *Guillermo Kahlo: Vida y obra*. Mexico City: Museo Estudio Diego Rivera, 1993.

Walter Reuter: Berlin-Madrid-México: 60 años de fotografía y cine, 1930–1960. Berlin: Neue Gesellschaft für Bildende Kunst, 1992.

Willumson, Glenn G. *W. Eugene Smith and the Photographic Essay*. Cambridge: Cambridge University Press, 1992.

Womack, John. *Zapata and the Mexican Revolution*. New York: Knopf, 1968.

The World of Agustín Víctor Casasola, Mexico: 1900–1938. Washington. D.C.: Fondo del Sol Visual Arts and Media Center, 1984.

Yeager, Gene. "Porfirian Commercial Propaganda: Mexico in the World Industrial Expositions." *The Americas* 34, no. 2 (1977): 230–43.

Yépez, Heriberto. "Como leer a Pedro Infante." *Confabulario* 155 (2007): 4–8. Supplement of *El Universal*, 7 April 2007.

Zea, Leopoldo. *The Latin American Mind*. Translated by James Abbott and Lowell Dunham. Norman: University of Oklahoma Press, 1963.

Zolov, Eric. *Refried Elvis: The Rise of the Mexican Counterculture*. Berkeley: University of California Press, 1999.

INDEX

photographs of, 4–5; picture histories and, 194, 228; of Porfiriato, 48–49; in *Prisionero 13*, 94; of revolutions, 72; vision of, 5

Hoy, 9, 130, 153, 155–58, 161, 170, 174, 176; *Life* as model for, 154

Huerta, Efraín, 162, 185

Huerta, Victoriano, 61, 64–66, 91, 115, 194; frame enlargement of, 96; icon of, 67, 234–35

Huertistas, 92; in films, 93–98, 104

Identity: Centenary of the Consummation of Independence (1921) and, 73; Centennial of Independence (1910) and, 54–58; construction of, 2, 66; extremes poles of, 159–60; film and, 112, 119; folk culture and, 84–85; Indians and, 220, 222; irony and, 86; Mexican obsession with, 6–7, 158–60; Mexico City and, 172; Modotti and, 83; photojournalism and, 170, 177, 188; of Porfiriato, 40, 47–49; in *Prisionero 13*, 94; of prostitutes, 22; revolution and, 76, 91; revolutionary icons and, 67; in *tarjetas de visita*, 20–26; transculturalism and, 235–44; transformation of, 120, 122–23. *See also Mexicanidad*; Nationalism

Illustrated magazines, 3, 9, 80, 153–55, 250; Cantinflas and Tin Tan in, 121, 130; celebrity-stars and, 118–19; conservatism of, 158; in Mexican Revolution, 61; *Mexicanidad* and, 156–60; national identity and, 119; pachucos and, 130; presidentialism and, 157; United States depicted in, 156, 160–61; wealth depicted in, 163. *See also individual publications*

Imparcial, El, 34–37, 42–44, 48–50, 54, 64, 66–67, 70; *nota roja* in, 45–47, 51–53

Imperialism, 72, 160, 190; internal, 83; of scientific expeditions, 29. *See also* Neocolonialism

Indians (Indigenous peoples), 7–10, 83, 118, 122, 165, 172, 177, 245; in *Albúm histórico gráfico*, 73; Álvarez Bravo's photographs of, 87, 90; Baroque churches built by, 42; Brehme's photographs of, 80; in Casasola's picture histories, 195, 198; Centenary of the Consummation of Independence (1921) and, 73; Centennial of Independence (1910) and, 55; Congress of Americanists and, 56; under Díaz, 37–38; exclusion from *El Mundo Ilustrado* of, 47–48; in films, 111, 125, 138–39, 142, 145–48, 151; Gamio and, 125; García's photographs of, 189; music of, 204–5; as national archetypes, 222; Neo-Zapatista rebellion and, 219–20; new photojournalists and, 217, 219; photograph of, 220; physiognomy of Fernández, 107; pornography and, 223

Indigenismo, 125, 144, 146–48

Infante, Pedro, 9, 120–21, 134–35, 137, 142–43, 149, 151; as cinema idol, 141; frame enlargement of, 140; Mexican machismo, 139

Iturbide, Graciela, 10, 91, 215, 222, 225; picturesque and, 223–24

Jackson, William Henry, 7, 31–33, 35, 42

Jornada, La, 215, 221

Journalism: bribes and, 156–57, 161; in *Canoa*, 208; independent and contestatory, 215–22; official, 37–38; during Porfiriato, 43, 46; poverty neglected

181–83, 217; Mexican representations in, 60, 63–64, 242; Mexico denigrated in, 60, 95; Mexico invaded by, 7, 13, 70–72, 75, 131; photographers and filmmakers in, 59–60, 169, 171, 225–26; stars in, 119, 133, 142

United States Information Agency (USIA), 173

Universal, El, 42, 44, 46

Unomásuno, 215

Urbanization, 9, 121–22

Valtierra, Pedro, 220

¡Vámonos con Pancho Villa! (de Fuentes), 101, 105, 117; as anti-epic, 103; cost of, 100; historical detail in, 102, 104; Villa demystified in, 99, 102–4

Vasconcelos, José, 108, 159

Veracruz invasion, 70–72, 75; photograph of, 71

Villa, Pancho (Francisco), 4, 8, 60, 66–67, 73, 91, 191; in Casasola's picture histories, 197, 228; charisma of, 101; in films, 63–64, 92, 99–105, 115–16, 137; icons of, 63, 69–70, 234; in official history, 101

Violin, El, 11, 222, 245, 247–50

Virgin of Guadalupe, 2, 20–21, 135, 154; photograph of 21

Waite, Charles B., 7, 31–38, 42

Weston, Edward, 77–79, 82, 85–87, 110

Women, 9–10, 16, 19, 66; in *Albúm*

histórico gráfico, 73; as artisans in postcards, 34; in Brehme's and Modotti's photographs, 77–78; critical photojournalists and, 172; in films, 113, 115, 135–37, 142–51, 235–44; feminism, 155, 215, 222; matriarchy and, 144–45, 224; as national essence, 215, 222; new photojournalism and, 216–17; photographs of, 17, 21, 30, 35, 37, 52, 74, 78, 217, 220; in picture histories, 196, 229–34; sections in illustrated magazines for, 155; sexual harassment of, 231; in *tarjetas de visita*, 23–26

Workers, 8–9, 181; in Álvarez Bravo's photographs, 89–90; in Casasola's photographs, 50–51; critical photojournalists and, 172, 177–79; in films, 94; in illustrated magazines, 155, 176; legislation to protect, 230–31; in Modotti's photographs, 84; new photojournalists and, 216; "phantom unions" for, 210; photographs of, 178–79, 227; in picture histories, 199, 229–31; strikes by, 45, 173, 178–79, 185–86, 189, 199, 227

Zapata, Emiliano, 4, 8, 63, 65–66, 81, 91–92, 101, 189, 192, 225, 228; depiction as bandit of, 69; documentary on, 62; frame enlargement of, 96; in films, 95–99, 114–16, 242; icons of, 67–70, 234; new photojournalists and, 218–19; photograph of, 68

JOHN MRAZ is a research professor with the Instituto de Ciencias Sociales y Humanidades "Alfonso Vélez Pliego" at the Universidad Autónoma de Puebla, Mexico. He is the author of *Nacho López, Mexican Photographer* (2003); *La mirada inquieta: Nuevo fotoperiodismo mexicano* (1996); and (with Jaime Vélez Storey) *Uprooted: Braceros in the Hermanos Lens* (1996).

Library of Congress Cataloguing-in-Publication Data
Mraz, John.
Looking for Mexico : modern visual culture and national identity / John Mraz.
p. cm.
Includes bibliographical references and index.
ISBN 978-0-8223-4429-2 (cloth : alk. paper)
ISBN 978-0-8223-4443-8 (pbk. : alk. paper)
1. National characteristics, Mexican. 2. Nationalism—Mexico.
3. Photography—Social aspects—Mexico. 4. Mass media—Social aspects—
Mexico. 5. Arts and society—Mexico. I. Title.
F1210.M75 2009
305.868'72—dc22 2008055245